DEGAS: The Artist's Mind

DEGAS

The Artist's Mind

THEODORE REFF

The Belknap Press of
Harvard University Press
Cambridge, Massachusetts, and London, England
1987

Earlier versions of some of the essays in this book were published as follows: ©️ March 1971, *ARTnews*, "The Butterfly and the Old Ox," Theodore Reff; September and October 1970, *Burlington Magazine*, "Degas and the Literature of His Time"; September 1972, *Art Bulletin*, "Degas's 'Tableau de Genre'"; Autumn 1970, vol. XXXIII, *Art Quarterly*, "Degas's Sculpture, 1880–1884."

Published by arrangement with The Metropolitan Museum of Art and Harper & Row, Publishers

Library of Congress Cataloging-in-Publication Data

Reff, Theodore.
 Degas, the artist's mind.

 Reprint. Originally published: New York: Harper & Row, 1976.
 Includes index.
 1. Degas, Edgar, 1834–1917—Criticism and interpretation. I. Title.
N6853. D33R44 1987 759.4 87-11827
ISBN 0-674-19543-4 (pbk.)

for Lisa and Jonathan

though they would have preferred
a longer father and a shorter book

Contents

PREFACE, 1987

To see these essays, first published in professional journals and in a hardcover book of limited distribution, now made available to a larger audience and especially to students, is a source of great satisfaction to me. That the publication of this softcover edition roughly coincides with the mounting of a major Degas exhibition at the Metropolitan and other museums, just as the appearance of the hardcover edition coincided with my "Degas in the Metropolitan" show in 1976, makes the occasion seem still more propitious. In the decade separating these events there have been many other exhibitions, accompanied by substantial catalogues, and several ambitious monographs have appeared, as well as the first full-scale biography and a steady stream of articles and reviews. This is not the place to survey that large literature, but I do want to comment on certain aspects that bear directly on these essays (readers unfamiliar with them should probably read the rest of this preface after reading the essays themselves). For as Degas knew so well, the process of revision never ceases: "Draw a line," he advised younger artists, "redraw it, trace it, draw it again."

CHAPTER I. Another intriguing comparison with Whistler has been made. In addition to his *Symphony in White* of 1865–1867, an earlier orientalizing composition, *The Balcony* of 1864, can be compared with Degas's *Mlle Fiocre in the Ballet from "La Source"* (Charles Stuckey, "Degas as an Artist; Revised and Still Unfinished," in *Degas, Form and Space*, Centre Culturel du Marais, Paris, 1984). Since *The Balcony*, unlike the *Symphony in White*, was inaccessible to Degas, its affinities with his work can only be explained by assuming that both men had "taken up the same pictorial challenge more or less simultaneously," inspired by discussions in the artists' circle to which they belonged. Besides Whistler's influence, that of Courbet can be seen in *Mlle Fiocre*, especially in the palette-knife treatment of the background (though this may reflect later revisions), the presence of the riderless horse, and the pose of Mlle Fiocre herself (ibid.).

1

CHAPTER II. Further examples of the influence of all three artists have been proposed. That of Ingres's *Comtesse d'Haussonville* is evident not only in Degas's *Thérèse Morbilli*, but also in Tissot's *Marquise de Miramon*, which, like the Ingres, was shown at the Exposition Universelle of 1867 and, given Degas's friendship with Tissot at this time, probably also affected Degas's conception of the portrait sitter formally posed before the mantle in her drawing room (Michael Wentworth, *James Tissot*, Oxford, 1984). The influence of Delacroix's *Entry of the Crusaders into Constantinople* is apparent not only around 1860 in Degas's *Daughter of Jephthah*, but also thirty years later in his pastels and prints of a bather combing her hair, whose expressive pose, arching to the left with her long hair falling straight, clearly derives from that of the grieving woman in the foreground of the Delacroix (Richard Thomson, *The Private Degas*, Manchester, 1987). And the influence of Daumier's sculpture (discussed in Chapter VI) can be seen not only in Degas's relief *The Apple Pickers*, for which *The Emigrants* was a model, but also in his statuette *Little Dancer of Fourteen Years* in her nude state, for which the well-known *Ratapoil*, likewise shown at the Daumier retrospective in 1878, was perhaps the most important model (Charles Millard, *The Sculpture of Edgar Degas*, Princeton, 1976). Even the key idea of linking Ingres, Delacroix, and Daumier as "the three great draftsmen in the nineteenth century" evidently had a source; for as Götz Adriani has noted (*Edgar Degas: Pastelle, Ölskizze, Zeichnungen*, Cologne, 1984), Baudelaire expresses the same idea in his *Salon of 1845*: "We only know of two men in Paris who draw as well as M. Delacroix—one in an analogous, the other in a contrary manner. The first is M. Daumier, the caricaturist; the second M. Ingres, the great painter"

CHAPTER III. New information is available about a number of the works discussed. In *The Bellelli Family*, the drawing in the background does indeed represent Degas's grandfather, and not his father as is sometimes still said; the date inscribed on the closely related painting proves this conclusively (Henri Loyrette, *Degas e l'Italia*, Rome, 1984). In *The Collector of Prints*, the scattered objects on the bulletin board resemble those in European *trompe-l'oeil* paintings of letter racks as much as they do the playing cards shown in Japanese pocket-book covers (M. L. d'Otrange Mastai, *Illusion in Art*, New York, 1975). In *Hélène Rouart in Her Father's Study*, the Egyptian figurine in the glass case is not an ushabti but a Ptah-Seker-Osiris, perhaps brought back by Rouart from a trip to Egypt in 1878; the Chinese wall hanging embroidered with kylins is of a type dating from the late nineteenth century; the armchair is Rouart's own and, following a well-established iconographic tradition, stands here symbolically for him (Dillian Gordon, *Hélène Rouart in Her Father's Study*, London, 1984). Similarly, in the earlier portrait of

Hélène seated on her father's knee, the landscape behind them, though broadly simplified in Degas's version, is indeed by Rouart himself and still exists in the family's possession (ibid.). In *The Billiard Room* and *The Interior*, the ingenious use of paintings, mirrors, windows, and doorways can be seen as more metaphorical than documentary, hence more Symbolist than Naturalist, more akin to Mallarmé's evocation of an empty room with a mirror in his "Allegorical Sonnet of Himself"; ultimately, these motifs serve not to describe the space but to "engage with the problem of narrative conventions and meaning in painting by inviting speculative and inconclusive interpretations on the part of the spectator" (David Kelley, "Degas: Naturalist Novelist or Symbolist Poet?" *French Studies*, July 1984).

CHAPTER IV. Further connections with several nineteenth-century writers have been suggested. Balzac's novels, absent from this chapter partly because there is little evidence of Degas's familiarity with them, could hardly have been unfamiliar to him; moreover, he shared with the writer an interest in the physiognomic theories of Lavater and the operas of Meyerbeer, and his close friend De Valernes greatly admired Balzac's works and claimed to have learned much from them; indeed some of Degas's own "narrative" pictures, such as *Sulking*, seem like a page out of one of them, as George Moore remarked long ago (Denys Sutton, *Edgar Degas, Life and Work*, New York, 1986). Zola's descriptions in *L'Assommoir* of laundresses at work resemble Degas's etching *The Laundresses* even more than they do his paintings of that subject, so much so that the print may actually "illustrate" the passage describing Gervaise's laundry shop and the street outside it (Richard Brettell and Suzanne McCullagh, *Degas in The Art Institute of Chicago*, Chicago, 1984); but whether Degas was directly inspired by Zola's preoccupation, in *Au Bonheur des dames*, with the shopgirl rather than the customer when he changed the central figure in his *Millinery Shop* from one to the other (ibid.) seems dubious. Huysmans' dependence on Degas in his highly pictorial descriptions of scenes of urban entertainment is evident not only in the passages on ballet and circus performers in his *Croquis parisiens*, but also in the vivid account of a café-concert singer in his novel *Les Soeurs Vatard*, published the year before (Annette Weissenstein, "The Influence of the Visual Arts in the Work of J.-K. Huysmans," dissertation, Columbia University, 1981). Mallarmé's aesthetic position seems less distant from Degas's than the latter claimed it was, when we consider how multiple and ambiguous in meaning the ballet dancer and race horse are in his own sonnets and how suggestive, mysterious, and self-reflective in mood even his most Naturalist paintings can seem; like Mallarmé's poems, they become "a rather complex and subtle reflection on the problematic relationship between perception and representation, life and

art'' (David Kelley, "Degas: Naturalist Novelist or Symbolist Poet?" *French Studies*, July 1984). Even Degas's well-known photograph of Mallarmé and Renoir can be seen as Symbolist in its ingenious use of lighting, blurring, and reflections to evoke as well as describe its Symbolist subject (Eugenia Janis, "Edgar Degas's Photographic Theater," in *Degas, Form and Space*, Centre Culturel du Marais, Paris, 1984), though it is possible to carry ingenuity too far in interpreting the photograph in those terms (Wayne Roosa, "Degas's Photographic Portrait of Renoir and Mallarmé: An Interpretation," *Rutgers Art Review*, January 1982).

CHAPTER V. The identification of Zola's *Thérèse Raquin* and to a lesser extent his *Madeleine Férat* as literary sources for Degas's *Interior (The Rape)* has provoked much discussion. Several authors have concurred, but others have raised thoughtful objections. David Kelley, noting the discrepancies already noted here between the picture and those texts, has argued that instead of trying to illustrate them, Degas was making "a painting which deliberately invites the attempt to interpret it in narrative and anecdotal terms, while equally deliberately foiling that attempt" ("Degas: Naturalist Novelist or Symbolist Poet?" *French Studies*, July 1984). And Roy McMullen, acknowledging that the passage in *Thérèse Raquin* "influenced and perhaps even inspired the [picture's] composition," has found the discrepancies between them so numerous as to force the conclusion that *"Interior* is a dumb show invented by Degas,"* perhaps involving a single woman roughly handled by a male acquaintance or "a working girl ruined by a member of the gentry" (*Degas, His Life, Times, and Work*, Boston, 1984). The model Degas used for the sullen male figure in *Interior* has been identified by Ronald Pickvance—not altogether convincingly, given the different proportions of the two heads—as Henri Michel-Lévy, an artist friend of whom Degas painted a portrait a decade later (discussed in Chapter III), where he stands in virtually the same dejected pose (*Degas 1879*, Edinburgh, 1979). And the men shown in the pastels called *Physiognomy of a Criminal*, discussed here as examples of Degas's interest in current theories of criminal physiognomic types, have been identified by Charles Millard, on the basis of newspaper accounts, as the notorious murderers Abadie, Kirail, and Knobloch (review of *The Notebooks of Edgar Degas*, in *Art Bulletin*, September 1978). Finally, there is additional evidence about contemporary responses to the subject matter of *Interior*, at least around 1906. René Gimpel later noted in his diary that it "was presented to the Acquisitions Committee of the Boston Museum, which was prepared to buy it, but some women objected, claiming that this canvas was immoral, that these two people were not married since the bed was a

single bed" (*Journal d'un collectionneur*, Paris, 1963). And Mary Cassatt, informing Louisine Havemeyer that a patron of another museum—probably Mrs. Chauncey Blair of Chicago—was enthusiastic about acquiring the work, "now known as the quarrel," added that "curiously enough Mrs. B. when asked what she thought the picture represented said a moral rape or words to that effect, now that is just what Degas told me he meant to represent" (unpublished letter, October 12 [1906], Metropolitan Museum of Art, New York).

CHAPTER VI. About the remarkable group of sculptures Degas made in the early 1880s, much new information has appeared. The *Little Dancer of Fourteen Years*, or at least the studies for it, were probably begun in 1878, not ca. 1880 as previously thought, since Degas's model, the dancer Marie Van Goethen, was born in 1864 (Charles Millard, *The Sculpture of Edgar Degas*, Princeton, 1976). The version he planned to show in 1880 may have been the nude study, details of which suggest last-minute adjustments made with an exhibition in mind (ibid.), though whether he would have made his debut as a sculptor with this relatively unimportant work is questionable. When, instead, he showed only the empty glass case, it was remarked on, and even found charming, not only by Charles Ephrussi, but also by Jules Claretie (ibid.). And when he showed the final version in 1881, Nina de Villars was as enthusiastic in her review as Huysmans was in his more frequently quoted one (ibid.). The articles of real clothing worn by the *Little Dancer* included, in addition to those usually listed, silk stockings and a neckband, if the reviews of Ephrussi and Huysmans are to be taken literally (Ronald Pickvance, *Degas 1879*, Edinburgh, 1979). In incorporating such materials in a wax sculpture, Degas was not only recalling the polychromed figures he had seen in Neapolitan Nativity groups, but was also relying on the examples in his own possession; he was undoubtedly affected, too, by the great interest in polychromed wax sculpture shown in French academic circles around 1880 (Millard, op. cit.). The proto-Surrealist aspect of this "frightening realism" seems all the more evident as we learn more about the Surrealists' own interest in puppets and mannequins (Kim Levin, "The Ersatz Object," in *Super Realism, A Critical Anthology*, ed. Gregory Battcock, New York, 1975) and about Zola's fascination with the same aspect in describing the mannequins in *Au Bonheur des dames* (J. H. Matthews, "Zola et les surréalistes," *Cahiers naturalistes*, [October] 1963). As for the relief *The Apple Pickers*, the reconstruction proposed here of the original clay version is confirmed by new technical evidence, and the later wax version is datable to ca. 1890, when, incidentally, the theme of apple picking was popular in French painting

(Millard, op. cit.). And as for the figurine *The Schoolgirl*, the two-dimensional work from which it derives, the *Project for Portraits in a Frieze*, was shown in 1881, not in 1879 as previously stated (Pickvance, op. cit.); but since some version of the composition, presumably now lost, did appear in the earlier exhibition, its relevance to the sculpture remains the same.

CHAPTER VII. Not surprisingly, given the tenor of recent research, much more has been learned in the last decade about Degas's technical experiments, both their sophistication and their naivety. The number of media he used in drawing *The Ballet Master*, even greater than previously thought, has been shown to include brush with watercolor and gouache, pen with black ink, and touches of brown oil paint, over graphite and charcoal (Richard Brettell and Suzanne McCullagh, *Degas in The Art Institute of Chicago*, 1984). The novel ways in which he used charcoal and pastel in his late drawings of dancers, building up their surface through accreted layers, and revising them through repeated tracings or by reworking counterproofs, have likewise been elucidated (George Shackelford, *Degas: The Dancers*, Washington, 1984). The complexity of his etching technique, including the use of a multipronged tool and a carbon rod (*crayon électrique*), as well as softground, drypoint, aquatint, burnishing, erasing with an emery stone, and variable inking and wiping of the plate, has been described in detail, as has the extensive transformation, through twenty or more states, of prints such as *Woman Leaving Her Bath*, which incidentally has been redated 1879–80 (Sue Reed and Barbara Shapiro, *Edgar Degas: The Painter as Printmaker*, Boston, 1984). Conversely, the technique he employed in *Head of a Woman* has been shown to be less enigmatic than was always said—a "relatively simple and straightforward use of liquid aquatint," as described in one of Degas's letters to Pissarro (ibid.). The experimental nature of Degas's lithographs, employing unusual processes and combinations of material, such as greasy drawings on celluloid, coated transfer papers, transferring by photographic means, and direct work on the stone, with brush and tusche as well as crayon and scraper, has likewise been clarified by closer examination (ibid.). The same is true of Degas's experiments in other media. In sculpture, it is clear now that he sought flexibility in his armatures by using multi-strand wire and occasionally hemp, secured to a metal rod attached to a wooden base, and ease of revision by combining wax and plastilene and adding what an eye-witness called "the strangest materials: corks, matches, sponges, or cloth plugs" (Charles Millard, *The Sculpture of Edgar Degas*, Princeton, 1976). In photography, he explored in six images of dancers, first printed from his collodion negatives only a decade ago, the use of solarization and enantiomorphic effect to create the kind of

luminosity and startling reversal found in his late paintings and pastels, some of which are based directly on these photographs (Janet Buerger, "Degas's Solarized and Negative Photographs," *Image*, June 1978, and her "Another Note on Degas," *Image*, March 1980). At the same time, we learn from a previously neglected source, he discussed the technique of fresco painting with other artists and yearned for a commission to produce a mural in that most traditional of media (Richard Thomson, *The Private Degas*, Manchester, 1987).

It might be useful, finally, to note the present locations of some of the works illustrated in these pages. Figs. 7, 40, 50, 78, 88, 126, 128, 146, 184, 214: Musée d'Orsay, Paris. Fig. 39: Collection of Peter Nathan, Zürich. Fig. 47: Private collection, Paris. Fig. 87: Yale University Art Gallery, New Haven. Fig. 95: Formerly collection of Erna Wolff Dreyfuss, New York. Fig. 96: Private collection, New York. Fig. 100: National Gallery, London. Fig. 103: Private collection, Paris. Fig. 116: Private collection, New York. Fig. 121: Private collection, New York. Fig. 122: Private collection, New York. Fig. 125: Thyssen-Bornemisza Collection, Lugano. Fig. 131: Collection of Eugene Thaw, New York. Fig. 160: Clark Art Institute, Williamstown. Fig. 167: Collection of Mrs. Jacob Kaplan, New York. Fig. 191: Formerly collection of Nathan Cummings, Chicago. Fig. 197: Formerly collection of Mrs. Horace Havemeyer, New York. Fig. 198: Norton Simon Museum, Pasadena. Fig. 213: Philadelphia Museum of Art, Philadelphia.

New York T.R.
April 1987

INTRODUCTION

In *The New Painting*, a pamphlet published in 1876 in defense of Realist and Impressionist tendencies in recent art, the critic Duranty attributed most of the important ideas underlying them to the intellectual power and originality of Degas. "The series of new ideas was formed above all in the mind of a draftsman," he wrote, "a man of the rarest talent and the rarest intellect,"[1] and there was no doubt whom he meant. Although his statement can hardly be taken literally, it does testify to the esteem in which Degas was held, not only as a painter, but as a thinker who had created new means of pictorial expression appropriate to the new forms of urban society. He had already impressed Duranty as "an artist of rare intelligence, preoccupied with *ideas*, which seemed strange to most of his colleagues,"[2] and in this respect he still seems the most interesting mind among them. Not necessarily the most universal—Monet had a more profound feeling for nature, Pissarro a shrewder understanding of history, Cézanne a more complex sense of structure—but surely the one best prepared by upbringing and education to appreciate the play of ideas and the one most drawn by natural inclination to formulate them effectively. This is why his judgments on art and other artists, those cleverly formed *mots* of his, were highly regarded and feared in his lifetime, and why his letters reveal a simple eloquence that led George Moore, in an expansive moment, to call them "the most marvellous collection of letters in literature."[3] It is also why his notebooks contain so many interesting observations and theoretical statements, so many surprising literary quotations and drafts of poetry, and why his carefully wrought sonnets convinced Valéry that "he could have been, if he had given himself wholly to it, a most remarkable poet."[4] Above all, it is why his paintings and pastels, his drawings and prints,

even his photographs, reveal such ingenious pictorial strategies and technical innovations, such knowing calculations of visual effect, that Valéry was forced to conclude: "Art, for him, was simply a series of problems in a more subtle kind of mathematics than the real one, a kind that no one has ever been able to expound, and whose existence is known to very few."[5]

If this is the most interesting side of Degas's achievement, it is also the most difficult to discuss in terms more specific than those Valéry employed, and in fact it rarely has been. The literature on him, previously dominated by personal memoirs and rather uncritical biographies inspired by the force of his remarkable personality, now consists largely of oeuvre catalogues and monographs devoted to one aspect of his rich production. Thus we have, on the one hand, thorough compilations of his paintings and pastels (Lemoisne), his etchings and lithographs (Adhémar), his monotypes (Janis, Cachin), his sculpture (Rewald), and his notebooks (Reff); and on the other hand, detailed studies of his portraits (Boggs), his ballet subjects (Browse), his technical experiments (Rouart), and his copies of older art (Reff); while the publications concerned with his art as a whole are, despite their value as syntheses, either outmoded by subsequent research (Jamot, Manson) or too broadly conceived to take sufficient account of it (Lemoisne, Cabanne).[6] Consequently, the one artist in the Impressionist group who was fascinated by ideas and consciously based his work on them, the one who confessed, "What I do is the result of reflection and study of the great masters; of inspiration, spontaneity, temperament I know nothing,"[7] is the one whose art has been least understood from this point of view, whereas that of his colleagues Manet and Cézanne, long considered too superficial or too purely visual to harbor ideas, has been the subject of penetrating discussions of its intellectual content.

The essays in the present volume can hardly be said to fill that large void in Degas studies, but they do span it in several directions by examining some essential and generally neglected features of his art, among them his ingenuity and wit in employing metaphorical motifs such as the window, the mirror, and the picture within the picture; his power of imagination in creating psychologically compelling compositions such as *Sulking* and *Interior;* and his sophistication in devising

a sculptural idiom at once formal and vernacular, as in the *Little Dancer of Fourteen Years.* Inevitably these essays are also concerned with issues that lead further afield, such as the sources of his theories of naturalistic description and physiognomic expression and their relation to contemporary thought; his contacts with some of the leading novelists and poets of his time and his efforts to illustrate or draw inspiration from their works; and the affinities of the latter with his own work, which underwent the same development from Romanticism through Naturalism to Symbolism at about the same time. Throughout the essays one more specific theme recurs, the diverse connections between Degas's art, the most cosmopolitan of any in the Impressionist group, and that of other nineteenth-century artists, among them the three he considered his greatest predecessors (Ingres, Delacroix, and Daumier), the one he was closest to in temperament and aesthetic ideal (Whistler), and others whose work directly influenced or was influenced by his own, both in France (Manet, Gauguin) and outside it (Millais, Tissot). Thus the emphasis is on his artistic and literary culture, on his contact with advanced aesthetic ideas, and on those supremely intellectual qualities of his art which already made it apparent to Huysmans in 1880 that "this artist is the greatest we have today in France," in the way that "Baudelaire is the poetic genius of the nineteenth century" and "Flaubert's *Sentimental Education* is the masterpiece of the modern novel."[8]

This thematic unity is neither accidental nor planned, but rather has emerged as a consequence of a continuing effort to discover what is unique in Degas's artistic thought by relating it as fully as possible to what preceded and surrounded it. The result of this effort was a series of articles published between 1968 and 1972 in art-historical journals, of which the present essays are thoroughly revised versions, except for the second one, which was written for this volume. The others, reprinted with the kind permission of their editors, appeared as follows: the first in *Art News,* 1971; the third in the *Metropolitan Museum Journal,* 1968; the fourth in *The Burlington Magazine,* 1970; the fifth in *The Art Bulletin,* 1972; the sixth in *The Art Quarterly,* 1970; the seventh in the *Metropolitan Museum Journal,* 1971. It is both appropriate and gratifying that they are published now in their revised forms by the Metropolitan Museum, where they will reach a larger, less specialized audience; not only be-

cause two of them first appeared in the Museum's *Journal*, but because its collection of works by Degas is so impressive in quality and size that it ranks second only to the one in the Louvre.

BOTH IN writing these essays and in revising them, I have been aided by many scholars, curators, dealers, and collectors, whose specific contributions are acknowledged in the footnotes; here I would like to thank those who have helped in more general ways. As always, Hélène and Jean Adhémar made available the full resources of their institutions, the Musée de l'Impressionnisme and the Cabinet des Estampes. At the latter, Nicole Villa was a constant source of assistance, as was Geneviève Monnier at the Cabinet des Dessins. I was also fortunate in having the cooperation of Charles Durand-Ruel and the late Denis Rouart, key figures in Degas studies. In this country, Beverly Carter, secretary of the Paul Mellon Collection, M. Roy Fisher, director of research at Wildenstein and Co., and Paul Rewald, head of the Impressionist painting department at Sotheby Parke Bernet, Inc., were most helpful in providing photographs and information. At Columbia University, my colleague Allen Staley was an astute reader of some of the essays, and my student Elizabeth Streicher an excellent research assistant. And at the Metropolitan Museum, Anne MacDougall Preuss and Leon Wilson read the whole manuscript with expert care and helped improve it in countless ways. I am also grateful to the John Simon Guggenheim Memorial Foundation for fellowships that enabled me to undertake research abroad in 1967 and 1975.

DEGAS: The Artist's Mind

I The Butterfly and the Old Ox

As far as painting is concerned," Whistler assured the young Austrian who had come to Paris to choose works for an exhibition, "there is only Degas and myself."[1] The impudence may have been Whistler's alone, but the sense of pride and independence that informed it were also Degas's. In any survey of their period these two stand out as perhaps the most original and intransigent personalities in the visual arts. Renowned and often feared for their penetrating, frequently sarcastic wit, their lofty disdain of dealers, critics, and patrons, their avoidance of any label or school that might restrict their freedom of action, they represented the very type of independent artist of the later nineteenth century. It is remarkable how clearly they already appear as such in self-portraits painted relatively early in their careers [1, 2]. Degas, recalling the aristocratic figures by Van Dyck that he had admired in Italy,[2] presents himself as a gentleman of leisure, worldly and aloof, one hand placed nonchalantly in a pocket, the other holding a silk hat and gloves. Whistler, relying instead on the self-portraits of his idol Velázquez,[3] assumes the pose of an artist at work, but despite his simple smock and beret, he looks no less fastidious or conscious of his superiority. Degas himself later implied as much when he linked "Monsieur Whistler" with Delacroix and Puvis de Chavannes as artists who were "grands seigneurs."[4] Ultimately, it was this fundamental similarity of temperament that sustained their long friendship, from its origin in the Manet circle around 1860, when both men were in their mid-twenties, to Whistler's death more than forty years later; this affinity, too, that inspired the many striking similarities in their conception and practice of art.

15

Although not very fully documented, their respect for each other and admiration for each other's work can be gleaned from a number of sources. In letters to Tissot and to Durand-Ruel's agent in London, Degas referred in 1873 to "that fellow Whistler [who] has really hit on something in those views of the sea and water that he showed me," and again in 1875 to "Whistler, for whom I have so much admiration."[5] Reporting to his friend Henri Rouart about the Salon of 1882, he singled out the *Arrangement in Black, No. 5: Lady Meux* for exceptional praise: "An astonishing Whistler, overly refined, but of a quality!"[6] And in unpublished notes to Whistler himself, one dating from the 1880s, the other from the following decade, he introduced "a great collector, mad about the English school, who must be one of your greatest admirers," and,

1.
Degas, *Self-Portrait*, 1863–1865. Oil on canvas.

Fundação Calouste Gulbenkian, Lisbon

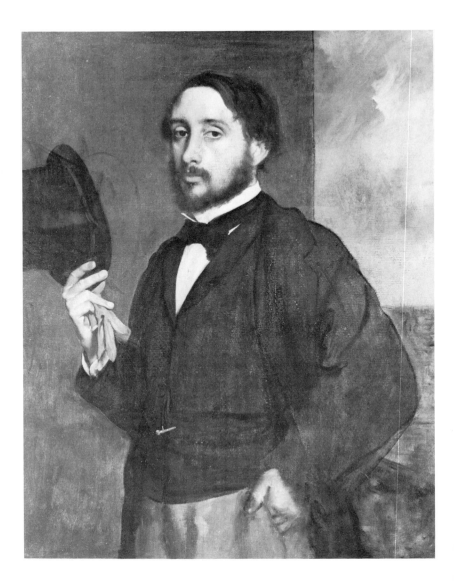

as an unusual gesture of friendship, sent his colleague proofs of a portrait photograph he had taken of him.[7] More revealing, perhaps, is a letter to Whistler from their mutual friend Mallarmé, written shortly after the *Arrangement in Gray and Black, No. 1: The Artist's Mother* was acquired by the French government in 1891: "I would have liked you to hear Degas speak with the greatest sincerity, yesterday evening, returning from dinner, on his admiration for the 'Portrait of My Mother.'"[8]

For his part, Whistler was equally enthusiastic about the work of Degas. The painter Jacques-Emile Blanche recalled having seen Whistler at the Impressionist exhibition of 1881, admiring the *Little Dancer of Fourteen Years* [157] in a typically extravagant manner: "He was wielding a painter's bamboo mahlstick instead of a walking stick; emitting

2.
Whistler, *Arrangement in Gray: Self-Portrait,* 1871–1873. Oil on canvas.

Detroit Institute of Arts, bequest of Henry G. Stevens in memory of Ellen P. and Mary M. Stevens

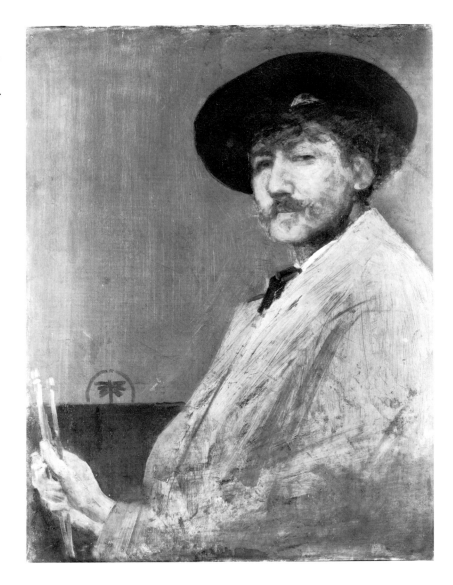

piercing cries; gesticulating before the glass case that contained the wax figurine."[9] On his visits to Paris he never failed to see the latest exhibition of Degas's work or to pay his respects to the master himself. "It is rare these days that I have the pleasure of seeing you," he wrote in another unpublished letter of the 1880s, "although I never pass through Paris without many efforts to find you."[10] In a similar letter, probably written a decade later, in a more pessimistic mood, he lamented their less frequent contacts: "So one no longer crosses the Channel for lunch, Degas, my old friend? Decidedly, then, it is only I who am still curious."[11] Despite this growing separation, Whistler continued loyally to encourage others to appreciate his colleague's art; for "behind most of the early purchases in England of works by Degas—by Ionides, Sickert, Mrs. Unwin, Sir William Eden, or William Burrell—one can trace a connection with Whistler."[12] And Degas in turn formed a small but very fine collection of Whistler's prints, notably the masterful etchings in *The Thames Set*, of which he had superb proofs.[13]

There were, it is true, also important differences between the brilliant, belligerent, frequently insecure American expatriate, who sought fame even at the price of notoriety, and the conservative, increasingly secluded Frenchman of bourgeois origin, whose ambition was to be "famous and unknown." As William Rothenstein, who knew both men well, recalled: "Degas's character was more austere and uncompromising than Whistler's. Compared with Degas, Whistler seemed almost worldly in many respects. Indeed, Degas was the only man of whom Whistler was a little afraid."[14] And with good reason, for Rothenstein went on to show that Degas could be more cutting than Whistler himself: " 'You behave as though you have no talent,' Degas once said to him; and again when Whistler, chin high, monocle in his eye, frock-coated, top-hatted, carrying a tall cane, walked triumphantly into a restaurant where Degas was sitting: 'Whistler, you have forgotten your muff.'"[15] Thus there is probably some truth in the remark of George Moore, another friend of theirs, that "when Degas is present, Mr. Whistler's conversation is distinguished by 'brilliant flashes of silence.'"[16] But when Moore's article containing this and some equally malicious remarks was published in 1890 and Whistler, fearing its intention was "to embroil me with Degas," wrote to Mallarmé for reassurance, he received at once Degas's reply: "Nothing

can embroil me with Whistler."[17] That the latter, deeply concerned, had also contemplated writing directly is evident from the unpublished draft of a letter which began: "This is what it is, my dear Degas, to allow into our homes these infamous journalistic studio gossips, and this one, this Moore, is one of the most wretched," and which rose to a level of destructiveness that few besides Whistler and Degas could attain.[18]

SUCH WERE the similarities in their reputations—both as the creators of difficult new styles and as difficult personalities themselves—that when a satirical comedy on contemporary artistic life was produced in Paris in 1877, its most pointed thrusts were naturally directed at Degas, and when an English version was produced in London some months later, they were just as naturally directed at Whistler. In *The Grasshopper*, written by Meilhac and Halévy while the controversies aroused by the first Impressionist exhibitions were still raging, the protagonist Marignan, an "Intentionist" painter, not only expressed some of Degas's favorite notions of modernity, but in one scene was shown working from a model whom he had posed as a laundress washing linen, in allusion to Degas's frequent treatment of this subject.[19] In the adaptation by John Hollingshead, made at a time when Whistler, then engaged in a lawsuit against Ruskin, was a more notorious symbol of the avant-garde in England, Marignan's counterpart Pygmalion Flippit declared: "We now call ourselves harmonists, and our work harmonies or symphonies, according to color," a reference to the titles Whistler had adopted; and in the third act a life-size caricature of Whistler, painted by his (and Degas's) friend Carlo Pellegrini, was actually wheeled on stage.[20]

More important, the abstract compositions displayed with such comic effect by Marignan and Flippit—a rectangle starkly divided into equal areas of red and blue, which could be read one way as a sunset over a vast sea and the other way as a desert under a bright sky—seem ultimately to have been inspired by the seascapes painted in the preceding decade both by Whistler and by Degas. The former's *Harmony in Blue and Silver: Trouville* [3] and the latter's *At the Seashore*[4],[21] for example, are so broadly conceived in large, luminous areas that they almost could be inverted to produce a different image. Ironically, it was only months after *The Grasshopper* was performed in London that one

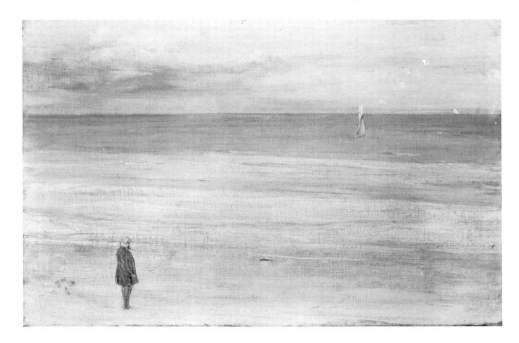

3. Whistler, *Harmony in Blue and Silver: Trouville,* 1865. Oil on canvas.
Isabella Stewart Gardner Museum, Boston

of the Nocturnes was actually shown to the court upside down—apparently by accident, but with unfortunate consequences for Whistler—during the trial of his suit against Ruskin.[22] The event thus illustrated perfectly what Whistler's protégé Oscar Wilde would later call life imitating art.

The conviction which led both artists to create works so radically simplified in design that they could be ridiculed in a popular comedy or at a public trial, the notion that a picture is independent of nature and ultimately superior to it, was perhaps the most significant link between them. To be sure, *At the Seashore* and the other pastel seascapes and landscapes of ca. 1869[23] constitute only one part of Degas's oeuvre, the other parts of which show a greater concern with the powerful definition of form and movement, character and local color; whereas the drastically flattened and attenuated Nocturnes and other seascapes of 1865–1880 are one of the essential aspects of Whistler's achievement,

along with the portraits and decorative ensembles. Nevertheless, the assertion of the independence of art runs like a leitmotif through their written and recorded statements on art, distinguishing them from most of their Impressionist and Victorian contemporaries. Thus, Whistler defining a Nocturne during the Ruskin trial as "an arrangement of line, form, and color first," and Degas explaining to the painter Georges Jeanniot that a picture is "an original combination of lines and tones which make themselves felt," were expressing the same unorthodox belief on both sides of the Channel.[24]

Hence Degas, who advised Jeanniot to work from memory rather than nature, so that "you reproduce only what has struck you, that is, the essential; in that way, your memories and your imagination are liberated from the tyranny that nature holds over them," would surely have approved of Whistler's statement, in his famous "Ten O'Clock" lecture,

4. Degas, *At the Seashore*, ca. 1869. Pastel.

Private collection, Scotland

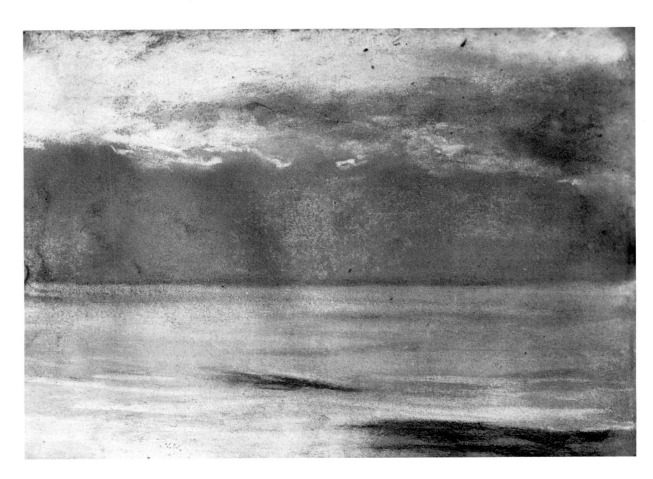

that "nature contains the elements, in color and form, of all pictures. . . . But the artist is born to pick, and choose, and group with science, these elements, that the result may be beautiful."[25] However, when Whistler carried the expression of this position to an extreme in other parts of his lecture, Degas rejected its preciosity, writing to Halévy, who was about to publish an article on it, "If it is the 'Ten O'Clock' that you are discussing, then it is irony, it is contempt of the arts by the worldly people in formal dress, it is bliss."[26] It was with good reason, then, that Whistler betrayed some apprehension in inscribing a copy of *The Gentle Art of Making Enemies*, where his lecture was reprinted, "to Degas—charming enemy—better friend!"[27]

Their shared conception of art as artifice rather than mere image manifested itself in the work of the two men in a number of remarkably similar ways. Both were fascinated by the materials and techniques they employed, and experimented ceaselessly with new means of improving or combining them. Of Whistler in the 1870s, we learn that "he had no recipe, no system. The period was one of tireless research. He had to 'invent' everything. . . ."[28] And this included the priming of canvases in tones that would establish the final color harmony from the beginning, and constant experiments with their textures; the use of brushes with handles unusually long, held at arm's length to achieve a broadly flowing stroke, and with hairs carefully reshaped by himself; the development of a novel method of washing and even dripping diluted color, which he called a "sauce," onto a canvas laid horizontally. Later he devised equally original means of producing subtle tonal variations in his etchings and delicate, pastel hues in his color lithographs.[29] Typically, Degas's interests were broader in scope and motivated in part by a fascination with the technical as an end in itself. Hence his rediscovery of, and subsequent innovations in, the printing of monotypes; his novel combinations of oil, pastel, gouache, and watercolor in a single picture; his introduction of actual fabrics and found objects into wax sculpture; his exploration of photography as an aid to painting and as an independent form of expression; and his lifelong preoccupation with the technical secrets of the old masters, whose effects he attempted to reproduce in his own art.[30] Yet both he and Whistler were sometimes led by their experimentalism into unsound procedures, the one impro-

vising armatures and adulterating his wax in a way that caused many of his statuettes to collapse or crumble, the other painting with unstable, bituminous pigments and pulling trial proofs on mildewed or worm-eaten old paper, with equally disastrous results.[31]

In addition, both artists were very much aware of the physical conditions in which their works were shown to the public, and succeeded in introducing a number of far-reaching changes in the organization and appearance of art exhibitions. Whistler's innovations in this sphere, his design and decoration of picture frames in an Oriental style, his subtle harmonizing of frames, mats, and wall hangings, his insistence on diffused lighting in galleries and ample spacing on walls, are all familiar manifestations of his devotion to an aesthetic experience.[32] Less well known, but equally original, were Degas's proposals to reorganize the annual Salon by eliminating the crowding and "skying" of pictures, by displaying smaller works on screens installed in the galleries, and by grouping the sculptures in an informal, asymmetrical manner.[33] Although ignored when they were published in 1870, they were adopted a decade later in the Impressionist group shows and were influential thereafter. As late as 1907 Degas was envisaging a reorganization of certain galleries in the Musée des Arts Décoratifs, so that the pictures, hung on screens projecting from the wall, would receive a raking rather than a direct illumination.[34] Also little known are the stories of his insistence—altogether Whistlerian in their imperious tone—on choosing the mats and frames for works he sold, and the many designs for new types of picture-frame molding that appear in his notebooks.[35]

A belief in the superiority of art to mere nature, that producer of "foolish sunsets" as Whistler put it, was probably what led both artists to prefer interiors with figures, and above all portraits, to the landscapes that dominated the work of their Impressionist contemporaries, although here Degas was more exclusive than the painter of the Nocturnes and the views of Venice. In retrospect they stand out as two of the most interesting portraitists of their time, innovators whose seriousness of purpose enabled them to make of this genre the major form of artistic statement it had been earlier in the century. Typically, however, Whistler's portraits are sophisticated designs that focus exclusively on a single, formally posed figure against a neutral ground, whereas Degas's

it. At times their contributions seem even to have reinforced each other, as in several of Vuillard's portraits of the 1890s that evoke both the sophisticated surface designs of Whistler and the intimate domestic settings and moods of Degas.[37]

HOWEVER similar their conception and practice of art may appear in retrospect, the careers of Whistler and Degas followed quite distinct paths, intersecting only at certain points. One of these, according to Degas himself, was at the very start: "When we were beginning, Fantin, Whistler, and I, we were on the same path, the road from Holland."[38] What he evidently had in mind, the type of sober, carefully constructed

7. Degas, *The Bellelli Family*, 1859–1860. Oil on canvas.

Musée du Louvre, Paris

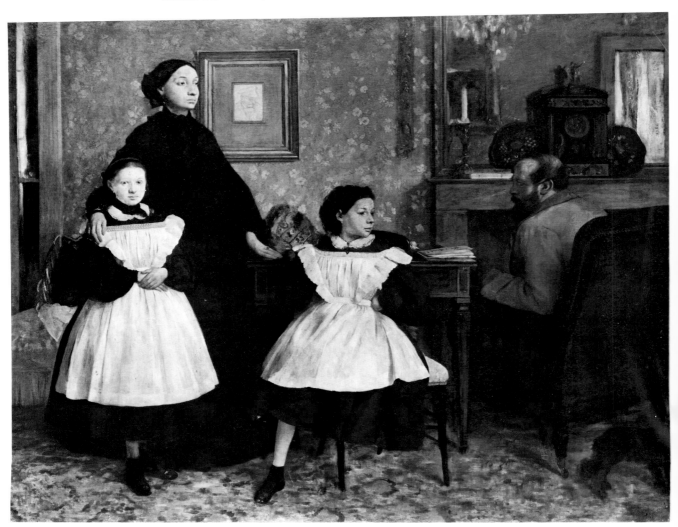

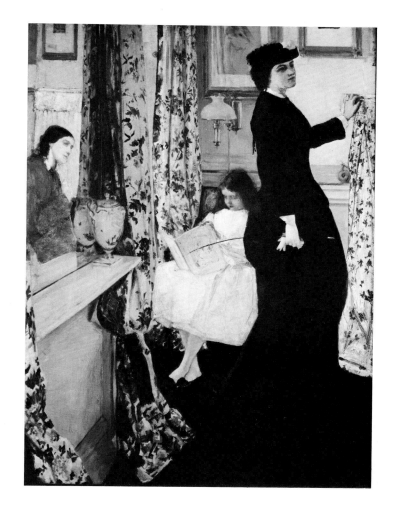

8.
Whistler, *Harmony in Green and Rose: The Music Room*, 1860. Oil on canvas.

Freer Gallery of Art, Smithsonian Institution, Washington, D.C., 17.234.

portrait or bourgeois interior that had become an advanced form of Realism by 1860, is best illustrated by Fantin-Latour's *Two Sisters*, Whistler's *At the Piano*, and his own *Bellelli Family* [7], all painted ca. 1859 and all indebted, among other things, to Dutch genre scenes and group portraits in their depiction of a serenely ordered middle-class existence and their harmonious pictorial style.[39] Even at this early date, however, Degas's greater psychological penetration, as seen, for example, in the alienation of the parents in *The Bellelli Family* and the contrasted allegiances of the children, differs from the more sentimental and decorous tendency represented by *At the Piano*. But if the latter also seems more simple in design, this is not true of other Whistler compositions of the same period. His *Harmony in Green and Rose: The Music Room* [8],

a work of 1860 that is comparable to Degas's family portrait in its contrast of strong, black and white shapes with delicate floral patterns, its introduction of background pictures and mirror reflections, is also more advanced than this or any other interior he painted before the late 1860s. The high, angular perspective and ingeniously cut and overlapping forms in *The Music Room*, the depiction of the little white girl's mother solely as a reflected element, were in fact prophetic of pictorial devices that Degas would first employ toward the end of the decade.[40]

Throughout the early 1860s, Whistler was generally more innovative than Degas, who, despite his growing attraction to Realism, remained deeply involved in painting historical subjects and in learning the lofty lessons of traditional art. There is nothing in his oeuvre before the *Woman with Chrysanthemums* of 1865 [36] that equals Whistler's *Wapping*, painted four years earlier, in its asymmetrical disposition of the principal figures or radical cutting of them at the edges of the field.[41] Nor is there anything comparable to the subtly attenuated harmony, the search for nuanced, almost colorless tones, that is found in *The White Girl* [155] as early as 1862; the relevant picture by Degas, the *Young Woman in a White Cotton Dress*, although more masterful in execution and subtler in expression, is dated ten years later.[42] Moreover, by 1865 Whistler had studied and collected Oriental ceramics and prints intensively, had represented them frequently in his own works, and had assimilated certain features of their coloring and composition, most completely perhaps in the *Variations in Flesh-Color and Green: The Balcony*, which is based on prints by Kiyonaga.[43] In contrast, the earliest sign of such an interest in Degas's work—and it occurs within a composition still thoroughly European, as we shall see in Chapter III—is the imitation of a Japanese garden scene, reminiscent of a type of triptych print, that appears in the background of his portrait of Tissot [68], painted in 1866–1868.[44]

By this time the paths of the two artists were once again crossing or at least paralleling each other stylistically, partly because Degas, having abandoned historical subjects and his intensive study of traditional art, was turning toward modern urban life and the popular art of Daumier, and partly because Whistler, having lost confidence both in Realism and in his overtly Japanese manner, was experimenting with friezelike com-

positions inspired by classical sculpture and the classicizing work of Albert Moore. In a letter of 1867, the year of Ingres's death, Whistler went so far as to write, "Ah! if only I had been a pupil of Ingres . . . What a master he would have proved, and how healthily he would have led us,"[45] thus expressing a view that Degas, who had been taught by Ingres's pupils and continued long afterward to admire him, would surely have endorsed. (Interestingly, both artists had chosen to copy the graceful female figure in Ingres's *Roger Freeing Angelica* as students in the mid-1850s.[46]) Moreover, just as Whistler could reconcile an appreciation of that master's importance with an acknowledgment of Delacroix's—he had, after all, figured prominently in Fantin-Latour's *Homage to Delacroix* three years earlier[47]—so Degas had assimilated first one and then the other master's style in the previous decade. Hence the latter half of the 1860s was a moment when either of the two artists might easily have influenced the other, and this is evidently what happened when Degas based the design of *Mlle Fiocre in the Ballet from "La Source"* [9][48] on Whistler's recently completed *Symphony in White, No. 3* [10], a picture whose exotic and musical qualities would have made it a natural source of inspiration.

From it Degas seems to have derived not only the passive, meditative mood of the principal figures, one seated on a rock at the upper left, the other on the ground at the lower right, but the strong diagonal that both links and isolates them. In fact, he made a copy of the *Symphony in White, No. 3* at this time [11],[49] either from the original, which was in Paris, at the home of Whistler's brother, early in 1867, or from the fairly detailed sketch of it that Whistler had sent to Fantin-Latour in a letter of August 1865;[50] and significantly, the changes Degas introduced in his copy, which was apparently drawn from memory, make it resemble his own composition still more closely. (Both the languid pose and the dreamy mood of the young woman in white at the left side of Whistler's picture recur around 1870 in Manet's *Repose*, where Berthe Morisot, wearing a white dress, reclines on a sofa beneath a Japanese print.[51])

It was also in the early 1870s that Degas, whose connections with England were, like Manet's, more extensive than they had been earlier, owing to the exhibition and sale of his work at Durand-Ruel's gallery

in London, was brought into closer contact with Whistler and his art. En route to New Orleans in 1872, he saw some of the latter's recent seascapes and admired in them "that melting, mysterious expression of the land and water," as he remarked in a letter to Tissot.[52] Several months later he returned to the theme in another letter, but characteristically he added, "There are still many other things to produce, believe me."[53] Among those other things were, of course, the scenes of modern Paris, particularly its racetracks and dance rehearsals, that he had begun to paint and almost immediately to exhibit in London. Some

9. Degas, *Mlle Fiocre in the Ballet from "La Source,"* 1866–1868. Oil on canvas.

Brooklyn Museum, gift of James H. Post, John T. Underwood, and A. Augustus Healy

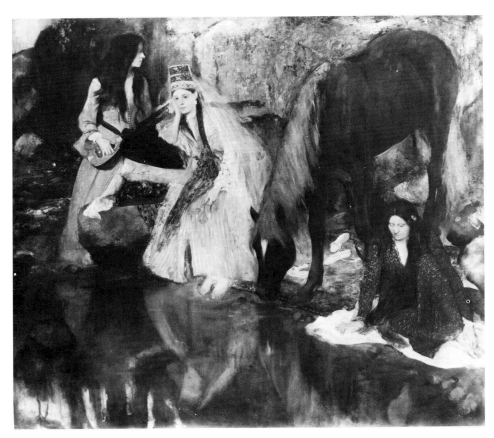

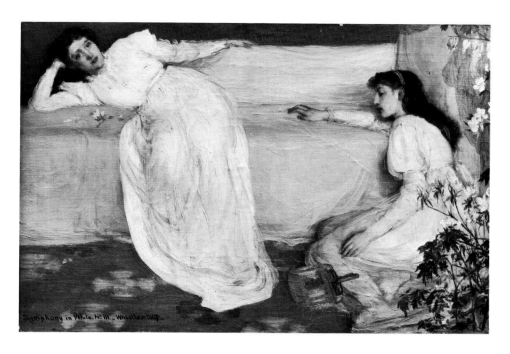

10. Whistler, *Symphony in White, No. 3*, 1865–1867. Oil on canvas.
Barber Institute of Fine Arts, University of Birmingham

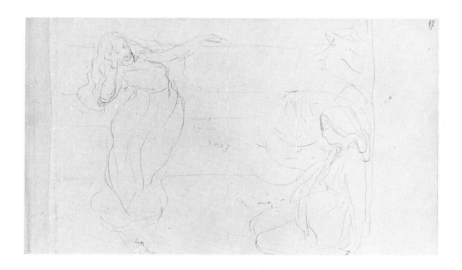

11. Degas, Copy after Whistler's *Symphony in White, No. 3*, 1865–1867.
Pencil.

Musée du Louvre, Paris

12. Whistler, *Harmony in Gray and Green: Miss Cicely Alexander*, 1873. Oil on canvas.

Tate Gallery, London

were in fact shown there by Durand-Ruel as early as 1872,[54] two years before the first Impressionist exhibition in Paris, and must have had a powerful impact on Whistler. Although there is no documentary evidence, his *Harmony in Gray and Green: Miss Cicely Alexander* [12], commissioned in 1872 and painted the following year, provides some suggestive visual evidence; for the young girl's pose is that of a dancer standing at rest, and her filmy white costume with its black velvet bows, set against a muted, greenish brown background, is also like that of the dancers Degas had painted. It is possible, however, that these pictorial subtleties were in both cases derived from Velázquez, Whistler's acknowledged master in portraiture, who was also cited at this time by Degas as a model of refined tonal painting.[55]

After the early 1870s, the directions followed by the two artists diverged once again. Having struggled unsuccessfully with classically inspired figure compositions, Whistler returned to his principal interests, portraiture and seascape, and in both domains his work became increasingly subtle, attenuated, and melancholy—qualities which were soon to be appreciated by Mallarmé and other Symbolist writers and artists, but which further removed it from the vital Naturalist tradition of Degas. For in these years he continued to explore those aspects of modern life that had already begun to attract him before 1870, producing his most familiar pictures of the café and café-concert, the racetrack and ballet, the laundry and brothel, in a style whose power and incisiveness continued to grow. Nowhere was the distance between them by this time more evident than in the works in which Whistler treated a theme of urban entertainment similar to the café-concerts of Degas. Although drawn to the Cremorne Gardens as a brilliant spectacle, with its fashionable crowds strolling in the darkness, its colored lights and firework displays, he transposed them pictorially, in the Metropolitan Museum's version [13] among others,[56] as a field of somber tones and delicate accents, ephemeral and purely artistic like the fireworks themselves; while Degas

captured the vitality of the gaudy colors and lights, the animation and even the animality of the performers and their audience, choosing audacious perspectives in order to focus on their distinctive appearance [e.g. 14].[57] Hence it was not only an obvious difference between his personality and Whistler's that he must have had in mind when he remarked to their mutual friend Walter Sickert, "The role of the butterfly must be very fatiguing, surely! I myself prefer to be the old ox, what?"[58] It was also the divergence that, despite their shared aesthetic ideals, had become so apparent in their art.

Yet in certain works of the later 1880s and 1890s, street scenes of modest proportions and simple design, but marked by a renewed interest in the observation of local color and piquant detail, Whistler approached the sophisticated realism of contemporary French art, that of the Nabis and ultimately of Degas. In paintings such as *Chelsea Shops* and in lithographs of Paris streets printed in 1894,[59] there is the same delight in recording the charm of urban life, the same skill in finding decorative patterns within it, that informs Bonnard's series *Some Aspects of Paris Life* five years later and Degas's *Place de la Concorde* and similar scenes some twenty years earlier.[60] In the same way, Whistler's late portraits

13. Whistler, *Cremorne Gardens, No. 2*, ca. 1875. Oil on canvas.
Metropolitan Museum of Art, New York, Kennedy Fund, 12.32

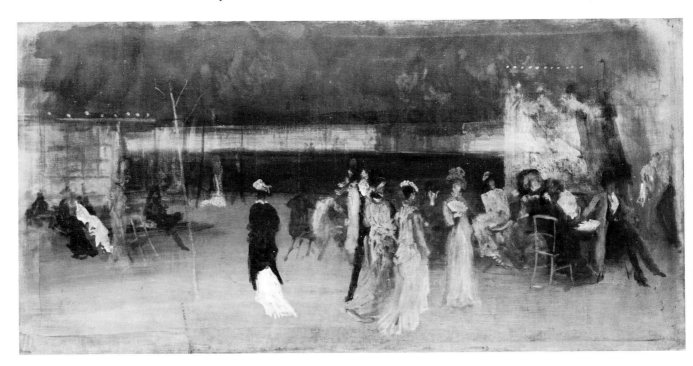

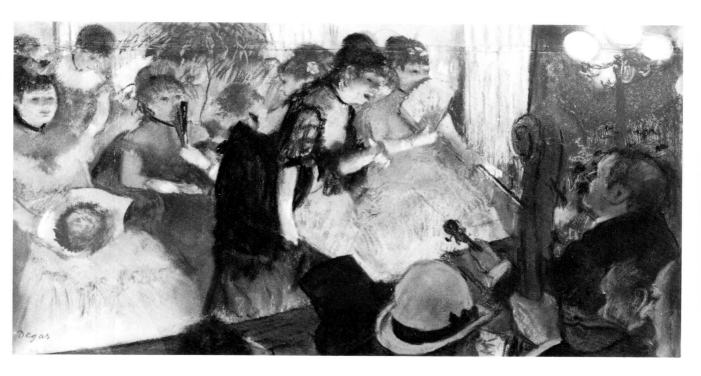

14. Degas, *At the Café-Concert*, 1875–1877. Pastel over monotype.
Corcoran Gallery of Art, William A. Clark Collection, Washington, D.C.

and domestic interiors, small in scale, intimate in mood, and painted
in a soft, slightly blurred manner that enhances their perfect stillness,
are related both to contemporary works by the Nabis, particularly
Vuillard, and to earlier pictures by Degas. Indeed, but for its lack of
psychological penetration, the portrait of *Mrs. Charles Whibley Reading*,
painted in Whistler's Paris home in 1894, is remarkably like Degas's
Woman Pulling on Gloves and similar pictures of the mid-1870s.[61] At the
end, then, the two artists, whose friendship and mutual esteem had never
diminished through the years, turned partly toward each other again
in their art.

APPENDIX: The Caricature of Whistler in
The Grasshopper

The image of Whistler that was wheeled on stage in the third act of
The Grasshopper, when it was produced in London in December 1877,
was later described by the Pennells, his excessively devoted biographers,
in a rather deprecating manner: "A large full-length, thought by many
more a portrait than a caricature, was painted by Pellegrini. . . . The
painting shows Whistler in evening dress, no necktie, and a gold chain
to his monocle; . . . it was pushed in on an easel, some say by Pellegrini,
with the announcement, 'Here is the inventor of black-and-white!' It was
a failure, and no wonder. It was impossible to see the point."[62] But
Whistler's printer, Thomas Way, with whom he was soon to work on
lithographs showing the Gaiety Theatre, where the play was produced,
recalled that "Whistler himself went to the rehearsals," and that "the
caricature in *The Grasshopper* was not a cause of offense to him, at least
I never heard any protest from him."[63] And when the caricature was
criticized in the press, John Hollingshead, the producer of the play, also
stated that "Mr. Whistler's consent was asked before he was painted,"
and that "he attended the last rehearsal and approved of the dialogue,"
which would hardly be surprising in view of his love of wit and satire.[64]
Unlike many stage properties, the portrait survived, and was subse-
quently in the collection of John W. Simpson of New York, although
its present whereabouts is unknown.[65]

 That it was painted by Carlo Pellegrini, the popular cartoonist for
Vanity Fair, is all the more interesting in that he was also a friend of
Degas's. In fact, the latter painted a portrait of him, in an idiom clearly
inspired by that of Pellegrini's political and social caricatures, in the very
year *The Grasshopper* was produced.[66] He may even have painted it in
London, since the ground plan of some of its streets and the addresses
of Pellegrini and others in notebooks Degas used around 1877 suggest
that he visited the city at that time.[67] And this in turn raises the possi-
bility that he also attended a performance of *The Grasshopper*, and thus
observed a scene he had helped to create on the French stage translated
into English and played, as it were, by an American artist.

II "Three Great Draftsmen"

However closely they may have resembled each other in their temperaments and conceptions of art, or have approached each other stylistically at certain moments, Whistler was neither the only nor even the most exemplary figure for Degas among the artists of his century. Given his conviction that all art was essentially artifice and that his own, despite its appearance of informality, was entirely "the result of reflection and study of the great masters,"[1] Degas was inevitably drawn into close and fruitful contact with many other types of current and recent art. The range of interests and independence of judgment that enabled him, in the last years of his life, to form one of the finest collections of nineteenth-century art assembled by anyone of his generation, a collection almost equally strong in Ingres and Delacroix, Daumier and Corot, Manet and Cézanne, had already led him, in his early and middle years, to copy and study intensively works representing all the major tendencies of the first half of the century, and to assimilate important elements of them into his own work.

As a pupil of Ingres's pupil Louis Lamothe around 1855, imbued with the master's Neoclassical taste, Degas drew repeatedly after his mythological and religious compositions and occasionally his portraits, which served as models for his own early portrait style; and returning to Ingres's sources, he reproduced both in pencil and oil some of the vigorously rendered figures in David's paintings of historical subjects and traced some of Flaxman's illustrations of *The Iliad* and *The Odyssey*, whose episodes he himself planned to illustrate.[2] He also copied after works by Hippolyte Flandrin, one of Ingres's chief disciples, and spent a summer studying ancient and Renaissance art in Lyons, the center of these disciples' activity.[3] In reacting against this doctrinaire classicism

four years later, Degas turned with equal enthusiasm to Delacroix and other artists of a dramatic or coloristic tendency. In museums and exhibitions, in public buildings and churches, he sketched and took extensive notes on the Romantic master's works, and referred to them often in planning his own ambitious paintings of literary subjects.[4] In addition, both the monumental religious compositions of Chassériau and the intimate genre scenes of Fromentin appealed to him now, their exotic imagery stirring his imagination, though he also painted copies of aristocratic portraits by Lawrence that reflect another aspect of Romantic colorism.[5]

In the same years, Degas began to work in still another tradition, drawing repeatedly after equestrian paintings and prints by Géricault and Alfred de Dreux in preparation for his own realistically rendered pictures of racetracks.[6] A decade later he continued to incorporate into them images of horses that he had encountered in the work of specialists such as Meissonier and the English sporting artist J. F. Herring.[7] By now he had also become acquainted with Manet, whose more sophisticated notion of Realism strongly influenced his own and was in turn influenced by it; there are similarities between several of their portraits and domestic interiors of the later 1860s, as there are a decade later between their representations of cafés and café-concerts.[8] These, however, are clearly indebted for their compositions and their satirical vision to the lithographs of Gavarni and especially of Daumier; and the latter's political caricatures, which Degas admired and occasionally copied, are an important source for his own.[9] He was no less aware of developments outside France, having known and admired Victorian artists such as Tissot and Millais, whose meticulously painted, psychologically disturbing scenes of modern life seem to have influenced him, and having also met the German artist Menzel, whose brilliant study in artificial illumination, *The Supper at the Ball*, impressed him so much that in 1879 he reproduced it in oil from memory.[10]

In each of these major movements of nineteenth-century art, one figure was of particular and even exemplary importance for Degas, not only in his early, formative years but in his maturity; they are Ingres, Delacroix, and Daumier. His admiration for the first two, amounting in his later years virtually to veneration, is evident enough in his letters, in the memoirs of those who knew him, and in his collection, which

was stronger in works by these masters—twenty paintings and ninety drawings by Ingres, thirteen paintings and 190 drawings by Delacroix—than any others.[11] More surprising is the importance ascribed to Daumier, about whom Degas wrote and said little; even the presence in his collection of six paintings and drawings and some 1800 lithographs by the great Realist, almost one-half of his graphic production, strikes the most recent student of Degas's taste as something inexplicable.[12] Yet he himself was quite explicit in ranking Daumier with the other two, as the incident he reported to the painter Georges Jeanniot around 1885 demonstrates: "I was speaking of him the other day with Gérôme at the Café La Rochefoucauld, I was praising Daumier. 'What,' said Gérôme, 'you admire this Prudhomme?' 'But I am of the opinion,' I told him, 'that there have been three great draftsmen in the nineteenth century: Ingres, Delacroix, and Daumier!'"[13] This flaunting of the popular cartoonist in the face of the distinguished academician was no doubt a gesture of defiance, but not a betrayal of Degas's convictions. Seven or eight years earlier, he had expressed the same thought in the privacy of his notebook, choosing spontaneously the same three names while examining the forms of artists' signatures.

A fascinating document of Degas's consciousness of the smallest elements of his art, even one so peripheral and traditionally personal as the signature, this notebook page [15] contains his own name at the

15.
Degas, Imitations of Signatures, ca. 1877. Pencil.

Bibliothèque Nationale, Paris

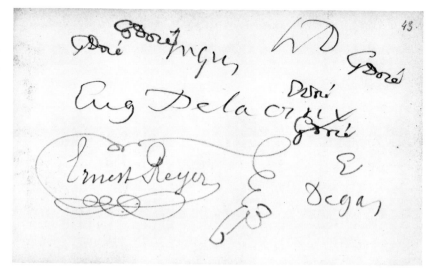

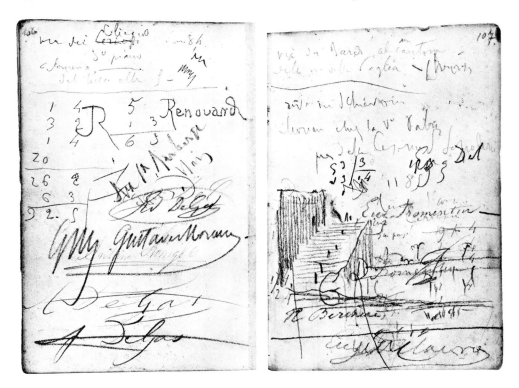

16. Degas, Notes and Imitations of Signatures, 1858. Pencil.

Bibliothèque Nationale, Paris.

lower right, Delacroix's in the center, Ingres's above it, and Daumier's
initials at the upper right; it also contains Gustave Doré's name, repeated
five times, and the composer Ernest Reyer's at the lower left.[14] Reyer,
a friend of Degas's, had recently been elected to the Institut de France;
hence no doubt his presence here and the extravagant flourish, ending
in a sexual image, around his name. It was no such satirical impulse
that led Degas to imitate the other signatures—more accurately than
Reyer's, although still from memory[15]—but rather a desire to compare
them with his own. Significantly, in three of the four the final initial
is a "D" and in one the first initial is an "E," which he repeats directly
above his name. There are also formal similarities between the "D" in
Daumier's signature, the "e," "g," and "a" in Delacroix's, the final "s"
in Ingres's, and the corresponding letters in his own. It is tempting to

see in these analogies Degas's search for a distinctive professional signature, but that was already established by the time he used this notebook. Only its initial "D" seems to have changed about then,[16] and this may explain the successive transformations of the same letter in Doré's signature to approximate its rounded form in his own. For Doré was of minor significance for Degas as an artist, whereas his choice of the other three, precisely because he made it so unprogrammatically, in such intimate circumstances, confirms their central place in his thinking about nineteenth-century art.

It was not the first occasion on which Degas imitated a favorite artist's signature or compared it with his own. On adjacent pages of a notebook he used almost twenty years earlier [16],[17] at the very moment of his "conversion" to Romanticism, he signed his own name in several ways, this time really searching for a distinctive form, and surrounded it with imitations or specimens of the signatures of those who were influential in effecting that conversion: Gustave Moreau, who had evidently communicated his admiration for Delacroix and the Venetians while they were traveling in Italy; Eugène Fromentin, who was a close friend of Moreau's and, in his more subtle, realistic way, a follower of Delacroix's exoticism; and of course Delacroix himself, whose work Degas studied closely at this time and took as a model for the expressive, coloristic qualities in his own. Only one year earlier, however, in a notebook used in Italy [17], he had written Ingres's name in Greek capital letters, as if imagining it incised in stone, like the long inscriptions in Ingres's

17.
Degas, Quotation from *The Iliad* and Signature, 1858. Pencil.

Bibliothèque Nationale, Paris

Apotheosis of Homer [20]; and as if to reinforce its classical connotation, he had copied on the same page the first two lines of *The Iliad*, also in Greek, and had noted on the facing page an edition of Poussin's correspondence.[18]

THE ADMIRATION that had led Degas to picture Ingres's name printed in Greek and later to imitate it written in script eventually became a kind of veneration, of which Georges Rouault could justly maintain, "He imposed on his time his worship of Dominique Ingres."[19] Half a century later, Degas still cherished the memory of a youthful meeting with the older master, whose famous *Bather* he had succeeded in persuading its

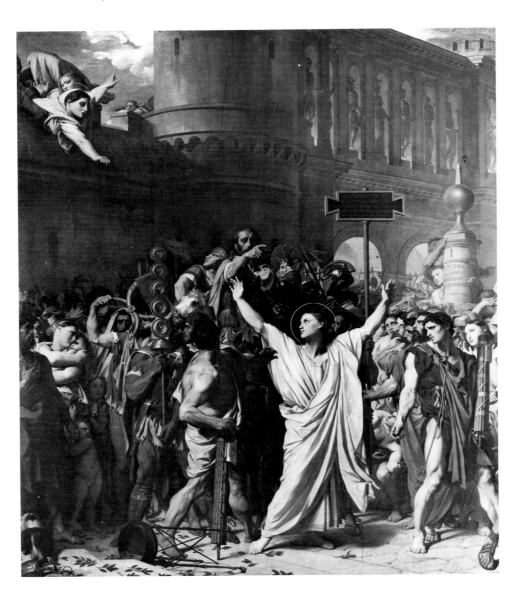

owner, Edouard Valpinçon, to lend to a retrospective exhibition of Ingres's work. Recounting that meeting for friends, he dwelled on the advice he had received when he confessed his own artistic ambition, advice that in retrospect seemed remarkably prophetic: "Study line . . . draw lots of lines, either from memory or from nature."[20] In another version, however, he was supposedly told: "Young man, never work from nature. Always from memory, or from the engravings of the masters,"[21] and indeed his early work was dominated by drawings after older art, above all after Raphael and the antique, which were Ingres's models, and after the latter's works. These Degas had a unique opportunity to study at the retrospective exhibition, organized as part of the World's Fair of 1855, for which he had helped to obtain *The Valpinçon Bather*.

The many copies Degas made on that occasion were in fact almost entirely after Ingres, despite the presence of equally comprehensive exhibitions of Delacroix and Courbet either at the World's Fair or outside it. Attracted primarily by the plastic perfection of the older master's forms, he concentrated on the mythological and religious subjects rather than the portraits, often isolating a particularly graceful figure—the naked Angelica in one version of *Roger Freeing Angelica*, the archangel Raphael in one of the cartoons for stained-glass windows—and rendering it in delicate detail.[22] Apart from a small, unfinished oil sketch of *The Martyrdom of St. Symphorian* and a careful, almost dutiful drawing of *The Valpinçon Bather*, none of these early copies is of an entire compo-

18 (*opposite*).
Ingres, *The Martyrdom of St. Symphorian*, 1834. Oil on canvas.

Cathedral of Autun

19.
Degas, Copy after Ingres's *Martyrdom of St. Symphorian*, 1855. Pencil.

Bibliothèque Nationale, Paris

sition, whereas Ingres's own copies after Raphael and Poussin were generally just that.[23] On the contrary, some of Degas's studies are of marginal, thematically insignificant elements that must have had a special appeal, like the group of painters and lyric poets at the left side of *The Apotheosis of Homer*, or that exhibited a striking movement or expression, like the animated figure of St. Symphorian's mother in the upper left corner of the *Martyrdom* and that of the stooping soldier half hidden in the throng at the lower right side [18, 19].[24] In this concentration on a subordinate yet visually arresting detail, there is a hint of that taste for the eloquent, unobserved fragment that is so characteristic of Degas's mature vision.

The emergence of such a taste is more apparent in drawings he made after some of the same pictures four or five years later, when he had come into contact, in Italy and through French artists he met there, with a greater range of styles than he had known previously and had already begun to develop his own style. These later copies are exclusively of single figures or parts of their costume, often chosen with a potential use in mind, and are rendered with a greater freedom and confidence.

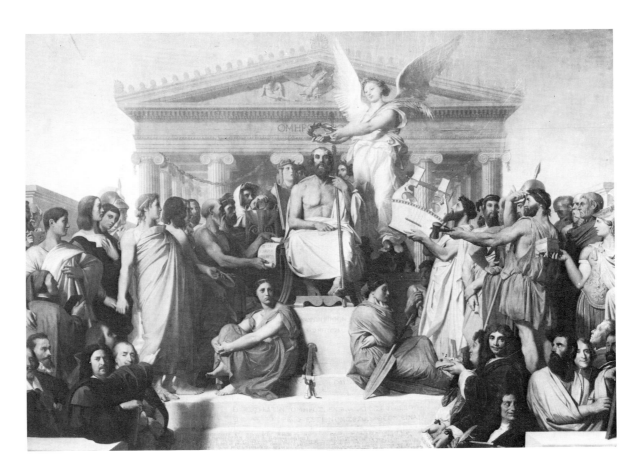

From the group of painters and poets in *The Apotheosis of Homer*, which he had once drawn in pale, delicate tints, he now extracted only the nobly poised figure of Apelles and part of "The Iliad" beside it, reproducing the classical drapery in tones of strongly contrasted light and dark [20, 21]; from the group of sculptors and philosophers at the far right, only the graceful figure of Alexander, intercepted by the frame in a way that foreshadows his more radical use of this device a decade or more later.[25] The image of Alexander, however, is also that of a famous hero, who is shown in ancient armor and standing in strict profile as in an ancient relief; this, too, would have interested Degas, who was at just this time planning to paint a picture of *Alexander Taming Bucephalus* [215].[26] In the same way, he now isolated from *Roger Freeing Angelica*, not the suave female form in the center, but a peripheral detail of potential use, the mounted knight's windblown cloak, whose intricate folds he drew repeatedly in a notebook containing studies for *The Daughter of Jephthah* [32], where it would easily have been incorporated.[27] This habit of assimilating admired elements of older art, perfectly familiar to Ingres himself, had already led Degas to base

20 (*opposite*).
Ingres, *The Apotheosis of Homer*, 1827. Oil on canvas.

Musée du Louvre, Paris

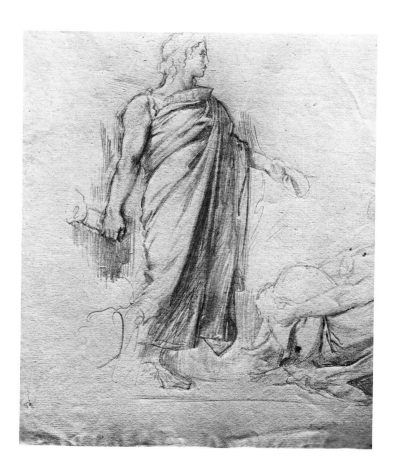

21.
Degas, Copy after Ingres's *Apotheosis of Homer*, ca. 1860. Pencil.

Present whereabouts unknown

22. Degas, Study for *The Daughter of Jephthah*, ca. 1859. Pencil.
Present whereabouts unknown

the figure of the queen in his first historical composition, *King Candaules'
Wife* [108], on *The Valpinçon Bather* and to form its classical setting on
that in Ingres's *Stratonice and Antiochus*, which he had likewise copied.[28]

It was around 1860 that Degas also began to imitate more extensively
than he had before the brilliant style of Ingres's drawings. One reason
was undoubtedly their greater accessibility, beginning with the important
exhibition at the Salon des Arts-Unis in 1861;[29] another was the growing
reaction within his own art against the exuberant Romantic style he had
explored previously, a reaction that led quite naturally from Delacroix
to Ingres. Increasingly in this period he employed the latter's favorite
medium, a finely pointed pencil on a smooth surface, to create his
favorite effect, an incisive, strongly accented line, which he allowed to
stand alone in defining form or supplemented with subtle, almost trans-
parent shading. A particularly striking example of this Ingresque style

is the study of a stooping soldier for an early version of *The Daughter of Jephthah* [22],[30] since the figure's action, too, was evidently based on one invented by the older artist [23], in fact the very one that had attracted Degas earlier in *The Martyrdom of St. Symphorian*. Despite this clear filiation, however, there are revealing differences: just as the attitude of Degas's figure seems more gentle and inward, and its members lack the energetic thrust of Ingres's, so the modeling of its forms is more nuanced and suggestive of mystery. In these studies in general, it has been observed, "there is a difference not unlike that between Greek refinement and Roman fullness, or between Leonardo's precious early drapery designs and those of Raphael."[31] The same may be said of the sensitive drawings of nudes that Degas made in preparation for *The Misfortunes of the City of Orleans* [146], some of which are reminiscent of Ingres's drawings for *Stratonice and Antiochus* and *Romulus Victorious over Acron*.

In portraiture, too, Ingres was by far the most important influence on the young Degas. The finest of his early self-portraits, painted at the age of twenty-one, is a kind of homage to the well-known one depicting Ingres at about the same age, in virtually the same format and position, which Degas undoubtedly saw at the World's Fair that year.[32] But it lacks the energy and determination of the earlier image,

23.
Ingres, Study for *The Martyrdom of St. Symphorian*, 1834. Pencil.

Fogg Art Museum, Cambridge, 1965.296, bequest of Meta and Paul J. Sachs

created shortly after the Revolution, and instead projects a mood of lethargy and doubt more characteristic of Degas's time and personality. That he continued to admire those opposite qualities in Ingres is evident in his sketch of him in full academic dress, in proud profile, some five years later.[33] That he also continued to follow the older artist's example is clear from the portraits he made of relatives in Italy in the late 1850s, and above all from the ambitious *Bellelli Family* [7], painted on his return. Its resemblance compositionally to Ingres's *Gatteaux Family* and *Forestier Family* has been noted more than once,[34] though the differences in content between these complacent images of domestic harmony and Degas's searching analysis of domestic tension are equally telling. In the following decade, such differences became more pronounced, even though he had by now mastered the elements of Ingres's draftsmanship as well. His portrait drawing of the younger Valpinçons, dated 1861, may still be Ingresque in its formality and refined linear style;[35] that of Mme Hertel [24], made four years later in preparation

24.
Degas, Study for *A Woman with Chrysanthemums*, 1865. Pencil.

Fogg Art Museum, Cambridge, 1965.253, bequest of Meta and Paul J. Sachs

for *A Woman with Chrysanthemums* [36], is more fully personal in both respects. Compared with the type of female portrait, such as that of Mme Ingres [25], from which it ultimately derives, it exhibits a more complex style, no less precisely linear, but swifter and more strongly accented, responsive to nuances of local color and expression.[36] The direction of the glance, the gesture of the hand, is no longer conventional and flattering but idiosyncratic, expressive of a tense, intelligent personality in a moment of distraction.

Long after Degas had abandoned historical subjects for modern ones, he continued to follow Ingres's example in portraiture, the least dated aspect of his oeuvre. The influence is not always as obvious as that of *The Comtesse d'Haussonville,* shown at the Ingres memorial exhibition of 1867, on *Thérèse Morbilli* [77], painted two years later, where the aloofness and studied gesture, the elegant costume and mirrored salon, and the smooth precision of style all recur.[37] Yet it continues to be felt even later in such works as *The Savoisienne,* both in the sober frontality

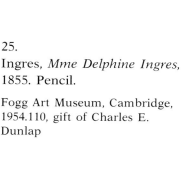

25.
Ingres, *Mme Delphine Ingres,*
1855. Pencil.

Fogg Art Museum, Cambridge,
1954.110, gift of Charles E.
Dunlap

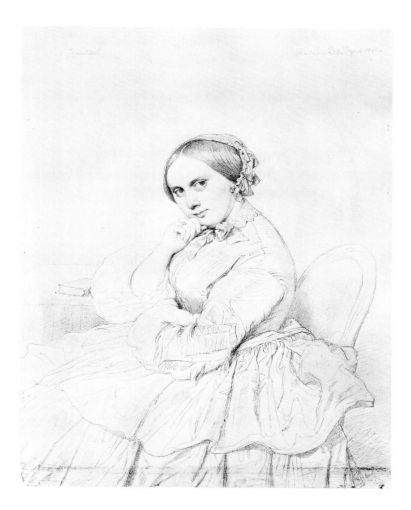

26. Degas, Study for *Edmond Duranty*, 1879. Charcoal and white chalk.
Metropolitan Museum of Art, New York, Rogers Fund, 19.51.9

and symmetry of the figure's design and in the breadth and definition of its forms.[38] The same is true of male portraits, such as the unidentified one in the Museum of Fine Arts, Boston, where the subject's formal dress and neutral background, unusual in Degas's mature work, are also reminiscent of Ingres, for example of *The Baron de Norvins*, which Degas subsequently acquired.[39] And, to take two well-known drawings in the Metropolitan Museum, a study [26] for one of the most thoroughly naturalistic of his later portraits, that of Duranty seated at a desk piled with books and papers, is surprisingly similar to a study [27] for the famous portrait of Bertin the Elder in its penetrating analysis of gesture and expression and its combination of delicate modeling and swift, emphatic lines, although Degas's lines are in places still more summary. Indeed, when he exhibited a number of drawings, along with the portrait of Duranty [6], at the Impressionist show in 1880, the critic

Charles Ephrussi recognized in him "not only a draftsman of more than estimable ability, but a pupil of the great Florentines, . . . and above all of a great Frenchman, M. Ingres."[40]

Duranty himself had long been aware that, despite his reactionary views and outmoded subjects, Ingres's pictures and especially his portraits revealed a vigor, a simplicity, and a fidelity to nature that made them important forerunners of Naturalism. In reviewing the Salon of 1872, he opposed to the facile colorism of Henri Regnault the probing draftsmanship of Ingres, "who raised drawing to a great elegance and keenness . . . marked by a strength of character that one rarely encounters."[41] And in tracing the origins of "the new painting" four years later,

27. Ingres, Study for *Louis-François Bertin*, 1832. Pencil and black chalk. Metropolitan Museum of Art, New York, bequest of Grace Rainey Rogers, 43.85.4

he found them in Courbet and Corot, in Millet and Ingres, "those sim-
ple, reverent souls, those men of powerful instinct," and insisted that
the latter, having "brought back from Greece only a respect for nature,
. . . never hesitates or deceives when confronting modern forms."[42]
These remarks are doubly important, since they were undoubtedly in-
fluenced by Degas; and indeed he, too, contrasted the authenticity and
probity of Ingres's art with the frequently contrived art of the Ecole
des Beaux-Arts, even hesitating to visit a major exhibition of photo-
graphs of the master's drawings because it was being held too close
to the Ecole.[43]

Like Duranty, the mature Degas could still find the personal and
naturalistic aspects of Ingres's oeuvre, above all the drawings and por-

28. Degas and the photographer Barnes, Parody of Ingres's *Apotheosis
of Homer*, 1885. Photograph.

Bibliothèque Nationale, Paris

traits, relevant to his own; but he could only parody the public and stiffly formal aspects seen in the mythological compositions. This he did in an amusing photograph that he arranged and had taken in front of a summer house at Dieppe in 1885 [28], showing himself as the solemn Homer of Ingres's *Apotheosis* [20] and some young friends as muses and reverent choirboys.[44] Many years earlier, we recall, he had taken that work seriously enough to copy several of its figures, though his choice of such details perhaps implied a reservation about the rigidity of the whole. Even now he was prompt to defend it when his friend Henri Rouart observed that "the gods in it, frozen as they were into lofty attitudes, breathed an icy atmosphere. 'What!' Degas burst out. 'But what could be more admirable? The whole canvas is filled with the air of the empyrean.'"[45] In fact, so deeply ingrained in him was Ingres's conception of form that he judged the parody itself in terms of it, regretting the looseness of design and loss of definition: "My three muses and my two choir children ought to have been grouped against a white or light background. The forms of the women in particular are lost. The figures ought also to have been compressed more."[46]

After this date, the contrast between Degas's admiration for Ingres and his own un-Ingresque practice became increasingly pronounced. Paradoxically, the more his art differed from the older master's in its freedom and intensity of expression, the more enthusiastically he acclaimed that coolly classical art and exalted the personality that had created it. In 1890 George Moore made public what was already known privately when he wrote that "Degas was a pupil of Ingres, and any mention of this always pleases him, for he looks upon Ingres as the first star in the firmament of French art."[47] The year before, in planning to visit an exhibition of the latter's drawings, Degas had referred to them as "those marvels of the human spirit."[48] What he admired in them, their conciseness and wit, their savor of a strong personality, he also found in Ingres's aphorisms on art, which he enjoyed citing. "You can't quote a remark of Ingres's that isn't a masterpiece," he declared, contrasting them with the far longer, more literary essays of Delacroix.[49] Indeed, the trenchant style of his own axiom, "Drawing is not the same as form, it is a way of seeing form," is reminiscent of one by Ingres that he used to repeat, "Form is not in the contour, it lies within the

contour."[50] Perhaps the most touching expression of his veneration of the great draftsman was Degas's long-cherished plan to classify and eventually to publish all the studies by him in the Montauban Museum, a plan he proposed to that city in 1897 with an offer, surprisingly art-historical in tenor, to exchange photographs of the paintings in his collection for those of the related drawings in the museum.[51]

By this time he had already formed an important collection of Ingres's works, though he was to continue adding to it for another decade. How passionately he pursued the latest acquisition is clear from a letter to his dealer Durand-Ruel, at once imperious and imploring: "Do not deprive me of the little copy by Ingres, do not affront me and grieve me thus. I really have need of it."[52] Eventually he possessed four major portraits, including those of M. and Mme Jacques-Louis Leblanc now in the Metropolitan Museum, and sixteen paintings or painted sketches, as well as ninety drawings.[53] Many of the latter were studies for, and some of the paintings replicas of, the famous compositions he had copied as a student half a century earlier, among them *The Martyrdom of St. Symphorian, Roger Freeing Angelica,* and especially *The Apoth-*

29.
Ingres, Study for *The Apotheosis of Homer,* 1827. Pencil and white chalk.

Musée du Louvre, Paris

eosis of Homer, for which he owned almost twenty sketches in all media [e.g. 29]. The poignancy of these echoes of the past also struck Valéry, who, in reporting Degas's account of his visit to Ingres's studio in 1855, added that "while they were talking, [he] cast an eye around the walls. At the time he was telling me this [fifty years later], he owned some of the studies he remembered seeing on them."[54]

Long after he had ceased collecting and even painting, Ingres remained a subject of veneration for Degas. One of the last vivid images we have of him is of his visits to the retrospective exhibition of the older master's works in 1911, visits made daily with a touching fidelity, though he could no longer see and instead had to touch the pictures he had known so well.[55] Among them, of course, was *The Apotheosis of Homer* [20], the central figure of which, old and blind and noble, he now bore a striking resemblance to, as several of his friends noted. Thus his placement of himself in that role in parodying the picture a quarter of a century earlier took on in retrospect a strangely prophetic significance.

IT IS NOT surprising that Delacroix's name, like Ingres's, figured prominently among the imitations of artists' signatures in the notebooks of Degas's youth as well as his maturity: throughout his life these two remained for him the brightest stars in "the firmament of French art." They were already recognized as such, at least among living artists, at the beginning of his career, when both were given retrospective exhibitions at the World's Fair of 1855 and, as the Goncourt brothers later wrote in *Manette Salomon,* a novel of artistic life, "all the young painters were turned, at that moment, toward these two men, whose two names were the two war-cries of art."[56] At that time, of course, Degas's allegiance was entirely to Ingres, and he seems neither to have copied after nor to have imitated any of the works Delacroix exhibited, though he was deeply impressed by the sight of him swiftly and intently crossing a street and remembered it to the end of his life: "Every time I pass that place," he remarked fifty years later, "I see Delacroix again, pressed for time, and hurrying."[57]

It was on his return to Paris in the spring of 1859, after spending nearly three years in Italy, that Degas began to study Delacroix's art intensively.

That his interest had been aroused while he was abroad, despite the absence of original examples, is indicated by his father's remark some months earlier, "You know that I am far from sharing your opinion of Delacroix."[58] That this in turn was due to the influence of Gustave Moreau, whom Degas respected highly and was closely acquainted with at the time, and who had earlier abandoned the academic Neoclassicism of his teacher Picot for the Romanticism of Chassériau and Delacroix, has already been suggested apropos the presence of Moreau's name, together with those of Delacroix, Fromentin, and Degas himself, in the notebook used both in Italy and in France in that moment of transition [16].[59] But this movement toward colorism, freedom of expression, and originality of conception, inspired by the great Romantic's example, went beyond the circle around Moreau; it was part of a larger reaction, as seen, for example, in Baudelaire's review of the Salon of 1859 and even in that of Duranty, who had spurned Delacroix previously and now declared him the only authentic artist in the exhibition and a model for younger ones, "not in order to copy him, but to follow his example and learn to detach oneself from the common herd."[60] Five years later, Duranty and Baudelaire were to figure, along with Manet, Whistler, Fantin-Latour, and other artists of Degas's generation, in Fantin's famous *Homage to Delacroix*.[61]

The depth of Degas's own admiration remained unknown, hidden in

30.
Delacroix, *Mirabeau Protesting to Dreux-Brézé*, 1831. Oil on canvas.

Ny Carlsberg Glyptotek, Copenhagen

his studies and notes. We now know of some twenty copies, both painted and drawn, in notebooks and on larger sheets, after pictures and murals representing almost every aspect of Delacroix's oeuvre, above all the great compositions with religious, historical, and literary subjects. Collectively they suggest a remarkably intense assimilation, as if Degas were actively seeking that master's works everywhere in Paris: at the Salon, where he sketched *The Entombment* and *Ovid in Exile among the Scythians,* the latter in pen and wash in a very pictorial style;[62] at the Chamber of Deputies, where he drew and took extensive notes on the mural of *Attila Scourging Italy* and two of the pendentive decorations;[63] at the church of Saint-Denis-du-Saint-Sacrament, where he made a rapid study in pencil of *The Pietà,* and the Hall of Battles at Versailles, where he made a more careful copy in oil of *The Entry of the Crusaders into Constantinople;*[64] at the Louvre, where he surveyed the Gallery of Apollo ceiling mural almost topographically, section by section, with many color indications, in his notebook;[65] and at an exhibition in the Galerie Martinet, where he reproduced three dissimilar pictures, *Christ on the Sea of Galilee, The Combat of the Giaour and the Pasha,* and *Mirabeau Protesting to Dreux-Brézé,* the latter apparently from memory, in the swift, expressive style characteristic of the group as a whole [30, 31].[66] Unlike his copies after Ingres, studies of an admired or potentially useful detail, these were usually of the entire composition or its principal

31.
Degas, Copy after Delacroix's *Mirabeau Protesting to Dreux-Brézé,* 1860. Pencil.

Bibliothèque Nationale, Paris

figures and were often accompanied by color notations or comments
on the conception of the subject. After analyzing Dreux-Brézé's expres-
sion and the deputies' symbolic role, for example, Degas wrote: "As for
the tonality, sober, dramatic in its ceremonial appearance. A master-
piece! Composition and harmony. Never has this subject been inter-
preted in this way."[67]

The focus of this concentrated study of Delacroix's use of color and
composition in depicting dramatic events was Degas's involvement in
creating convincing images of such subjects himself. At the same time,
and even in the same notebooks, that he copied after *The Entombment,
The Pietà,* and *Christ on the Sea of Galilee,* he made countless sketches
for his own picture of religious pathos and resignation, *The Daughter
of Jephthah* [32]; and it was probably with that work in mind that he
reproduced in paint *The Entry of the Crusaders into Constantinople* [33],

32. Degas, *The Daughter of Jephthah,* 1859–1860. Oil on canvas.

Smith College Museum of Art, Northampton. Purchased 1933.

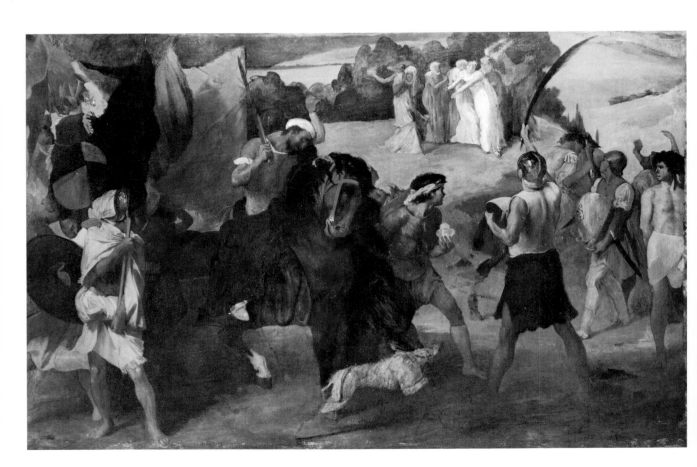

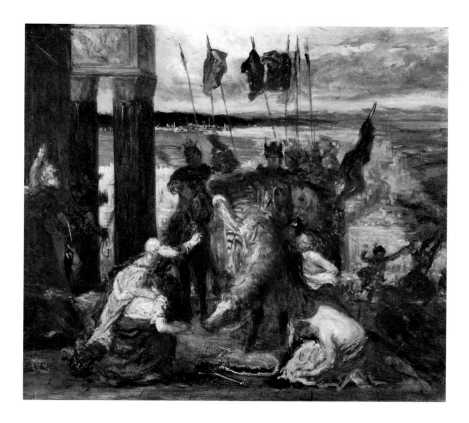

33. Degas, Copy after Delacroix's *Entry of the Crusaders into Constantinople*, ca. 1860. Oil on canvas.

Private collection, on loan to the Kunsthaus, Zurich

an image of military triumph and defeat like the one he was planning, and in doing so stressed the dramatic effect of the bright banners fluttering against the ominous sky. Indeed, in conceiving the color harmony of *The Daughter of Jephthah*, he referred repeatedly to the older master's example. "Almost no green," he wrote of its landscape background, "the hills in a half light as in Delacroix, with a gray sky,"[68] alluding to the latter's luminous grays. For the color of Jephthah's robe, now dark brown but once vermilion, he noted, "Remember the orange-red tones of the old man in Delacroix's picture," probably the *Pietà* he had copied previously.[69] And though he did not mention it, the principal figure in *Attila Scourging Italy*, which he had also sketched, evidently inspired Jephthah's pose and striking gesture. Beyond such specific forms and colors,

the exuberant style of the picture as a whole and the turbulent, impassioned character of the drawings for it likewise reveal the Romantic artist's influence. This "vibrant and vigorous style" derived from Delacroix is, in fact, precisely what characterizes Degas's draftsmanship at this moment in his development.[70]

But as we have seen, he also drew on Ingres for inspiration, specifically on the use of drapery in *Roger Freeing Angelica* and on the posture of a figure in *The Martyrdom of St. Symphorian*. Indeed, when he worked directly from the model in studying the related figure for *The Daughter of Jephthah* [22], his drawing style, too, was much closer to that of Ingres in its precision and subtlety. Yet when, on the other hand, he worked from imagination in visualizing this figure in its pictorial context [34],[71] he reverted to Delacroix, adopting the broad, painterly manner of the latter's oil sketches [e.g. 38] and even going beyond them in freedom of execution. To achieve this expressive unity of color and touch, he was forced to sacrifice the clear definition of form he had attained in the drawing. In the final painting, the conflict remained unresolved: after moving the stooping soldier closer to the center and transforming it into a leaping dog with the same silhouette [35], he half obliterated this, too, as though he had planned to revise it once again before he finally abandoned the project.[72] Thus his choice of Ingres and Delacroix revealed, for perhaps the first time in his career, that ambition to reconcile opposed yet equally attractive modes of vision with which he would

34.
Degas, Study for
*The Daughter of
Jephthah*, ca. 1859.
Oil on cardboard.

Formerly collection
of Marcel Guérin,
Paris

never cease to struggle. It was one of the sources of his perpetual dissatisfaction with his work and of his irresistible need to revise it, a need whose fulfillment often brought disastrous results.[73] Yet he was hardly alone in attempting to combine the styles of Ingres and Delacroix, the acknowledged masters of the kind of traditional painting he still sought to produce: Moreau, who led him from one to the other, and Chassériau, who in turn led Moreau, had done this earlier. In fact, he later spoke warmly of his acquaintance with Chassériau, whose refined and subtle Romanticism was much like his own, "half Indian, half

35.
Detail of Figure 32

Greek," as he said, and of the influence the latter had exerted on young artists of his generation.[74]

Characterizing the milieu in which Chassériau had played so symbolic a role, the Goncourt brothers wrote in 1867, in *Manette Salomon*, that "brilliant personalities, ardent, full of promise, . . . moved, like Chassériau, from the shadow of one master [Ingres] to the shadow of another [Delacroix]."[75] But that milieu, preoccupied with traditional themes and styles, had existed two decades earlier; whereas Degas, who had by 1867 turned to modern subjects, seemed still to be oscillating stylistically between these masters only two years earlier, as is evident in *The Misfortunes of the City of Orleans* [146], the last of his historical composi-

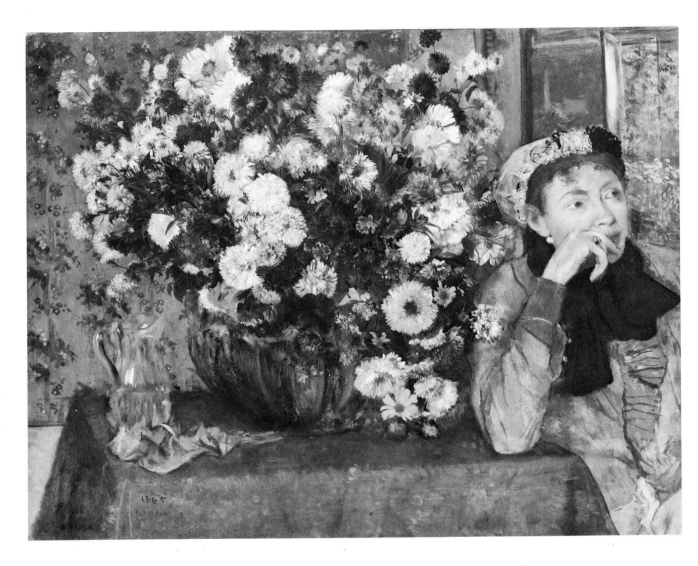

36. Degas, *A Woman with Chrysanthemums*, 1858–1865. Oil on canvas.
Metropolitan Museum of Art, New York, The H. O. Havemeyer Collection, bequest of Mrs. H. O. Havemeyer, 29.100.128

tions, and above all in *A Woman with Chrysanthemums* [36], one of the first with a distinctly modern look.[76] If the image of the woman in this picture, now in the Metropolitan Museum, is reminiscent in its linear definition and subtle modeling of Ingres's late female portraits, the painting of the bouquet is equally indebted in its brighter coloring and

37. Delacroix, *A Bunch of Flowers in a Stone Vase,* 1843. Oil on canvas.
Kunsthistorisches Museum, Vienna

freer execution to Delacroix's still lifes of flowers, several of which
figured in exhibitions and sales held in Paris in 1864 [e.g. 37].[77] There
are, of course, differences in pictorial conception between the dramatic
radiance of the Romantic artist's bouquet and the delicate restraint of
the young Realist's, just as there are differences in psychological content
between Degas's treatment of the figure and Ingres's. But the deri-
vation from Delacroix seems no less evident than the other one; and
even if the still life was initially painted in 1858, without the figure, as
a recent laboratory examination has indicated, and was therefore prob-

38.
Delacroix, Sketch for
The Battle of Poitiers,
ca. 1829. Oil on
canvas.

Walters Art Gallery,
Baltimore

39.
Degas, Copy after
Delacroix's Sketch
for *The Battle of
Poitiers*, 1880. Oil on
canvas.

Formerly Emil G.
Bührle Foundation,
Zurich

ably based on Italian Baroque flower paintings,[78] it was almost entirely repainted in 1865, in the fresher, more vivid colors of the French master, as a similar examination has shown.

Unlike the influence of Ingres, which continued to be felt in Degas's work, at least in portraiture, that of Delacroix seems to have declined in the later sixties and seventies, probably because his work was then at its most soberly realistic and subtly refined, and artists such as Velázquez and Mantegna came more readily to mind.[79] But when, toward the end of this period, it began to change stylistically, becoming bolder in execution, brighter and more complex in coloring, Delacroix's art once again seemed relevant. It was his signature, the largest and most centrally placed, that Degas must have written first on the notebook page of 1877 [15]; his name that occurred most often in Degas's correspondence in the following decade. Indeed, he found the name itself symbolic of the artist's alienated condition, remarking to a colleague, in a letter written in a particularly bleak mood in 1882, "De la Croix has a painter's name."[80] Sending greetings to the same colleague from Tangier seven years later, he recalled that "Delacroix passed here," adding with barely concealed emotion, "One loves in nature those people who have not been unworthy to touch it."[81] And in 1880, when pastel had begun to replace paint as his preferred medium, he described for another colleague "a tiger [by Delacroix] which under glass looks like

40.
Degas, *Gentlemen's Race: Before the Start*, 1862–1880.
Oil on canvas.

Musée du Louvre, Paris

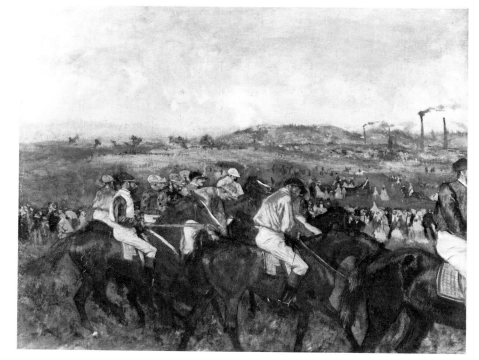

41. Degas, *The Singer in Green*, ca. 1885. Pastel.

Metropolitan Museum of Art, New York, bequest of Stephen C. Clark, 61.101.7

a watercolor. It is pastel applied very lightly on a somewhat smooth paper. It is very vibrant, it is a lovely method."[82]

The effect on Degas's own art of this renewed interest in the great colorist's technique was apparent at once to Huysmans, who, in reviewing the Impressionist exhibition of 1880, asserted that "no other painter, after Delacroix, whom he has studied closely and who is his true master, has understood as M. Degas has the marriage and adultery of colors."[83] As evidence Huysmans cited the portrait of Duranty [6], where he observed the use of an "optical mixture" reminiscent of Delacroix's in the forehead streaked with rose, the beard flecked with green, and the yellow fingers outlined in violet. But his statement that this reflected a prolonged study of Delacroix's work probably originated with Degas himself, since no examples of such a study had left his studio.

What they looked like, we learn from his copy after an oil sketch for *The Battle of Poitiers* [38, 39], which very likely also dates from 1880, when the Delacroix was temporarily accessible to him at a dealer's in Paris.[84] Working, perhaps from memory again, from this brilliantly executed sketch, itself greatly simplified in relation to the larger, more conventional picture at Versailles, he carried the process further, reducing the representational aspects so drastically that they form an almost abstract pattern of loosely brushed spots of color. If the same degree of freedom is not found in Degas's other works in these years, they do exhibit the same tendency in color and touch and even the same kind of composition at times, especially in scenes showing horsemen in an open landscape like Delacroix's. The most striking example is *Gentlemen's Race: Before the Start* [40], which was painted in 1862 but largely reworked around 1880,[85] perhaps with the *Battle of Poitiers* sketch in mind, since it bears the closest resemblance not only in its placement of the horsemen below the horizon, but in its summary treatment of the distant forms and its color harmony dominated by vivid spots of red and white against a tan and green ground.

As Huysmans recognized, it was above all in their new approach to color, their intense, vibrant hues juxtaposed in complementary pairs or fused in optical mixtures, that Degas's works were most clearly indebted to Delacroix's in this period. A retrospective exhibition of the latter, held at the Ecole des Beaux-Arts in 1885, was undoubtedly a fresh stimulus;[86] and the Metropolitan Museum's pastel *Singer in Green* [41], with its

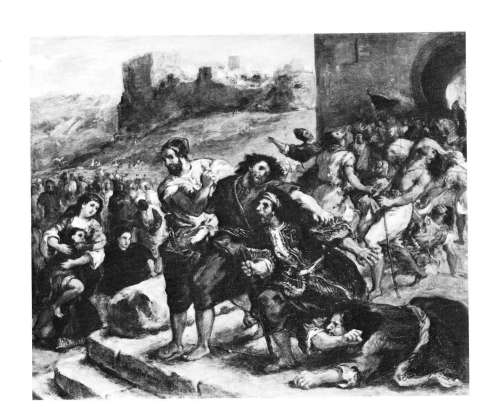

42. Delacroix, *The Fanatics of Tangier*, 1857. Oil on canvas.
 Art Gallery of Ontario, Toronto

brilliant alteration of turquoise and vermilion flecked with yellow in the skirt, its subtle repetition of turquoise and vermilion over yellow in the bodice, is one measure of the response.[87] At that exhibition Degas would also have seen the late version of *The Fanatics of Tangier* [42], of which he made an unusual copy in oil [43] that has been dated to the time of the exhibition,[88] but seems stylistically to be much later. Its heavily simplified contours and broadly painted areas of color, partly independent of the contours, link it most closely to his latest known copy, made in 1897 from a Mantegna in the Louvre [214],[89] just as its composition and color harmony, dominated by bluish greens, yellowish whites, and a vivid orange, recur in his ballet pictures of that period.[90]

Pursuing his investigation of Delacroix's color, as he pursued that of Ingres's line, virtually as an art historian, Degas read and discussed with colleagues the many passages on color phenomena in the great Romantic's *Journal* when it began to appear in 1893, and even managed to obtain some of the palettes found in his studio, in which small doses of mixed color, labeled to indicate their components, were arranged in various sequences, depending on the harmony to be created.[91] In fact, Degas supposedly used such a prepared palette himself at this time, finding it analogous to a box of pastels, and advised young artists to do the same. But he also admired the effect of color that Delacroix obtained in his black and white lithographs and the ease with which he evoked a vivid personality in his portraits, praising two of those he had just acquired as "cleverly, freely done. . . . [He] did them like a great man who enjoys everything."[92] And if he preferred the wit and brevity of Ingres's statements on art, he was fond nevertheless of quoting Delacroix's advice on the advantages of working from memory.[93] Even the appearance of his great predecessor, as fierce and aloof as he himself wished to appear, interested him, and he often repeated Redon's de-

43. Degas, Copy after Delacroix's *Fanatics of Tangier*, ca. 1897.
 Private collection, Paris

scription: "the head of a tiger, with a cold, imperious air and black, squinting eyes of an unbearable brilliance."[94]

In addition to the two early portraits just mentioned, Degas's impressive collection of works by Delacroix, largely formed in the decade after 1895, contained a more important portrait, the one of Baron Schwiter now in the National Gallery, London, and paintings representing every major aspect of his achievement: religious and mythological scenes, including a large, very dramatic version of *The Entombment;* exotic and historical subjects, among them a sketch for *The Battle of Nancy* that resembles the *Battle of Poitiers* sketch Degas had once copied; a spirited copy by Delacroix himself after one of Rubens's Marie de'Medici pictures in the Louvre; studies of landscape and animals; even an interior, *The Comte de Mornay's Apartment* [107], which Degas later considered one of the three finest pictures in his possession.[95] His excitement in bidding for such works, his eagerness to install them in his collection, is reported by a number of his friends. What is more surprising, in view of his primary interest in Delacroix's color, he also acquired 190 of the latter's drawings;[96] and if many were painted in watercolor or pastel, many others were drawn in pencil with rapid, broken, pulsating strokes, which, in contrast to the contours in his own drawings, locate rather than define forms in space. Like some of the paintings he bought, some of them were studies for pictures he had copied forty years earlier, and must also have had a sentimental appeal. In examples such as these, we discover once again that remarkable continuity of taste, that unswerving loyalty of attachment, which was so characteristic of Degas's relation to Delacroix as well as to Ingres.

THE SAME continuity did not exist in Degas's relation to Daumier; and appropriately the great Realist's name, unlike those of Ingres and Delacroix, appears only in the later page of artists' signatures in his notebooks [15], written after Degas had turned from historical subjects to scenes of modern life. Equally significant are the other differences between this page and the earlier ones [16]: the absence now of Moreau's name and Fromentin's, the presence of Gustave Doré's. For if the latter's tenebrous, visionary art does not seem to have interested Degas—there were no examples of it in his collection, no references to it in his letters

and reported conversations—it did resemble and even anticipate his own at times in depicting such familiar urban subjects as the stock exchange, the café-concert, and the music hall.[97] And if, on the other hand, Degas maintained his friendship with Moreau, it was no longer based on shared artistic ideals; on the contrary, his contempt for both the esoteric imagery and the excessive detail of his colleague's work prompted some of his most sarcastic sayings: "He would like us to believe that the gods wore watch-chains"[98] is one example. Similarly, Fromentin's failure to develop beyond the refined exoticism of the pictures Degas had admired at the Salon of 1859, indeed his refusal to accept the vitality and modernity of Impressionism, inevitably alienated him from Degas, whose views did develop and were now expressed in Duranty's pamphlet *The New Painting*, written in response to Fromentin's attack on the new tendencies in 1876.[99]

To this antagonism between two artistic ideals, each one realistic in its way, belongs also the controversy between Degas and Gérôme over the importance of Daumier, quoted earlier in this chapter; for Gérôme, too, believed he was upholding the dignity of traditional art in choosing exotic or historical subjects and in rejecting as banal the modern urban ones treated by the Impressionists and by Daumier. Hence Degas's insistence in that controversy on ranking the latter with Ingres and Delacroix as one of the "three great draftsmen" of the nineteenth century. Hence, too, his response to Gérôme, who, on learning of his admiration for Daumier, sent him several lithographs: "These precious proofs were lacking in my collection. I thank you warmly for them, and hope that these sublime hooligans will occupy your mind a little"[100]—in other words, that they will teach him a more authentic, vigorous form of realism.

For Degas himself, however, they were also models of a convincing, vital form of classicism. "Daumier had a feeling for the antique," he remarked to Jeanniot, "He understood it to such an extent that, when he drew Nestor [sic] pushing Telemachus, it was shown as it would have been at Tanagra."[101] Thus, quite apart from its mythological subject, one of fifty in the famous series entitled *Ancient History*, the lithograph of Telemachus and Mentor [44] possessed for Degas a classical strength and simplicity in its style. Its harmonious forms, perfectly legible despite

44.
Daumier, *Telemachus and Mentor*, 1842. Lithograph.

Metropolitan Museum of Art, New York, Harris Brisbane Dick Fund, 36.12.22

45 (*below*).
Daumier, *The Legislative Belly*, 1834. Lithograph.

Metropolitan Museum of Art, New York, Rogers Fund, 20.60.5

their small size, can indeed be compared with those of the Hellenistic figurines he mentioned, though its imagery of sadistic pleasure is foreign to them, suggesting a deeper reason for its appeal to him. Long before the Tanagra figures were discovered in the early 1870s, Degas had drawn in the Louvre after similar figures from Cyrenaica,[102] but the others came more naturally to mind around 1885, when he compared Daumier's art with them, since he had recently planned a picture centered on one of them. It was a portrait of Henri Rouart's wife and daughter examining

such a figurine, in which the daughter's costume and pose were reminiscent of Tanagra types;[103] and in this witty, highly personal, yet ultimately respectful interpretation of the antique, it resembled Daumier's print. Clearly the same could not be said of the stiffly posed, impersonally realistic statue of a seated nude, holding a pseudo-antique statuette and entitled *Tanagra*, that Gérôme exhibited at the Salon of 1890, though his slightly later picture *The Roman Pottery Painter* revealed greater historical wit.[104] Indeed, when Degas and Daumier turned to sculpture —and their deep interest in it, their preference for vigorous modeling, and their treatment of subjects taken from their paintings are all further links between them—they achieved a simple grandeur of form, a veracity of movement, which were authentically classical.

The distinction was important and already recognized at the time, at least among artists. According to Duranty, the Barbizon painter Daubigny expressed his admiration for Raphael's frescoes in Rome by exclaiming, "It's like Daumier!"[105] And after admitting that such a comparison "seems at first very surprising," Duranty himself claimed that the heads in the well-known print *The Legislative Belly* [45] "are modeled as broadly as those in a picture by Poussin," and that the faces and figures in other prints reveal as profound an understanding of expression as those in Holbein's portraits,[106] thus identifying Daumier with other artists of a classical tendency whom Degas, too, admired. He may in fact have inspired these comparisons, since the article in which they occur, a review of the retrospective exhibition of Daumier's work

46.
Degas, Copy after Daumier's *Legislative Belly*, 1878. Pencil.

Bibliothèque Nationale, Paris

in 1878, dates from the period when he was closest to Duranty, witness his contribution to *The New Painting* two years earlier and his portrait of the writer one year later [6]. Moreover, the only work in the exhibition that Duranty discussed at length, *The Legislative Belly*, was the one that Degas chose to copy in a notebook at this time [46], perhaps during a discussion with him.[107]

If so, however, it was to illustrate a very different interpretation of the print; for what impressed Duranty was its coloristic style—"a marvel of coloring, of vivid tones, harmonized and balanced"—and its realistic content—"the profound, the intense feeling of life and of truth"[108]— whereas Degas ignored both aspects, reducing its tonal harmony to a stark contrast of black and white, and its imagery to a pattern of scribbled shapes and lines. In drastically simplifying the original, in effect caricaturing a caricature, he expressed literally, in purely graphic terms, that energy of aggression which Duranty described figuratively in calling Daumier "the caricaturist who is bent on disparaging and destroying the ideal," one whose crayon "is almost always full of impulsiveness, of violence."[109] It is clear from Degas's portraits and caricatures that, more than any of his Impressionist colleagues, he shared Daumier's deep

Le passé. Le présent. L'Avenir.

interest in physiognomic expression and must have examined *The Legislative Belly* in those terms as well.

In fact, when Degas began experimenting with caricature in the later 1860s—he had made a few attempts previously and had copied satirical prints by Hogarth[110]—his starting point was Charles Philipon's image of the reactionary Louis-Philippe as "the pear," which Daumier's lithographs had made famous thirty-five years earlier. On succeeding pages in one of Degas's notebooks, we find variations on the "pear" motif [47], based on such prints as *The Past, The Present, The Future* [48], and primitive versions of his own satirical images of contemporary political leaders, Napoleon III and Bismarck.[111] His progressive simplification of the graphic elements constituting each image, that "boiling down to an easily remembered formula" which is the essence of caricature and the lesson he had learned from Daumier, we find next in the pages of another notebook of this period, where the weaknesses of each personality—the French emperor's shallowness and effeminacy, the Prussian chancellor's bristling arrogance [49]—emerge with increasing clarity.[112] Unlike his predecessor, however, Degas eventually found the inherent expressiveness of his graphic formulas more important than their topical signifi-

47 (*far left*).
Degas, Caricature Studies, ca. 1868.
Pencil.

Formerly collection of Marcel Guérin, Paris

48 (*left*).
Daumier, *The Past, The Present, The Future*, 1834. Lithograph.

Metropolitan Museum of Art, New York, Harris Brisbane Dick Fund, 41.16.1

49.
Degas, Caricatures and Other Studies, ca. 1870. Pencil.

Bibliothèque Nationale, Paris

cance, for he applied one of them equally well to a different personality: several caricatures in a notebook of the late 1870s, while continuing to resemble Napoleon III, look remarkably like Edmond de Goncourt, an acquaintance whose signature and address appear above one of them [123].[113]

Surprisingly, in view of his closeness to Degas, Duranty hardly touched on an aspect of Daumier's art that now seems important in defining its influence on later Realist art: his frequent choice of scenes of urban entertainment and diversion—the café, the café-concert, the ballet, the theater, the art exhibition, the boulevard with strollers—and his invention of designs which, in their striking viewpoints and juxtapositions, their daringly cut and brilliantly lit forms, convey a corresponding sense of the movement, vitality, and social contrast inherent in urban life. Although more aware of this side of Daumier's achievement, later writers have either denied that specific examples of its influence can be found

50.
Degas, *The Orchestra of the Opera*, 1868–1869.
Oil on canvas.

Musée du Louvre, Paris

51.
Daumier, *The Orchestra during the Performance of a Tragedy*, 1852. Lithograph.

Metropolitan Museum of Art, New York, Rogers Fund, 22.61.304

in Degas's work or have tended to cite the same one, so that the full extent of its significance for him has never been appreciated.[114] On the contrary, one writer has maintained that Gavarni's prints, which Degas admired and collected in even greater numbers, were equally significant for him as sources of inspiration.[115] But perhaps because he recognized their artistic limitations—"It is a manner of expressing oneself in drawings," he told Jeanniot, "but it is only a manner; it is not a truly artistic expression"[116]—he seems to have borrowed far less from them.

Daumier's influence is most apparent in those pictures of theatrical performance in which Degas could indulge his own delight in juxtaposing the artificial and the natural while drawing on his great predecessor's innovations. The example generally cited, *The Orchestra of the Opera* [50] of ca. 1869, is indeed reminiscent of *The Orchestra during the Performance of a Tragedy* [51], where the animated, brightly lit performers on stage are contrasted to the grave, somberly dressed musicians below it, the horizontal footlights acting as a strong divider, though Degas characteristically portrays the musicians as individuals rather than as

members of a class or profession.[117] In *Musicians in the Orchestra*, painted three years later, he transformed this relatively static opposition of the two groups into a visually more dramatic one, viewed as if from a position directly behind the three musicians, whose heads and instruments loom large in the foreground, overlapping the small, luminous figure of the dancer above them; yet this situation, too, can be found earlier, in a more clearly contrived, symmetrical form, in Daumier's *Dancer Who Prides Herself on Having Conserved the Noble Traditions.*[118] Still more dynamic in composition than the corresponding work by Daumier, but still closely related to it in conception, is *The Duet* of ca. 1877, an image of performers on stage, seen from behind as if from the wings, with the prompter peering out of his box at one side and the audience faintly indicated in the background, very much as in the print *The Evening of a First Performance*, though again the latter is more formal and frontal in design.[119]

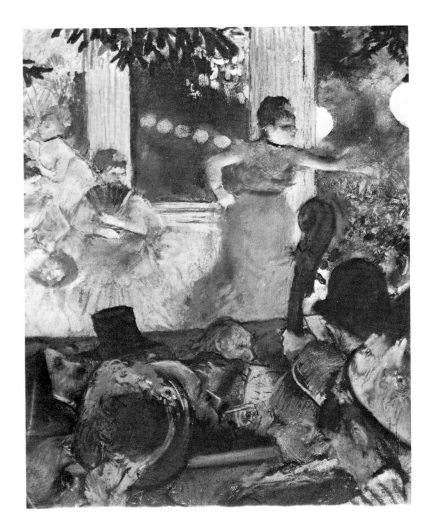

52.
Degas, *The Café-Concert at Les Ambassadeurs*, ca. 1876. Pastel over monotype.

Musée des Beaux-Arts, Lyons

In Daumier's treatment of the café-concert, a more specifically popular form of entertainment, which allowed for a shrewder psychological analysis of the performers and spectators, Degas seems to have found inspiration for the somewhat satirical content as well as the striking pictorial form that characterize his own treatment. Unlike the sensitive faces in *The Orchestra of the Opera*, those of the lower-class audience and musicians in *The Café-Concert at Les Ambassadeurs* [52] display a coarseness reminiscent of the beer-drinking workers and clerks in Daumier's print *At the Champs Elysées* [53], just as the bold division of the surface into two zones, one dominated by heavy, somber shapes, the other by light, delicate ones, with a sharply silhouetted hat linking the two, is similar to it in composition.[120] When Degas turned his satirical attention to the singer rather than the spectators, as he did in *The Song of the Dog* [197], subtly underlining the vulgarity of her expression, her miming of the animal's gesture, he seems to have drawn once again on

53.
Daumier, *At the Champs Elysées,* 1852. Lithograph.

Bibliothèque Nationale, Paris

54. Degas, *Ludovic Halévy Meeting Mme Cardinal Backstage,* ca. 1878.
Monotype.

Private collection, Paris

Daumier's prints, particularly on *The Leading Singer of a Café-Concert,*
whose subject is shown in virtually the same position and illuminated
from below in the same unflattering manner, though the effect is rather
of haggardness and straining to continue the performance.[121]

This fascination with the mundane reality behind the theatrical illusion
naturally led both artists to dwell on scenes set behind the scenes, with
the result that here, too, the older one could provide the younger one
with some useful hints. Thus, Degas's monotype *Ludovic Halévy Meeting
Mme Cardinal Backstage* [54] evidently has, in addition to its literary

55. Daumier, *The Mother of the Singer,* 1857. Lithograph.

Metropolitan Museum of Art, New York, gift of E. de T. Bechtel, 52.633.1(17)

source in that author's *Cardinal Family,* a visual source in Daumier's print *The Mother of the Singer* [55], a composition that is likewise divided by the wavy edge of a stage flat into two domains, one dominated by a sullen mother standing in its shadow, the other by a graceful daughter performing under the lights.[122] As in the previous examples, however, the earlier Realist stresses the social significance of the contrast, whereas the later one is content merely to record its charm for a subtle observer's eye.

If Daumier's lithographs were readily available to Degas, who eventually owned some 1800 of them,[123] many supposedly clipped from the pages of *Le Charivari* each week, his paintings and drawings were much more difficult of access. Rarely shown at the Salon or in dealers' gal-

leries, entirely absent from public collections, they were first displayed in large numbers at the retrospective exhibition of 1878 and again at the Ecole des Beaux-Arts a decade later, although by then Degas's art was too completely formed for them to affect it. Earlier he may also have seen works that passed through the hands of Hector Brame and Paul Durand-Ruel, dealers with whom he was friendly, or that belonged to the Rouarts and other collectors in his circle, but it is often impossible to specify which ones and when.[124] Hence the retrospective show of 1878 was for him, as it was for Duranty and others, his most important encounter with Daumier's paintings, and the works he produced after that date are those in which their influence can be sought.

This is why a contemporary critic's observation that Degas's *Laundresses Carrying Linen*, shown at the Impressionist exhibition of 1879,

56.
Daumier, *The Laundress*, ca. 1863. Oil on wood.

Metropolitan Museum of Art, New York, bequest of Lizzie P. Bliss, 47.122

"looks from afar like a Daumier" is misleading.[125] For if one of the latter's pictures of laundresses, now in the Metropolitan Museum [56], had figured in the retrospective the year before, Degas's had been completed some years before that; and if another of Daumier's pictures had been shown at the Salon of 1861, Degas would hardly have recalled it very clearly after fifteen years.[126] Much more likely to have been inspired by the *Laundress* exhibited in 1878 is one that Degas painted four years later [57].[127] Although an image of skilled labor rather than human hardship, set in the laundress's shop rather than on a deserted quay, it is remarkably similar in design: here, too, the woman is depicted *à contre-jour,* as a dark, curved form silhouetted against light, generally rectangular ones in the background, and she appears bending far to the left, concentrating on her task, so that her face becomes an anonymous,

57.
Degas, *Woman Ironing, Seen Against the Light,* ca. 1882. *Peinture à l'essence* on cardboard.

National Gallery of Art, Washington, D.C., 1972.74.1, Collection of Mr. and Mrs. Paul Mellon

58. Daumier, *The Amateurs*, 1860–1863. Oil on canvas.

Museum Boymans—van Beuningen, Rotterdam

shadowy profile; and here, too, a small, round form, a bowl instead of a child's head, becomes a focus of the composition. In other Laundress paintings of the 1880s, Degas again explored the *contre-jour* effect reminiscent of Daumier, but never with such strikingly similar results.[128]

Among the other paintings shown in 1878 that must have impressed Degas was *The Amateurs* [58], for he clearly had it in mind in painting his own version of this subject some three years later [59].[129] Although his version is a portrait of two friends devoted to art, the collector Alphonse Cherfils and the scholar Paul Lafond, whereas Daumier's is of unidentified figures interesting only as types, its dependence on the latter seems evident enough both compositionally and in its presentation of the two men as true *amateurs*, absorbed in the silent contemplation of a small canvas one of them holds. It is likely, too, that in the various versions of *Comic Actors on Stage*, which were also shown in 1878, Degas

was struck by the distortions caused by footlights illuminating the actors' faces from below, for in the *Café-Concert Singer Wearing a Glove*, executed in that year, he depicted with equally dramatic effect a performer seen in a glaring footlight from an unusually low and proximate viewpoint.[130]

Whatever the influence of Daumier's paintings may have been at that time, Degas made little effort to collect them later, when he had the means; instead he chose to concentrate on Ingres and Delacroix, Corot and Manet, and other masters. The one canvas he owned, the *Man Seated in an Armchair*, reveals nothing precise about the nature of his interest in Daumier, nor do the five drawings,[131] though one of them, a study of *amateurs* admiring a picture, probably appealed for the same reasons as the painting whose influence he had felt earlier. Far more important was his collection of lithographs, many of them rare proofs obviously not taken from *Le Charivari* but purchased individually and valued as

59. Degas, *The Amateurs*, ca. 1881. Oil on wood.

Cleveland Museum of Art, bequest of Leonard C. Hanna, Jr.

fine prints. Here Degas's admiration for Daumier's draftsmanship, which he had once declared equal to that of Ingres and Delacroix, expressed itself in a characteristically expansive form.

THAT Degas admired and collected the works of Ingres, Delacroix, and Daumier, that he often copied after and drew inspiration from them, is not in itself surprising; along with the works of Corot, Courbet, and Millet, they were models of an authentic art, independent of the academy, for many advanced artists of the later nineteenth century.[132] What is remarkable is the extent to which he was able to appreciate the distinctive and in many ways mutually exclusive styles of all three simultaneously and, without any hint of eclecticism, to assimilate important elements of them into his own style. As we have seen, Ingres's art epitomized for him from the beginning a Neoclassical ideal of harmonious form and incisive drawing, just as Delacroix's embodied a Romantic ideal of poetic conception and vibrant coloring, and Daumier's later represented a Realist ideal of trenchant observation and unconventional design, all of which were essential features of his own art. In addition, each of the three was pre-eminent in a genre or type of subject matter in which he himself specialized at some time in his career, Ingres in portraiture and nude female figures, Delacroix in narrative composition and horses in movement, Daumier in caricature and scenes of urban life. Thus the achievements of these three not only represent the principal sources of Degas's art, its major links with the artistic culture of his time; they also correspond to important aspects of his own achievement and together symbolize that complexity of style and content which is perhaps its most impressive characteristic.

Certainly it is a synthesis unequaled even in the most ambitious art of his generation, that of his Impressionist colleagues: not simply because the landscape painters among them rejected the example of earlier art altogether, so that already in the 1860s, while he was in the Louvre studying his chosen masters, pencil or brush in hand, Monet was outside on its balcony, painting views of Paris, and Pissarro was in the café opposite, demanding that such "necropolises of art" be burned down;[133] but because even the figure painters, who were conscious of the lessons to be learned from earlier nineteenth-century art, never struggled as he

did to reconcile such fundamentally dissimilar styles. On the contrary, when Renoir turned to the linear precision and bland bather subjects of Ingres in the 1880s, it was in reaction against the vivid colorism and exotic themes he had learned from Delacroix in the previous decade, and as for the emphatic, popular art of Daumier, this seems never to have interested him.[134] If Cézanne was influenced by the latter in his early, expressionist phase, and throughout his career made studies of and drew inspiration from the art of Delacroix, whose homage he planned to paint, he had little but contempt for Ingres, whom he identified with the academy.[135] Only Manet, in many ways the closest in this group to Degas artistically and socially, seems to have appreciated all three masters and to have borrowed from them at times, but he did so with greater confidence and powers of assimilation, rarely experiencing the tension or frustration that Degas felt in striving for so ambitious a synthesis.[136] As Valéry reports, "he admired and envied the assurance of Manet, whose eye and hand were certainty itself," whereas for him, "who missed nothing, who enjoyed—and suffered—from everything," the mere existence of several diverging styles "constituted the great problem."[137]

However, the problem must have been more acute at certain times than at others. If Ingres commanded his admiration from beginning to end, his actual influence was confined to the period 1855–1880, and especially to its first fifteen years, those of Degas's greatest interest in historical subjects and family portraits and of his most classical draftsmanship. Although Delacroix, too, was an idol throughout his career, his impact stylistically was most apparent in the early 1860s, when Degas reacted against his conservative early training, and again in 1880–1900, when color increasingly became the dominant element in his art. As for Daumier, whom he began to appreciate later than the other two, his work was evidently a source of inspiration only in the years 1870–1885, those of Degas's most active involvement with themes of urban work and entertainment and problems of physiognomic expression. Consequently, the periods of greatest tension between conflicting artistic ideals were that of the sixties, when he sought to combine the opposed stylistic qualities of Ingres and Delacroix, and that of the seventies, when he attempted to unite with these the imagery and vision of Daumier. But

so schematic a summary hardly does justice to the complexity of Degas's art, the product of a subtle interaction of all three tendencies during much of his maturity. Nor does it acknowledge that sense of challenge, almost of exhilaration, that he seems to have felt in responding to all three simultaneously.

APPENDIX: **Degas's Notes on Two Portraits by Ingres**

The following notes are among a large number that Degas wrote late in life—1904 is the latest date mentioned in them—as an inventory of the principal paintings and drawings in his collection; hitherto unpublished, they are in a private archive in Paris.[138] The longest and most interesting are also the most relevant here, those on Ingres's portraits of M. and Mme Leblanc, which Degas cherished as the masterpieces of his collection and contemplated giving to the Louvre: "Then I shall go and sit in front of them," he told Daniel Halévy, "and look at them and think about what a noble deed I have done."[139] In fact, he was unable to part with them, and it was only at the posthumous sale of his collection in 1918 that they were acquired by another museum, the Metropolitan.[140] His notes on them shed light not only on his habits and attitudes as a collector, but on the history of these portraits, including an unsuspected alteration made to one of them.

> Ingres. Portraits of M. and Mme Leblanc, painted in Florence in 1823, bought at the Hôtel [Drouot], the man for 3500, the woman for 7500, [total] with the charges 11,550, January 23, 1896, in a sale after the death of Mme Place, their daughter.
>
> I remember having seen these portraits in 1854 in the home of M. Leblanc, their son, in the Rue de la Vieille Estrapade, a house with an iron fence that still exists, on the ground floor. M. Poisson-Séguin, a lawyer and friend of Father's, took us there with his wife. The younger M. Leblanc was an assistant teacher at the Ecole Polytechnique. I saw these portraits again in 1855, at the World's Fair, on the Avenue Montaigne. Mme Place obtained these portraits from her brother, a bachelor, who came to live with her after the death of her husband and who died before her.

There were [also] portraits in pencil: Mme and M. Leblanc standing, which entered Bonnat's collection;[141] the young Leblanc, which was once owned by Albert Goupil and which Gérôme, his heir, sold to Mme de Scey-Montbeliard;[142] two others, a man and a young woman with head-bands [and] leg-of-mutton sleeves who could well have been the young Mme Place.[143] These two drawings were sold together at the same sale to Morgand, of the Passage des Panoramas, and sold by him to Bonnat (at the sale, sold for 2160 Francs). I also have the two photographic reproductions of the two full-length portraits in pencil that Bonnat gave to the family.

The family, whence the two large portraits had never emerged, had had the background of the man repainted, in order to make it identical to that of the woman. I was able to have it removed in my presence, easily enough to prove that this revision must not have been more than ten years old.[144] The [original] red background was found intact.[145] There are fools among the aristocrats as well as elsewhere.

III Pictures within Pictures

Three of the paintings in the Metropolitan Museum's great collection of works by Degas—*The Collector of Prints, James Tissot in an Artist's Studio,* and *Sulking* (or *The Banker*)—are doubly intriguing as images because other images are represented within them. The anonymous collector [65] is surrounded by a variety of objects, including color prints of flowers in the portfolio and on the table, a statuette of a horse in the cupboard, and what appear to be fragments of wallpaper, calling cards, photographs, and envelopes on the bulletin board. The artist Tissot [68] is seated in a studio amid pictures of remarkably diverse subject matter and style: at the top, a Japanese or pseudo-Japanese garden scene; at the sides, landscapes with figures in two types of modern dress; behind the easel, a colorful sketch of a narrative episode; and in the center, a small, serene, richly framed portrait. And the two people in *Sulking* [83] are seen against a large engraving of a steeplechase, whose strenuous action provides a foil for their brooding inertia and also seems to offer a clue to the mystery of their identities and relationship. In each of these paintings, the presence of works of art that are distinctly different in subject, scale, and visual texture from the larger work complicates and enriches our experience of the latter to an extraordinary degree.[1] For the minor picture is not only an independent creation with its own content and circumscribed field, but a means of extending or dividing the major field and of deepening the content of

90

its imagery through formal or iconographic analogies. In doing so, the smaller work also calls attention to the artificial aspects of the larger one in which it occurs, reminding us that even pictures such as these three, all painted between 1866 and 1871, in the most naturalistic period of Degas's development, are after all products of his mind and hand, like the more visibly contrived works within them.[2]

In these respects, the picture within the picture is analogous to the literary devices of the play within the play and the narrative flashback, which likewise reveal the ambiguous relation to reality of the works in which they appear. In the visual arts, it is similar to two other motifs that Degas frequently employed, at times in conjunction with that of the picture; namely, the mirror whose surface reflects in a condensed and essentially pictorial form a sector of the visual field before it, and the window or doorway whose frame intercepts in a fixed and equally

60. Degas, *The Interior*, 1892. Oil on canvas.

Collection of Mr. and Mrs. Saul Horowitz, New York

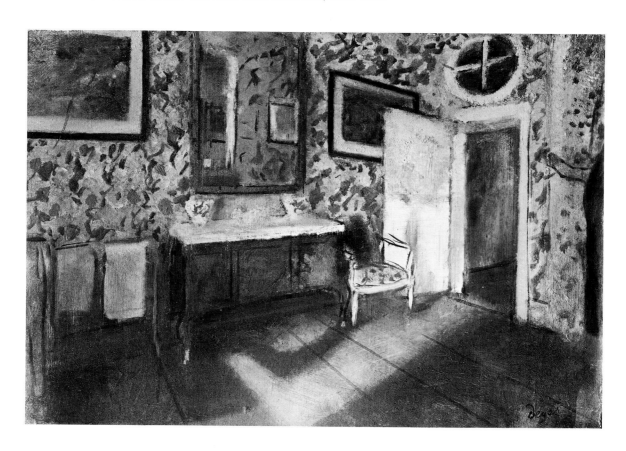

pictorial manner a sector of the larger field behind it. Frequently he juxtaposed these effects in a single work: in *Yves Gobillard-Morisot*, to take an example in the Metropolitan Museum, by framing her head between a doorway at one side that opens onto a garden and a mirror at the other that reflects a portion of the room itself; and in *The Dancers' Green Room*, another example in the Museum, by representing some of the figures in the background as reflected in a cheval glass and a wall mirror and others as glimpsed through an opening into an adjacent room.[3] In *The Interior* [60], painted in the home of his friend Paul Valpinçon in 1892, he achieved a virtual tour de force in combining all three motifs inventively, playing on the similarities of shape among the framed pictures, the mirror reflections, and the doorway vista, while preserving an effect of informality through the lighting and choice of viewpoint.[4]

Surprisingly, this fascination with the tension between the artificial and the natural in painting, which seems so characteristic of the mature Degas, was already present in his earliest comment on and experiments with the picture in the picture. In a notebook dating from 1855, the very beginning of his career, he remarked on a watercolor by J. B. Fortuné de Fournier, a view of the Tribuna of the Uffizi; and despite its miniature scale, he was able to identify the Raphael portraits reproduced in it and to distinguish their styles.[5] On a page in a notebook used around 1860 [61], he pasted two sketches of contemporary figures and a copy after Giorgione's *Fête Champêtre*, then drew at the bottom a couple who appear to look at the Giorgione, so that the spatially neutral page is converted into an illusion of a wall in the Louvre's Grande Galerie.[6] Elsewhere in the same notebook, he sketched a rather prosaic couple conversing in a business office, then commented on the boredom of their situation by adding an amusing motif, a child who turns his back on them to contemplate a picture hanging on the rear wall.[7]

When its functions are conceived in the general terms just discussed, the picture obviously can occur in any image showing a conventional interior; as such it occurs often in the work of Degas, who was more deeply interested than any artist of his time in recreating the appearance of the rehearsal rooms, millinery shops, offices, cafés, and salons in which his contemporaries worked and lived.[8] In fact, when the critic

61.
Degas, Studies of Figures and
Copy after Giorgione, ca. 1860.
Pencil.

Bibliothèque Nationale, Paris

Duranty asserted in *The New Painting,* "We will no longer separate the person from the apartment setting. . . . Around him and behind him are furniture, a fireplace, wallpaper, a wall that reveals his fortune, his class, and his profession," he illustrated this Naturalist program with identifiable paintings by Degas.[9] It is not surprising, then, that several of the ones we shall discuss are, like *Sulking,* images of an office or drawing room, among whose carefully depicted furnishings a picture seems naturally to belong. It may even allude to the profession of the person portrayed, like the lithograph behind the musician Pilet [88], or to his social status or aspiration, like the portrait behind Thérèse Morbilli [77], or to his relation to the artist himself, like the drawing behind Degas's aunt in *The Bellelli Family* [7].

But if these works reflect the Naturalism of his own age, they are also

indebted to that of the seventeenth century, especially in Holland, where Rembrandt, Hals, and Vermeer had often depicted paintings, mirrors, and maps in the backgrounds of their portraits and genre scenes, both to heighten their verisimilitude and to deepen their visual resonance and symbolism.[10] Appropriately, this was first observed in the work of Vermeer by the Naturalist critic Thoré, who was largely responsible for rediscovering that artist in the 1860s.[11] Degas later acknowledged his debt to Dutch art, remarking that "when we were beginning, Fantin, Whistler, and I"—and the other two also experimented frequently with the picture in the picture in their early work—"we were on the same path, the road from Holland."[12]

In most cases, however, the kind of milieu we will discuss is not simply a modern office or drawing room, but that of an individual who is professionally concerned with the creation or criticism of art. Like the portrait of Tissot, those of Henri Rouart [93] and a hitherto unidentified artist [91] show Degas's colleagues in their studios, surrounded by what appear to be their own works. And like the portrait of a print collector, those of Hélène Rouart [100] and the critic Diego Martelli [94] show his friends in their apartments, with the paintings and objects in their possession. In a public version of the latter type, Mary Cassatt is portrayed with a companion, contemplating pictures in the Louvre's Grande Galerie [95] or a sarcophagus in its Etruscan gallery [97].[13] In these images, we encounter the studios, collections, and museums that constituted Degas's own world, where he was equally at home as an artist, as a distinguished collector, and as an authority on traditional art. Pictures of a world in which pictures themselves are the most conspicuous objects, they are ideal expressions of that veneration of art and the artificial which was so characteristic of his thought.

But like his images of more conventional interiors, they belong to a historical tradition, that of the representation of the artist's studio and the collector's cabinet. For in the self-portraits and "painted galleries" that have been popular in European art since the sixteenth century, the works shown surrounding the subject serve also to identify his profession or avocation, to characterize his taste or interests, and to symbolize the relation of art and nature in general.[14] As a young man, Degas had copied after one example of this type, Bronzino's *Portrait of a Sculptor*,

and had undoubtedly studied another, *The Picture Bearers* in Mantegna's *Triumph of Caesar* series.[15] But more important, he had painted a variation on one of the most interesting examples of all, Velázquez's *Maids of Honor*, where the mythological pictures on the rear wall, the mirror below them reflecting the king and queen, and the doorway beside it, in which a court official is silhouetted, function simultaneously as spatial and symbolic motifs.[16]

THE INGENIOUS use of these devices in *The Maids of Honor*, an image of the artist's studio that is also a portrait of the royal family, may well have been what inspired Degas to employ them in the impressive group portrait in which his early studies of traditional art culminated, *The Bellelli Family* [7] of 1859–1860.[17] Here, too, the picture, the mirror, and the doorway serve both to extend the interior space, which is much more shallow than in the Velázquez, and to deepen its expressive significance by means of analogies. Thus the somber, upright figure of Degas's aunt is placed against a wall whose hard flatness is broken only by the narrow doorway and the sharply defined picture frame, while the lighter, more recessive figure of his uncle is seen against a mantelpiece surmounted by small objects and a mirror reflecting the blurred and luminous forms of a chandelier, a painting, and a second mirror. Although this contrast corresponded to linear and coloristic tendencies which, as we saw in Chapter II, were already present in Degas's art at the time,[18] it undoubtedly also expressed his insight into tensions within the Bellelli household. He had in fact been living with them in Florence for several months before he undertook the ambitious portrait, and must have perceived the great distance between husband and wife, a distance that he has in effect made visible in his composition. For shortly after he returned to Paris, his uncle Achille, apparently replying to Degas's own observations, admitted: "The domestic life of the family in Florence is a source of unhappiness for us. As I predicted, one of them is very much at fault and our sister a little, too. Incompatibility of personality and background and as a result a lack of affection and leniency that enlarges like a magnifying glass the individuals' natural faults."[19] Expressive of this estrangement, and perhaps also of the couple's roles, are the dissimilar

objects shown behind them in Degas's portrait—the ambiguous, receding images in the mirror and the clear, advancing shape of the drawing.

When its subject and author are recognized, the drawing [62] acquires additional significance.[20] It appears to be a study for the etched and painted portraits of his grandfather, René-Hilaire de Gas, that Degas made in Naples around 1857, which show him wearing the same peaked cap and reading glasses and sitting in the same position [63].[21] But since this "study" is otherwise unknown and does not reverse the image in the etching, it may never have existed, but may instead have been based on the etching and made to look like a sanguine drawing. About a year after Degas had executed the portraits in Naples and gone on to Rome and then to Florence, René-Hilaire died.[22] His daughter Laure and her daughters were still wearing mourning for him when Degas made studies of them in preparation for the group portrait in the winter of 1858–1859. In that work, painted in Paris the following year, he introduced an image of their deceased relative in the form of his putative drawing, placing it directly behind them and so near Laure Bellelli's head that one inevitably connects them. In doing so, he was following a well-established

62.
Detail of Figure 7

63 (*opposite*).
Degas, *René-Hilaire de Gas*, ca. 1857. Etching.

Art Institute of Chicago, The Stickney Collection, 1943.1059

tradition: the image of his grandfather plays precisely the same role in *The Bellelli Family* as the effigies of ancestors that have appeared in European portraits since the Renaissance, especially in Netherlandish group portraits; in *The Van Berchem Family* by Frans Floris, for example, the prominently displayed image of the deceased member unites him with the living ones shown eating, conversing, and playing music.[23] That the drawing, if it existed, was by Degas himself was no less meaningful, for it subtly identified him with his aunt and affirmed his presence, if only as an artist-observer, in her home. His relation to her must have been unusually close, to judge from the tone of her letters to him after he returned to Paris, in one of which she noted bitterly: "You must be very happy to be with your family again, instead of being in the presence of a sad face like mine and a disagreeable one like my husband's."[24]

As a work of art, remarkably accomplished despite its small scale, the portrait drawing in *The Bellelli Family* also testifies to Degas's artistic progress, which was at the time most evident in just this type of dignified family portrait, and which he has characteristically identified with skillful draftsmanship. At the same time, it hints at one of the sources of his early portraiture; for its three-quarter view of the head and bust, its delicate red-chalk technique, even its traditional blue mat and gold frame, give it the appearance of a Renaissance drawing, especially one by the Clouets or their school, which it resembles also in its use of costume.[25] Before going to Italy in 1856, Degas had copied a red-chalk drawing of this type, formerly considered a self-portrait by François Clouet; and on his return, he reproduced a portrait of Elizabeth of

64.
Degas, Studies for *The Bellelli Family*, 1859. Pencil.

Bibliothèque Nationale, Paris

Austria attributed to the same artist.[26] This ambition to rival the perfection of Renaissance art was undoubtedly what led him to lavish so much attention on the background of *The Bellelli Family,* including the carefully rendered frame on his drawing. Among the many preparatory studies, there is even one [64] in which he envisaged the entire painting as it would appear when framed, and drew in detail the type of Louis XVI molding that he would use.[27] Already present here is that characteristic notion of the work of art as an artifice which would lead him to reproduce with equal care the Renaissance frame in the background of his portrait of Tissot [68] and to copy part of a Baroque frame in the Louvre in preparation for his portrait of Mary Cassatt [96].

IN *The Collector of Prints* [65], painted about six years later than *The Bellelli Family,* Degas virtually reversed the roles of the figure and the

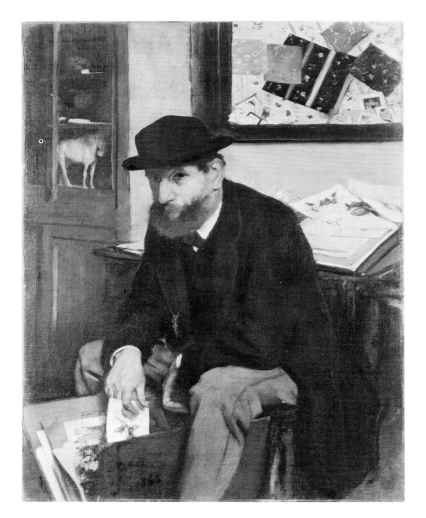

65.
Degas, *The Collector of Prints,* 1866. Oil on canvas.

Metropolitan Museum of Art, New York, The H. O. Havemeyer Collection, bequest of Mrs. H. O. Havemeyer, 29.100.44

66 (*right*).
Detail of Figure 65

67 (*far right*).
Pocketbook covers, Japanese, XVIII–XIX century. Woven silk.

Victoria and Albert Museum, London

background picture, giving the latter a prominence and interest that almost outweigh those of the former.[28] Appropriately, the anonymous subject must be considered a type rather than an individual, the type of old-fashioned collector who flourished during the Second Empire, and whom Degas had met as a young man in the company of his father. Recalling those visits many years later, he dwelled on precisely that dedication to art and indifference to self which seem to characterize the anonymous figure in his painting: "A room in which canvases were piled up pell-mell. . . . [Marcille] wore a hooded cape and a used hat. People in those days all wore used hats. LaCaze, ah! LaCaze, too, wore a used hat."[29] Indeed, the description would apply equally well to Degas himself in his old age and to such dedicated *amateurs* among his friends as Paul Lafond and Alphonse Cherfils, of whom he painted a sympathetic double portrait that shows them seated together, gazing intently at a small canvas [59].[30] Here, as in the roughly contemporary picture of an unidentified collector bending over a print to examine it more closely, Degas was evidently inspired by the example of Daumier, whose paintings of *amateurs* scrutinizing the works on display in print sellers' stalls or admiring the objects in each other's apartments [58] likewise focus on the intensity of their concentration, the consuming quality of their passion.[31] In contrast to these, *The Collector of Prints* shows an introspective and disenchanted person, almost detached from the works of art that he idly handles or appears to turn his back on. As a result, the latter seem more expressive in their fascinating stylistic diversity of his real interests.

The objects surrounding him are indeed remarkably varied, and in-

clude examples of popular as well as sophisticated art, from the Far East as well as Europe; and significantly, they are seen as representative types rather than unique works. In the collector's portfolio and on the table behind him are some of the small color lithographs of roses for which Pierre Redouté, the so-called "Raphael of flowers," had become famous earlier in the century.[32] In the cupboard is a ceramic statuette of a horse, evidently one of those produced in China during the T'ang Dynasty: the positions of the legs on the small base, the bowed head, and the flaring nostrils are characteristic of this type, which Degas has Westernized in rendering the anatomy and hair realistically.[33] Oriental and Occidental styles are also juxtaposed in the objects placed on the bulletin board and inserted in its frame [66], for the smaller ones are such typically European products as envelopes, calling cards, and photographs, placed against pieces of wallpaper, while the larger, more vividly colored ones are fragments of Japanese woven silk.[34] A daring composition, apparently without order yet ultimately balanced, the bulletin board symbolizes both the collector's fascination with even such small, almost worthless scraps of paper and fabric, and the artist's recognition of aesthetic qualities in their very profusion of overlapping shapes, diagonal stripes, and surprising spots of color.

By far the most important elements in this design are the fragments of Japanese woven silks, which were either cut from larger fabrics or manufactured as such, to be sewn into covers for pocketbooks and into jacket linings. Popular among French collectors from the 1860s on, they were admired for their workmanship and rare color harmonies, what Edmond de Goncourt, a pioneer among these connoisseurs, described as consisting "entirely of broken chords, delightful to the eye of a colorist."[35] Degas and the Goncourts were not, of course, alone at the time in appreciating these novel qualities. Among the other writers, artists, and craftsmen in Paris who also began to collect Japanese art in these years were Degas's friends Manet, Whistler, Tissot, Fantin-Latour, Félix Bracquemond, Zacharie Astruc, and Alfred Stevens.[36] However, the majority of them were attracted primarily to its unusual forms and exotic appearance, and as a result painted interiors filled with Japanese screens, ceramics, costumes, and figures with vaguely Oriental features, of which Whistler's *Golden Screen* of 1864 and Tissot's *Young Woman Holding Japanese Objects* of 1869 are good examples.[37]

Degas was one of the few who attempted instead to assimilate the distinctive stylistic features of Japanese art. In contrast to the color woodcuts at the right side of *The Golden Screen*, which are cleverly arranged but remain within a traditional perspective space, the woven silks in the background of *The Collector of Prints* form a pattern of flat, piquantly silhouetted and colored shapes. Moreover, the pattern itself closely resembles one of those often found in Japanese fabrics of the type that Degas has shown [67].[38] Such a fabric represents the scattered cards used in a popular Japanese game, some of which bear familiar poems and others the portraits of famous poets, the object being to match each poem with the corresponding portrait. That compositions of this kind were known in France at the time is clear from Astruc's reference in 1867 to "that curious and Lilliputian page engraved with the hundred Japanese poets, shown in a little design that also includes a famous excerpt from their poetry."[39] The effects of condensation, random distribution, and cutting at the edges that occurred in such designs were obviously what drew Degas to them, and as such they anticipated precisely the effects he would achieve a decade later in his own compositions.

AN EXAMPLE of Japanese art, or rather an imitation of one, also appears in the background of Degas's portrait of Tissot [68], painted in the same years as *The Collector of Prints*,[40] and this time in a design which, although severely classical in its overlapping and interlocking rectangles, like those in Poussin's famous *Self-Portrait* in the Louvre, shows an even greater taste for the cutting of forms at its edges. All but one of the six pictures in the background are intercepted by other elements, three of them by the frame. As a result, they seem more vital than Tissot himself, who assumes a singularly passive attitude, a kind of elegant nonchalance. Neither actively at work in his own studio nor clearly a visitor to another artist's—and the slender walking stick that could also be a mahlstick held idly in his hand,[41] the hat and coat placed casually on the table behind him, only heighten this ambiguity—he turns sideways on the chair and leans on the table, confronting us with an expression that is at once worldly and world-weary.[42] That this image of the artist as a dandy was an appropriate one for Tissot, who was already becoming the fashionable painter who would later specialize in scenes of Victorian

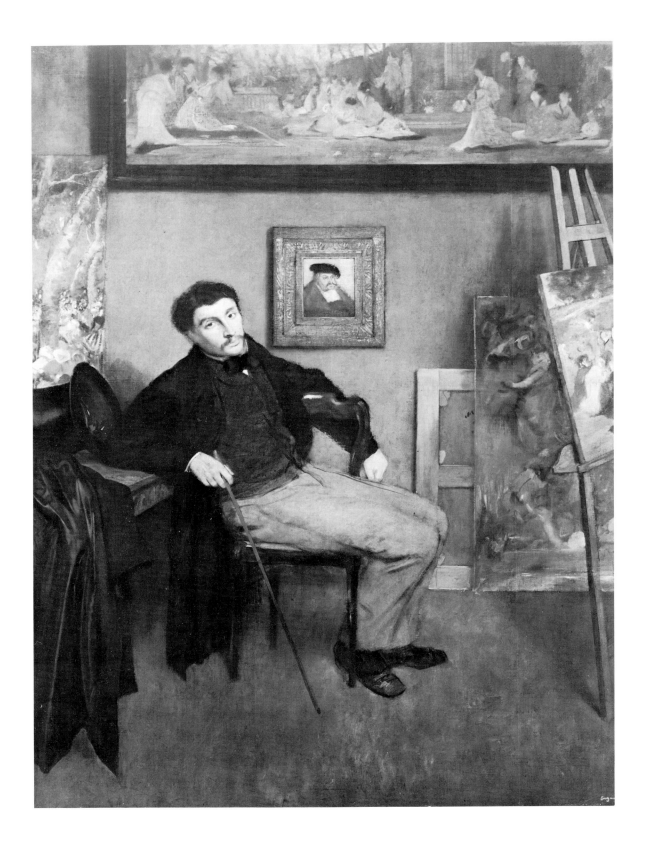

68. Degas, *James Tissot in an Artist's Studio*, 1866–1868. Oil on canvas.
Metropolitan Museum of Art, New York, Rogers Fund, 39.161

high life, seems evident enough. But that Degas also expressed in it his own conception of the artist becomes equally clear when it is compared with his self-portraits of these years, where he appears as a somewhat haughty gentleman, defensive and slightly ironic [e.g. 1].[43] Hence what is most characteristic in his portrait of Tissot, what distinguishes it from the more prosaic pictures of the artist in his studio painted by the young Impressionists at this time, derives as much from Degas himself as from his subject. And this identification manifests itself not only in the ambiguities already mentioned, but in the paintings surrounding the figure, since most of them could have been produced by Degas as well as by Tissot at this moment in their careers.

Significantly, none of the five canvases whose faces we see is a known work by either artist, and only one can be identified at all. This is the small, handsomely framed picture hanging near Tissot's head [69], which

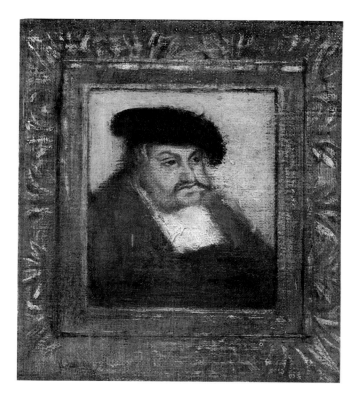

69. Detail of Figure 68

70 (*above*).
Cranach workshop,
Frederick the Wise,
after 1532. Oil on
wood.

Musée du Louvre, Paris

is a free copy after a portrait of Frederick the Wise, attributed to Cranach, in the Louvre [70].[44] Such a copy could easily have existed in either artist's studio, though more easily perhaps in Tissot's, since the meticulously painted genre scenes in which he had specialized in the early 1860s were clearly dependent on German Renaissance art, or rather on the "neo-Germanic" art of Henrik Leys, a popular Belgian artist with whom he was often compared at the time.[45] This would account not only for the presence of a copy after Cranach in Tissot's studio, but for its evident analogy with the portrait of himself. Although subtly contrasted in coloring, both heads are turned toward the right, surmounted by a dark mass, and marked by a drooping moustache, as if to suggest the stylistic affinities of the two artists by a physiognomic one. However, the manner in which the copyist has eliminated the Gothic features of his model and made its forms more compact and legible suggests that he was a less pedantic artist than Tissot—in fact, was one with the classical taste of Degas. For it is also conceivable that this copy once hung in his own studio: he, too, appreciated German Renaissance art, had drawn repeatedly after works by Holbein and Dürer, and had collected photographs of others by Cranach and Dürer.[46] In fact, in a notebook of the early 1860s he referred to this very portrait of Frederick the Wise as a model of firm drawing and subtle coloring for a portrait he was then planning.[47]

Like the copy after Cranach, the horizontal picture of Japanese women in a garden [71], which extends across the top of Degas's composition, is not the historical work it appears to be, but rather a modern copy or imitation. For if its format is that of a five-sheet Japanese woodcut, or of a scroll of the *makimono* type, and if its figures wear Oriental costumes and are seen in a landscape partly closed by partitions and latticed windows in the Oriental manner, the style in which it is painted is thoroughly Western. The modeling and cast shadows of the women, their recession into depth, and the atmospheric space all point to that conclusion. Behind this "Japanese" picture is undoubtedly a polyptych color woodcut by one of the followers of Utamaro, such as *Evening under the Murmuring Pines* by Eishi [72], an artist whose figural style it particularly recalls and who was among the first of the Ukiyo-e school to become known in France.[48]

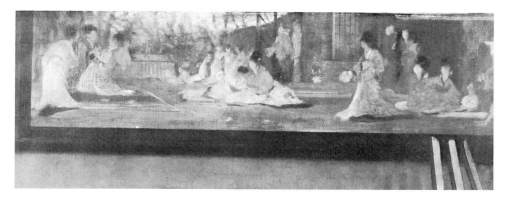

71. Detail of Figure 68

That Tissot was one of the earliest collectors of this art we have already seen; that he was also one of the most enthusiastic, we learn from a letter written by Rossetti in 1864: "I went to the Japanese shop [of Mme de Soye], but found that all the costumes were being snapped up by a French artist, Tissot, who it seems is doing three Japanese pictures, which the mistress of the shop described to me as the three wonders of the world."[49] Unfortunately, none of them can be identified with certainty, but it is likely that they resembled Tissot's *Japanese Woman at the Bath* of 1865, a work that makes conspicuous use of a

72. Eishi, *Evening under the Murmuring Pines*, ca. 1800. Color woodcut.
British Museum, London

Far Eastern costume and setting, but remains altogether Western in composition and style.[50] Hence the picture in Degas's portrait, which appears more authentically Oriental in subject as well as design, can hardly reproduce any of the pictures mentioned by Rossetti, though it may well allude to them. Like the woven silks shown in *The Collector of Prints*, it also reflects Degas's own interest in Japanese art, an interest only slightly less keen than that of Tissot, according to Ernest Chesneau and other contemporaries.[51] And since it does not represent an actual work, whether Japanese or pseudo-Japanese, but is improvised in the manner of both, it may well be Degas's unique attempt to produce such a work—not altogether seriously, but in the guise of one that Tissot himself had painted, and in this friendly competition clearly capturing a more convincingly Oriental look.

If the framed and relatively complete "Cranach" and "Japanese" pictures may never have existed, the three seen in an unframed, fragmentary state were even more obviously invented to fill the peripheral spaces they occupy. Pictorially, they represent styles distinctly different from those just discussed, yet equally indicative of interests shared by Degas and Tissot, at least at this time in their careers. Thus, the picture placed on an easel at the right [73] shows figures in modern dress seated outdoors in the manner of early Impressionist picnic scenes. One of these, a *Luncheon on the Grass* painted by Tissot himself around 1865 [74], when he had abandoned his earlier "neo-Germanic" style and was assimilating the more advanced naturalistic style of Monet and his colleagues, may well be the kind of picture that Degas had in mind.[52] But if it seems broadly painted in relation to Tissot's earlier work, it lacks the vivid outdoor light and boldly simplified forms found in the picnic scene invented by Degas, whereas these are precisely the qualities that characterize some of his own pictures of these years, among them the brilliant oil sketch of *Three Women Seated Outdoors*.[53]

The same is true of the picture placed on the table behind Tissot [75], which serves as a pendant to the other one and with it encloses the examples of historic and exotic art shown between them. For it, too, represents people in contemporary costume—women in capes and bonnets seated beneath tall trees, girls in striped dresses running among them—and in a manner reminiscent of such recent works as Manet's

Concert in the Tuileries Gardens.[54] And it, too, is more vividly colored and more boldly executed than any extant painting by Tissot, although there is nothing really comparable in subject among the known works of Degas either.

Even more puzzling is the large canvas leaning against the wall behind the easel [73], which apparently represents The Finding of Moses, its upper half showing the Pharaoh's daughter and a servant descending toward the Nile, its lower half another servant lifting the infant from his basket.[55] As an illustration of a biblical episode, dramatic in content and painted in resonant red and green tones, it provides a striking contrast to the modern picnic scene adjacent to it. Yet no picture of this subject by either Degas or Tissot is known; and no Renaissance version of it—assuming that what we see is a copy—would arrange the figures so eccentrically on the surface, which in fact must have been improvised within the irregular space available. Behind the improvisation, however, there is a historical type, the depiction of The Finding of Moses in late Renaissance and Baroque art, particularly that of the Venetians and their followers. The version in the Louvre by Charles de la Fosse [76], for example, shows the figures in similarly twisted postures, disposed vertically on an inclined ground plane, and rendered in similarly warm colors.[56] Moreover, in the mid-1860s Venetian art was of particular interest to Degas, who painted several copies after works attributed to Giorgione, Tintoretto, and Veronese, including a *Finding of Moses* by the latter which was clearly the prototype for La Fosse's.[57] A few years earlier, Tissot, too, had studied and copied after Venetian art; but characteristically, he preferred the more sober style of the Quattrocento, and wrote to Degas from Venice: "Titian's *Assumption* left me cold—the Tintoretto of St. Mark diving down really amazed me—but Andrea Mantegna and Bellini delighted me."[58] Like the other pictures in Degas's portrait, then, the "Venetian" one reflects artistic interests which he shared with Tissot, but which were more fundamentally his own.

Indeed, only an artist of Degas's complexity could have invented five pictures so remarkably varied in subject and style, or have juxtaposed them so deliberately. For taken together, they constitute a kind of summation, a statement of his artistic affinities in what we now recognize was a critical period of transition for himself and others of his genera-

73.
Detail of Figure 68

74.
Tissot, *Luncheon on
the Grass,* ca. 1865. Oil
on canvas.

Collection of A. R. Mac-
William, London

75.
Detail of Figure 68

76.
La Fosse, *The Finding of Moses,* ca. 1700. Oil on canvas.

Musée du Louvre, Paris

tion, among whom of course was Tissot. In effect, Degas asserts his belief in the relevance for modern art of several distinctly different tendencies: the artificiality of Japanese prints and the naturalism of European paintings; the immediacy of contemporary genre scenes and the formality of traditional portraits and narrative compositions; the sober, linear style of the Renaissance and the dramatic, colorful style of the Baroque. And in doing so, he expresses in art-historical terms that ideal of sophistication and self-awareness which he has also expressed in psychological terms in his image of the artist as a nonchalant yet cultivated dandy.

THE RICHLY framed portrait and the ambiguously reflecting mirror, already encountered in *The Bellelli Family* [7], occur again in the background of Degas's portrait of his sister, Thérèse Morbilli, around 1869 [77].[59] Here, however, the two motifs are juxtaposed in depth rather than on the picture surface, and serve to define the personality and social status of an individual rather than the opposed temperaments of a married couple. For there is a correspondence between the portrait, the other pictures in the room, and the ornate candelabra reflected in the mirror, just as there is between these Rococo objects, at once expensive and antiquated, and the elegant, rather aloof young woman who stands before them, apparently at home in this richly furnished place. Actually it is her father's drawing room, and the portrait was painted during one of her visits to Paris; yet it is an appropriate setting, reminding us of her own palatial home in Naples and of her position as the wife of the Duke of Morbilli, a wealthy cousin whom she had married with special papal dispensation.[60]

In another portrait, painted in Paris on the eve of her marriage in 1863 [78], Degas showed Thérèse standing in an equally dignified manner, elegant and impassive, and in the background he introduced an equally appropriate detail—an open window providing a glimpse of Naples, the city in which she would soon begin her married life [79].[61]

77. Degas, *Thérèse Morbilli*, ca. 1869. Pastel.

Formerly collection of Mme David-Weill, Paris

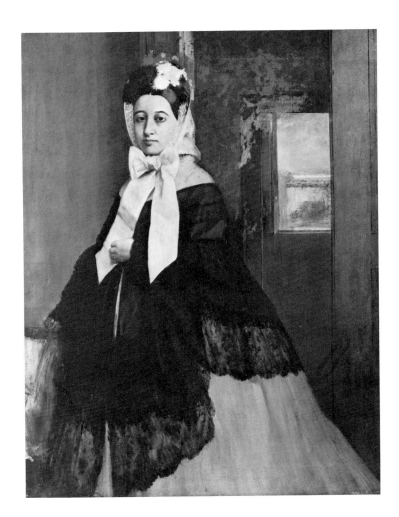

78.
Degas, *Thérèse
de Gas,* 1863. Oil
on canvas.

Musée du Louvre,
Paris

In depicting the city and the Gulf of Naples, Degas relied on a watercolor
sketch that he had made in a notebook during a visit in 1860 [80], and
his incorporation of it three years later in the portrait, where it is framed
as carefully as a painting, demonstrates again how deliberately he
planned such apparently casual background effects.[62] As in his imagina-
tive use of the mirror and the picture, he drew here on a well-established
motif, widely employed in the Romantic period: the metaphorical win-
dow view or open window.[63] But he was probably also inspired by a
recent literary phenomenon, the detailed description of the milieu in the
Naturalist novel, where a window view or a picture frequently plays a
symbolic role. An example relevant to both portraits of his sister is the

79.
Detail of Figure 78

80.
Degas, *View of Naples,* 1860. Watercolor.
Bibliothèque Nationale, Paris

description of Mlle de Varandeuil's bedroom in the Goncourts' novel *Germinie Lacerteux,* published in 1865; it evokes her austere existence and devotion to a despotic father by describing the musty furnishings and limited views of the room to which she is confined, then introduces the father himself in the guise of a portrait hanging above her bed, "which seemed to bend down over the sick woman and oppress her with its gaze."[64]

Unlike the fine chalk drawing in *The Bellelli Family* [62], the picture in the background of the second portrait of Thérèse, even when examined in comparable detail [81], remains a broadly painted sketch, featureless and evidently without further significance for the whole. Yet it

is rendered explicitly enough to be recognized as the *Bust of a Woman* —now identified as Mme de Portioux—by Jean-Baptiste Perronneau that later figured in the sale of Degas's collection [82].[65] And when this, rather than the sketchy copy, is compared with the image of Thérèse herself, the appropriateness of its presence behind her, as the only recognizable picture among all those shown, becomes apparent. Although Perronneau represents a mature woman in a conventional pose, and Degas a younger one posed more informally, there is an obvious affinity in the turn of their heads, the composure of their features, and the cool manner in which they confront us. Thus the Rococo portrait, discreetly introduced into the background of the Second Empire one, places its subject in a larger social context and confirms our impression of her personality. That Degas also relied, as we saw in Chapter II, on Ingres's *Comtesse d'Haussonville* for other aspects of its style and imagery does not invalidate the comparison he seems deliberately to have drawn with Perronneau's work. Just how deliberately we cannot say, since we know nothing about his attitude toward Thérèse at the time he painted her portrait.[66] But he may well have sensed in her that haughtiness which later made him observe wryly, during one of her visits to Paris, "that my home must be well appointed, otherwise the foreign nobles will not flock there," and which she herself expressed in complaining that "living near him is too distressing; he makes money, but never knows where he stands."[67] Certainly the contrast between his portraits of Thérèse and those of his younger sister Marguerite, who was more artistically inclined and later married an architect, would seem to confirm this.[68]

Although the provenance of Perronneau's *Bust of a Woman* cannot be traced before its appearance in Degas's portrait around 1869, it undoubtedly did belong to his father, a cultivated banker of the old bourgeoisie, who was acquainted with such outstanding collectors of eighteenth-century art as Louis LaCaze and Eudoxe Marcille and had in his own collection several pastels by La Tour, which his son also inherited but later was obliged to sell.[69] That Degas, too, admired the psychological penetration and technical accomplishment of La Tour and Perronneau is evident not only from the memoirs of his friend Jacques-Emile Blanche and his niece Jeanne Fèvre, but from his own pastel portraits.[70] That of Thérèse Morbilli is particularly reminiscent of the older masters'

palette in its subtle tones of yellow ochre, pearl gray, claret, and white. This admiration was in turn part of a revival of interest in Perronneau, which took place precisely in the 1860s and in the circle of critics and collectors to which Degas and his father belonged. In these years, an important pastel by Perronneau was acquired by Emile Lévy, a successful painter and friend of Degas, and the Goncourts discussed him in *The Art of the Eighteenth Century* as "an artist whom La Tour had good reason to fear and who, in following behind him, must often have caught up with him."[71] They themselves had recently bought "a magnificent pastel by Perronneau," before which they would sit "in adoration," and in the same years Eudoxe Marcille, a friend of Degas's father, and Camille Groult, later a friend of Degas, added still others to their collections.[72] Hence no doubt his own interest at this time in the Rococo artist's portraiture and his decision to introduce an example of it into a portrait whose setting was, appropriately, his father's drawing room.

81. Detail of Figure 77

82. Perronneau, *Mme Miron de Portioux*, 1771. Oil on canvas.
 Private collection, New York

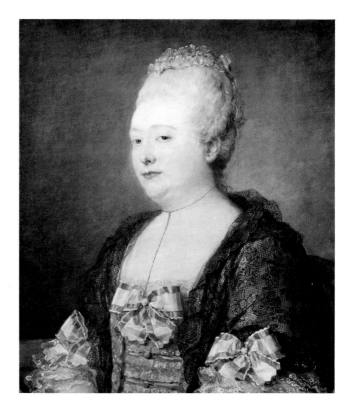

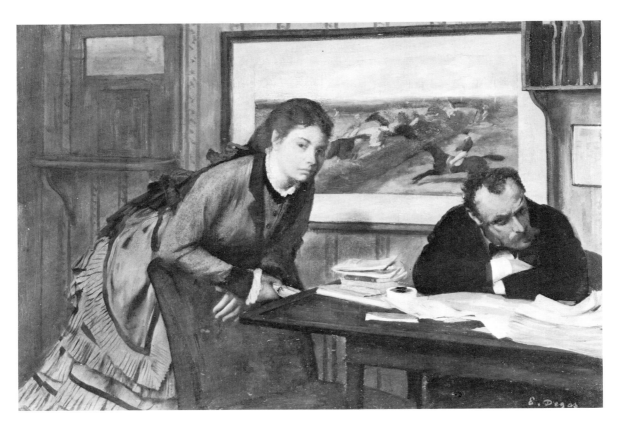

83. Degas, *Sulking* (*The Banker*), 1869–1871. Oil on canvas.

Metropolitan Museum of Art, New York, The H. O. Havemeyer Collection, bequest of Mrs. H. O. Havemeyer, 29.100.43

THE SMALLEST and also the most puzzling of the pictures containing other pictures is one that Degas painted in the same period as *Thérèse Morbilli*, but with a far more obscure intention. Generally called *Sulking*, and occasionally *The Banker* [83], it seems to waver between the kind of narrative episode implied by the first title and the kind of modern genre scene implied by the second.[73] The positions and expressions of the two figures, their relation to each other, even the identity of the setting and its significance for them, are at once suggestive and ambiguous. This ambiguity extends to the large picture that hangs behind them, its rectangular shape carefully placed to enclose their heads; for its prominence implies that it contains a clue to the meaning of the whole, yet it cannot be related easily to their personalities or taste, as in the examples discussed previously.

Although rendered in a broad, simplified style, this picture was obviously copied from an English racing print; more specifically, from a color engraving of a painting by J. F. Herring entitled *Steeple Chase Cracks* [84].[74] It probably belonged to Degas, since he seems also to have used the galloping jockey in its lower right corner as a model for the one in the foreground of *The False Start*, a work that is exactly contemporary with *Sulking*.[75] As early as 1861, he had observed in a notebook that the landscape around the stables at Haras du Pin in Normandy was "absolutely similar to those in English color engravings of races and hunts."[76] But whether the presence of a sporting print in *Sulking* signifies that the man shown in it is a bookmaker or habitué of racetracks, as has been suggested, is another matter.[77] The period when it was painted was indeed one of greatly increased interest in horse racing and betting in France: the first agency of organized betting, based on a system of *paris mutuels* that is still used today, was founded in 1867; and the first periodical devoted exclusively to racing news, the *Journal des Courses*, edited by Joseph Oller, began to appear in 1869. By that date, Oller's Agence des Poules, J. S. Harry's Betting Office, and the Office Jones were all flourishing in Paris, and any one of them could conceivably have inspired the setting of Degas's picture.[78]

In all likelihood, however, it represents one of the small, privately owned banks that also flourished at this time, before corporate banking replaced them; perhaps the bank on Rue de la Victoire owned by Degas's

84.
Herring,
*Steeple Chase
Cracks*, 1847.
Color engraving.

Bibliothèque
Nationale, Paris

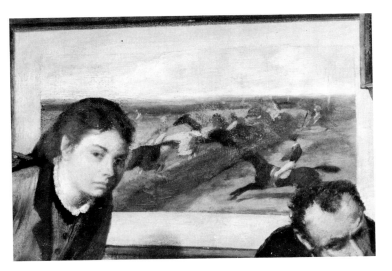

85. Detail of Figure 83

86. Degas, *Emma Dobigny*, 1869. Oil on canvas.
Collection of Mrs. Walter Feilchenfeldt, Zurich

father. For the furnishing and décor, which he has depicted in detail—the window counter fitted with opaque glass at the left, the table piled with papers in the center, and the rack filled with ledgers at the upper right, all of which he studied separately at the site in notebook drawings—are those of a banking rather than a betting office.[79] Moreover, it is known that Degas, acting through his patron, the singer Jean-Baptiste Faure, bought back six paintings from his dealer Durand-Ruel in March 1874, and that one of them was entitled *The Banker*.[80] In that context, too, of course, an English sporting print would have been an appropriate element of the décor. Yet Degas's conception of *The Banker* as an image of an exceptional moment, charged with anticipation and tension, transcends the purely naturalistic description of a milieu, and still more the frequently discussed influence of photography,[81] and seems instead to have been inspired by another work of art. This is Rembrandt's *Syndics of the Drapers' Guild*, which also represents a business meeting that we seem to have momentarily interrupted, one figure turning in virtually the same way to challenge us, and which also has in the background a picture that plays an important role—symbolically, if not compositionally.[82]

If the steeplechase print does not allude to the professional relationship of the two people in *The Banker*, it does unite them visually, its arch of galloping and leaping horses effectively linking their heads [85], and in a manner that heightens the apparent tension between them by providing a contrasting image of strenuous action directly behind them. Indeed, so poignant is their mood that some writers have sought a specific narrative content, even a source in contemporary fiction; but none has been found, and none probably existed.[83] For as in the later picture *Absinthe*, whose title is as inaccurate as *Sulking* is here, Degas has not illustrated a Realist novel, but rather a theory of expression similar to that of the novelists, a theory that he and Duranty, his closest acquaintance among the latter, both held at this time.[84] It was, as we shall see more fully in Chapter V, formulated both in Duranty's essay "On Physiognomy," published in 1867, and in Degas's contemporaneous scheme to transform the exaggerated expressions typical of rhetorical academic art into portrayals of the more subtle emotions characteristic of modern life, such as the angry withdrawal of the man in *The Banker* and the sullenness of his companion.[85]

Hence it is appropriate that, again as in *Absinthe*, these figures, although essentially models for a genre scene rather than sitters for a portrait, were friends of Degas's, with whose personalities and moods he was well acquainted. And it is particularly appropriate that the man is Duranty, as is evident when his contracted features and receding, dark blond hair are compared with those in other portraits of him, including the well-known one by Degas himself painted about a decade later [6].[86] Although he is shown in a different mood there, we know from other sources that Duranty, a pioneer in the Naturalist movement whose career was later eclipsed by the fame of Flaubert and Zola, was often as bitter and withdrawn as he appears in *The Banker*, his "countenance soft, sad, and resigned. . . . His whole life was written, as it were, in the sometimes painful grin of his mouth."[87] As for the woman in *The Banker*, her full yet rather fine features and chestnut-colored hair are those of Emma Dobigny, a favorite model of Degas's and one for whom he felt a special sympathy, to judge from the unusually tender, self-ironic letter he wrote to her and the portrait he made of her at this time [86], where she appears in a similarly pensive mood.[88]

87. Degas, *The Conversation*, 1884–1895. Oil on canvas.

Collection of Mr. and Mrs. Paul Mellon, Upperville

That Degas's use of the racing print as a compositional and expressive device in *The Banker* is typical only of a certain period in his development becomes evident when the picture is compared with a later version called *The Conversation* [87], which he began in 1884 as a portrait of his friends, the sculptor Paul Bartholomé and his wife, and finished a decade later.[89] Here the emphasis falls entirely on the two figures, shown in intimate proximity rather than estranged; and the print behind them, no longer serving as a means of linking them visually or of identifying their social milieu, is reduced to a barren landscape whose horizon alone is indicated by the contrast between two broad areas of color.

IT WAS also shortly before 1870, and also in the form of a popular print

apparently employed merely as a decorative element, that Degas devised one of his most ingenious background pictures. It is the lithograph showing a gathering of musicians that hangs behind the cellist Pilet in Degas's portrait of him seated in his office at the Opera [88].[90] In contrast to the sporting print, this one contains many figures, apparently portraits of individuals, and is more vigorously rendered in black and white; indeed, the very absence of color, especially in relation to the vivid tones found elsewhere in the composition, calls attention to it. So does the open cello case in the foreground, whose powerfully silhouetted form, probably influenced by the bold treatment of such elements in Japanese prints, seems to point directly toward it.[91] Moreover, part of the case overlaps the lithograph, its large, blocklike form contrasting sharply with the diminutive figures behind it. Through this device, and through the equally striking contrast between these figures and the imposing one of Pilet himself, we are led almost inevitably to examine their relation to him.

When the picture behind Pilet is studied more closely [89], it can no longer be described simply as a lithograph showing a group of celebrated musicians, of a type popular in the Romantic period. Its unconventional features become obvious once it is compared with an example of that type, such as the *Celebrated Pianists* by Nicolas Maurin [90], a popular portraitist of the 1840s.[92] Instead of a few figures, formal and equally prominent, Degas's print shows a gathering of eighteen, some of whom are partly obscured; and instead of facing toward the center, the majority seem to look at something outside the field at the left, the pianist even turning away from his instrument to do so. What they look at, of course, is their colleague Pilet, and the homage that they thus appear to pay him is all the more flattering in that they can be identified as some of the most illustrious musicians and *amateurs* of music of the immediate past.

In the right-hand group, we recognize Chopin seated at the piano in a typically lethargic pose, and surrounding him several members of his circle: behind and slightly to the left, Heine; behind and slightly to the right, Liszt; and at the extreme right, Delacroix.[93] Between the latter and Liszt stands Jacques Halévy; between Liszt and Heine, Berlioz; and leaning on the piano is Balzac.[94] In the left-hand group, we recognize

88. Degas, *The Cellist Pilet*, ca. 1869. Oil on canvas.
Musée du Louvre, Paris

Gautier seated in the center, and around him some of Chopin's other literary friends: directly above Gautier, George Sand (looking toward Chopin and Delacroix); to her left, the Polish poet Zalewski; and to her right, Alfred de Musset.[95] At the extreme left are the musicologist Hiller and the actor Bocage; the other figures cannot be identified as positively, but the cellist standing behind the piano is probably Franchomme, Pilet's predecessor at the Opera.[96] As a whole, then, the scene is conceived as one of the reunions in Chopin's studio in which he gave impromptu performances, and may well have been inspired by an account of the first such performance—at which Heine, Delacroix, Sand, Hiller, and

Liszt were present—in the latter's well-known memoir of Chopin, published in 1852.[97] If Degas was not already familiar with it, he could easily have learned about it from some of the musicians, including Pilet himself, with whom he was friendly around 1870 and whose portraits he painted in *The Orchestra of the Opera* [50].[98]

In the context of these musical friendships, Degas's conception of the lithograph as a playful homage to Pilet seems entirely appropriate. It recalls Manet's use of a similar device in his portrait of Zola, exhibited

89.
Detail of Figure 88

90.
Maurin, *Celebrated Pianists*, 1842. Lithograph.

Bibliothèque Nationale, Paris

in 1868, where the principal figures in the three works framed together in the background—a Japanese color woodcut of a wrestler, a lithograph of Velázquez's *The Drinkers*, and a photograph of Manet's *Olympia*—are either modified or so chosen to begin with that they seem to look respectfully toward the much larger figure of Zola.[99] And it anticipates Pissarro's use of the same motif in a portrait of Cézanne painted in 1874, in which satirical prints taken from popular illustrated weeklies are placed on either side of him in such a way that the figures of Courbet and Thiers shown in them turn toward and appear to salute the rustic yet imposing Cézanne.[100] The lithograph in Degas's portrait is conceived in the same spirit, but even more ambitiously, since it attempts to capture the appearance of a familiar type of print rather than to reproduce an actual example, and it contains a great many figures, each of which has been adapted from still another source, a portrait of the person represented. That he was successful, despite the small area in which he had to work, testifies to his remarkable ability to summarize a physiognomy with a few strokes, a skill of which his caricatures are also impressive evidence,[101] and his portrait of another musician, *Mme Camus at the Piano*, a different kind of demonstration. For in it, as he later told Walter Sickert "with glee," the music on the piano is depicted so accurately that an expert was able to identify it as Beethoven's.[102]

If the lithograph behind Pilet reflects a playfulness appropriate to the spirit of friendship in which Degas conceived this portrait, it was also inspired by a respect that makes even more meaningful the deference shown him by so many famous colleagues. For Pilet was more than an accomplished musician; he was also a courageous individual who had risked his position in the orchestra of the Opera a few years earlier by openly challenging its administration.[103] In January 1866, after many months of protesting for higher wages, a few of its members met with one of Louis Napoleon's ministers, and the results were reported by their conductor, Georges Hainl. "The majority received this communication very well," he wrote to the Director of the Opera. "However, one voice pronounced the following words: 'It is money that we need.' This voice was that of M. Pilet, the cellist." Incensed by this challenge to his authority, Hainl insisted that Pilet, who had played in the orchestra for over twenty years, be dismissed immediately: "I cannot, I will not, be

a victim of the bad will of a few. An example is needed. It is needed at once."[104] Actually, Pilet was not dismissed, since he figures prominently in *The Orchestra of the Opera*, painted three years later; but his outspoken attitude was undoubtedly discussed among musicians and known to Degas, who at this moment was mounting his own attack on the Salon administration and would surely have admired it.[105] That he recognized in Pilet an independent spirit like his own is evident in his portrait, both in the calm, determined expression on the musician's face and in the respectful attitudes of his illustrious predecessors, whom Degas has ingeniously placed behind him.

IN ANOTHER portrait of a friend, this one a fellow artist [91], probably painted around 1878, Degas returned to the theme of the studio, which he had treated a decade earlier in portraying Tissot; and here, too, the dimensions and legibility of the pictures surrounding the figure give them an important role in the composition and invite speculation as to their meaning in relation to him.[106] But their consistency of subject and style, their unframed and apparently unfinished condition, and the prominently displayed paintbox, palette, and brushes all imply that they are his own works, recently completed or currently in progress. In fact, the mannequin propped up against the wall beside him must be the model he has used for the similarly costumed figure in the larger of the two pictures. Unlike the portrait of Tissot, then, this one seems simply to represent a colleague flanked by some of his recent works—outdoor scenes of informal diversion, Impressionist in spirit, that have little to do with Degas's own art of the later 1870s. Yet this portrait, too, expresses an attitude of disillusionment that reveals as much of Degas as of his sitter, and in effect does so through the choice and relation to him of the pictures and objects as much as through his own appearance.[107] This becomes evident, however, only when the pictures and indeed the artist himself have been identified.

It has been suggested several times that he is Cézanne, a painter with whom Degas was of course acquainted, and who might well have used a mannequin for lack of live models.[108] But the photographs and portraits cited in support, and particularly the one by Renoir that is not cited, show a quite different head, rounder and more compact, with

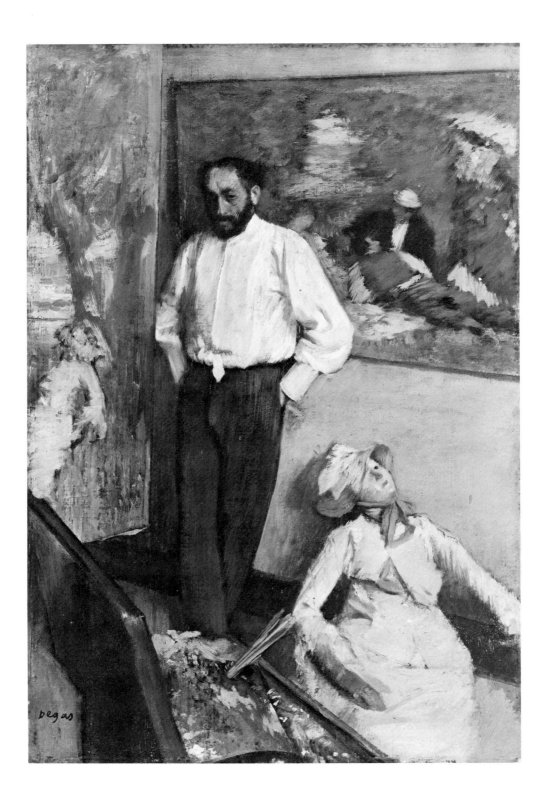

more open eyes, a fuller beard, and a balder pate; and the picnic scene mentioned in relation to the picture at the right resembles it only superficially.[109] A more reliable clue was provided by Degas himself, when he listed among his entries in the catalogue of the Impressionist exhibition of 1879 a "Portrait of a Painter in His Studio" in the collection of a "Mr. H. M.-L."[110] Although no contemporary review or memoir mentions it, very likely because Degas decided not to exhibit it after all, it was undoubtedly the one under discussion. For the only others in his oeuvre that could be so described are those of Tissot and of a man in a white blouse, of which the former was too early in date and the latter too unfinished in appearance to be exhibited then.[111] Now in 1879, before the portrait could have changed hands, "Mr. H. M.-L." could only be the artist who is its subject, and he in turn could only be Henri Michel-

91 (*opposite*). Degas, *Henri Michel-Lévy*, ca. 1878. Oil on canvas.

Fundação Calouste Gulbenkian, Lisbon

92. Michel-Lévy, *The Regattas*, ca. 1878. Oil on canvas.

Present whereabouts unknown

Lévy (1844–1914), the one recorded artist with these initials. A somewhat conservative, minor Impressionist, he was known to the major figures in the movement, particularly Manet and Monet, with whom he occasionally painted, and a work he exhibited at the Salon of 1877 was singled out for praise by Duranty.[112] Like Degas at an earlier date, he had been a pupil of Félix Barrias, through whom they may have met; in any event, they were acquainted, for his addresses appear three times in Degas's notebooks in the early 1870s.[113] In fact, Michel-Lévy himself later reported that "they had been studio companions and had made portraits of each other," that he had sold Degas's portrait of him for a high price, and that the latter, learning of this, had remarked mercilessly: "You have done a despicable thing; you knew very well that I couldn't sell your portrait."[114]

If the main outlines of Michel-Lévy's career are known, his works have virtually disappeared. Hence it is hardly surprising that the picture at the right in Degas's portrait cannot be identified, although one that Michel-Lévy exhibited at the Salon of 1878 as *Promenade in a Park* suggests a similar subject.[115] It is only through the chance discovery of an old photograph that the one at the left can be identified as *The Regattas* [92], which he showed at the Salon of 1879, the very year when Degas planned to show this portrait.[116] Obviously working from memory, Degas has altered the seated woman's position and rendered the foliage around her in a more boldly simplified style, but it is clearly the right side of *The Regattas* that he has reproduced. The other picture, although painted even more summarily, represents a similar situation—two men and a woman seated or reclining outdoors, and two women with parasols strolling toward them. In choosing these elegant, idyllic scenes, Degas in effect characterizes his friend's art as an Impressionist equivalent of the Rococo *fête galante*, although it was also an art of landscapes and urban genre scenes, to judge from the titles in exhibition and sale catalogues.[117] Thus Degas alludes not only to the general affinities between Impressionism and the Rococo, but to the influence exerted on Michel-Lévy by his own outstanding collection of eighteenth-century art, especially that of Watteau, the creator of the *fête galante*. Indeed, the posthumous sale of his collection contained twelve paintings and thirty-

three drawings by Watteau, as well as important works by Boucher, Fragonard, and others, some of which might well be compared with the two by Michel-Lévy himself that Degas has reproduced.[118]

Ironically, however, he appears in this portrait as a withdrawn and disillusioned man, altogether remote from the scenes of pleasure and conviviality surrounding him, and made to seem still more isolated by their presence. Moreover, the most conspicuous figure in each picture appears to turn its back on him, as does the mannequin placed on the floor beside him. In effect another work of art, the latter closes a series of triangles that surround the artist on all sides; and this hermetic mood is enhanced by the shallowness of the space in which he stands, his back literally against the wall, his exits blocked visually by his own creations or instruments of creation.[119] Symbolically, the mannequin plays the part of his companion, one that is indeed lifelike in scale, costume, and coloring, yet is shown in a singularly awkward, lifeless posture, propped against the wall. (In Jacques Villon's *Woman and Mannequin*, a color aquatint of 1899, the roles of the sexes are reversed and the erotic implications much stronger.[120]) The poignancy of the mannequin is echoed in the seated woman of *The Regattas*, who appears still more inanimate and remote—an imitation of an imitation of reality. How effectively such details establish a mood of pessimism and alienation becomes clearer when Degas's image of the artist in his studio is compared with a typically Impressionist one, such as the portrait by Armand Guillaumin of his patron Dr. Martinez, which conveys an air of confidence and ease not only in the relaxed position of the figure, but in the small, informal, casually arranged pictures around him.[121]

That Degas's subject, a man of whom one acquaintance wrote, "I know of no one more reticent, more distrustful of himself, than this fine, sincere artist. . . . He has dreamed, observed, painted, traveled, lived for himself, far from the futile and foolish tumult,"[122] is effectively summed up in such a portrait cannot be doubted. But that there is also in it much of Degas's conception of the artist as an unsocial being who inhabits a world of his imagination, and particularly of his sense of himself as a frustrated, embittered man whose deepest needs remained unfulfilled, is equally evident. We have only to read his letters, such as

the one he wrote to a colleague in 1884, "If you were a bachelor and fifty years old, . . . you would experience those moments when one shuts oneself like a door, and not only on one's friends; one suppresses everything around one, and once all alone, one destroys oneself, in short, one kills oneself, out of disgust,"[123] to realize how profoundly true an image of Degas himself this painting is.

IF, IN THE portraits discussed thus far, the pictures shown in the background appear either to have existed in reality or to have been invented with a metaphorical purpose in mind, the one seen behind Henri Rouart in Degas's portrait of him with his daughter [93], of about 1877, cannot be understood in either sense.[124] It has been called "one of his landscapes," but its boldness of conception and freedom of execution are without parallel in his art. A talented amateur who was better known as an industrial engineer and as a collector of modern art, Rouart had studied with Corot, from whom he acquired a taste for such picturesque sites as Venice, Avignon, and Marseilles, and worked in a rather cautious style, of which Valéry later observed: "He fashioned for himself a technique of the greatest discipline, of a remarkable precision and accu-

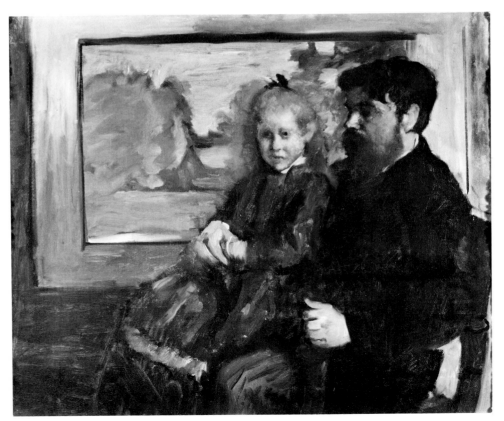

93.
Degas, *Henri Rouart and His Daughter Hélène*, ca. 1877. Oil on canvas.

Collection of Dr. and Mrs. Rudolf Heinemann, New York

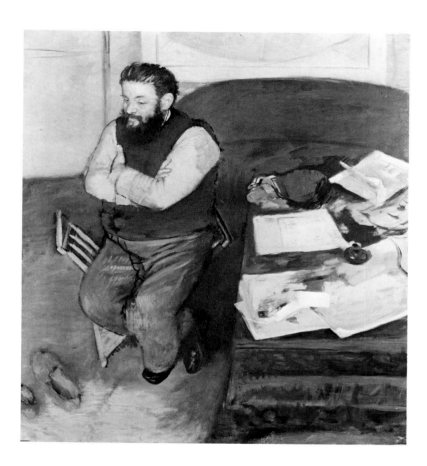

94.
Degas, *Diego Martelli,*
1879. Oil on canvas.

The National Gallery of
Scotland, Edinburgh

racy."[125] Therefore, the landscape in Degas's portrait should probably be understood as an acknowledgment of Rouart's interest in landscape painting, one that his more illustrious friend encouraged by inviting him to exhibit with the Impressionists, rather than as a particular work by him. Compared with the easily identified, symbolically significant works of art that often appear in portraits of artists in the Romantic period, such as that of Michelangelo in his studio by Delacroix and those of Tintoretto and Raphael by Ingres, this one clearly has no such purpose,[126] even if Degas seems to have had Ingres's pictures of the Fornarina seated on Raphael's lap in mind when he chose to portray Hélène Rouart seated on her father's.

Also without special significance is the large picture in the background of Degas's portrait of Diego Martelli [94], a Florentine art critic who visited Paris in 1878–1879, at which time Degas painted him in his apartment, and who on his return to Italy was the first to champion Impres-

sionism.[127] The background painting should probably be seen as an allusion to his professional activities rather than as a work he actually owned. For not only is there no such work in the inventory of his collection, which he willed intact to the Galleria d'Arte Moderna in Florence,[128] but its appearance varies from one to another of the preparatory studies for the portrait, and takes still another form, that of a loosely painted landscape, in a second version of it.[129] And unlike the latter, the picture in our version is impossible to identify even generically; it has been described as a "framed fan," but the curvature of a fan would be downward rather than upward and its size much smaller. What we see, then, is not a fragment of a real or putative picture, but an abstract design whose pale red, yellow, and blue tones echo those found elsewhere in the composition, just as its curved contour repeats that of the sofa below it, effectively reinforcing the apparent rotundity of Martelli's compact figure.

A NUMBER of conspicuous yet unidentifiable pictures also appear in the background of Degas's pastel *Mary Cassatt at the Louvre* [95], a work contemporary with the portrait of Martelli, and they also serve to characterize the setting rather than to comment on the personality or taste of the persons represented.[130] For if this apparently simple scene of visitors in the Grande Galerie is in fact a rather sophisticated portrait of Degas's friend and pupil Mary Cassatt and her sister Lydia,[131] its effectiveness in evoking their personalities depends neither on the pictures shown behind them nor on their facial expressions, which are likewise hidden or ambiguous, but rather on the expressiveness of their postures and the silhouettes that these produce against the strikingly bare surfaces of the parquet floor and marble dado of the gallery. Although probably inspired by the piquant flattening of shapes in Japanese prints, the shrewdly contrasted silhouettes of the two women are fundamentally European in their revelation of personality.[132] That of the standing woman, which Degas studied repeatedly in a notebook of around 1879, is particularly effective in this respect, for "her slender, erect figure, neatly tailored, and her crisply furled umbrella all convey to us something of Mary Cassatt's tense, energetic character."[133] This essentially European interest in realism is also evident in the care he

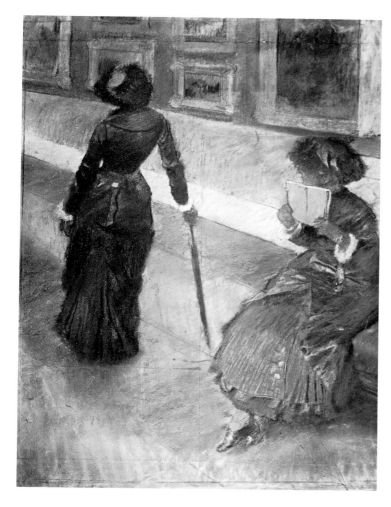

95. Degas, *Mary Cassatt at the Louvre*, 1879–1880. Pastel.
Private collection, New York

96. Degas, Study for *Mary Cassatt at the Louvre*, 1879–1880. Pencil.
Formerly collection of Marcel Guérin, Paris

took to reproduce accurately the appearance of the Grande Galerie: on another page of the same notebook [96], he drew a faint outline of Mary Cassatt's head and shoulders and above it part of the elaborately carved frame on one of the pictures that used to hang there, reproducing a corner of it so faithfully that it can be identified as Rubens's composition *The Birth of Louis XIII*.[134]

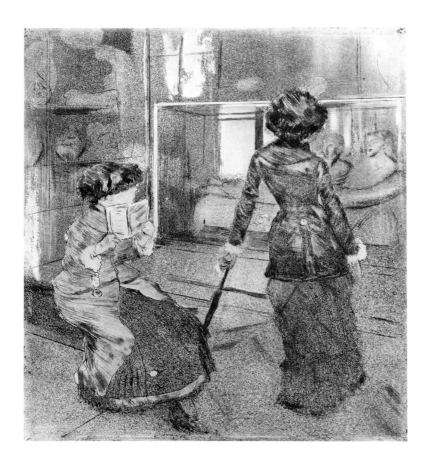

97.
Degas, *At the Louvre: Mary Cassatt in the Etruscan Gallery*, 1879–1880. Etching, aquatint, and *crayon électrique*.

Metropolitan Museum of Art, New York, Rogers Fund, 19.29.2

The figures of Mary and Lydia Cassatt, based directly on those in the pastel, but now shown contemplating the Etruscan sarcophagus in the Louvre's Salle du Tombeau Lydien rather than the pictures in its Grande Galerie, appear once again in an etching with aquatint that Degas made around 1880 [97].[135] His choice of the fine sarcophagus from Cervetri [98] reveals an appreciation of Etruscan art, and of archaic art generally, which was unusual at that time. The first modern study of Etruscan civilization had appeared only three years earlier, and as late as 1892 this sarcophagus was described in a popular guidebook as "a strange work, at once refined and barbarous."[136] In addition to the appeal of its unfamiliar style, the difficulty in representing its complicated forms —seen through a glass case that both reflects light and frames the luminous window behind it—undoubtedly posed a technical problem for Degas, one which he must have been all the more eager to solve in that

this print was to mark his public debut in the field of graphic art. It was to be his contribution to *Le Jour et la Nuit*, a periodical devoted to original prints, which he was then organizing with Bracquemond, Pissarro, and Mary Cassatt herself. The technique of aquatint, which he has employed here so freely and inventively, was to be an important element in all their prints.[137]

That he achieved far more than a technical tour de force, however, becomes evident when his print is compared with contemporary pictures of visitors in the Louvre's sculpture galleries, such as the ones of his former friend Tissot. If the latter's view of the Rotonde de Mars [99], probably painted around 1884, is more successful as an illusion—so much so, that all the antiquities shown in it and even the Pavillon de Sully seen through the window can be identified—it is also more pedantic, and lacks the flair and especially the wit that characterize Degas's image.[138] This is evident not only in his handling of the graphic media, but in a carefully contrived and amusing detail: the husband and wife shown reclining on the Etruscan sarcophagus appear to turn toward, and the

98. Sarcophagus from Cervetri, Etruscan, VI century B.C. Polychromed terracotta. Musée du Louvre, Paris

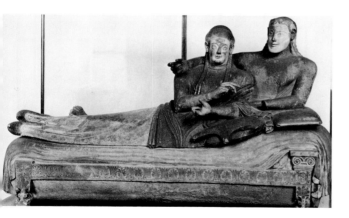

99 (*right*).
Tissot, *In the Louvre: The Rotonde de Mars*, ca. 1884. Oil on canvas.

Museo de Arte de Ponce, Fundación Luis A. Ferré

husband to beckon toward, Lydia Cassatt, who in turn seems to look up from her guidebook in order to meet their glances, while her sister Mary faces them directly. When seen from this angle, the figures on the sarcophagus do indeed appear this way, and in a carefully executed drawing [160] made in preparation for the print Degas indicates as much,[139] but he undoubtedly chose that angle to begin with in order to produce such a confrontation between the pairs of living and sculpted figures. In effect, then, his image is a witty, modern equivalent of the older one, especially popular in late medieval and Renaissance art, of The Three Living Meeting the Three Dead. Yet it remains a scene of contemporary life and a rather shrewd portrait of two of his friends.

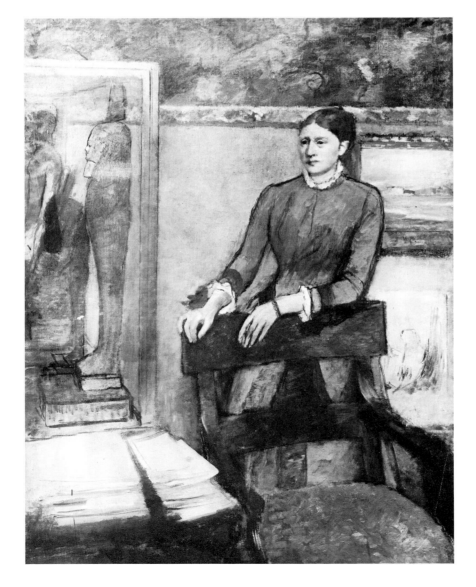

100.
Degas, *Hélène Rouart*, 1886. Oil on canvas.

Private collection, London

THE LATEST in date and also the most varied in subject matter of the portraits in which works of art appear is the one that Degas painted of Hélène Rouart in 1886 [100], almost a decade after he had shown her as a girl on her father's lap.[140] Although a poised and independent young woman now—and her unusual position relative to the chair, particularly in the preparatory studies, is one indication of this—she is still depicted in her father's library, surrounded by books and objects in which his presence is felt.[141] As we have seen, it was largely as a collector rather than as an artist that Henri Rouart was best known, and Degas, who was one of his closest friends, has acknowledged this by characterizing the pictures and objects behind her as vividly as

101.
Detail of wall hanging, Chinese, Ch'ing Dynasty. Woven silk.

Formerly collection of Edmond Fournier, Paris

Hélène herself. If it is a portrait of her as the daughter of a famous collector, however, it is also an image of the cultivated milieu which his intelligence and taste enabled him to create, and in which she was raised to appreciate many different kinds of art. How much at ease she seems in it becomes apparent when this portrait is compared with the one of Thérèse Morbilli standing rather stiffly in her father's richly furnished drawing room [77], with an equally haughty portrait by Perronneau behind her.[142]

As if to emphasize the essentially artistic and intellectual character of Hélène Rouart's home, Degas has placed a table piled with books and papers in the foreground, and has surrounded her with a remarkably diverse group of objects. In the glass case are three Egyptian wood statues, of which the nearest one alone is rendered clearly enough to be identified; it is an ushabti, or funerary figurine, of the Middle Kingdom, and was for many years in the collection of Louis Rouart, who

inherited it from his father.[143] As in the etching of Mary and Lydia
Cassatt in the Louvre, examining an Etruscan sarcophagus whose figures
seem in turn to contemplate them [97], Degas has drawn a subtle com-
parison between the ushabti and the equally solemn and dignified young
woman, whose head moreover appears at the same level. On the wall
behind her is part of a large Chinese silk hanging, its embroidered
ornament (more legible when seen in color) consisting of dragons and
traditional "dogs of Fo" on a crimson ground, of a type woven in the
Ch'ing Dynasty [101].[144] Yet these works of ancient and Oriental art,
although part of Henri Rouart's collection, were hardly typical of it; its
greatest strength, in fact, was in European art, especially of the nine-
teenth-century French school, some of whose masters he had known
personally. Hence the presence of these works probably reflects Degas's
own interests as much as his friend's. As a student, he had copied
extensively after Egyptian art; and according to his niece, "after reading
[Gautier's] *Romance of the Mummy,* [he] became interested in every-
thing that touched on Egyptian life at the time of the Pharaohs."[145] Early
in his career, he had also been deeply interested in Far Eastern art, as
we have seen in *The Collector of Prints* and the portrait of Tissot, where
Oriental costumes and woven fabrics are actually represented [65, 68].

More appropriate as expressions of Rouart's taste are the painting and
drawing behind Hélène at the right side of the composition [102]. Al-
though rendered in paler tones and a broader style than the figure and
chair adjacent to them, both can be identified. The painting is Corot's
Naples and the Castello dell'Ovo [103], one of an outstanding group of
early landscapes by him which particularly impressed those who visited
Rouart's collection.[146] Many years later, a visitor remembered both the
vivid coloring of this "magnificent seascape" and the many hours he
had spent discussing the master's work with his host, who had known
Corot and received some lessons from him.[147] The same was true of
Millet; and appropriately, he is represented in Degas's portrait by the
study of a peasant woman [104] that hangs below the Corot; it is one
of an even larger series of pastels and sketches by him that were among
Rouart's most valued possessions.[148] A colleague later described how,
even as an old, infirm man, "ill and hardly able to raise himself from
his armchair, . . . [he] wished to discuss Millet again with me, and

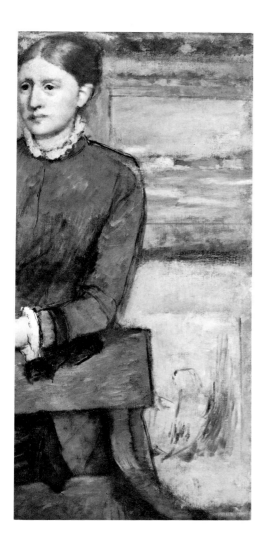

102.
Detail of Figure 100

103.
Corot, *Naples and the Castello dell'Ovo,* 1828. Oil on canvas.

Formerly collection of Henri Rouart, Paris

104.
Millet, *A Peasant Woman Seated against a Haystack,* 1851–1852. Black crayon.

Musée du Louvre, Paris

leaning on my arm, dragged himself to a dark corner, where he lit a candle to show me a very small drawing."[149] Thus the early Corot landscape and the Millet drawing, although not the most valuable works in a collection that included pictures by El Greco, Chardin, Goya, and Degas himself, were evidently among the most significant in Rouart's own judgment, and were probably introduced here as such.

Like the Chinese silk hanging and the Egyptian sculptures, however, they must also have had a special attraction for Degas. The Corot, a view of the Gulf of Naples, recalled a scene he had often admired as a young man, while visiting relatives in that city, and had seen again in 1886, the very year in which he painted this portrait.[150] What he responded to above all was its vivid contrasts of color and light, observing in a notebook of 1860 that "the Castello dell'Ovo stands out against the roseate slopes of Vesuvius, itself greenish and black as in winter."[151] Two of his earliest landscapes are in fact small, broadly executed views of the Gulf of Naples and the Castello, undoubtedly painted under Corot's influence.[152] Hence the picture in Rouart's collection would also have interested Degas as a brilliant example of that master's early style, which he, too, preferred to the later, more popular one. His own collection contained seven Corots by the time of his death, almost all of which were small landscapes of the early Italian period; and appropriately, when he was considering the purchase of two of them in 1898, he asked Rouart to confirm their authenticity.[153] Unlike the Corot, the Millet in the portrait of Hélène Rouart would have attracted Degas not for its subject matter, the rustic in art having little appeal for him, but for its qualities as a fine drawing. The only works by Millet in his collection were in fact sketches and studies, to which he could respond in purely graphic terms.[154] That he did so, and with as much emotion as he felt for Corot's work, is clear enough from Walter Sickert's memoir: "His whole-hearted adoration seemed, among the moderns, to be given to Millet, to Ingres, and to the earlier Corot."[155]

IF, IN THE portrait of Hélène Rouart, as in the earlier ones of Tissot and Michel-Lévy, the works of art around them seem as important as the subjects themselves in defining their interests or personalities, they are nevertheless subordinated to the latter compositionally. Only on two

occasions, during a sojourn in his friend Paul Valpinçon's château at Ménil-Hubert in the summer of 1892, did Degas eliminate the figure and attempt instead to paint a portrait of his environment. In *The Interior* [60], he represented his own room at the château, playing ingeniously with the motifs of the picture, the mirror, and the doorway, as we have seen, but also capturing the provincial charm of this simply furnished yet cheerful and luminous place.[156] And in *The Billiard Room* [105], he depicted one of the more elaborately furnished areas used for entertainment and the display of the Valpinçons' extensive collection of paintings.[157] Paul was in fact the son of a famous collector and friend of Ingres, and it was through this family that Degas was able as a young man to meet that master—an occasion he never forgot.[158] Hence the prominence he has given to the pictures, which fill both walls of the billiard room, the space above the doorway, and a wall of the room visible beyond it, creating an effect like that in the portrait of Mary Cassatt in the Grande Galerie, but with a greater emphasis on the pictures themselves. In doing so, he was once again fulfilling an ambition of Naturalist aesthetics that Duranty had formulated in *The New Painting:* "The language of the empty apartment will have to be clear enough for one to be able to deduce from it the nature and habits of the person who inhabits it."[159]

Yet only the largest of the works of art shown, the one in the center of each wall of the billiard room, is depicted in sufficient detail to be identified. At the right is an eighteenth-century tapestry representing Esther Swooning before Ahasuerus, which was still at Ménil-Hubert before the Second World War, but was removed or destroyed during it.[160] At the left is a painting of a typically rustic scene by the Neapolitan artist Giuseppe Palizzi, the *Animals at a Watering Place* of about 1865 [106].[161] Clearly uninterested in its rather dryly rendered genre details, Degas has suppressed the foreground entirely in his copy and given the earth, especially the horizon, a rhythmic curvature lacking in the more static original. However, these changes do not necessarily imply a criticism, since there is a similar tendency toward simplifying and abstracting a broad pattern of tones in his late copies after artists he surely did admire, such as Delacroix and Mantegna [43, 214].[162] In fact, he may have met Palizzi, the leader of the so-called School of Pausilippus, during

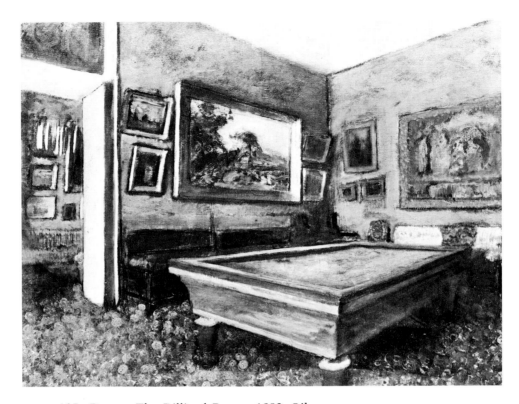

105. Degas, *The Billiard Room*, 1892. Oil on canvas.

Formerly collection of Charles Comiot, Paris

one of his many visits to Naples, and may have been interested in the picture for that more sentimental reason.

Despite the absence of human beings, both of the Ménil-Hubert interiors are conceived so entirely in terms of human associations that they can be considered "portraits" of the rooms in question. In their concern with personality and mood, they resemble Impressionist interiors far less than those of the Romantic period, where the temporarily uninhabited space projects a powerful image of its occupant through the character of its furnishings and decoration and the expressive quality of its color and light.[163] A particularly fine example of this type, Delacroix's painted sketch of *The Comte de Mornay's Apartment* [107], was acquired by Degas two years after he stayed at Ménil-Hubert; and

appropriately, he considered it one of the three most important pictures in his collection.[164]

VIEWED IN retrospect, the pictures within Degas's pictures are not only surprisingly numerous, but so diverse in subject and style as to appear almost unintelligible as a group. Nevertheless, when they are arranged chronologically, as they have been here, they reveal patterns of occurrence, function, and taste that are meaningful in terms of Degas's artistic development. It is surely no coincidence, for example, that the first and last works in which pictures appear prominently, *The Bellelli Family* of about 1860 and *The Billiard Room* of 1892, are also the first and last in which he attempts to characterize a room in relation to the personalities and interests of the individuals who inhabit it. In the only later works in which pictures appear—*The Toilette,* ca. 1897, and *Woman Drying Her Hair,* ca. 1906—both the figures and the pictures behind them

106. Palizzi, *Animals at a Watering Place,* ca. 1865. Oil on canvas.

Formerly collection of Paul Valpinçon, Ménil-Hubert

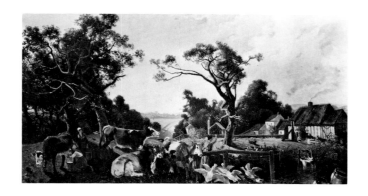

107.
Delacroix, *The Comte de Mornay's Apartment,* 1833. Oil on canvas.

Musée du Louvre, Paris

are anonymous.[165] It was only in composing photographs that Degas continued to use the motif imaginatively, as in the fascinating portrait of himself with the sculptor Bartholomé.[166] Nor is it an accident that, between the terminal dates just mentioned, all the examples we have considered are either portraits or, in the case of *The Banker* and *Mary Cassatt at the Louvre*, portrait-like genre scenes, whose background pictures or objects serve to identify the characteristic ambience of the person shown or to comment on some aspect of his professional life. Unlike his colleagues Cézanne and Gauguin, whose still lifes sometimes include works of figurative art strikingly juxtaposed to the objects around them, Degas was too deeply attached to the representation of human beings ever to experiment with this form.[167]

Thus the period of Degas's greatest interest in the motif of the picture coincides roughly with that of his greatest interest in portraiture. Within that, however, there is a smaller interval, from 1866 to 1880, or rather, two still smaller intervals, from 1866 to 1871 and from 1877 to 1880, which comprise most of the examples we have discussed. It is especially in the first of these that Degas, encouraged by Duranty, Manet, and others in the Naturalist movement, who are convinced that in modern portraiture "we will no longer separate the person from the apartment setting,"[168] explores the expressive possibilities of the background, and particularly of the picture in the background, in such complex and subtle works as *The Collector of Prints*, *The Banker*, and the portraits of Tissot and Pilet. Moreover, it is in just these years that Degas tends to include small prints of an essentially documentary value in such realistically depicted interiors as those of the *Portraits in an Office*, *The Cotton Merchants*, and *The Pedicure*.[169] In the most interesting of these interiors, the so-called *Le Viol* [134], his practice actually coincides with that of the Naturalist writers, since it is directly inspired by a passage in Zola's *Thérèse Raquin*, in which a portrait hanging in the bedroom where the action takes place suddenly assumes a dramatic importance, and it is possibly also based on a scene in that author's *Madeleine Férat*, in which a series of engravings decorating the hotel room where the episode occurs are given a striking symbolic significance.[170]

In most cases, Degas copies the background picture or object from an actual one, often in a broader, more summary style, but with sufficient

fidelity for his model to be identified. Here he relies on his phenomenal visual memory and on techniques he has acquired in years of practice as a copyist.[171] In the relatively few cases where he obviously invents the work of art, it is for a specific reason: to characterize a style or type of art, in a portrait of an artist (Tissot, Rouart); to introduce a humorous marginal comment, in a portrait of a friend (Pilet); or to reinforce a compositional element, in a portrait whose subject alone is important (Martelli). Whether copied or invented, however, the picture or object in the background always seems appropriate for the subject of the portrait, and sometimes actually belongs to him (the Bellellis, the print collector) or to his family (Thérèse Morbilli, Hélène Rouart).[172] Nevertheless, in most of these examples and in a few others (the banker, Mary Cassatt), the particular work of art seems also to be chosen because of Degas's own interest in it, his taste agreeing with or even dominating that of his subject, although this may appear so partly because much more is known about his artistic interests than about those of his subjects.

Whatever the reasons for their choice, the mere presence in Degas's paintings and prints of works as varied as Egyptian and Etruscan sculptures, Chinese and Japanese fabrics, Renaissance and Rococo portraits, Romantic and Impressionist landscapes, Neoclassical and Victorian prints, is evidence of a responsiveness to art of almost every type and style that is in itself characteristic of him.[173] Within this extraordinary diversity, certain preferences can be observed; notably for nineteenth-century and for Far Eastern art. To the former group belong not only the landscapes and genre scenes by (or apparently by) his colleagues Michel-Lévy, Tissot, and Rouart, which are perhaps inevitable in portraits showing them in their studios, but also those by Corot, Millet, and Palizzi, which represent less externally conditioned choices, and also the flower prints by Redouté, the steeplechase print after Herring, and the print depicting musicians designed by Degas himself. To the group of Far Eastern works belong the T'ang figurine and Japanese pocketbook covers in *The Collector of Prints*, the Ch'ing silk hanging in the portrait of Hélène Rouart, and the imitation of an Eishi color woodcut in that of Tissot. And as we have seen, the influence of Oriental art is also present in the design of the bulletin board in *The Collector of Prints*,

the composition of the portrait of Pilet, and the figural type used in that of Mary Cassatt.[174]

In the period between 1860 and 1890, when Degas painted almost all the pictures within his pictures, many other artists also took up this theme; in fact, the years around 1885 in France have in this respect been compared in importance with the years around 1660 in Holland and Spain.[175] The Delacroix sketches in Renoir's portraits of M. and Mme Chocquet, the Japanese prints in Van Gogh's portraits of Père Tanguy, and the Cézanne still life in Gauguin's portrait of Marie Derrien all are familiar examples of this motif.[176] So, too, on a larger scale, are the Delacroix self-portrait in Fantin-Latour's homage to him, the Impressionist landscapes and figures in Bazille's picture of his studio, and the fragment of the *Grande Jatte* in Seurat's painting *The Models*.[177] Less familiar, but particularly relevant here, are the works by Degas himself that appear in other artists' pictures: the fan decorated with Spanish dancers in Morisot's *Two Sisters on a Sofa*, the pastel of a dancer adjusting her slipper in Gauguin's *Still Life with Peonies*, and the paintings of dancers and jockeys in Renoir's *Yvonne and Christine Lerolle at the Piano*.[178] As we have seen, however, the device of the picture has a unique significance for Degas, who employs it more often and on the whole more ingeniously than his colleagues, and not only in subjects whose imagery seems to require it. Quite apart from its documentary role in portraits of artists, critics, and collectors, the picture is for him a motif of purely visual fascination: like the mirror, the doorway, and the window, it is a means of playing on the artificial and the natural in the art of making pictures.[179]

IV The Artist and the Writer

No other artist's career illustrates more vividly than Degas's the history of that troubled yet fruitful marriage of painting and literature in the second half of the nineteenth century which, despite the partners' frequent avowals of independence and occasional liaisons with other arts, seems in retrospect to have been one of the essential features of the period. For he was both a painter dedicated to purely formal variations on a restricted group of themes and an illustrator responsive to many types of fiction, drama, and poetry; an outspoken, even violent critic of writers who meddled in art and a close friend of many leading novelists and poets of his time; a parochial thinker of whom Redon remarked, "He has read nothing, except some book or other of 1830, some studio gossip in which Ingres or Delacroix is spoken of,"[1] and a catholic reader of whom his niece recalled, "Literature had always deeply interested him. . . . Sometimes, for his own pleasure, he read one of his favorite authors aloud."[2] In short, he is an ideal figure in which to study those intimacies and tensions in the union of the two arts that have troubled the modernist tradition from Courbet's and Baudelaire's time down to our own.

As is often the case, Degas's vehement rejection of the literary profession barely concealed an equally powerful attraction to it. According to Valéry, who was a rather shrewd judge in such matters, there was in him, in addition to the artist, a potential writer, "as was made sufficiently clear by his *mots*, and by his rather frequent habit of quotation from Racine and Saint-Simon."[3] Inevitably, some of the cleverest of these

aphoristic remarks concerned the superiority of art to literature, such as the one later reported by Rouault: "Literature explains art without understanding it, art understands literature without explaining it."[4] The sense of literary form revealed by this saying is equally apparent in the eight sonnets that Degas composed around 1889, whose quality and originality Valéry admired: "I have no doubt that this amateur who knew how to labor at his task . . . could have been, if he had given himself wholly to it, a most remarkable poet in the style 1860–1890."[5] For us, it is even evident in his correspondence, where he often alludes to works of literature, or parodies the styles of other writers, or contrives highly expressive forms of his own, such as the letter, obviously composed in a bleak and lonely mood, which consists entirely of short, unconnected sentences, accented by ironic puns: "Not to finish at the Salon, a life spent elsewhere—in the kitchen. There are bad moments when one must use one's reason. De la Croix has a painter's name. . . . There are travelers happier than I am. Do I myself travel? asked a station master."[6]

In retrospect, the "man of letters" in Degas seems to have been particularly fortunate in the circumstances of his birth and later career, which enabled him both to cultivate a taste for the French and Latin classics and to become intimately acquainted with the leading movements of his own day. Having been born into a well-connected bourgeois family with an interest in the arts, and having received a solid classical education at the Lycée Louis-le-Grand, he acquired early the varied interests that those who were familiar with the contents of his library still remarked at the end of his life.[7] Moreover, he was in his middle years an active member of the avant-garde literary and artistic circles at the Café Guerbois and the Café de la Nouvelle-Athènes, and in his later years a participant in such fashionable salons as those of Mme Emile Straus and Jacques-Emile Blanche, where he met many of the writers of the next generation. Even the decade of his birth seems to have been propitious, for it permitted him to witness a series of extraordinarily vital developments in French literature—in his youth, Romanticism and Realism; in his maturity, Naturalism and the Parnassians; in his old age, Symbolism and the Decadents—developments that were, in addition, closely involved with parallel phenomena in the visual arts.[8]

Like these movements themselves, but with some significant time lags,

Degas's contacts with them can be schematized as beginning with a Romantic phase from about 1850 to 1865, shifting to a Naturalist phase from about 1865 to 1885, and ending with a Symbolist phase from about 1885 to 1900. Needless to say, the three periods were of unequal importance for him, the Naturalist one easily dominating the other two; and there were, as we shall see, many continuities of taste. Nevertheless, the schema is sufficiently valid to serve as an outline for the following discussion, whose subject, strictly speaking, is Degas's taste in, affinities with, and illustrations of nineteenth-century French literature and the appearance of his person and pictures within it.

IN THE FIRST phase of his career, driven by his ambition to rival the masters of Renaissance and Romantic art whom he admired, Degas projected in his notebooks, studied in countless drawings, and occasionally realized in major paintings a remarkably large number of illustrations based on his reading in biblical, classical, and Renaissance literature.[9] Although their full discussion cannot be undertaken here, their mere number and variety are worth noting, for they reveal both the extent of Degas's literary culture and the strength of its hold on his imagination in these formative years around 1860. Despite the unusual subjects among those he selected from the Bible and the Lives of the Saints, from Homer, Herodotus, and Plutarch, from Dante, Brantôme, and Tasso, the historical and literary interests that inform them are on the whole typical of the Romantic period; whereas the texts he chose to transcribe or illustrate and the figures he chose to portray among the Romantic writers themselves are more revealing of a personal taste that emerged in these years. That taste centers on five figures—Gautier, Vigny, George Sand, Musset, and Barbey d'Aurevilly—who were all a generation older than Degas and, except for Barbey, unknown to him personally, although all were still widely read when he turned to them in the fifties and sixties.

There were, of course, other Romantic writers in whom he may have been equally interested. His niece reports that he placed among the greatest poets not only Gautier, Vigny, and Musset, but Leconte de Lisle and Hugo, that he considered Sainte-Beuve "the most subtle mind of his time," and that he read repeatedly Flaubert's novels as well as his

correspondence: "He knew by heart certain passages in the letters written by the hermit of Croisset to Louise Colet,"[10] no doubt discovering in them a solace for his own unhappy loneliness. And according to Daniel Halévy, he enjoyed having the historical novels of the elder Dumas read to him in his later years, and even spoke "with a certain admiration" of the Socialist philosopher Proudhon, whose revolutionary books *On Justice* and *On the Principle of Art* he admired.[11] Surprisingly, however, one of the greatest Romantic writers, Baudelaire, is nowhere mentioned in Degas's correspondence or in the memoirs of his friends; and were it not for a notebook reference around 1867 to the poet's essay on Gautier[12] and an unpublished letter of 1869 in which Manet asks him to return "the two volumes of Baudelaire"—undoubtedly *Romantic Art* and *Aesthetic Curiosities*, both published the year before—his acquaintance with these essential texts would remain unknown.[13] But if Gautier, Vigny, George Sand, Musset, and Barbey d'Aurevilly are not the only writers of this period whom Degas appreciated, they are nevertheless those who either directly inspired his art or appeared in it themselves.

"In reading Gautier," it has been observed, "one is constantly struck by the similarities of outlook between him and Degas."[14] Both men admired the plastic beauty of ancient art and wished to resurrect its splendor in the modern world: Gautier's dream of "continuing the Greek hymn to human beauty with modern feelings and ideas" was shared by Degas, who, when asked why he always painted the ballet, replied, "Because it is only there that I can rediscover the movements of the Greeks."[15] Earlier in their careers, both had attempted to reconstruct this ideal classical world in their work, relying on the example of Ingres's historical pictures and on ancient art itself; and in at least one case, a projected painting of King Candaules' Wife, Degas was also influenced by Gautier.

In planning and collecting material for the project, in a notebook of 1856, he mentioned only the passage in Herodotus where the story of King Candaules' scheme to expose his wife's beauty to another man's eyes is first told; but this brief passage merely notes that "when she turned her back upon him, going to her bed," the intruder "slipped privately from the room; the woman saw him as he passed out."[16] It was in Gautier's tale "King Candaules" (1844) that Degas must have

108.
Degas, Study for *King Candaules' Wife*, 1856. Pencil.

Bibliothèque Nationale, Paris

discovered the startled expression and attitude of arrested movement that appear in all his studies [e.g. 108]: "By a sudden motion she turned around before taking her place on the couch by the side of her royal husband. . . . If Nyssia by a fatal chance had not turned her head as she set foot on the bed and seen him flee. . . ."[17] From the same source, as well as from Ingres's *Antiochus and Stratonice*, an equally vivid image of a Greek interior, Degas must have drawn many of his ideas for the setting of his projected picture, just as Jean-Léon Gérôme was to do in painting *King Candaules' Wife* three years later.[18] But like Gérôme and other *Pompéistes* of the period, including Gautier himself, Degas also studied the representation of figures, costumes, furniture, and accessories on Greek vases. In the same notebook of 1856 there are copies of such details from the plates in F. P. H. d'Hancarville's monumental *Etruscan, Greek, and Roman Antiquities*,[19] sometimes indeed of the very ones that Gautier must have had in mind when he evoked "one of those lovely Etruscan vases with black backgrounds and red figures, adorned

109.
Degas, Copies after Engravings of Greek Vases, 1856.
Pencil.

Bibliothèque Nationale, Paris

with one of those subjects known as 'Greek toilette.'"[20] Thus, the woman shown dressing her hair in one such scene is the source both of Degas's copy [109] and of Gautier's image of Candaules' wife, whose "arms undulating like swans' necks curved above her head to roll and fix the tresses."[21]

In addition to Greek civilization, that of ancient Egypt stirred the imaginations of both men, and at almost the same moment. For the writer, this interest culminated in *The Romance of the Mummy* (1857), a brilliant evocation of the appearance of Egyptian life, based on the accounts of travelers such as Flaubert and on the illustrations in archaeological publications such as Joseph Passalacqua's.[22] For the artist, whose curiosity was reportedly stimulated by reading Gautier's novel, it resulted in a long series of copies after the plates in other archaeological publications, notably the magnificent *Description of Egypt* of Napoleonic vintage, and in an attempt, around 1860, to incorporate some of this material in his own paintings of historical subjects as is particularly evident in his studies for *The Daughter of Jephthah*.[23]

In this picture [32], the largest and most ambitious of Degas's histori-

cal reconstructions, the influence of another Romantic writer is evident, and in fact helps to explain some of its unusual features. For contrary both to the account in the Book of Judges and to earlier pictorial representations of Jephthah returning home victorious from war, Degas sets the scene in an open, somewhat desolate countryside rather than near the walls or city gates of Mizpeh; shows Jephthah's daughter surrounded by a group of her companions rather than coming forth alone to greet him; and has her father, who has vowed to sacrifice the first creature he sees, almost collapsing at the sight of her, his head bowed and his eyes closed, rather than looking heavenward or gesticulating dramatically.[24] Even more clearly than in the painting, this last feature is evident in a preparatory study for the figure of Jephthah [110].[25] Now precisely these unusual elements are found in Vigny's dramatic poem "The Daughter of Jephthah" (1820), one of a series on biblical and classical themes that were very popular at the time and were reportedly among Degas's favorites in Romantic poetry.[26] Describing the moment when Jephthah recognizes his daughter in the distance, Vigny writes: "The

110.
Degas, Study for *The Daughter of Jephthah,* ca. 1859. Pencil.

Present whereabouts unknown

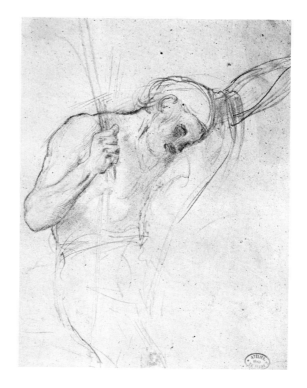

whole population thrills to the celebration. But the somber victor walks with lowered head; deaf to this sound of glory, silent and alone. Suddenly he stops, he has closed his eyes. He has closed his eyes because, from the city far away, the maidens are approaching with a slow, tranquil pace and singing. He sees this religious chorus. That is why, full of dread, he has closed his eyes."[27]

Like Degas, then, Vigny isolates and emphasizes the principal actors visually—the father, who alone is aware of his fate, closing his eyes in dread, and the daughter, unaware but already part of a religious chorus, moving toward him from the city far away. In a later passage, Vigny develops further this theme of religious resignation, making the daughter's fate a central element in his interpretation, whereas traditionally she had merely been the occasion of her father's grief;[28] and Degas, too, shows her swooning and her companions despairing, as if already aware of her destiny. A similar emphasis on the daughter's lamentation also occurs in other Romantic treatments of the subject, such as those in Byron's "Hebrew Melodies," Tennyson's "Dream of Fair Women," and Chateaubriand's "Romantic Melodies," but none of them opposes it so dramatically to a corresponding emphasis on the father's despair, and none describes the scene in such graphic terms. Indeed, the biblical account itself is far more abstract and colorless, so that Vigny, while following its outlines closely, also had to supplement it with descriptive details gleaned from other passages in the Bible and from the commentaries of Augustin Calmet, Claude Fleury, and other scholars in order to paint his vivid and dramatic picture.[29] It was no doubt this essentially pictorial aspect of his version of the tragedy that made it so congenial a model for Degas.

An attraction to the visual element in Romantic literature—in this case, the rendering of a picturesque type rather than a dramatic action—is also apparent in Degas's transcription of a long passage in one of George Sand's rustic novels describing a peasant girl's wedding costume. It occurs in the essay "A Country Wedding," published as an appendix to *The Devil's Marsh* (1846), and it dwells nostalgically not only on the charming, old-fashioned form of the costume, which had once been traditional in her native region of Berry, but on the innocence and purity of manners it had expressed so well. "Nowadays they display their scarfs

more proudly," she writes of the peasant girls of her own day, "but there is no longer in their dress that delicate flower of the purity of long ago, which made them look like Holbein's Virgins."[30] A familiar theme in her pastoral novels, this nostalgia for the modesty and dignity of an earlier age was also characteristic of Degas, who in later years was often outspoken in regretting the disappearance from contemporary life of the sober bourgeois morality he had known in his youth.

However, this was probably not his only reason for choosing to transcribe the passage in a notebook that he used around 1860 [111].[31] Since he obviously did so after having drawn the woman's head and the wandering lines that appear above it, its content must somehow have been suggested by that of the drawing. And since the latter reproduces a Renaissance drawing in the Louvre—a *Head of the Virgin* by Roger van der Weyden [112][32]—Degas must have recalled the appropriate passage in *The Devil's Marsh* after having copied the drawing, the text thus "illustrating" the image rather than the reverse. Moreover, this text,

111. Degas, Copy after Van der Weyden's *Head of the Virgin*, ca. 1860. Pencil.

Bibliothèque Nationale, Paris.

112. Van der Weyden, *Head of the Virgin*, ca. 1455. Silverpoint.

Musée du Louvre, Paris

although based on George Sand's memories of her native region, is in turn inspired by an image, the "Virgins of Holbein" to which she refers in the passage just quoted. In fact, Holbein's art played an important role in the genesis of the novel, as she indicates in a prefatory statement acknowledging her debt to one of the woodcuts in his famous series *The Dance of Death.*[33] And in her earlier novel *Jeanne* (1844), the heroine is partly based on one of Holbein's pictures of the Virgin, which she characteristically describes as depicting "a musing girl of the fields, severe and simple."[34] The works to which she refers, both there and in *The Devil's Marsh*, are presumably the Darmstadt and Solothurn *Madonnas*, Holbein's most familiar paintings of this subject.[35] And since the Darmstadt *Madonna* in particular shows a type of Virgin strikingly similar to the one by Van der Weyden that Degas copied, which in his day was attributed to Dürer, a contemporary of Holbein, we have returned, by a rather curious path, to a point quite close to the one where we began.

Alfred de Musset, the third Romantic writer in whom Degas was interested, was of course one in whom George Sand herself had shown a certain interest. That Degas was aware of their liaison, and of the many others in the poet's life which had become public knowledge by this time, is evident in an amusing composition that he painted around 1869 to decorate a woman's fan [113]. In it, Musset appears at the left, as a reveler who has temporarily joined a troupe of Spanish dancers and musicians performing outdoors and is serenading one of the dancers with a guitar.[36] This, at least, was the traditional identification of the figure in the family of Berthe Morisot, to whom Degas offered the fan shortly after painting it; and it is supported by comparison with the most widely reproduced portraits of Musset, one of which must have served as Degas's model.[37] In this case, of course, the poet's amorous adventure is a purely imaginary one, perhaps inspired by those he describes so vividly in the *Tales of Spain and Italy* (1830).

Yet the fact that Degas conceived it as part of the decoration for a fan, which he offered to Morisot, suggests that he was practicing a playful, appropriately artistic form of courtship himself. Indeed, she intimates as much in a letter of 1869 describing a recent gathering in Manet's home: "M. Degas came and sat beside me, pretending that he

113. Degas, *Fan: Spanish Dancers and Musicians,* 1867–1869. Brown ink and watercolor.

Formerly collection of Mme Ernest Rouart, Paris

was going to court me, but this courting was confined to a long commentary on Solomon's proverb: 'Woman is the desolation of the righteous.'"[38] Despite this unusual tactic, Degas must have been persuasive, at least artistically, for Morisot not only copied this fan in several watercolors, but reproduced it prominently in the background of a double portrait she painted that year.[39] In ironically assuming the role of a suitor, Degas may well have been competing with Manet, through whom he had met Morisot only a year earlier. For Manet, too, had shown a particular interest in her and had even portrayed her in a Spanish guise in *The Balcony,* a composition obviously based on one by Goya; moreover, he had already depicted a company of Spanish dancers and musicians in *The Spanish Dancers* of 1862, and in the same year had decorated a fan with motifs from the bullfight.[40]

Already fascinated a decade earlier by the legends surrounding Musset, Degas tried to envisage an "epic portrait" of him that would combine the grandeur of Renaissance art with a spirit of modernity. In a notebook of about 1859, he sketched a seated figure of the Romantic poet, his head

114. Degas, Study for a Portrait of Alfred de Musset, ca. 1859. Pencil.
Bibliothèque Nationale, Paris

115. Palma Vecchio, *Portrait of Ariosto*, ca. 1515. Oil on canvas.
National Gallery, London

turned meditatively downward to the right [114], and opposite it he remarked: "How to make an epic portrait of Musset? The *Ariosto* of M. Beaucousin says a great deal, but a composition that will depict our time remains to be found."[41] The *Portrait of Ariosto* [115], a sixteenth-century Venetian work formerly in the collection of Edmond Beaucousin, a friend of Degas's family, is now attributed to Palma Vecchio rather than Titian, but its subject is still identified as the great Italian poet; he is in fact shown with laurel leaves behind him and with an expression of reverie that might well be called poetic.[42] In using this image of Titian's famous contemporary as a model, Degas probably hoped to endow his

own portrait of a nearly contemporary figure with something of its nobility. Musset had died only two years earlier, and was in 1859 the subject of a literary controversy sparked by the publication of George Sand's autobiographical novel *She and He*, where, by the way, the principal figures are both artists.[43] Degas may also have connected the *Ariosto*, a work attributed to Titian, with Musset's popular story, "The Son of Titian" (1838), whose hero is endowed with his father's talent but is so overwhelmed by love that he renounces art.[44] Unable to find the specifically modern form he was seeking, Degas abandoned the project; but it remains a document of his fascination with Musset's personality.

In Barbey d'Aurevilly, too, it was not the writer but the man, not the author of the sadistic and licentious stories in *The Diaboliques*, but the dandy who cut an extravagantly modish, yet curiously outmoded, figure in the literary salons of Paris, that interested Degas. Thus he portrays Barbey, in a notebook sketch of about 1877 [116], as the dominant personality in one of the most fashionable of these salons, that of Mme Charles Hayem, where he was accustomed to playing the lion.[45] Seated before him are the philosopher Adolphe Franck, a distinguished professor at the Collège de France, and his hostess, a talented sculptor who later modeled a portrait bust of Barbey; but it is clearly the latter's figure that attracts Degas, who repeats its elegant silhouette in the margin. That

116. Degas, Barbey d'Aurevilly in the Salon of Mme Hayem, 1877. Pencil. Formerly collection of Ludovic Halévy, Paris

this was indeed a characteristic pose, both physical and social, is evident from a contemporary drawing by Félix Régamey of another literary salon, where Barbey's imposing figure dominates a still more distinguished company.[46] Unlike Régamey, however, Degas seems to have taken the metaphor of the lion seriously, for in another sketch, drawn a few years later, he depicts the writer's frowning, rather shaggy head in those very terms.[47]

The element of cultivated fierceness in Barbey's personality undoubtedly struck a responsive chord in Degas as he grew older and outwardly fiercer himself. A hint of his admiration for it appears beneath his indignation even when he is reporting to friends a particularly unpleasant story of the writer's rudeness to Louise Read, his devoted companion.[48] Moreover, Barbey's reactionary political and religious views, based on those of Joseph de Maistre and the Catholic restoration generally, must have appealed to Degas, for whom "the *Mémorial* was, with Maistre, one of his favorite readings."[49] On the other hand, the one passage in Barbey's innumerable publications that Degas actually transcribed, an aphorism he found in the newspaper *Le Nain Jaune* (1867), expresses a typically dandyish ideal of elegance as nonchalant and even as enhanced by a touch of awkwardness: "There is at times in awkwardness a certain ease which, if I am not mistaken, is more graceful than grace itself."[50] Clearly it was the youthful Barbey, the apologist of Beau Brummel and author of *Dandyism*, who appealed here to the youthful Degas.

IF Degas's quotation from Barbey, like his sketches of the latter a decade later and the enthusiasm he showed for *Don Quixote* and *The Arabian Nights* two and even three decades later,[51] is a sign of a lingering Romantic taste in literature, that quotation was nevertheless something of an anachronism by 1867 both in his own development and in that of advanced art generally. By this time he had already been introduced, through Manet and Duranty, into the circle of artists and writers at the Café Guerbois who were creating Naturalism and Impressionism, and he himself had turned away from historical subjects of a Romantic inspiration toward the contemporary urban scene that would occupy him henceforth. For at least twenty years now his principal literary

contacts and affinities would be with the Naturalist writers, especially Duranty, Zola, Edmond de Goncourt, and Huysmans, all of whom, except Huysmans, were of his own generation. In this period, too, he would collaborate on various projects with the librettist and playwright Ludovic Halévy, who was also an exact contemporary, in fact a former schoolmate.

Surprisingly, however, there is little evidence of Degas's interest in the work of two major Naturalist writers, Daudet and Maupassant, although he was acquainted with both.[52] Evidently he and Maupassant did admire the graphic power of each other's art; for according to his niece, Degas considered the writer "an absolutely remarkable stylist who could create vital, colorful images of life and men,"[53] and Maupassant, despite a predilection for fashionable Salon art—typically, the works of art in his novels are based on the Bathers of Henri Gervex and the Dancers of Alexandre Falguière rather than those of Degas—did send the latter a copy of *Pierre and Jean* (1888) inscribed to him: "[He] paints life as I would have liked to be able to paint it."[54] Yet when Degas, who had already devoted a powerful series of monotypes to the brothel, was commissioned to illustrate *The Tellier Establishment,* he began (and never completed) a drawing of a ballet dancer.[55]

The first and probably the most important of Degas's contacts with the Naturalist writers was with Duranty, whom he met about 1865.[56] At this critical moment in his development, Duranty, who had been a leading advocate of Realism for over a decade, must have been of particular significance for him. In fact, Duranty's conception of Realism as the depiction of contemporary subjects in a dryly impersonal style devoid of virtuosity was precisely the one Degas himself began to follow, in contrast to that of Manet and the emerging Impressionists. Degas may also have been touched by the writer's personal aloofness, growing disillusionment, and frequently mordant irony, qualities that he was beginning to experience in himself.[57] Hence it is understandable that, of all the literary figures in this circle, Duranty alone appears in his portraiture, and more than once. In addition to the well-known likeness painted in 1879 [6], which shows him in his book-lined study, his hand supporting his head in a characteristic gesture, there is another one, painted a decade earlier, which was not recognized until recently be-

cause it occurs in a genre scene.[58] Generally called *Sulking*, but occasionally also *The Banker* [83], it represents the office of a small, privately owned bank of the Second Empire, perhaps the one directed by Degas's father, and the banker himself, with his contracted features and receding, dark blond hair, is modeled on Duranty.

What makes his presence in *The Banker* so fitting is the extent to which this work illustrates theories of expression and description that he had already developed and that Degas was coming into contact with at just this time. The former theory, as we shall see more fully in Chapter V, is stated both in Duranty's essay "On Physiognomy" (1867) and in Degas's contemporaneous program to transform the schematized faces typical of academic art into portrayals of the more complex emotions characteristic of modern sensibility, such as the sullen withdrawal of Duranty himself in *The Banker*.[59] The theory of description, an important one in Naturalist aesthetics to which we shall return presently, is also well illustrated by this painting, whose furnishings and décor Degas depicts in scrupulous detail, basing the window counter fitted with opaque glass, the table piled with papers, and the rack filled with ledgers on studies he had made in a notebook [e.g. 117], again perhaps in his father's bank.[60] Although Duranty did not comment publicly on this work, he did remark on Degas's portrait of Mme Gaujelin, shown at the Salon of 1869, "One definitely feels that she has been painted for a certain place, with which she harmonizes well."[61]

117.
Degas, Study for *Sulking* (*The Banker*), 1869–1871. Pencil.

Bibliothèque National, Paris

Just as Duranty appears in a fictional guise in *The Banker*, a realistic genre scene with narrative implications, so Degas appears in his own guise in "The Painter Louis Martin," a fictional story with real characters and situations. First published serially in 1872, but largely based on Duranty's souvenirs of the years around 1863, this curious blend of fact and fantasy brings together invented characters such as Louis Martin, the young protagonist of Realism, and contemporary celebrities such as Courbet, Manet, and Degas himself.[62] When Martin arrives at the Louvre to begin copying a Poussin, he discovers that "beside him, also struggling with the Poussin, was installed Degas," and in fact such a copy by him after Poussin is not only known—it is of *The Rape of the Sabines*—but is datable ca. 1862 precisely on the evidence provided by Duranty's story.[63] When Martin, expressing a typically Realist position, criticizes the Poussin for being "of a ridiculous banality and insignificance," the astonished Degas, still very much a disciple of Ingres, praises its "purity of drawing, breadth of modeling, grandeur of composition."[64] This essentially intellectual approach, which was evident not only in Degas's copies but in his art generally, must have impressed Duranty, for he goes on to characterize him as an "artist of rare intelligence, preoccupied with *ideas,* which seemed strange to most of his colleagues," and refers to "his active mind, always in ferment."[65]

What this active mind was thinking, Duranty does not say; but in his well-known pamphlet *The New Painting* (1876), written on the occasion of the second Impressionist group exhibition, he discusses Degas's contribution to recent art in detail. Without naming him—paradoxically, none of the figures in this factual account is named, whereas the fictional one in "The Painter Louis Martin" identifies them explicitly—but alluding unmistakably to him, Duranty asserts that "the series of new ideas was formed above all in the mind of a draftsman, . . . a man of the rarest talent and the rarest intellect."[66] These new ideas consist above all in establishing an intimate rapport between the figure in a work of art and its setting, which must be characterized as carefully as the figure itself: "Since we embrace nature closely, we will no longer separate the personage from the apartment or street that forms the background. He never appears to us, in actual life, against a neutral, empty, or vague background."[67] And just as this program is perfectly illustrated by a

picture such as *The Banker,* so the examples that Duranty goes on to give clearly allude to other works by Degas: "He will examine his sample of cotton in his business office, he will wait behind the set for the moment to come on stage, or he will press the laundry iron on the trestled table," and so forth.[68]

This does not mean, however, that the radical ideas in *The New Painting* were dictated by Degas, as some writers have maintained. Although many of these ideas do reflect recent developments in his art, the latter were inspired by a theory of description that had already been formulated by Duranty and others in the Realist movement two decades earlier. In 1857, when the backgrounds of Degas's portraits were still conventionally neutral, a friend of Duranty's had written in their periodical *Réalisme:* "In describing an interior, one often narrates the private life of an individual or a family."[69] Yet in his own fiction Duranty wavered between detailed, inventory-like descriptions, to which he sacrificed the psychological development of his characters, and very summary ones inspired by his colleague Champfleury's conviction that literature cannot compete with painting and should employ its own techniques, which are in fact superior to those of painting.[70] In this uncertainty, Duranty expressed a dilemma that pervades Naturalist literary theory as a whole. Even Zola, a far more assertive personality, acknowledged that a concern with the pictorial aspects of description would lead writers into vain competition with painters. In *The Experimental Novel,* and again in *The Naturalist Novelists,* he argues that "the clear, precise definition of the surroundings and their effect on the characters [are] scientific necessities of the contemporary novel."[71] But he is also aware that "there can be abuses, especially in description. . . . One competes with the painters, to demonstrate the suppleness and brilliance of one's prose."[72]

Nowhere were the lines of this competition more sharply drawn than in Zola's frequent exchanges with Degas—and not surprisingly, for of all the Impressionists he was not only the most literate and articulate, but also the most deeply involved in the representation of modern urban life, hence the one who could pose the greatest threat of competition. In reviewing the 1876 Impressionist exhibition, about which Duranty had written enthusiastically, Zola acknowledges that Degas "is enamored of modernity, of domestic life, and of its everyday types," but feels obliged

to add: "The trouble is that he spoils everything when it comes to giving the finishing touches to a work. His best pictures are sketches."[73] And in discussing the Impressionists' reasons for exhibiting together in 1880, he observes rather maliciously that in Degas's case, "he could show the sketches, the scraps of studies, the simple strokes in which he excels, and which would not have been accepted at the Salon."[74] Only in 1877, in the course of a brief, generally favorable review in a provincial newspaper, does he admit that Degas is "a draftsman of admirable precision, whose least important figures take on a striking plasticity."[75] More indicative of his real opinion is the letter he wrote to Huysmans in 1883 on receipt of the latter's book *Modern Art:* "The more I break away from merely curious corners of observation, the more I like the great copious creators who bring us a world. I know Degas well, and for a long time. He is only a constipated [artist] of the finest talent."[76]

Equally disdainful in his turn of the pettiness of Zola's encyclopaedic conception of art, Degas remarked: "He gives me the impression of a giant studying a telephone book."[77] And the epigrammatic conciseness of this statement, like that of his other *mots,* is itself the expression of an aesthetic of which he was perfectly conscious: "In a single brushstroke we can say more than a writer in a whole volume."[78] Appropriately, this was said in a conversation about Zola. When questioned further about him, Degas recalled that he had known him well, "with Manet and Moore at the [Café de la] Nouvelle-Athènes; we discussed things endlessly," but that fundamentally they had disagreed about the nature of Realism: "Zola's idea of art, cramming everything about a subject into a book, then going on to another subject, seemed to me puerile."[79] Berthe Morisot records several other examples of Degas's insistence on the limitations of Zola's method, and precisely where it touched on painting. On one occasion, he suggested to the publisher Charpentier a New Year edition of Zola's novel *Ladies' Delight* (1883), whose setting is a department store, to be "illustrated" with actual samples of fabric and lace[80]--a suggestion that today seems like a brilliant anticipation of Pop Art, but at the time must merely have seemed malicious.

Perhaps the most striking evidence of the great distance between Degas and Zola is in their comments on *The Masterpiece* (1886), the latter's novel about the failure of a modern artist. According to Morisot,

Degas insisted that it had been written "simply to prove the immense superiority of the writer over the painter,"[81] and this in fact is what Zola himself, in an interesting conversation reported by Moore, maintained was "the theory of the book—namely, that no painter working in the modern movement had achieved a result proportionate to that which had been achieved by at least three or four writers working in the same movement."[82] When Degas was proposed as an exception to this rule, Zola replied: "I cannot accept a man who shuts himself up all his life to draw a ballet-girl as ranking co-equal in dignity and power with Flaubert, Daudet, and Goncourt." It is not difficult to guess whom he meant by the fourth writer. Ironically, however, it was Zola who here expressed a narrowly Naturalist conception of art, one that was rejected both by his Impressionist friends and by the Symbolist poets of the following generation, who were already able to admire the artistic rather than the realistic aspects of Impressionism. "The young are very enthusiastic about our work," Pissarro observed in 1886. "They tore Zola's *Masterpiece* to pieces, it seems to be completely worthless—they are very severe."[83]

Beneath the disdain that Degas and Zola felt for each other's art, there was no doubt the realization that in many respects it resembled and rivaled his own. In April 1876, when the first installments of Zola's novel *The Dram-Shop*, containing graphic descriptions of laundresses at work, began to appear, five of Degas's recent pictures of laundresses were shown at the Impressionist exhibition.[84] In reviewing the latter's contribution to the show, Zola naturally began with those pictures, which he found "striking above all for their artistic truth," but he did not mention their resemblance to scenes in his novel.[85] Nor could they have influenced him directly; for even if some may have been painted as early as 1869, and two had been shown at the Impressionist exhibition in 1874, which Zola also reviewed, he had already decided some years earlier that the protagonist of this novel about urban working-class life would be a laundress, a familiar type in the poor neighborhoods he had formerly inhabited.[86] Nevertheless, Degas's pictures must have struck Zola, as they have more recent critics, as remarkably—and perhaps uncomfortably—similar to his own images.

Like the *Woman Ironing* now in the Metropolitan Museum [118], one of those shown in 1876, his description of Gervaise's shop on a summer

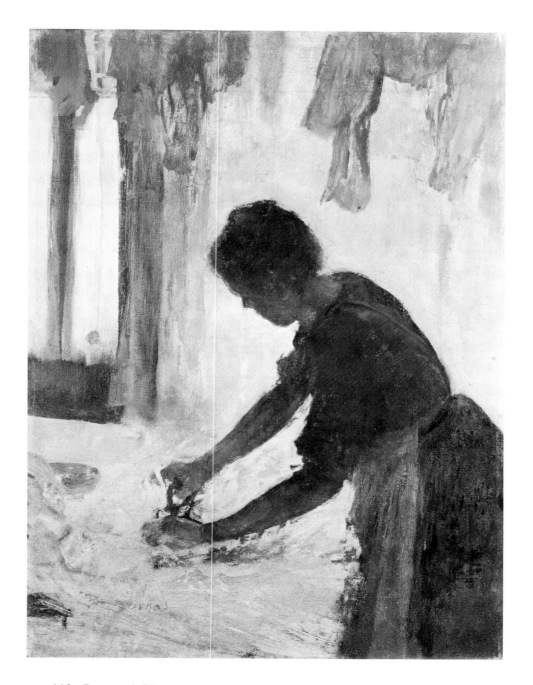

118. Degas, *A Woman Ironing*, ca. 1874. Oil on canvas.

Metropolitan Museum of Art, New York, The H. O. Havemeyer Collection, bequest of Mrs. H. O. Havemeyer, 29.100.46

afternoon evokes an atmosphere of sweltering heat and brilliant light: "This flood of light . . . threw a blinding brightness on the shop-board, like a cloud of gold-dust sifted all over the fine linen. . . . The things hung upon wires to dry steamed and were as dry as shavings. . . ."[87] And like the *Laundress* now in the Louvre, which was shown in 1874, his account of Clémence ironing a shirt makes acutely evident the effort she exerts: "Leaning heavily on the board, her wrists bent out, her elbows up in the air and wide apart, [she] bent her neck in a great effort, and . . . her shoulders heaved up, the tension of the muscles setting the fine skin palpitating."[88] To achieve this effect of visual authenticity, one of the principal goals of their Naturalism, both the artist and the writer had investigated their subject thoroughly, entering into it even to the extent of mastering its technical vocabulary. In describing Gervaise at work on a bonnet, for example, Zola specifies the kind of iron she uses for each operation—"the *polonais*, a little iron rounded at both ends, . . . the *coq*, an egg-shaped instrument fitted into a wooden holder"[89]—just as Degas, in showing his *Laundresses* to a visitor, delighted in "speaking their language and explaining to us technically the *pressing* stroke of the iron, the *circular* stroke, etc."[90]

This search for authentic documents of modern life also led Degas to accompany his women friends to millinery shops, and Zola to spend long afternoons visiting department stores when, at the same moment in the early 1880s, one was preparing to paint a series of pastels and the other to write a novel about these closely related subjects. The writer, it is true, was intent on gaining an encyclopaedic knowledge of the commercial operation of such a store, whereas the artist, when asked what he found so interesting in such a shop, replied: "The red hands of the little girl holding the pins."[91] As a result, *Ladies' Delight* reads in places like a mail order catalogue, as Degas implied in proposing that it be "illustrated" with actual samples, whereas his pastels are brilliantly condensed compositions that focus on a few telling details. The salesgirl in the Metropolitan Museum's version [119], for example, is so cleverly concealed by the mirror that she seems reduced to just such a detail, like the pin-girl in the anecdote.[92] Yet these works also reveal a shrewdness in observing social types that is closely akin to the novelist's. As Moore remarked about "the fat, vulgar woman" in the same pastel, "you

can tell exactly what her position in life is," while the shopgirls in another pastel make you "realize the years of bonnet-showing and servile words that these women have lived through."[93] It is the kind of distinction that is drawn repeatedly in *Ladies' Delight*, most effectively perhaps in the scene where Mme Desforges, "determined to be uncivil," examines and rejects "with an air of disdain" the garments shown her by Denise, who must "unfold the garments and fold them up again, without allowing herself to make a gesture of irritation."[94] Even the picture of Mme Desforges coolly observing herself in a mirror corresponds to that in

119. Degas, *At the Milliner's*, 1882. Pastel.

Metropolitan Museum of Art, New York, The H. O. Havemeyer Collection, bequest of Mrs. H. O. Havemeyer, 29.100.38

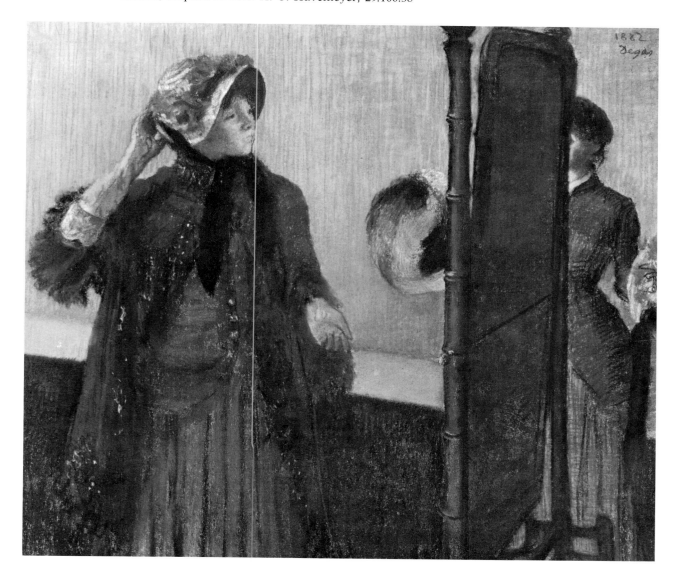

At the Milliner's. Yet even more clearly than in the case of the laundresses, there can be no question of direct influence: the first installments of Zola's novel appeared in December 1882, and Degas's pastels were all painted in that year; conversely, they were not exhibited until 1886.

Given their mutual interest in portraying the labors and pleasures of modern Paris, such coincidences were almost inevitable. Nor are they the only ones that have been noted: at one end of the social spectrum, Degas's *Absinthe* "recalls irresistibly the atmosphere of Zola's *Dram-Shop,*" especially the scene where Gervaise, having abandoned pride and hope, drinks herself into a stupor with Coupeau and his cronies;[95] and at the other end, Degas's *Portraits at the Bourse* anticipates some of the descriptions of the Paris stock exchange in Zola's *Money*, which likewise dwell on its frenetic activity and somber, dreary tonalities.[96] What is more remarkable, one of Degas's most important early works, *Interior* [134], was directly inspired by one of Zola's early novels. *Thérèse Raquin,* and perhaps also by its successor, *Madeleine Férat*, as we shall see in Chapter V.

Intersections such as these of art and literature are just as frequent in the work of Degas and that of the Goncourt brothers and in some ways more revealing, since he shared with them a broader range of social, psychological, and stylistic affinities. This was already observed by Huysmans, who wrote in 1880: "They must have been, the one and the others, the most refined and most exquisite artists of the century,"[97] and by Georges Rivière, who later wrote: "Degas was more attached to the Goncourts than to Emile Zola; their elegant realism suited the spirit of this well-born bourgeois. . . . The painter professes the same disdain as the novelists for people of a different social class than his own."[98] As Huysmans remarked, this lofty conception of Realism resulted in both cases in an emphasis on the subtle observation of manners and incisive definition of forms, and on ingenious innovations in the use of language or pictorial technique. It also resulted in a fascination with those aspects of modern life in which the artificial seems to dominate the natural, especially in such subjects as the ballet, the brothel, and the circus.

It was in fact the brilliant artificiality of a circus performance that

enabled Degas to contrast his own art most clearly with that of the Impressionist landscape painters, to one of whom he declared: "For you, natural life is necessary; for me, artificial life."[99] It also enabled him to create one of his most remarkable images, that of the acrobat Miss La La dramatically silhouetted against the rafters of the Cirque Fernando, literally hanging on by her teeth high above the unseen audience [120].[100] That was early in 1879; and when, a few months later, Edmond de Goncourt published *The Zemganno Brothers*, which depicts the courage and skill of two circus acrobats, Degas responded enthusiastically.

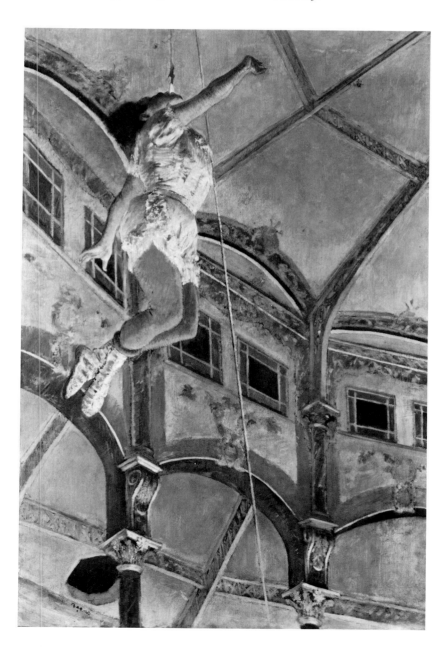

120.
Degas, *Miss La La at the Cirque Fernando*, 1879.
Oil on canvas.

National Gallery, London

"He acknowledged all that was unnatural in the so-called realism of the novel," Rivière recalled, "he spoke of it to all his friends."[101] Its startling images of acrobats performing on an invisible wire, as if suspended in air, of the female star La Talochée, for example, walking swiftly back and forth or lying perfectly still, achieving for one miraculous moment "the nonchalant balancing in the air of a woman's body which seemed to be resting on nothing,"[102] must have struck him as close verbal equivalents of his circus picture. Like the latter, moreover, they were also idealized images of his performance as an artist, constantly concerned with maintaining a tense equilibrium between opposed forces. Indeed, one of the friends to whom he would have spoken about *The Zemganno Brothers* was Barbey d'Aurevilly, who, in reviewing the novel, developed a parallel between the grace and strength of the acrobat and that of the writer which would surely also have appealed to the painter: "I am convinced that, for whoever has a feeling for analogies and a capacity for mysterious assimilations, to watch them is to learn how to write."[103]

Aesthetically, if not morally, the brothel, too, was an exemplary subject for Edmond de Goncourt as well as Degas, one in which the natural and the artificial, the naked truth and the cynical disguise, mingled with a special poignancy. Between 1877 and 1880, each of them treated this subject in an impressive form, the artist in a series of monotypes we

shall discuss presently, the writer in a novel about prostitution which
the other then illustrated. He did so in his own manner, however, for
the rapid sketches that he drew in an after-dinner album while visiting
friends in 1877 [121, 122], although identified as illustrations of the then
recently published work *The Prostitute Elisa*, are as much Degas's own
inventions.[104] Whereas for Goncourt the novel's significance lay in its
realistic depiction of the inhuman conditions in contemporary prisons—
"prostitution and the prostitute, that is only an episode," he explained
in the preface, "prison and the prisoner, that is the interest of my
book"[105]—for Degas this episode was the sole source of inspiration.
Concentrating on the one scene set in a brothel near the Ecole Militaire,
and proceeding with a sense of humor altogether foreign to the text,
he caricatures the sly rather than the sordid aspects of the soldiers and
their companions, picturing them soberly playing cards or quietly con-
versing, as if in a bourgeois salon.

Nevertheless, the general conception, as well as specific details of the
milieu, the physical types, and the costumes they wear are clearly in-
spired by Goncourt's text. This is all the more interesting in that the
latter, although the product of direct observation, was also based on
works of art; as Gustave Geffroy noted at the time, much of its pictorial
form and tonality derive from drawings of soldiers and prostitutes by
Constantin Guys.[106] He was in fact an acquaintance of the Goncourts,

121, 122.
Degas, Illustrations
of Goncourt's *The
Prostitute Elisa*,
1877. Pencil.

Formerly collection of
Ludovic Halévy, Paris

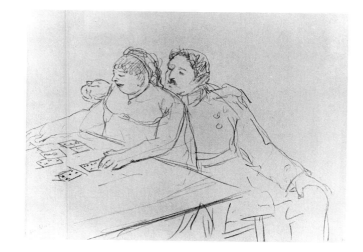

123.

Degas, Caricature of Edmond de Goncourt, ca. 1879. Pencil.

Bibliothèque Nationale, Paris

and one whom Edmond described in their *Journal* as "the painter of the common whore."[107] As in the case of Degas's relation to George Sand, then, but with a rather different type of subject, his images illustrate a text that in turn "illustrates" an older artist's images.

Given this mutual contamination of art and literature, it was almost inevitable that Degas and Edmond de Goncourt should consider themselves rivals. Acquainted from 1874 on, and alike in their capacity for rancorous wit, as the writer's gossipy *Journal* and the painter's sarcastic sayings make clear, each found satisfaction in caricaturing the other. Edmond's image of "this tiresome, captious Degas, with his affectations of wit and his clever *mots* from the Café de la Nouvelle-Athènes," is but one of many in his *Journal* in the 1880s;[108] just as Degas's sketch of Edmond as an effeminate, self-important creature remarkably like the former emperor Napoleon III [123] is but one of many in his notebooks in the previous decade, though more interesting in that the writer's name and address in his own hand appear directly above.[109] It was probably also inevitable that each should resent the other's mastery of his medium or his discovery of novel subjects. Thus Degas, whose fre-

quently self-conscious letters betray his unfulfilled literary ambitions, parodies the excesses of Edmond's "artistic style" in several letters of the 1880s. Describing a bust he is making in a friend's home, for example, he writes: "You do not believe I am *pursuing it relentlessly, with a family leaning over my talent* (Goncourt's style)."[110] And the latter, in recording his first visit to Degas's studio in 1874, admitted that he was "the one who has best been able, in representing modern life, to catch the spirit of that life," but like Zola he felt obliged to add: "Now, will he ever achieve something complete? I doubt it. He is too restless a spirit."[111]

Indeed, in revising this account much later, Edmond retained the passage, "He has become enamored of the modern, and within the modern, he has chosen laundresses and dancers," but added, "I cannot find his choice bad, I who, in *Manette Salomon* [1867], have celebrated these two professions as providing for a modern artist the most pictorial models of women in our time."[112] Edmond was, however, deceiving himself; for if his novel of artistic life was an important statement of the new aesthetic, and if Degas, who later acknowledged it, according to one visitor, "as a direct source of his new perception,"[113] was undoubtedly encouraged by the example of its protagonist Coriolis to take up modern subjects in general, he could hardly have been led by the novel to laundresses and dancers in particular. In fact, it does not mention the latter, and its only reference to the former—Coriolis' notation of "the hip-shot pose of a laundress with a heavy basket"—although apparently a description *avant la lettre* of Degas's *Laundresses Carrying Linen*, is based on earlier representations of the same subject by Daumier and Gavarni.[114] It was, as William Rothenstein reports, probably because "Degas had told him that modern writers got their inspiration from painters," that Edmond was compelled to assert his own priority retrospectively.[115]

With much more justification, he might have cited those passages in their *Journal* where, already in the early 1860s, he and his brother had described precisely the types of theater and ballet subjects that Degas was to paint a decade later. With an artist's eye for the novel effects of perspective and illumination characteristic of the stage, indeed with repeated references to similar effects in Rembrandt and Goya, the Goncourts had created in their own medium vivid pictures of dancers

rehearsing with the ballet master behind the scenes, or mounting the spiral staircase in the practice room, or moving as luminous shapes against the somber stage sets, very much as in some of Degas's later canvases and pastels.[116] In one such passage, written in 1862, the very structure of the vision seems to anticipate that of *The Ballet* [124], painted some eighteen years later. In both cases, the artist views the stage from a loge, seated beside a young woman: "We are at the Opera, in the director's box, above the stage. At our side, Peyrat and Mlle Peyrat, a young girl. . . ." In both, he looks past her to observe the glittering star on the stage: "And while conversing, I have my eyes on a stage flat opposite me. . . . La Mercier, quite blonde, bedecked with golden baubles, . . . is modeled by light, absolutely like the little girl with the chicken in Rembrandt's *Night Watch*. . . ." And in both, he glimpses behind the star the vague shapes of other performers in the distance: "Then, behind the luminous figure of the dancer, . . . a marvelous background of shadows and glimmers, . . . of forms that lose themselves. . . ."[117] Even the allusion to Rembrandt is relevant to Degas, who often remarked, apropos that master's dramatic use of light and dark, "If Rembrandt had known about lithography, heaven alone knows what he might have made of it,"[118] and, as is apparent in *The Ballet* itself, was often influenced by the older artist's chiaroscuro.

The resemblances between Degas's image and the Goncourts' were not, however, signs of a mysterious affinity, but rather the result of their mutual reliance on a conventional method of representing space by means of three contrasting planes, a method he had absorbed while copying in the Louvre and they while preparing to write *The Art of the Eighteenth Century* (1859–1870); the influence of their art-historical studies on their imaginative writing has already been observed.[119] But the extent to which both he and they stress the subjective quality of vision, by placing the observer in the foreground of their images and allowing his eccentric position to determine the structure of the whole, indicates the extent to which Degas and the Goncourts were able to modify the conventional method in order to express the greater subjectivity of modern experience.

Like the Goncourt brothers, Huysmans often exhibited in his work of the 1880s striking similarities in subject and style to the work of Degas; and not surprisingly, since he was both a disciple of theirs in

124. Degas, *The Ballet*, ca. 1878. Pastel.

Museum of Art, Rhode Island School of Design, Providence, gift of
Mrs. Murray S. Danforth

literature and a champion of his in art. If, as Pissarro remarked about
Huysmans's exhibition reviews in *Modern Art,* "Like all critics, under
the pretext of *naturalism* he makes literary judgments, and most of the
time sees only the subject of the picture,"[120] the impact of Impres-
sionism, and especially of Degas's unusual version of it, was so great
on his own vision around 1880 that, in addition to being "sometimes
an extension of his experience of life, at others a parallel to his own
work,"[121] Degas's pictures must also have played an important role in
shaping that experience and work. From the beginning of his career,
which was as an art critic, Huysmans had been concerned with the most
minute description of pictures, and their influence on his fiction has been
noted more than once.

Significantly, the clearest examples of his debt to Degas are in his

scenes of brilliantly contrived entertainment: the descriptions of ballet and circus performances in his prose poems on modern life, the *Parisian Sketches* (1880). Thus, he sees the dancers at the Folies-Bergère exactly as Degas's ballet pictures, about which he had already written perceptively in 1876,[122] had taught him to see them. It is, however, a different vision from that which some of Degas's images share with those in the Goncourts' *Journal*, a vision that focuses more on the physical dynamism of the dancers' movements than on their sequence of positions in space, more on the dazzling effects of artificial illumination than on a mysterious half-light evocative of Rembrandt. In Huysmans's text, precisely as in a Degas pastel such as *Dancers Rocking Back and Forth* [125] of about 1879, "for a moment, under the streams of electric light inundating the stage, a whirlwind of white tulle appears, spattered with points of blue light, and, in the center of it, a writhing circle of naked flesh; and then the *première danseuse* . . . dances on her toes for a while, shaking the false sequins which surround her like a circle of golden dots; then she leaps in the air, and sinks back into her skirts, imitating a fallen flower with its petals on the ground and its stalk in the air."[123]

Huysmans was familiar with Degas's ballet pictures more intimately than as a critic who saw them in occasional exhibitions; for according to his friends, he had installed one in a place of honor in his apartment.[124] And as is often the case in Huysmans's work, the same picture appears in his description of a fictional setting, that of the writer André Jayant in *En Ménage* (1881). A "scene backstage, with dancers in rose gauze, resting, in front of stage flats daubed with greens,"[125] it is obviously a work such as the pastel *In the Wings: Two Dancers in Rose* or the small oil *Rose Dancers before the Ballet*. It is true that Degas's disciple Forain, an intimate friend of Huysmans's and an artist whom he praised highly in *Modern Art*, also treated this subject in the late 1870s, but the extant examples by Forain do not resemble so closely the picture described in *En Ménage*.[126]

Even more evidently indebted to Degas—in this case, to *Miss La La at the Cirque Fernando* [120], which Huysmans had admired when it was

125. Degas, *Dancers Rocking Back and Forth*, ca. 1879. Pastel. Private collection, United States

exhibited in 1879—is his description of an acrobatic performance at the Folies-Bergère. Again insisting on the purely phenomenological aspect, in contrast to Goncourt, who, in *The Zemganno Brothers*, had kept the personal and pathetic aspects in view, Huysmans paints a verbal picture closely resembling Degas's: "Next, the woman climbs up to the net, which sags under her weight, . . . [and] directly opposite the man but separated from him by the entire breadth of the hall, she stands waiting. . . . The two streams of electric light directed onto her from the back of the Folies completely cover her from behind, breaking off at the bend of her hips, splashing her from head to toe, painting her, so to speak, with an outline of silver gouache."[127] The last phrase points unmistakably to a pictorial influence, and precisely that of Degas, who was almost alone among the Impressionists at this time in exploiting the brilliant, matte quality of gouache. Here, too, the one exception is Forain, who, in imitation of Degas, not only worked in pastel and gouache, but used them in depicting scenes of popular entertainment; moreover, he was closely enough acquainted with Huysmans to be asked to illustrate the first edition of *Parisian Sketches*. But like his paintings of this period, Forain's etched illustrations, even of the Folies-Bergère section of the *Sketches*, focus entirely on intimacies and encounters witnessed behind the scenes or in the theater's bar,[128] hence do not correspond as closely as Degas's picture does to the performance described by Huysmans.

Nothing reveals more clearly the latter's fascination with the technical aspects of Degas's art than his observation that in *Miss La La at the Cirque Fernando* the painter, "in order to give the exact sensation of the eye that follows Miss La La . . . [has made] the ceiling of the Circus incline completely to one side,"[129] an observation whose equivalent in Degas's practice is the scrupulously detailed perspective drawing of the ceiling, on which he actually noted that "the rafters incline more [than he has shown them]."[130]

More than the ballet and the circus, the brothel had a special fascination for both Degas and Huysmans as a subject imbued with that melancholy spirit of isolation and disillusionment which each of them identified with a modern sensibility. Drawn by nature to the closed, nocturnal world of urban entertainment and distraction rather than the sunlit one chosen by their Impressionist contemporaries, they found in the brothel an ideal source of imagery. Of course, others in the Naturalist

movement also took up this theme around 1880—not only Edmond de Goncourt, but Maupassant, Forain, Félicien Rops, and several lesser figures—but in treating it, none of them expressed so profoundly cynical an attitude toward women as that which informs Huysmans's novel *Martha, A Girl of the Streets,* and Degas's monotypes of houses of prostitution, an attitude of which there is further evidence elsewhere in the work of the two men.[131] Their treatments are roughly contemporary, the novel having appeared in 1876 and again in 1879, the monotypes having been executed about 1879–1880; yet the former seems definitely to have influenced the latter. Not simply because Huysmans singles out the same details in describing the setting and the women's dress,[132] since these are more or less standard in images of the brothel in that period; but rather because he depicts the women themselves in the same positions of total physical abandon, in contrast to which their attitudes in other works, such as *The Prostitute Elisa* and the drawings of Guys, seem restrained, almost conventional.

Thus Huysmans, viewing the brothel through Martha's eyes, writes: "She gazed with stupefaction upon the strange poses of her companions, those droll and vulgar beauties, . . . stretched upon their bellies, their heads in their hands, crouching like bitches upon a taboret, or clinging like faded finery from the corners of divans."[133] And Degas, in the monotype *In the Salon* [126], strews the room in a similar manner with bodies of vulgar proportions and depraved postures, including one

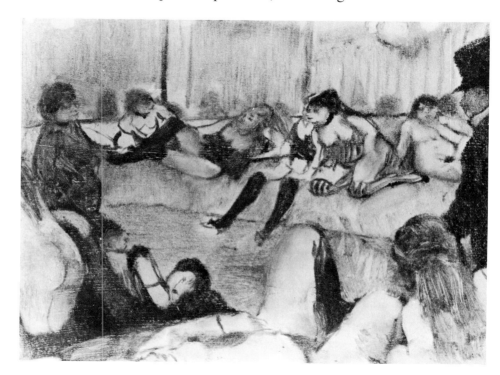

126.
Degas, *In the Salon,* ca. 1880. Monotype.

Formerly collection of Pablo Picasso, Mougins

127.
Degas, *Repose*, ca. 1880.
Monotype.

Private collection, United States

shown crouching like a bitch, as in the text.[134] Indeed, in another mono-type, now ironically entitled *Repose* [127], he juxtaposes three bizarrely placed nudes—one lying on the floor with her back to us, another re-clining on a sofa with her legs in the air, and a third scratching herself with her legs widespread—whose grotesque appearance illustrates per-fectly Huysmans's text and may well have been meant to do so.[135] In contrast to Degas's images, those of Forain, which were actually con-ceived to illustrate the second edition of *Martha*, are more conventionally lewd and lack their psychologically disturbing features.[136]

After Huysmans, the Goncourts, and Zola, it is a relief to turn at last to Ludovic Halévy, who was neither a bitter competitor of Degas nor a source of pessimistic subject matter for his work. Both in his personal relations with the artist—as a former schoolmate who became one of his few really intimate friends—and in his professional achievement—as a highly successful author of light comedies and libretti who satisfied his taste for Parisian worldliness—Halévy stands in sharp contrast to these other figures. Of all the Naturalist writers, only Duranty was as close to Degas personally and, like Halévy, was the subject of one of

his portraits. But if the portrait of Duranty [6], the studious novelist and art critic, shows him seated amid his papers and books, that of Halévy [128], which was also painted in 1879, shows him standing in the wings of the Opera, conversing with the dilettante Albert Boulanger-Cavé.[137] Like Degas himself, he was thoroughly at home there, having begun to frequent the Opera as a young man, when his uncle Fromental Halévy was the director of its chorus. Despite his fashionable attire and nonchalant pose, Halévy appears curiously somber and thoughtful; as he himself observed rather wistfully, "Myself, serious in a frivolous place: that's what Degas wanted to achieve."[138] Nothing sums up better the sophisticated detachment that Degas admired in him than this image of Halévy and his own wry comment on it; yet he, at least, rejected the role as too shallow, and when, a few years later, Degas criticized his recent novel *The Abbé Constantin* (1882) for its supposed sentimentality, he lamented: "He said insulting things to me this morning. I must

128.

Degas, *Ludovic Halévy and Albert Boulanger-Cavé*, 1879. Pastel and distemper.

Musée du Louvre, Paris

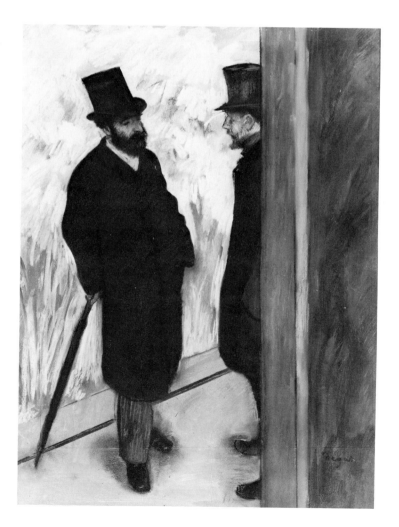

always do things like *Madame Cardinal,* dry little things, satirical, skeptical, ironic, without heart, without feeling."[139]

Consequently, it was not *The Abbé Constantin* but *The Cardinal Family,* that "masterpiece of bantering impassivity . . . [and] decency in handling unsavory things,"[140] which Degas chose to illustrate in a series of monotypes in the latter half of the 1870s. And appropriately, one of the first [54] represents Halévy and Mme Cardinal standing backstage at the Opera in positions very much like those of himself and Cavé in Degas's portrait.[141] It represents the first episode narrated by Halévy, his meeting with the mother of two young dancers whose fortunes at the Opera and in marriage, as recounted to him in several such meetings, constitute most of the book. Here Degas follows the text rather closely, both in the vivid portrait of Mme Cardinal, "a stout lady, carelessly dressed, with an old plaid shawl over her shoulders and huge silver spectacles on her nose," and in the placement of the figures "in the little corner at the side."[142] And elsewhere, too, in the series he is content to illustrate its more vividly rendered incidents faithfully; for example, the amusing one in which Halévy and three companions—one of them, "a painter," is perhaps Degas—accost the Cardinal girls in a passage at the Opera in order to persuade them to accept a dinner invitation [129].[143] "The

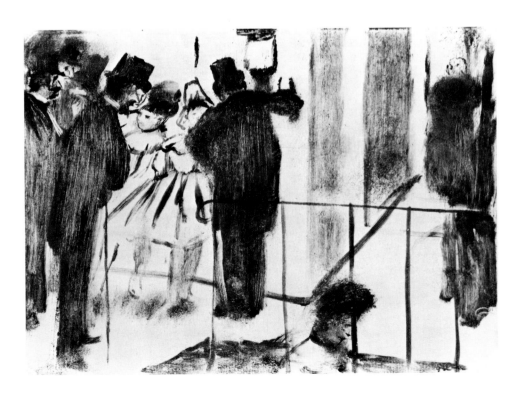

129.
Degas, *Pauline and Virginia Conversing with Admirers,* ca. 1878. Monotype.

Collection of Mr. and Mrs. Clifford Michel, New York

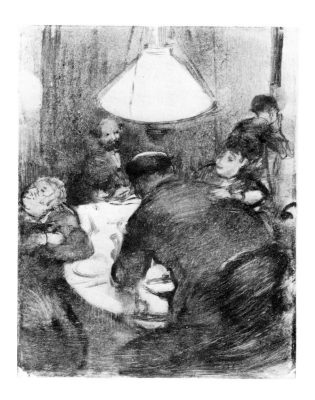

130.
Degas, *The Famous Good Friday Dinner,* ca. 1878. Monotype.

Staatsgalerie, Stuttgart

two little Cardinal girls were bursting to accept. 'But mamma will never consent,' they said. 'You don't know mamma!' And suddenly that re-doubtable parent appeared at the end of the passage," exactly as in Degas's monotype.[144]

In other cases, however, Degas ignores specific indications in the text and instead represents simple, if ingeniously varied, groups of dancers and their admirers conversing in the wings and dressing rooms of the Opera, very much as in his other works of these years. So absorbing is his interest in this milieu that he avoids most of the incidents not situated within it, including such highly entertaining ones as M. Cardinal's career as a local politician, one daughter's marriage to a marquis and affair with an Italian tenor, and the other daughter's romance with a soldier. In contrast, the etchings made by Charles Léandre for the 1893 edition of *The Cardinal Family* single out precisely these picturesque and dramatic aspects of the story. However, Degas does represent a few scenes of domestic drama, notably that of M. Cardinal almost coming to blows with his son-in-law the marquis during the famous Good Friday dinner [130], which he renders in a remarkably expressive manner,

seizing on the moment of greatest tension when, as Mme Cardinal later recalls, "At that the marquis calls me a strumpet; M. Cardinal gets up and tries to throw a carafe at the marquis's head; Pauline rushes out of the room, weeping; and Virginia, half fainting, cries: 'Papa! Mamma! Edward!'"[145] But on the whole, Degas's illustrations are more a recreation of the spirit and ambience of Halévy's book than authentic illustrations, and this is probably why the latter refused to accept them for publication, despite his friendship with the artist.[146]

At about the same time, the two friends collaborated fruitfully on another project, the stage production of Halévy and Meilhac's *The Grasshopper* (1877), a satirical comedy about contemporary artistic life written, as we saw in Chapter I, in the wake of the first Impressionist exhibitions and the violent reactions they had elicited. Some of its satire is of a type traditionally dear to critics of modern art, one painter, for example, lamenting that a canvas which he began ten minutes ago is not yet finished, another exclaiming that a canvas which has accidentally fallen on his palette is actually improved; but most of it is directed specifically against the Impressionists. In fact, although the stage directions for the third act merely mention "strange pictures . . . bizarre paintings," Zola's review refers explicitly to "the set for the studio, with its caricatures of famous canvases by Manet, Claude Monet, Degas, Cézanne, Renoir, Sisley, Pissarro, etc.,"[147] and we may well wonder whether Degas was responsible for this set. He himself implies as much in a letter to Halévy, written while the play was in rehearsal, offering his services "for Dupuis's studio," the one shown in this act: "There is no use my finding fault with it; the thing pleases me very much, and I shall do it."[148]

He may indeed have played a larger part in the creation of *The Grasshopper,* for according to Rivière, who was present with Renoir at the opening, "No one had any doubt about Degas's involvement in the elaboration of the play."[149] When Marignan, the painter protagonist, admires the modernity of La Cigale's nose—"It isn't Greek, that one, it isn't old fashioned. . . . Isn't it Parisian! Isn't it modern!"—he is merely repeating a sentiment already expressed by Degas in a letter to Duranty, which the latter had published in *The New Painting* the year before.[150] And when Marignan alludes mockingly to Impressionist theories of color

131.
Degas, Illustration of Meilhac and Halévy's *The Grasshopper*, 1877. Pencil.

Formerly collection of Ludovic Halévy, Paris

and light—"I am a luminist. . . . I understand light in a certain manner . . . and I treat [things] the way I see them," even if that means painting a face violet or green—he is simply echoing Degas's low opinion of those theories.[151] Yet he himself is not spared a few satirical thrusts, notably when Marignan has a model pose as a laundress washing linen, in allusion to Degas's well-known interest in this subject. It was evidently a topic of discussion at the Halévys,' too, for in the after-dinner album kept for him there he sketched this incident twice, once with Marignan at his easel [131], thus illustrating a theatrical conception he had originally inspired.[152] However, the allusion may also be to the scene in *The Dram-Shop* in which Gervaise is shown washing linen; in 1877 Zola's novel was no less topical a subject.[153]

A more important instance of Degas's influence on *The Grasshopper* is the later scene in which Marignan, declaring that "we are no longer Impressionists now, we are Intentionists, we have intentions," displays an abstract composition consisting of two equal areas, one blue, the other red, and describes it as a landscape, or rather as two landscapes: with the blue area below, "It's the sea, the immense sea . . . lit up by a magnificent sunset," but with the red area below, "It's the desert, . . . the burning sands of the desert . . . and above, an azure sky."[154] For

if the design of such a picture, its horizon cleanly bisecting its surface, recalls that of a Courbet or a Barbizon School seascape[155]—and the first act of the play is set in an inn at Barbizon—its radically simplified imagery is closer to that in a series of works executed about 1869 by Degas himself. Among them is *At the Seashore* [4], a pastel whose surface is divided into two roughly equal areas of color so uninterrupted in their sweep that it almost could be inverted to create an image of the opposite situation in nature.[156] Thus the subjects Degas shared with the Naturalist writers, although largely confined to the labors and pleasures of modern Paris, could also include a landscape almost devoid of content, one conceived primarily as a field of luminous colors, in a manner that today seems prophetic of the art of Mark Rothko.

IF IN THE 1870s the boldly anti-Naturalist content of Marignan's "Intentionist" landscape and, by implication, of Degas's Impressionist seascape seemed so exceptional as to provoke laughter, it became in the following decades a major direction both in his own art and in advanced art and literature generally. And just as his work became increasingly abstract in form, brilliant in color, and subjective in expression after about 1885, so that of the Naturalist writers with whom he had been associated also evolved toward a more spiritualized form with affinities to Symbolism. In that year, Edmond de Goncourt admitted: "I remain faithful to reality, but sometimes I present it in a certain light, which modifies it, poeticizes it, tints it with fantasy."[157] Many of the younger writers with whom Degas now came in contact were Symbolists who rejected the positivism of the preceding period, among them Mallarmé, Valéry, Mirbeau, Camille Mauclair, and Proust. Except for Mallarmé, who became prominent only at this time, all of them were a generation younger than Degas and on the whole less intimately acquainted with him than the Naturalists had been. Moreover, their relations with him were largely one-sided: while they admired his supremely intellectual art and intransigent personality, he professed not to understand or appreciate their writings, clinging instead to his Romantic tastes and Naturalist theories.

Surprisingly, he did respond positively to Edouard Dujardin's Symbolist play *Antonia* when it was performed in 1891, but this was probably for its Romantic setting and theme of melancholy love, rather than for

its highly contrived rhythmic prose.[158] Nor is there any evidence of his interest in the novels and poems of Gide, at that time an important figure in the Symbolist movement and one with whom he was already acquainted, although for his part Gide repeatedly expressed admiration for his art and even found his reactionary ideas congenial.[159] Degas seems in fact to have had more in common with the Parnassian poets of the preceding generation: when he began to compose sonnets in the late 1880s, he turned at once to Banville's *Treatise on Versification,* and dedicated the first of them to Heredia, whose mastery of that form was one of his sources of inspiration, just as, a decade earlier, he had received the dedication of one of Charles Cros's lapidary poems.[160]

Nothing reveals more clearly the fundamental differences between Degas and the Symbolist writers than his problematic relationship with Mallarmé, the one who was perhaps the most sympathetic to him personally, sharing his deep interest in art and his friendship with the other Impressionists, particularly those in the circle of Berthe Morisot. He had written very perceptively about Degas's art, and in a manner that suggests they were already acquainted, as early as 1876: "A master of drawing, he has sought delicate lines and movements exquisite or grotesque, and of a strange new beauty, if I dare employ towards his works an abstract term, which he himself will never employ in his daily conversation."[161] And Degas, who was evidently attracted by the poet's gentle, thoughtful manner, created an image of him that Valéry considered "the finest likeness of Mallarmé I have ever seen"—a photograph [132], taken in 1895, that shows him leaning against a wall near a mirror, with Renoir sitting on a sofa beside him and Mallarmé's wife and daughter, as well as Degas himself at the camera, appearing as ghostly reflections in the mirror.[162]

Yet when Mallarmé read his moving tribute to Villiers de l'Isle-Adam in Morisot's studio, Degas, alone among the distinguished company, claimed not to understand a word and left abruptly before the reading had ended. Henri de Régnier, who tells the story, adds that "Degas's favorite author was Brillat-Savarin; he used to have the *Physiology of Taste* read to him."[163] Several incidents of Degas's stubborn refusal to comprehend the poet's work, even when a sympathetic reading would have penetrated some of its admitted obscurities, are also reported by

132.
Degas, *Renoir and Mallarmé in Berthe Morisot's Salon*, 1895.
Photograph.

Metropolitan Museum of Art, New York, gift of Mrs. Henry T. Curtiss, 65.500.1

Valéry.[164] Furthermore, on two occasions—once in 1888–1889, when Mallarmé planned an illustrated edition of his prose poems, and again a decade later, when his daughter planned a posthumous edition of his poetry—Degas agreed to provide a drawing and then declined.[165] For the earlier publication, the drawing was presumably to represent a ballet dancer, to illustrate the prose poem "Ballets"; yet despite their similarity of subject, the two works would inevitably have differed in conception, and in a way that illuminates a basic difference between the painter and the poet. In contrast to the powerful realism of Degas's forms, which, even in this relatively subjective phase of his development, were ultimately based on visual experience, Mallarmé's subtle meditation on the meaning of the dance, with its paradoxical thesis, "that the ballerina *is not a girl dancing;* that, considering the juxtaposition of those group motifs, *she is not a girl,* but rather a metaphor . . . , and that *she does not dance,* but rather *suggests* things. . . ," was bound to seem obscure and arbitrary.[166]

Nevertheless, Degas must have realized the importance of Mallarmé's

achievement, for when he became temporarily obsessed with writing poetry himself, it was to him that he turned for advice after reading Banville's *Treatise*. And the poet, although fearful that this new interest would further delay delivery of the promised drawing, was sympathetic and encouraging: "In reality, he is no longer of this world," he confided to Morisot. "One is perturbed before his obsession with a new art, in which he is, I must say, quite proficient."[167] Yet there was a profound difference between the two men here, too, as is evident from their exchange on one of the occasions when Degas sought Mallarmé's advice. Lamenting his inability to complete a certain sonnet, he remarked, "And all the same, it isn't ideas I'm short of . . . I'm full of them . . . I've got too many," to which the other replied, "But, Degas, you can't make a poem with ideas . . . *You make it with words*."[168] It seems ironic, yet also characteristic of Degas's relation to Symbolist literature, that he failed to grasp the significance of this distinction in composing his poems or in judging those of Mallarmé and others, though it coincided with one he himself often stated in affirming the essentially subjective nature of his art, which indeed had become increasingly evident in this final period. As Valéry observes, "Degas saying that drawing was *a way of seeing form*, Mallarmé teaching that *poetry is made with words*, were summing up, each for his own craft, a [fundamental] truth."[169]

In the formation of Valéry's own conception of art, Mallarmé and Degas were, for all their differences, clearly the two greatest influences, the latter as much through the force of his personality as through his pictures. What Valéry admired above all was his intellectual rigor and moral probity, his relentless search for perfection and indifference to material success, his ideal of art as a series of difficult problems and of the artist's life as a dedicated effort to solve them—qualities that Valéry had already begun to cherish before he met Degas in the winter of 1893–1894 in the home of Ernest Rouart.[170] "Knowing Degas is very precious [to me]," he wrote to Gide a few years later. "This man pleases me infinitely, as much as his painting. He looks so intelligent!"[171] Even before they became acquainted, Valéry had formed an image of Degas from the pictures he had seen and the anecdotes he had heard. "The idea I had formed of Degas," he later recalled, "was of a character reduced to the strict lines of a hard drawing. . . . A certain brutality, of intellectual origin, would be the dominating trait."[172]

This image, its outlines partly strengthened by contact with the real Degas, was evidently in Valéry's mind when, in the summer of 1894, he wrote "An Evening with Monsieur Teste," the first of several puzzling and difficult pieces—he himself described them variously as portraits, stories, and episodes in a novel—in which the personality and thought of this extraordinary character constitute the sole interest. Monsieur Teste, it is true, resembles Degas neither physically nor psychologically, and is at least as much inspired by Mallarmé and, oddly enough, by the detective Auguste Dupin in Poe's *Tales of Mystery and Imagination;* but he reflects nevertheless that notion of Degas's intellectual discipline and moral uprightness which Valéry had already formed.[173] Indeed, he later admitted that "Monsieur Teste" had been "more or less *influenced,* as people say, by the kind of Degas whom I had imagined."[174]

Consequently, we may also wonder whether Degas's art, which Valéry knew through the great examples in Rouart's collection, through exhibitions at Durand-Ruel's gallery, and even through photographs he purchased, played a role in the creation of this work.[175] Its central section, the most concrete and "visual" of the three, is after all set at the Opera, and although it does not describe a performance in any detail—on the contrary, Monsieur Teste deliberately turns his back on the stage in order to enjoy the spectacle of the audience—it does portray him in a manner reminiscent of certain portraits by Degas. Behind the description of Teste, "standing beside the golden column at the Opera, . . . his dark figure splashed with light, the shape of the whole clothed block of him propped against the heavy column,"[176] there may well lie a portrait like the one discussed earlier of Halévy and Cavé standing in the wings of the Opera [128], where the figure is likewise seen as a strikingly dark silhouette, its surface enlivened by reflected lights, its form deliberately compared with a vertical architectural form behind it.

Hence it seemed altogether appropriate for Valéry to think of dedicating "An Evening with Monsieur Teste" to Degas; but when, too timid to ask for permission, he had one of the Rouarts do so, the almost predictable answer was a brusque No: "I would rather not have something dedicated to me that I won't understand. I have had enough of poets. . . ."[177] In retrospect, Degas's refusal seems all the more ironic in that Valéry later wrote a most charming and perceptive memoir,

entitled *Degas Dance Drawing,* which is in effect dedicated to him. A meditation on the nature of art and artists, it is inspired by the very qualities in Degas's thought and personality that had originally inspired the invention of Monsieur Teste. Its conception is actually contemporary with the latter, Valéry having informed Gide as early as 1898, "I shall write (about Degas, not identified more clearly) *Monsieur D. or Painting.*"[178] Like "Monsieur Teste" itself, however, *Degas Dance Drawing* owes much to the parallel example of Mallarmé and is also a vehicle for the expression of Valéry's own aesthetic thought, to which he sometimes adapts that of Degas.

Although, as Valéry and a few other close friends realized, there was in Degas "a humanity beneath the inhuman face he insisted on presenting to the world,"[179] it was the latter alone that most of his acquaintances saw and that the writers among them seized on in their fictional portraits of him. A decade before Valéry transformed that side of Degas into an intellectual image of Monsieur Teste, it had already appeared in a more exaggerated form in another character, the artist Lirat in Octave Mirbeau's novel *Calvary* (1886). An influential critic as well as a novelist, Mirbeau knew many of the leading artists of his day, including Monet, Gauguin, and Rodin, whose work he championed in his widely read newspaper columns. According to the dealer Ambroise Vollard, who tells a curious story of an encounter between Mirbeau and Degas, he was also well acquainted with the latter, although he seems to have written very little about him.[180] In *Calvary,* however, the violent pessimism of Mirbeau's vision distorts the characterization of Lirat to the point where it becomes as much a caricature of the misanthropic traits in Degas's personality as a tribute to the independence and originality of his art. For if Mirbeau was as a critic responsive both to the Impressionism of Monet and the Symbolism of Gauguin, he was as a novelist far closer to the Decadents in his obsession with the perversity and cruelty of modern life, as is evident in that supremely Decadent work, *The Garden of Tortures* (1899).

Thus it was above all the legend of Degas's antisocial behavior that Mirbeau fastened on, using it as a model for the alienated and embittered artist he wanted to portray in *Calvary.*[181] Like Degas, at least according to this legend, Joseph Lirat "had the reputation of being a misanthrope,

unsociable and spiteful. . . . He was so severe, so relentless to everybody; he knew so well how to discover, to reveal the ridiculous side in artists, . . . and to characterize them by some apt remark, unforgettable and fierce"—an obvious allusion to Degas's malicious sayings—that even young Mintié, who admired him, trembled in his presence.[182] And like Degas, he had an equally austere artistic ideal, so that ultimately "he had decided not to exhibit any more, saying: 'One works for oneself, for two or three living friends, and for others whom one has never known and who are dead,'"[183] a notion of himself in relation to past and present art which corresponds closely to that of Degas.

If in *Calvary* it was the artist's character that resembled Degas's, in *The Lover of Dancers*, a slightly later, Decadent novel by Félicien Champsaur, it was the character of his art. The protagonist's name, Georges Decroix, recalls Delacroix's (allowing one wit to observe, "To resemble Delacroix, he lacks only the 'la'"), but it also recalls Degas's;[184] and as we have seen, he himself had compared his name with Delacroix's more than once. In appearance and behavior Decroix, who has led "a life of excess in all sectors of Parisian society," is altogether unlike Degas, whose existence seemed to Gauguin as orderly and sober as that of a notary or bourgeois of the July Monarchy.[185] Although Champsaur had met Degas in the Impressionist circle when he began writing art criticism around 1880,[186] he was less interested now in portraying him from life than in creating an alter ego whose adventures in the demi-monde of actresses and dancers that he knew so well he could chronicle in detail.

Nevertheless, the art of Decroix, a "painter of modernity" and "painter of dancers," is based unmistakably on Degas's and, even allowing for Champsaur's preoccupation with those aspects that depict "the lower depths of Paris," sheds an interesting light on how it was seen in sophisticated circles such as Les Hydropathes in the mid-1880s. "Visitors to Decroix's studio found in this eminently Parisian painter the atmosphere of backstage scenes, of actors' and actresses' dressing rooms; they felt, in looking at his pictures, a bit of the titillation, of the pleasant shivers, of an unnatural, strangely attractive existence. . . ."[187] And as in Degas's pictures of the theater, illusion and reality were brilliantly contrasted: the dancer who appears on stage, "in the splendor of her somewhat artificial beauty, in her glorification under electric lights," is also shown backstage, "breathless with fatigue, her features sagging, the muscles

of her calves and thighs bulging, the lines of her body graceless and almost brutal. . . ."[188] This fascination with the artificial also leads Decroix, as it had Degas, to frequent the circus; in fact, his studies of Lulu, a female acrobat, whom he finds "astonishing, dumbfounding in her dangerous jumps and leaps," are clearly indebted to Degas's painting of Miss La La or to Huysmans's description of it.[189]

Closer to the image of Degas in *Calvary*, and likewise inspired by stories that had circulated in the art world of Paris about his artistic genius and irascible behavior, is the portrait of him as Hubert Feuillery, "the painter of dancers, the great misanthrope, admired for his art and feared for his cruel sallies," in Camille Mauclair's novel *The City of Light* (1903).[190] Like Lirat, Feuillery is a rather bizarre and hostile figure, "a creature of strange appearance, small, nervous, contracted . . . known for his fierce and tragic remarks, his sudden attacks, his diabolical ironies. . . ."[191] But unlike Mirbeau's essentially Decadent artist, he is capable of noble sentiments and actions, revealing "at bottom an exquisite soul, always wounded, an immense conflict within himself, a rebellious compassion, and a disgust with his epoch."[192] The last point is significant, for Feuillery is clearly conceived as a symbol of uncompromising integrity, in contrast to the materialism and self-seeking that motivate the painters, dealers, and critics whose machinations in the so-called "city of light" Mauclair chronicles.

A Symbolist poet in the circle of Mallarmé and an art critic for the Symbolist magazine *Mercure de France*, he quite naturally adopted an idealist position in condemning the cynicism of the contemporary art world and in exalting a selfless dedication to art, even when it was accompanied by personal eccentricities, as in the case of Degas.[193] Whereas his colleagues actively seek publicity, Feuillery goes so far as to bribe one critic with a drawing "to obtain in exchange that you will publish nothing about me."[194] In his art-historical essays, too, Mauclair admired in Degas "a man worthy of great respect for the noble integrity of his life, his indifference to fame, his work, and his discreet pride."[195] Ironically, however, he was hostile to almost all the other original artists of his day, sarcastically rejecting Pissarro and Guillaumin, as well as Cézanne, Gauguin, and Toulouse-Lautrec, so that the idealism of *The City of Light* seems in retrospect rather false.

So vivid was the impression Degas made on his contemporaries to-

ward the end of his life that its influence is still felt in two novels
published after his death: *Aymeris,* a fictional autobiography of the
painter and writer Jacques-Emile Blanche, and *The Cities of the Plain,*
the fourth volume of Proust's great work, *Remembrance of Things Past.*
By coincidence, both novels appeared in 1922, although they were largely
written before the First World War and were prepared even earlier, in
that *fin-de-siècle* Parisian society where their authors were acquainted
with each other as well as with Degas. In fact, when Blanche published
the first volume of his essays on art, one of which is a valuable memoir
of Degas, Proust contributed a long preface evoking their youthful
friendship and interest in painting.[196]

In *Aymeris,* Degas appears in his own guise, but his behavior is as
eccentric and antisocial as it is in *Calvary* and *The City of Light,* where
he appears in a fictional guise. Like Blanche himself, Georges Aymeris
is a young art student in the early 1880s who hears about "the curious
pictures of the theater by a certain Degas" and determines to make his
acquaintance.[197] Unfortunately, the latter "does not want to see anyone,
especially young people, whom he despises and considers stupid," and
instead Georges visits the conservative painter William Bouguereau,
who, he discovers, "has a manner as fierce as that of M. Degas."[198] When
he finally gains access to this artist's studio, he is shown "a thousand
drawings, pastels, of race horses, of dancers," and more surprisingly "all
his early works, his *Young Spartans' Games,* his *Semiramis.*"[199] But when
he returns another day, he is rebuffed brusquely: "You again? Please
leave me alone, I'm working."[200] The extent to which this portrait of
Degas differs from the more attractive one in Blanche's memoirs shows
how much he had already become identified as the type of misanthropic
artist around 1885. For as Blanche recalled, he was "in the most complete
intimacy with us. . . . He was like a respected, cherished uncle for my
wife and her sisters, the protective deity of our home."[201] Moreover, it
was precisely in 1885, during a summer holiday at Dieppe, that Degas,
far from "despising" his younger colleagues, portrayed three of them—
Henri Gervex, Walter Sickert, and Blanche himself—together with three
neighbors—Ludovic and Daniel Halévy and Boulanger-Cavé—in a re-
markable composition [133], whose brilliant design does not conceal his
sympathetic understanding of their diverse personalities.[202]

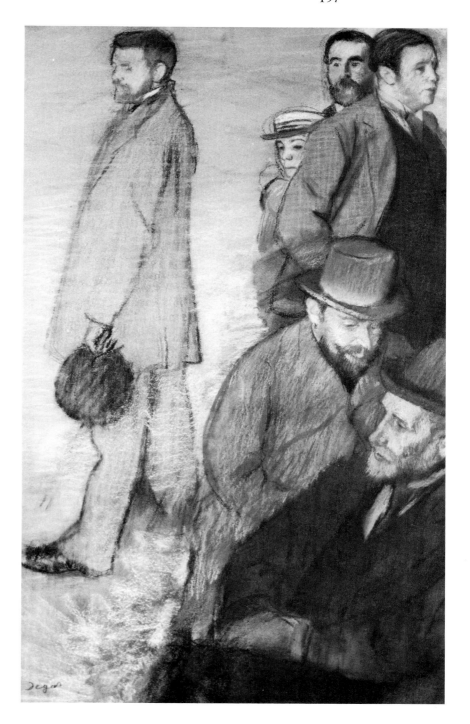

133.
Degas, *Six Friends at Dieppe*, 1885. Pastel.

Museum of Art, Rhode Island School of Design, Providence

In *The Cities of the Plain*, too, Degas appears under his own name, but some of the fictional painter Elstir's traits may also have been inspired by Proust's acquaintance with him and with his work. A classmate of Daniel Halévy and an intimate friend of Mme Straus and of Blanche, all of whom were well known to Degas, Proust would have had many opportunities to meet him in the early 1890s, and would surely have appreciated his strong personality and penetrating remarks. How well he knew Degas's art is more difficult to determine: his own statement, in a letter to Blanche in 1919, that "Cézanne, Degas, and Renoir are the painters I understand least and the ones whose works I would have been most eager to see,"[203] cannot be taken literally, since he had undoubtedly seen many of those works in the exhibitions organized by Durand-Ruel, in the publications that had proliferated by 1914, and in the collections of friends such as the Prince de Wagram and Blanche himself.[204] Some writers have therefore maintained that he "must have studied Degas's tricks of composition and taste for novel perspectives; that is surely what Elstir's art makes one think of," and that thematically, too, his "pictures giving intimate glimpses of women at their daily tasks bring definitely to mind the work of Degas."[205] But the general opinion is that Elstir, a composite figure representing the type of the modern painter, is based primarily on Manet, Monet, Whistler, and Turner, with whose art Proust was better acquainted, and above all on Paul Helleu, whose life and work resemble Elstir's in many respects and whom the author himself reportedly addressed as such.[206]

More rewarding are the explicit references to Degas in *The Cities of the Plain.* Two of them are almost identical in form and seemingly conventional in content: a ballet dancer kept by a wealthy man is described as "a dancer in this case of a distinct and special type, which still awaits its Degas," and again, a little further on, as "a dancing girl of another kind, which still lacks a Degas."[207] But the curious repetition of the formula, and its real function as a metaphor for a kept boy rather than a girl, make one wonder how much Proust had guessed or heard rumored about Degas's fascination with sexually ambiguous subjects. The third reference to him occurs in a debate on the merits of Poussin and is of another order entirely. When Mme de Cambremer, a lady of rather precious taste, affects to find Poussin "an old hack without a

vestige of talent . . . the deadliest of bores," Swann cleverly replies: "M. Degas assures us that he knows nothing more beautiful than the Poussins at Chantilly," and Mme de Cambremer, "who had no wish to differ from Degas," begins at once to revise her opinion.[208] Although published much later, this incident undoubtedly reflects the legend of Degas's admiration for Poussin that had been current in the 1890s, when Proust would have known him. Both Julius Meier-Graefe and George Moore comment on the fame of his copy after *The Rape of the Sabines,* the latter pretending it is "as fine as the original."[209] And a friend of Gide's indicates the reactionary basis of this admiration in writing to Degas: "What I like about you is that you do not like the Jews and that you read *La Libre Parole* and that, like me, you consider Poussin a great French painter."[210]

Clearly the situation had changed in the twenty-five years since Duranty's story "The Painter Louis Martin" was published and the fact that Degas, "an artist of rare intelligence, preoccupied with *ideas,*" had copied a Poussin painting in the Louvre very successfully was first made known.[211] By the time Proust knew him, and even more by the time *The Cities of the Plain* appeared, Degas's essentially intellectual approach to art, like his veneration of Poussin, had become the basis for another, much narrower cult, dominated by nationalism and a doctrinaire classicism.

V "My Genre Painting"

The most interesting example of Degas's contact with the literature of his time has also been the most widely admired of his early works, the *Interior* now in the Henry P. McIlhenny Collection [134].[1] Georges Grappe, the first critic to discuss it, was convinced it was the artist's greatest achievement, "among his masterpieces, *the* masterpiece," and alone would assure his fame: "All his pastels and all his other canvases could be engulfed by a cataclysm; if it survived, it would establish his name for the present and the future."[2] Arsène Alexandre, another early critic, went even further to declare it the greatest achievement of any modern artist: "There is not in the whole of modern painting a work more striking, more austere, and of a loftier morality, compared to which Rousseau's *Confessions* is merely a highflown platitude."[3] For all that, however, it remains the most puzzling of Degas's major works, a picture full of mystery and one still shrouded in mystery as far as interpretation is concerned, having inspired the most contradictory statements about its meaning, its literary source, its place in his oeuvre, and even its title.[4] Moreover, a preoccupation with these issues has diverted attention from others of a more general significance—its relation to his ideas on physiognomic expression, his interest in artificial illumination, and his contacts with contemporary art in England as well as France. It is to all these aspects of *Interior*, and to the illuminating comments made on it at the time by another artist, that this chapter is addressed.

SEVERAL writers who knew Degas personally, including P.-A. Lemoisne, and Paul Lafond as well as Grappe, have asserted that originally the

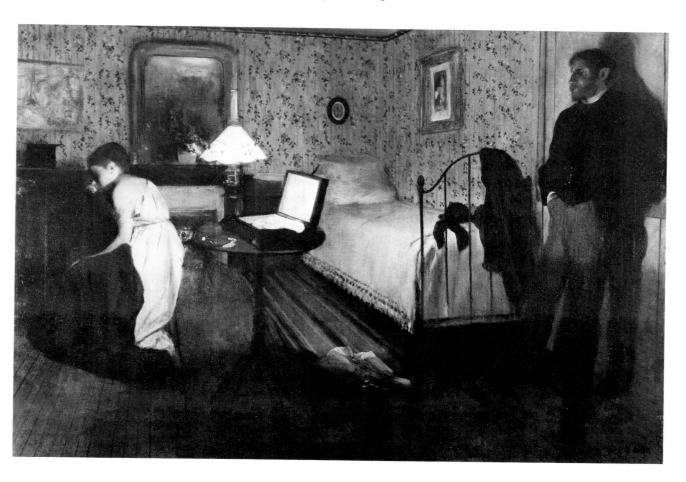

134. Degas, *Interior (The Rape)*, 1868–1869. Oil on canvas.
Collection of Henry P. McIlhenny, Philadelphia

picture was called *The Rape* and that this described its content per-
fectly.[5] "The subject was defined precisely," wrote Paul Jamot, "even
too precisely. The vaguer title now in use [*Interior*] corresponds better
to the spirit of the picture."[6] But several other writers, also closely
acquainted with the artist, have insisted that the latter title is the only
authentic one. His younger colleague Georges Jeanniot referred to "a
very handsome picture entitled *Interior Scene*" that he watched Degas
restore ca. 1903;[7] and according to his oldest friend, Henri Rouart, he

himself called it either *Interior* or "my genre painting."[8] In fact, Paul Poujaud, another close friend, who saw the picture in Degas's studio in 1897 and remembered his remark, "You know my genre painting," was so incensed by the melodramatic term *The Rape* that he later wrote: "That title is not from his lips. It must have been invented by a writer, a critic."[9] Curiously, however, Poujaud himself employed the titles *The Quarrel* and *The Dispute*, which, although less emotionally charged, still imply a dramatic confrontation. Thus the several titles used, alternating as they do between implications of violence and neutral genre, are as ambivalent as the image itself. Only a positive identification of its literary source, if indeed one exists, would clarify this uncertainty. Obviously the picture does bring to mind the kind of intimate scene in modern dress so often found in the Naturalist theater and novel of Degas's day, and the possibility that it was directly inspired by such a scene has often been raised. But here, too, there have been many conflicting statements, none of which has gained general acceptance.

It was Georges Rivière, a friend of Renoir and other Impressionists, who first suggested that *Interior*, which was usually dated ca. 1874, was meant to illustrate Duranty's novel *The Struggle of Françoise Duquesnoy*, published the year before.[10] But since he felt that "Degas had too much imagination and independence to constrain himself to follow an author in the usual manner of illustrators," Rivière did not attempt to specify a particular episode in the novel, contenting himself with observing the probable appeal of its realistic style and July Monarchy setting. Despite this vagueness, several later writers, including Camille Mauclair, Jean Nepveu-Degas, and R. H. Wilenski, accepted the suggestion, the latter even converting it into a statement of fact: "*Interior (The Rape)* illustrates a scene from Duranty's novel *The Struggle of Françoise Duquesnoy*."[11] Neither of the leading authorities on this author, however, was as willing to accept it. After searching in vain for such a scene, one of them concluded: "It is hard to see to which episode in the novel this composition (which has also been called *The Rape!*) could be related."[12] And the other extended this stricture to all of Duranty's fiction: "Degas's picture represents an emotional scene following an act of violence that we do not find in our author."[13] This is bound to be one's impression on reading *Françoise Duquesnoy*, for if the mood of silent

conflict between a husband and wife that pervades it corresponds to the mood of Degas's painting, no episode within it is set or narrated in sufficient detail to have been his point of departure.[14]

More recently, some historians have proposed that his literary source was another contemporary novel, Zola's *Madeleine Férat*, published serially in *L'Evénement*, a newspaper widely read in Degas's circle, in the fall of 1868 and issued in book form at the end of the year.[15] In the climactic scene, set in a dreary hotel room where Madeleine and her husband Guillaume are spending the night to escape the fate they feel closing around them, both the mood and certain physical details correspond to those in Degas's picture, where "the quiet despair of the woman, the tense exasperation of the man are true to Zola's meaning, while the round table and the narrow virginal bed are actually mentioned in the text."[16] Many other elements, including the relative positions of the two figures, correspond so poorly, however, that "if Degas did have *Madeleine Férat* in mind, then, certainly, he has taken extensive liberties with his text, . . . [since] Zola describes the bedroom in the Auberge du Grand Cerf with great care and at every stage in the action indicates the situation of his characters, [whereas] Degas disregards this detailed scenario at almost every point."[17] And as for the dramatic version, *Madeleine*, which has also been cited, this was written in 1865 but not produced until 1889.[18]

So strongly evocative of fiction or drama is *Interior*, and so apparently relevant is *Madeleine Férat* in its mood of somber sexual conflict, its vividly descriptive style, and even its date, which coincides with the one ca. 1868–1870 now generally given for the picture, that when the episode originally proposed could not be accepted without reservation, others were suggested in its place. To one writer, the painting seemed "closest to the terrible night Madeleine and her husband Guillaume spend up in the bedroom of their cottage near Vétheuil," where they attempt in vain to recapture the happiness they had known there and are instead confronted by their tragic fate.[19] Here, too, however, there are so many discrepancies in the appearance and positions of Zola's figures, both of whom are casually dressed and seated before the fire, and so little description of the room itself, that the picture can hardly be taken as an illustration of the passage in question. Subsequently,

another writer proposed the episode in the Auberge du Grand Cerf, immediately preceding the one we first considered, where Madeleine's former lover Jacques, "who is by strange coincidence spending the night in this very hotel, steals in during her husband's temporary absence and, remaining near the door ready to depart, while she cringes before him helpless and ashamed, unconsciously torments her with memories of their former loves, which had by even stranger coincidence taken place in this very room."[20] But again there are too many differences between picture and text, though the latter may well have been a secondary source, as we shall see.

Hence it is not surprising that still another writer, after reviewing most of the efforts to find a literary inspiration in *Interior*, sensibly concluded: "The legend has grown up that the painting was suggested by a novel; the particular novel suggested fails to support this theory and so we hunt for another and more probable source. But there is no hard evidence that Degas looked for or needed to look for literary inspiration."[21] Perhaps not; and here his well-known aversion for the literary in art and contempt for writers who meddled in it come to mind. As Valéry observed, "[he] would always profess some unspeakable, sacred horror of our craft, whenever it dared to meddle with his. He was always quoting Proudhon's contempt for the 'literary gentry.'"[22] Nevertheless, Degas was probably well acquainted with more writers than any major artist of his day; and that he could draw inspiration from them and on occasion follow their texts quite closely is evident, as we saw in Chapter IV, in the monotypes he made to accompany Ludovic Halévy's *The Cardinal Family* and the sketches he drew to illustrate Edmond de Goncourt's *The Prostitute Elisa*.[23] He had, of course, begun his career by painting historical subjects directly inspired by ancient authors such as Herodotus and Plutarch, as well as modern ones such as Gautier and Vigny.[24] In any event, whether or not he "needed to look for literary inspiration" in conceiving *Interior*, it seems likely that he did find it, and in another novel by Zola.

Late in 1867, a year before *Madeleine Férat* appeared, Zola published a similar tale of violence and passion, *Thérèse Raquin*. Issued serially with the ironic title "A Marriage of Love" in the August, September, and October numbers of *L'Artiste*,[25] it appeared in book form in Decem-

ber of that year. Here, too, "Realism is of course forgotten, and replaced by a lurid Impressionism which transports a thoroughly unlikely story into a sphere of dark poetry."[26] In Chapter 21, a turning point in the grim narrative, Zola describes the wedding night of Thérèse and her lover Laurent, who have murdered her first husband and waited over a year to avoid arousing suspicion, and now begin to discover that their tormented consciences will not only prevent any intimacy, but will eventually drive them to despair and suicide. The chapter begins as follows:

> Laurent carefully shut the door behind him, then stood leaning against it for a moment looking into the room, ill at ease and embarrassed. A good fire was blazing in the hearth, setting great patches of golden light dancing on the ceiling and walls, illuminating the whole room with a bright and flickering radiance, against which the lamp on the table seemed but a feeble glimmer. Mme Raquin [Thérèse's aunt] had wanted to make the room nice and dainty and everything was gleaming white and scented, like a nest for young and virginal love. She had taken a delight in decorating the bed with some extra pieces of lace and filling the vases on the mantelpiece with big bunches of roses. . . . Thérèse was sitting on a low chair to the right of the fireplace, her chin cupped in her hand, staring at the flames. She did not look round when Laurent came in. Her lacy petticoat and bodice showed up dead white in the light of the blazing fire. The bodice was slipping down and part of her shoulder emerged pink, half hidden by a tress of her black hair.[27]

In almost all respects—the positions and attitudes of the two figures, the furniture and decoration of the room, even the distorted light and shadow cast upon the walls—the scene Zola describes corresponds so closely to the one in *Interior* that it must surely be considered Degas's principal literary source. He has, it is true, omitted some features mentioned in the text, such as the woman's staring into the fire, the long black tresses on her shoulders, and the bouquets of roses on the mantel, although the latter do recur, with the same ironic effect, in the delicate floral wallpaper. He has also introduced a number of details not specified in the text,[28] such as the sewing box on the table, the man's top hat on the commode, the woman's cape and scarf on the bed, and above all her corset lying on the floor—precisely the details that encouraged earlier critics to see in the picture the aftermath of a bourgeois gentle-

man's violation of a working girl.[29] The apparent social distinction in their dress is, however, better explained by Zola's novel; for in the preceding chapter he describes the wedding costume, including "a high and stiff collar," which Laurent continues to wear as he enters the bedroom, and also indicates that while the latter remained outside with their guests, Thérèse "was preparing for the night."[30] Moreover, some of the elements Degas has introduced also have a purely formal origin, as we shall see presently.

Chronologically, too, *Thérèse Raquin* coincides perfectly with *Interior*, the first compositional study for which is on the verso of a business document dated December 25, 1867 [135].[31] It is a rapid sketch, which omits many of the details that in the painting seem, in Grappe's phrase, so "hallucinatingly real," yet which for that very reason comes even closer to Zola's text; indeed, few of the discrepancies we have just noticed are seen in it. It is also possible, however, that Degas relied on the serial publication in *L'Artiste*, since the passage in question appeared in a particularly conspicuous place, at the beginning of the final installment, and differed from the definitive version only in insignificant respects.[32] The same scene also occurs in the dramatic version of *Thérèse Raquin*, which, in view of the strongly theatrical effect of *Interior*—as one writer observed, it is "constructed with the calculation of a set on a stage"[33]—is worth considering. But this version was first produced in July 1873, a date that agrees less well with that of Degas's first sketch, and the corresponding scene is less vividly narrated: "Thérèse, left alone, slowly returns to sit near the fire. A silence. Laurent, still in his wedding costume, enters softly, closes the door, and comes forward with an uneasy look."[34] In any event, it is a wedding night and not the aftermath of a rape that Degas has represented, and this gives additional meaning to the caustic remark he reportedly made upon learning that one of the trustees of a major museum, worried about the picture's subject matter, had declined to recommend its purchase: "But I would have furnished a marriage license with it."[35]

Thérèse Raquin is the most important, but perhaps not the only, literary source for *Interior*; some of its most conspicuous elements, including several unaccounted for thus far, may have been derived from the scene in *Madeleine Férat* that was discussed previously as a possible

135.
Degas, Study for
Interior, ca. 1868.
Pencil.

Musée du Louvre,
Paris

source. Like the wedding night scene in *Thérèse Raquin,* the one in the Auberge du Grand Cerf marks a turning point in the story; it is a tense confrontation in which the figures are given essentially the same roles, the woman vulnerable and the man domineering, and the room itself is described in the same macabre detail, evoking the history of their tragic love. Hence this scene could easily have become associated with the one from *Thérèse Raquin* in Degas's imagination. Specifically, he seems to have taken from it the following elements:[36] the woman's cloak and scarf on the bed— "[Madeleine] removed her hooded cloak and the silk scarf from her throat"; the floral pattern of the wallpaper—"the garlands of old-style flowers with which it must once have been strewn"; the reddish brown floor, once a stronger red, as we shall see—"the room was paved with large tiles painted a blood red"; the rug between the bed and table—"a piece of carpet under the round table"; and, symbolically most significant of all, the oddly narrow bed with its eerily white cover—"a bed singularly narrow for two people, . . . a narrow bed, arched in the center like a white tombstone." In addition, the woman in *Interior* has reddish brown hair, which resembles Madeleine's "red hair" far more than Thérèse's "tress of black hair." If Degas did derive these elements from *Madeleine Férat,* which first appeared in *L'Etendard* in September and October 1868,[37] he must either have begun the painting

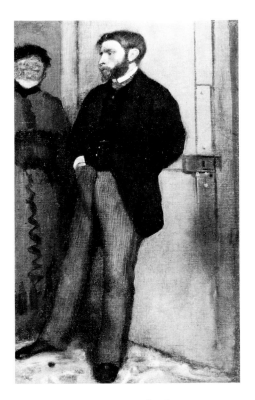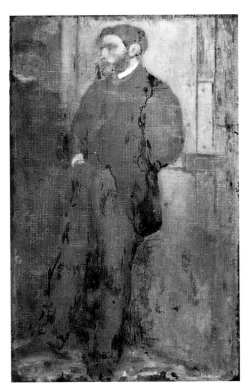

136. Degas, Study for *Interior*, ca. 1868. Oil on canvas.
Private collection, London

137. Ultraviolet photograph of Figure 136

at that time or, what seems more likely in view of the compositional study datable shortly after December 1867, have incorporated them into the picture after it had been begun.

NEITHER OF Zola's novels helps explain why the most impressive study for *Interior*, an oil sketch formerly in the Norton Simon Collection [136],[38] shows, beside the man leaning against the door, a woman in street costume who seems about to enter the room through another opening. According to one writer, this sketch is "mysterious in its space, its illumination and its meaning, but, taken in conjunction with the final version, it does suggest an imprecise purpose; it is as though the artist was looking for a solution, a solution which was, therefore of his own making."[39] That the picture is authentic and already contained the woman in street costume at the time of Degas's death is evident from

its appearance in the catalogue of the sale of his studio, although at that time there were strips of unpainted canvas at the bottom and the left side, which have since been removed.[40] They, of course, suggest that he had once intended to expand the composition, as he so often did by adding strips of canvas or paper, and in that case the woman's role might well have become more comprehensible. But they also suggest that she had in the first place been added to a study of the man alone, and this is confirmed not only by the odd manner in which she is fitted into the small space remaining beside him, but by the far more tentative and unsubstantial way in which she is painted. It is in fact obvious in ultraviolet and infrared photographs [e.g. 137] that the woman's figure is thinly executed and lacks the firm structural modeling of the man's; the meaningless stroke of light pigment on her chin is perhaps the most telling indication.[41] At that time, too, the right side of the background was evidently repainted, since its contour impinges slightly on the man's, and his figure does not cast on it the powerful shadow that it casts in every other study. Moreover, the earliest compositional sketch [135] shows that Degas's conception was in all essential respects clear from the very beginning; and that it remained unaltered is apparent from the many subsequent studies.

What these studies reveal is the power of his imagination, as it seeks to visualize in increasing detail the appearance of a scene that is vividly but incompletely described in Zola's text. It is significant of the important role the setting itself plays that the first of them, in a notebook used in 1867–1874 [138],[42] concentrates entirely on the fireplace, the mirror above it, the chair and table before it, and above all the striking patterns

138.
Degas, Study for *Interior*, ca. 1868. Pencil.

Bibliothèque Nationale, Paris

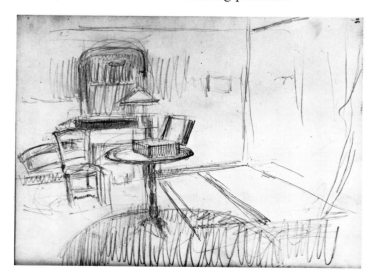

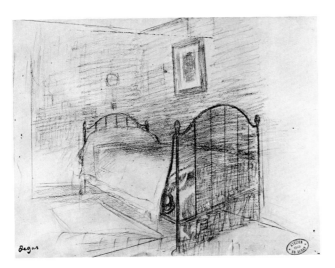

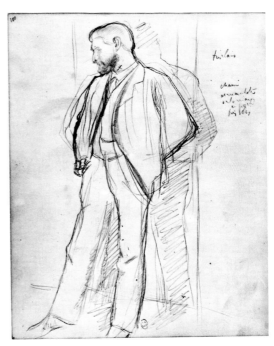

139. Degas, Study for *Interior*, ca. 1868. Pencil.

Present whereabouts unknown

140. Degas, Study for *Interior*, ca. 1868. Pencil.

Bibliothèque Nationale, Paris

of light and shadow cast by the lamp, while the man's figure is merely outlined at the right. Another drawing, on a somewhat larger scale [139],[43] is devoted solely to the bed and the pictures hanging above it, representing them half in precise detail, half in mysterious shadow, as they will appear in the painting. The remaining studies are of the two figures, especially that of the man, whose unusual posture, outwardly nonchalant yet inwardly tense, Degas evidently took great pains to define precisely.

In the first of these, a sketch in the notebook already used for the setting [140],[44] the man's attitude merely repeats in fuller detail that in the earliest compositional study, with marginal notes specifying that his collar and partly exposed right cuff are to stand out as light accents from

the deep shadow in which he is engulfed. But in the next drawing, made on a larger sheet [141],[45] his head is held more rigidly erect and the whole right side of his silhouette runs more stiffly from head to foot, thus no longer expressing the "ill at ease and embarrassed look" mentioned by Zola, but rather the "hebetude mingled with a trace of brutality" noted by Lemoisne and other critics who took the title *The Rape* literally.[46] Somewhat more relaxed in mood is the oil sketch based on this drawing [142],[47] probably because Degas concentrated here on the pictorial problem of relating the figure to the wall and floor adjacent to it, working within a narrow range of beige, brown, and gray tones; in any event, it remains the least impressive of the studies. By contrast, the large pastel and gouache drawing of the head alone [143][48] is a

141. Degas, Study for *Interior*, ca. 1868. Pencil.
 Private collection, New York

142. Degas, Study for *Interior*, ca. 1868. Oil on wood.
 Private collection, Paris

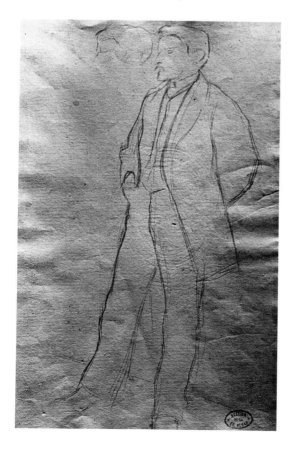
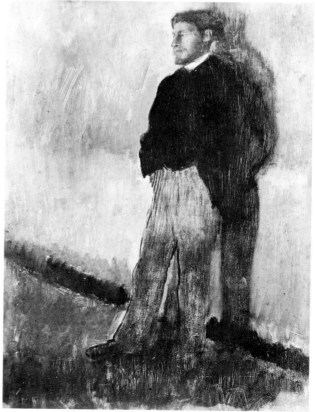

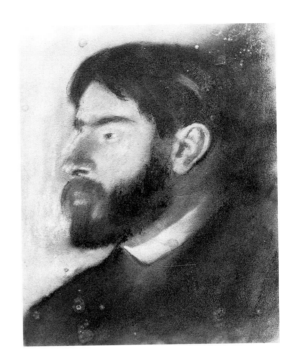

143.
Degas, Study for *Interior*, ca.
1868. Pastel.

Present whereabouts unknown

powerful investigation of the features and the ways in which they reveal the man's conflicting feelings of uneasiness and desire—a point we shall return to later, in considering Degas's ideas on physiognomic expression. The culmination of these studies is, of course, the superbly painted oil sketch discussed previously [136]; here the wedding costume is rendered in greater detail, not exactly as in Zola's account, which specifies "his black trousers and coat and his white waistcoat,"[49] but clearly under its influence.

The two studies of the woman, on the other hand, indicate a change that brings the image closer to Zola's text. In the first of these, a pencil drawing obviously made from a model [144],[50] she is draped in a long, flowing garment or sheet that leaves her torso exposed to the waist. In the oil sketch that follows this drawing, but is once again made from life [145],[51] she wears a light chemise and has a darker robe draped over her legs, resembling more closely, though not exactly, the "petticoat" and "bodice" mentioned by Zola, while the chemise slipping off her shoulder does illustrate his phrase, "her bodice was slipping down and

part of her shoulder emerged." Still another oil sketch, of a half-dressed woman stooping slightly and holding some clothing before her in a defensive manner, has often been identified as a study for the same figure.[52] But apart from her exposed condition, little about her can be related to the woman in *Interior*, whose altogether different posture was already established from the beginning.

DEGAS's decision to base a major painting, not a series of monotypes or notebook drawings, on a work of contemporary literature, surprising though it is in view of his professed disdain for the literary in art, becomes more intelligible when we consider the context in which it was made and the special appeal of Zola's narrative. Since February 1866, when Zola began to frequent the Café Guerbois,[53] the two men had been

144. Degas, Study for *Interior*, ca. 1868. Pencil.
Present whereabouts unknown

145. Degas, Study for *Interior*, ca. 1868. Oil on paper applied to canvas.
Collection of John S. Thacher, Washington, D.C.

acquainted. Later there was to be much rivalry between them and some mutual contempt: as we saw in Chapter IV, Zola's comment, "He is only a constipated [artist] of the finest talent," was easily matched by Degas's, "He gives me the impression of a giant studying a telephone book."[54] But at the time there was no evidence of this; on the contrary, the novelist's review of the 1868 Salon contained a complimentary remark about *Mlle Fiocre in the Ballet from "La Source,"* and the painter later acknowledged having read *The Dram-Shop* and *Nana*, though he made no mention of earlier works such as *Thérèse Raquin*.[55] Hence the publication of that novel, which was by far Zola's most ambitious demonstration of Naturalism in literature, a counterpart to the pamphlet on Manet he had published earlier in 1867,[56] must have been discussed at the Café Guerbois and have been familiar to Degas from the beginning.

In addition, the generally hostile critical response to *Thérèse Raquin*, above all in Louis Ulbach's article, "Putrid Literature,"[57] made it at once a *cause célèbre*. The critics also seized on one feature that would especially have appealed to an artist, the vividly pictorial character of Zola's style. "There are in *Thérèse Raquin*," wrote Gustave Vapereau, "paintings that would be worth extracting as samples of the most energetic and the most repulsive that Realism can produce."[58] And Ulbach himself had to admit that one of these "paintings" was the very one that had attracted Degas: "The night of this hideous wedding is a striking picture."[59] A recent critic has in fact observed that, in keeping with the melodramatic tone of *Thérèse Raquin*, the pictures Zola paints are dominated by violent contrasts of light and dark, which have a distinctly symbolic role;[60] and the same is, of course, true of the expressive use of chiaroscuro in *Interior*.

Zola's pictorial style was in turn influenced by the artists in his circle —first of all by Manet, whose *Olympia* was evidently a source for the brutally direct portrayal of Thérèse and the motif of her black cat,[61] and above all by Cézanne, whose work at this time, like Zola's, was filled with images of violence and sensuality, painted in a somber, dramatic style. In *Thérèse Raquin* itself, Laurent's occasional practice as a painter is modeled on that of Cézanne, and the pictures he produces, including a series of portraits that fatally resemble each other, are clearly inspired by the early works of Zola's boyhood friend.[62] That Degas saw in one

of the novel's principal characters a modern artist, whether or not he sensed the latter's relation to Cézanne, may well have been another reason for his interest in it. And that its other protagonist is named Thérèse, like one of his sisters, who had recently been married, may have been still another. But it was surely the depiction of a married yet utterly estranged couple, doomed to live together yet without intimacy, that moved Degas to illustrate Zola's text more than their names or professions. For in this image he would have seen projected powerfully some of his most disturbing feelings about marriage and the relations of the sexes.

About this scene and those that follow it, a recent authority has stated: "I know of no counterpart in French literature to these fantastic pages, nor of any writer who has so compellingly evoked in comparable terms the fear and horror that sex can undoubtedly give rise to."[63] This is essentially the same attitude, though usually expressed in milder terms, that has been attributed to Degas, a man whose sarcastic comments about women suggest that "he had closed down on his *éducation sentimentale* after some bitter experience, and had allowed passion to wither," and an artist from whose pictures "a bewildering indifference to the grace of women emerges, a disinclination to become involved with them emotionally."[64] Although the sight of a happily married couple—an English family he met in Italy in 1858, his brother René's family whom he visited in 1872—made him long at times for a similar existence,[65] his other experiences seem only to have reinforced the inhibitions and fear of involvement that eventually thrust him into an embittered solitude. No one has described it more poignantly than he himself, in a letter written when he was fifty: "Fundamentally, I don't have much affection. And what I once had hasn't been increased by family and other troubles; I've been left only with what couldn't be taken from me—not much. . . . Thus speaks a man who wants to finish his life and die all alone, with no happiness whatever."[66] Even at the age of thirty-five, at the very time he was painting *Interior*, the effect he produced on one friend was "that of an old bachelor, embittered by hidden disappointments, if not cantankerous, at least unexpansive,"[67] and another declared flatly: "He lacks spontaneity, he isn't capable of loving a woman, much less of telling her that he does or of doing anything about it."[68] Significantly,

the first marriage he had been able to observe closely in his maturity, his mother having died when he was young, was the singularly unhappy one of an aunt and uncle whom he portrayed in 1860, after spending several months in their home.

In *The Bellelli Family* [7],[69] the physical distance between the husband and wife already served, as it would later in *Interior*, to express the emotional distance between them, just as the differences in their postures served, as they would later, to underscore the differences in their roles. In the portrait, it is the resolute female figure that stands out against a solid wall broken only by a sharply defined picture, and the more recessive male figure that merges with the mottled forms on the mantel and in the mirror, whereas in the narrative scene it is the reverse; yet the similarities between the two works, both compositional and thematic, are unmistakable. So, too, are the resemblances between *Interior* and four other pictures of the 1860s, two of them set in modern Paris—*Sulking* [83] and another *Interior Scene*—and two in ancient or medieval times—*The Young Spartan Girls Provoking the Boys* and *The Misfortunes of the City of Orleans.*[70] As one writer has observed, "In all these pictures the left is, so to speak, the female side to the canvas—it is separated from the right by a central element, across which Degas sets a unifying diagonal . . . [and] the element of hostility between the sexes is apparent."[71] Particularly relevant is the so-called *Misfortunes* [146], which Degas exhibited in 1865, a few years before painting *Interior*, for here all that is intimated as estrangement or tension in the other pictures is exposed as aggression; moreover, between the mounted soldiers at the right and the naked women at the left, whom they have raped and murdered, there opens up a seemingly untraversible void as great as that which separates the man and woman in *Interior.*[72] Thus these are the earliest examples of the kind of unconventional composition, with figures crowded toward the edges and the center left vacant or filled with inanimate forms, that is so familiar an expression of psychological alienation in Degas's later work.

WHATEVER ITS personal and no doubt largely unconscious meaning for Degas, *Interior* depends for its dramatic pictorial effect on theories of physiognomic expression and artificial illumination that he formulated

quite consciously in the very years when he painted it. Indeed, none
of his works illustrates more fully his then recently developed ideas on
expression than the oil study of the man in it [136] and the pastel study
of his head [143]. These ideas appear in a notebook he used in 1868–1872,
in a passage that is often quoted yet never seriously discussed or even

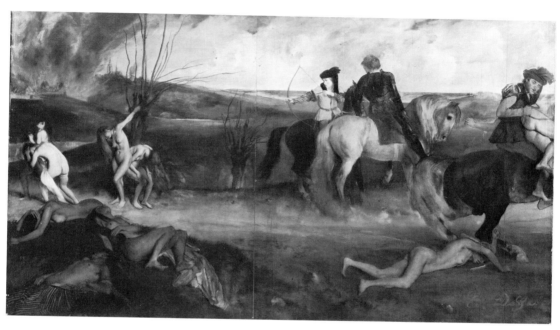

146. Degas, *The Misfortunes of the City of Orleans*, 1865. Oil on paper
applied to canvas.

Musée du Louvre, Paris

correctly translated: "Make of the *tête d'expression* (in academic par-
lance) a study of modern feelings. It is Lavater, but a Lavater more
relative, as it were, with accessory symbols at times. Study the observa-
tions of Delsarte on the expressive movements of the eye. Its beauty
should be only a certain physiognomy."[73] Characteristically, Degas for-
mulates his ideas in terms of three older theories of expressive behavior,
dating from the seventeenth, eighteenth, and nineteenth centuries.

The first of these is the academic *tête d'expression*, a system of clearly
distinguished types representing the different emotions, first stated in

Le Brun's *Characteristics of the Emotions* (1696), then perpetuated in exercises and prize competitions at the Ecole des Beaux-Arts.[74] Hence Degas's punning reference, later in the same notebook passage, to "that unfortunate *tête d'expression (Prix débattre et rebattre),"* the word *prix* meaning both "prize," as in the titles of those competitions, and "price," as in the idiom *prix à débattre,* or "price to be negotiated."[75] That he adds the word *rebattre,* or "hammer again and again," suggesting the futility of such an approach, is hardly surprising, since his own ambition is to transform Le Brun's excessive schematization of expression into a more subtle instrument, capable of rendering the ambivalent feelings of modern man, such as the mingled uneasiness and desire of the man in *Interior.*

The second of the older theories to which Degas refers, that of Lavater on cranial and facial types and their separate features as revelations of character and personality, was published as *Physiognomic Fragments* (1775–1778) and remained especially popular in France, where it went into many editions, including more than one "pocket Lavater" that Degas may have owned.[76] An improvement, in his view, over the academic notion of expression, it is nevertheless still too abstract, its illustrations of heads and features isolated against a neutral ground requiring the addition of a setting and accessories to make them meaningful in the modern realistic sense. This is evident in the importance he himself attaches to the milieu in pictures such as *Interior.* Curiously, however, he quotes in another notebook of this period Goethe's comment that Lavater was merely a realist: "'Strictly speaking,' Goethe says somewhere, 'Lavater was a realist and only understood the ideal in its moral aspect.'"[77]

Closer chronologically and also in spirit to Degas's own theory is the third of those he mentions, that of François Delsarte, a singer and professor of music and declamation, highly regarded by musicians and artists alike, whose Course on Aesthetics (1839–) treated of the expressive functions of various attitudes, postures, and features, including the "expressive movements of the eye," to which Degas refers.[78] Ignoring much that is arbitrary in these lectures, in which each of the functions is reduced to a tripartite schema, he evidently responds to Delsarte's emphasis on that unity of expression called a "physiognomy." It is in

fact just such a movement of the eye as the one he singles out that dominates the expression of the man in *Interior*, one that led a later writer to exclaim: "A burning sensuality still sparkles in his look—oh! that white, luminous spot on the pupil!"[79]

Degas's interest around 1868 in theories of expressive behavior, like his concurrent decision to illustrate a recent novel by Zola, undoubtedly reflects the many discussions among artists and writers at the Café Guerbois in which he participated at the time. Two years earlier, the Goncourt brothers had made precisely the same distinction between expressiveness and conventional beauty, noting in their *Journal* that "the beauty of the ancient face was the beauty of its lines," whereas "the beauty of the modern face is the expression of its emotion."[80] And in a long article "On Physiognomy," published in 1867, Duranty had reviewed the traditional theories, including Lavater's, and like Degas had found them abstract and reductive, insufficiently grounded in close observation of individuals in their typical settings: "At the present moment, we are cleverer than Lavater, and he could not compete with a contemporary novelist."[81] This conclusion, however, ignored the influence that Lavater's theories had exerted on a whole generation of French writers, including Gautier, George Sand, and above all Balzac, whose novels are filled with characterizations directly inspired by them. And more important, it ignored their influence on the next generation as well, particularly on Zola, who was later to make hereditary traits the determining factors in personality development, but who in early works such as *Thérèse Raquin* "still provided Lavaterian descriptions."[82]

Indeed, the portrait of Laurent, in its insistence on coarse, powerful features like those of a peasant or an animal, "his low forehead surmounted by a thick mop of black hair, his full cheeks, . . . his broad, short neck, thick and powerful,"[83] is one of those descriptions. It is, of course, also the portrait of a criminal, who will use this physical force to murder his rival and subdue his mistress, and as such it provides another link between the physiognomic studies of Zola and Degas. For in 1881 Degas, too, painted a criminal's physiognomy [147],[84] a dramatic, close-up portrait based on sketches he had evidently drawn in a police station or courtroom, but characterized in terms of the

147.
Degas, *Physiognomy of a Criminal,* 1881. Pastel.

Formerly collection of Armand Dorville, Paris

current conception of a criminal physical type, half animal or savage in appearance and displaying such atavistic traits as a small, receding forehead and chin, a drooping upper eyelid, and a wildly irregular hair pattern. Lavater, too, had described such a type, but now Degas's inspiration was more likely the recent publications of anthropologists such as Bordier and criminologists such as Lombroso, the first edition of whose classic study *Criminal Man* appeared in 1876.[85]

The close connection between *Interior* and Degas's current ideas on art is also evident in the extent to which it illustrates the notes he made on artificial illumination in the very years in which he painted it. They occur in the same notebook as the remarks on physiognomic expression, and are conceived in the same ambitious spirit: "Study nocturnal effects a great deal, lamps, candles, etc. The smartest thing is not always to reveal the source of light, but the effect of light. This area of art can become very important today. Is it possible not to realize that?"[86] Although obviously related, as Lemoisne has observed, to the portrait of Mme Camus exhibited at the Salon of 1870, one of the few works by Degas in which a powerful light projects striking patterns of shadow on both figure and setting yet is barely visible itself,[87] these notes are equally relevant to other works by him of the period. They include *The Orchestra of the Opera* [50], ca. 1869, where the dancers appear as

luminous forms above the concealed footlights, *The Ballet from "Robert le Diable,"* 1872, where the theatrical lighting produces a similar effect,[88] and above all *Interior*, here dated 1868, the earliest of his studies of nocturnal illumination. Moreover, the notes just quoted must have formed one part of a more comprehensive theory; for in his review of the Salon of 1870, Duranty referred to the portrait of Mme Camus as "this rose background, against which is silhouetted as in a shadow-theater the *Lady in Social Chiaroscuro* (a little joke played on the painter by his friends, because of his artistic theories),"[89] thus hinting at Degas's interest in expressive as well as visual effects of chiaroscuro. It is in fact in *Interior* itself that the greater scope of his thought on the subject becomes evident.

Here the sources of light, the faintly glowing fire and vividly incandescent lamp, are of course visible, in contrast to those in the portrait and theater scenes; but their effect is no less dramatic in its unexpected reversals. Placed near the center of the room, the lamp casts a brilliant light on the woman's back and head, yet leaves her features mysteriously shaded; projects deep and disturbing shadows around the man, yet singles out the whites of his collar and cuff;[90] and by a similar visual paradox, thrusts the banal sewing box and bed into prominence. That these forceful contrasts were central to Degas's conception from the beginning is evident in the extensive shading of his first compositional sketch [135], although it merely hints at the mysterious resonance of shadow he will achieve in the final painting. Perhaps already in this sketch, and surely in that of the unoccupied room [138], he reverses the relative importance of the fire and lamp in Zola's text—"A good fire was blazing in the hearth, . . . illuminating the whole room with a bright and flickering radiance, against which the lamp on the table seemed but a feeble glimmer"[91]—but retains their roles in creating an intimate yet profoundly troubled atmosphere. We have already seen that in passages such as this "throughout the novel, the various gradations of light and dark serve thematic purposes."[92] However, it is doubtful that Degas would have responded so imaginatively to them if he had not been interested in similar visual effects at this time.

In this interest, he was not alone among the artists and writers at the Café Guerbois, and may in fact have been influenced by discussions with

them. Less than a year before he began *Interior*—assuming that the date we have given and presently shall confirm is correct—Duranty, in an article on "The Middle Class Drawing Room," observed: "When in the evening the curtains are drawn and the lamp has become the sun of this little world, when it concentrates light and life around the table, while distancing and throwing into shadow all the furniture, this little world expands and becomes mysterious, grave, and meditative."[93] And in the very year that Degas completed *Interior*, Monet painted two versions of the dining room in his house at Etretat or Fécamp, one with his family and friends at dinner [148],[94] that show a strikingly similar effect of artificial light. Here, too, the feeble glow of a fire is overpowered by that of a lamp placed near the center of the room, in this case suspended above a round table rather than standing on it, and its concentrated light brilliantly illuminates certain forms, while casting others into deep shadow. Here, too, the shapes of these lights and darks, including the circular shadow the table projects onto the floor, dominate our first impression of the scene.

By the late 1860s, however, such effects were hardly an innovation in Realist art, at least not in the graphic arts, which naturally encouraged the development of a powerful chiaroscuro; witness the prints of interiors by Courbet and Alphonse Legros[95] and especially by Whistler, with whom Degas was closely acquainted at this time. In the etchings *Reading by Lamplight* and *The Music Room* [149],[96] both executed in 1859,

148.
Monet, *The Dinner*, 1868–1869. Oil on canvas.

Emil G. Bührle Foundation, Zurich

149.
Whistler, *The Music Room*, 1859. Etching.

Metropolitan Museum of Art, New York, Harris Brisbane Dick Fund, 17.3.26

Whistler, too, had studied the striking patterns of light and shadow produced by an oil lamp shining in the center of a dark room, and had captured the mood of intimate silence it creates among the figures seated within its bright sphere. But if Degas shared, and perhaps even discussed, with his Realist colleagues an interest in nocturnal illumination, he developed it along distinctly different lines. Whereas the chiaroscuro in *The Dinner* and *The Music Room* records a vivid, essentially lyrical impression, in *Interior* it creates a mysterious and vaguely disturbing atmosphere; and whereas the faces in Monet's and Whistler's works are rendered summarily, with little interest in personality, those in Degas's are characterized with the subtlety of a novelist.[97]

NO LESS important an element in the effectiveness of *Interior* as a dramatic tableau is its convincing illusion of deep space, represented by means of linear perspective. It is this, more than the realistically rendered objects within it, that makes the whole appear so much like a theatrical stage set. Moreover, apart from a few student works of modest scope,[98] it is the first of Degas's pictures in which perspective is employed consistently and effectively to such an end. His earlier interiors, in portraits such as *The Bellelli Family* [7] and *James Tissot in an Artist's*

Studio [68], are not only dominated by their human subjects, naturally placed near the center of the field; they are also much shallower, and are closed at the rear by a wall hung with pictures or mirrors that tend to reduce the depth still further.[99] It was only in painting historical events which required a panoramic setting, such as *Semiramis Founding a City*, that he had used perspective extensively, and these were, of course, set outdoors.[100] Thus we find for the first time in *Interior* that concern with the expressive potential of enclosed space that was to manifest itself so often in Degas's ingeniously composed scenes of modern life after about 1870. But if his purpose in the latter was to view familiar subjects in an unfamiliar manner, often piquant or playful in their abrupt angles and oddly cut or overlapping forms, here it was rather to heighten the dramatic effect by creating an image of physical confinement that reinforces the doomed couple's own sense of imprisonment. Hence his placement of the station point of his perspective construction rather close to the objects shown, so that their receding surfaces and edges appear to converge rapidly, exaggerating the feeling of enclosure in a small space. Hence, too, his location of the vanishing point close to the woman's head—it is on the mantel's edge, directly behind her—so that it nearly coincides with the focus of the man's gaze and of the entire dramatic action.

The effectiveness with which Degas employs linear perspective in *Interior* seems the more remarkable when we discover that few of his later pictures are constructed with the same degree of certainty. His *Portraits in an Office*, painted in 1873, is accurate enough, and indeed suggests the influence of photography in its rapidly diminishing forms;[101] but increasingly in that decade and the following one, his interiors reveal inconsistencies and signs of hesitation or revision precisely in the definition of orthogonal lines, such as the floor boards and wall moldings in ballet rehearsal scenes.[102] Aware of the impatience with traditional means and the confidence in intuition that led to these results, Degas himself admitted in 1892: "I thought I knew a little about perspective, I knew nothing about it at all. I thought that one could replace it by a process of perpendiculars and horizontals, measure the angles in space by means of good will alone."[103] In the same years, he also experimented with a homemade perspective device, a portable wooden

frame fitted with a wire grid that would enable him to measure the convergence of planes and edges visually.[104]

THE MOOD OF mystery, appropriate to its subject, that Degas achieved in *Interior* by representational means, he later stated as a broader artistic goal, independent of subject matter, and sought to achieve by purely pictorial means. "A painting demands a certain mystery, vagueness, fantasy," he told Jeanniot. "When one dots all the i's, one ends by being boring."[105] And, sounding a familiar lament of his later years, he told Daniel Halévy: "Beauty is a mystery, but no one knows it any more. The recipes, the secrets are forgotten."[106] At the time he painted *Interior*, however, his style, formed initially by teachers who were disciples of Ingres, and refined by prolonged study of Renaissance art, was still sufficiently precise that he had to struggle to attain the degree of shadowy ambiguity he ultimately did attain. That the picture lacked this quality at an earlier stage is evident from the criticism he received from another artist, who saw it in his studio and commented: "The room too light in the background, not enough mystery. The sewing box too conspicuous, or instead not vivid enough. The fireplace not enough in shadow. . . ."[107] These remarks are part of a longer commentary, written by someone who was obviously well acquainted with Degas and his ambitions in this work, and hence could discuss them freely and in technical detail, even illustrating his points with sketches. It is therefore a document of the greatest interest, and was recognized as such by Marcel Guérin, who received it from Degas's family and discussed it at length with Paul Poujaud,[108] although, curiously, he refrained from publishing it.

Hastily written on both sides of a used envelope inscribed "Monsieur de Gas, rue Laval 13,"[109] this text was evidently composed in his studio during his absence. It begins on the back and inside flap of the envelope [150]:

> Jenny turned out of the house, Pierre very annoyed, carriage difficult to find, delay because of Angèle, arrived at the café too late, a thousand excuses. I shall compliment you on the picture only in person. Be careful of the rug beside the bed, shocking. The room too light in the background, not enough mystery. The sewing-box too conspicuous, or instead not vivid

150, 151. Tissot, Commentary on Degas's *Interior*, ca. 1868. Pencil.

Bibliothèque Nationale, Paris

enough. The fireplace not enough in shadow (think of the vagueness of the background in the "green woman" by Millais without subjecting yourself). Too red the floor. Not proprietary enough the man's legs. Only hurry up, there is just enough time. I shall be at Stevens's house tonight. For the mirror here is the effect, I think [a sketch of the mirror above the fireplace]. The ceiling should be lighter in a mirror. Very light, while throwing the room into shadow. Hurry up, hurry up.[110]

The manuscript continues in a more disconnected manner on the front and outside flap of the envelope [151]:

Beside the lamp on the table, something white to thrust the fireplace back, a ball of thread (necessary) [a sketch of the table, sewing-box, lamp, and ball of thread]. Darker under the bed. A chair there or behind the table would perhaps be good. It would make the rug beside the bed acceptable [a sketch of the table, with a chair in front of it].[111]

Who is the author of this unusual document? In transcribing it for Poujaud, Guérin suggested an artist of critical intelligence, such as Bracquemond, or a critic of artistic sensibility, such as Duranty; in replying, Poujaud rejected both names and, noting the reference to Millais, proposed instead an English artist, such as Whistler, Edwin Edwards, or Legros.[112] Since there is also an allusion to Alfred Stevens, in whose house Tissot, Fantin-Latour, Puvis de Chavannes, and others in the circle around Manet, including Degas himself, often gathered at this time, their names, too, must be considered. The final references, to Jenny, Pierre, and Angèle, point in the same direction, for if the latter may simply be a model, such as the Angèles whose addresses appear in Degas's notebooks in this period,[113] the first two are probably the musician Jenny Clauss and the painter Pierre Prins, both of whom are known to have been closely acquainted with Manet at this time.[114] Of the artists and writers just mentioned, however, all but one can be eliminated, either because they were not in Paris in 1868 or because their handwriting does not match that of the manuscript. In fact, the one whose writing corresponds best, James Tissot,[115] is also the one whose experience and reputation as a realistic genre painter would best have qualified him to make so detailed a critique in so authoritative a tone.[116] Moreover, he must have been friendly with Jenny Clauss, who visited him in London in 1871;[117] and his friendship with Degas, which was later to decline somewhat, was at this moment at its strongest—witness the ambitious portrait Degas painted of him about 1866–1868 [68] and the references to him in notebooks of the same years.[118] This intimacy is also evident in the thoroughness of Tissot's criticism of *Interior* and in his insistence that Degas finish it quickly, presumably so that he could exhibit it at the Salon of 1868, the one opportunity he would have had. If this was indeed the purpose of Tissot's urging, then his commentary, like the initial work on the picture itself, can be dated to the first months of the year.

That Degas acknowledged his friend's authority in the field of realistic genre is apparent from the extent to which he incorporated the latter's criticism into the final version of *Interior*. Ironically, it was only a few years later, in *The Parting* and *An Interesting Story*, both of 1872, and above all in *A Passing Storm* [152], ca. 1875,[119] scenes of modern life

152. Tissot, *A Passing Storm*, ca. 1875. Oil on canvas.

Beaverbrook Art Gallery, Fredericton, presented by the Sir James
Dunn Foundation

in which a physical distance implies a psychological tension between
the staring or brooding figures, that Tissot's art in turn revealed the
influence of precisely the type of composition he had seen in *Interior*
and in *Sulking* [83], a roughly contemporary picture.[120] But in 1868
Degas, who had concentrated on historical subjects and portraiture, had
far less experience in this field and was therefore prepared to accept
Tissot's criticism. Of the ten points it covered, he definitely rejected only
one, the introduction of a chair in front of the round table. Three of
the other points—that the rug beside the bed was "shocking," the rear
of the room too light, and the fireplace not sufficiently in shadow—he
may or may not have heeded, the preparatory studies and numerous
pentimenti in the picture itself providing no conclusive evidence either

way.[121] However, it is clear from the same types of evidence that he did accept the remaining six points. Thus, he intensified the illumination of the sewing box, to make it more conspicuous; stained parts of the floor with thin black washes, to make them less reddish; redrew the man's legs several times, to make his stance more imposing; lightened the tone of the upper half of the mirror, to make it reflect more accurately the lighter ceiling; added a small ball of white thread on the table, to make the latter stand forth from the fireplace; and deepened the shadow beneath the bed, presumably to make its light tones emerge more forcefully, though Tissot did not explain the purpose of this revision.[122]

Both from his criticism and from the nature of Degas's acceptance or rejection of it, we learn in unusual detail how responsive artists of this period remained to the smallest elements of imagery and representation, but also how willing they were to invent an element in order to satisfy a purely pictorial need. The demand for "something white" on the table, for example, resulted in the addition of a ball of white thread whose presence we might otherwise have sought to explain in iconographic terms. In fact, some of the early critics did precisely this, in interpreting it, along with the sewing box, as an indication of the woman's lower social status.[123]

CURIOUSLY, none of Tissot's comments indicated that he was aware of Degas's literary source; but one of them pointed to a previously unsuspected pictorial source—the "green woman" by Millais, whose somber and mysterious background he recommended to Degas as a model for that of *Interior*. The picture to which Tissot cryptically alluded is the well-known *Eve of St. Agnes* [153], which had been exhibited in Paris in the spring of 1867 at the World's Fair.[124] In reviewing the latter, the critic Théophile Thoré, too, called Millais's picture "the Green Woman," a popular title evidently inspired by the presence in it of "greenish rays . . . a green glaze," and he made it apparent why the correct title, derived from a poem by Keats, was generally misunderstood in France: "I do not know, any more than the first day, why this picture by M. Millais is entitled *The Eve of St. Agnes.* No doubt there is in England some legend about a mysterious night, where anything can happen."[125] Thoré

also noted that "[it] was very much admired by certain artists"; and indeed, the attitude of Degas and Tissot was shared by their friend Whistler, who remarked when it was first exhibited in 1863: "Millais has produced *a real picture* this year! In short, nothing could be more artistic."[126] By the 1880s it had become one of the most popular Pre-Raphaelite pictures in France, one that Huysmans placed among the masterpieces admired by Des Esseintes, the hero of his novel *Against the Grain,* and that Duranty, recalling the impression it had made at the World's Fair, praised as *"par excellence* a poetic and artistic work."[127] Hence it is not surprising that Tissot should have advised Degas to remember its "vagueness of background" or that the latter should have followed this advice in painting the background of *Interior.* In fact, there are indications that both artists were more inclined in the years around 1870 than at any other time to accept the influence of Millais and of recent English art in general.

153 (*opposite*).
Millais, *The Eve of St. Agnes*, 1863. Oil on canvas.

Collection of Her Majesty Queen Elizabeth the Queen Mother, London, copyright reserved

154.
Tissot, *The Staircase*, 1869. Oil on canvas.

Collection of Mr. and Mrs. J. M. Tanenbaum, Toronto

In 1871, Tissot settled in London, where he had already exhibited and visited in the previous decade, and almost at once he was acclaimed by the circle of prominent artists that included Millais.[128] Even before he left France, the meticulous realism of his genre pictures was reminiscent of the latter's, as Paul Mantz observed somewhat maliciously about his *Springtime* at the Salon of 1865: "It so happens, by accident no doubt, that M. Tissot has translated into French a painting by the Pre-Raphaelite, M. Millais, which we saw in London in 1862 and which struck us: *Apple Blossoms*, said the catalogue."[129] Another example, of particular interest for our discussion, is Tissot's *The Staircase* [154], painted in 1869;[130] for it is probably inspired, both in its Romantic conception of the pensive female figure and in its detailed yet deliberately somber and suggestive treatment of the setting, by the very picture he had recommended to Degas the year before, *The Eve of St. Agnes*. It is also reminiscent of Millais's *Swallow! Swallow!*, exhibited at the Royal Academy

in 1865;[131] and appropriately, the influence of both pictures is apparent in two of Whistler's female figures—*The Little White Girl*, ca. 1865, and one of the *Three Figures*, 1867–1868—as has recently been shown.[132]

Degas himself, although neither acquainted with Millais nor as strongly influenced by his work, was perhaps more aware of him than of any other Victorian master. In his letters to Tissot, who became his principal contact with the artistic life of London, the Englishman's name figured repeatedly. "If you see Millais," he wrote in 1872, "tell him I am very sorry not to have been able to see him and tell him of my appreciation for him."[133] "Millais will not understand my little Anglo-American [artistic] baggage," he wrote almost deferentially in 1873, explaining his refusal to send something to the Royal Academy exhibition; but he added, "my regards to Millais."[134] That Degas had studied recent English art attentively even earlier, at the World's Fair, is evident not only in Tissot's assumption that he would recall *The Eve of St. Agnes*, but in the titles of Victorian landscapes and seascapes by Hook, Inchbold, Lewis, Severn, and others that Degas listed in a notebook at the time.[135] In an open letter to the Salon jury in 1870, he referred again to the English works at the World's Fair, mentioning one by Frederick Leighton in particular; it must be *Golden Hours*, whose composition bears a strong resemblance to that of *Sulking*, painted in the same years.[136] And in the background of the latter, Degas reproduced a color engraving of a typical equestrian subject by J. F. Herring, the most popular Victorian sporting artist.[137]

A more important link than Tissot between modern French and English art in the 1860s, and one with which Degas's own art was closely linked at the time he painted *Interior*, was the truly cosmopolitan art of Whistler. One example of the mediating role it played is his *Symphony in White, No. 3* [10], begun in 1865 and completed two years later. For on the one hand, it was clearly influenced by the classical themes and designs, the musical conceptions and titles, of recent works by Albert Moore, such as *The Marble Bench* and *A Musician;*[138] and on the other hand, it directly influenced the unusual arrangement and languid, introspective poses of the figures, once again coupled with a musical theme, in a slightly later work by Degas, *Mlle Fiocre in the Ballet from "La Source"* [9].[139] In fact, one of his studies for the latter appears in the same notebook as his copy of Whistler's composition, presumably made

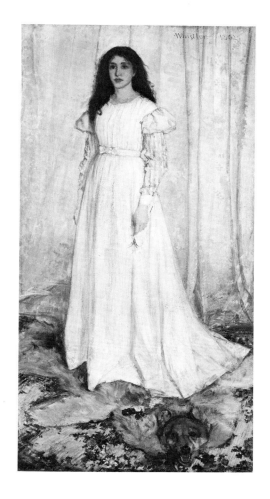

155.
Whistler, *Symphony in White, No. 1: The White Girl,* 1862. Oil on canvas.

National Gallery, Washington, D.C., 1943.6.2. Harris Whittemore Collection

when it was in Paris early in 1867. (Tissot, too, saw it then, and according to Fantin-Latour was "like a madman about this picture, he jumped for joy over it."[140])

Another example of Whistler's role as an intermediary, more important in relation to *Interior,* is his *Symphony in White, No. 1* of 1862, known originally as *The White Girl* [155]. Again there is a dependence on English art, specifically on Millais's *Apple Blossoms,* which Whistler admired, and in which "the figures display, besides their psychological isolation and intensity of mood, a certain element of troubled eroticism,"[141] an element that is also present in his own picture. Indeed, one contemporary critic, inspired no doubt by the tensions in the virginal figure's pose and expression, as well as the wilted lily in her hand and the fallen flowers at her feet, had interpreted its subject as "the morning

after of the bride."[142] And again there is an impact on French art, in fact on *Interior* itself, which Degas painted shortly after seeing at the World's Fair not only *The White Girl*, but *The Eve of St. Agnes*, a picture even more explicitly about the unhappiness of love and one whose heroine was in turn inspired by Whistler's and captured in her mysterious isolation and moody expression something of the latter's strangely suggestive feeling.[143] On the eve of painting *Interior*, then, Degas was in close contact—both directly, through Millais, and indirectly, through Whistler—with a current in recent English art concerned with precisely the kind of tense and ambiguous erotic theme that he was about to be concerned with himself. Given his attitude toward women, it is a theme that would naturally have had a greater appeal than the frankly sensual treatment of love in recent French pictures, such as Manet's *Olympia* and Courbet's *Woman with the Parrot*, both of which were exhibited at the time of the World's Fair.[144]

Beginning with the Pre-Raphaelites in the 1850s—witness Rossetti's *Found*, Holman Hunt's *Awakening Conscience*, and a number of Millais's drawings[145]—this current flowed more broadly in the following decade through Victorian narrative pictures, some of which bear so curious a resemblance to *Interior* that its relation to them must also be considered. Like it, they are a visual equivalent of modern literature, often inspired by actual works of fiction or drama, with figures and settings based on contemporary models and represented in meticulous detail, but in ambivalent situations that create suspense and invite the viewer's imaginative participation—we recall the many viewers who converted *Interior* into *The Rape*. Like the latter, too, Victorian narrative pictures often deal with themes of temptation, moral conflict, guilt, and despair, and in a realistic idiom that demands psychological insight in portraying the various human types—again we recall *Interior* and Degas's studies of physiognomy. He would in fact have learned as much about this subject from his English colleagues as from the treatises of Le Brun, Lavater, and Delsarte, and had perhaps already done so in copying numerous heads and figures from the engravings of Hogarth, the greatest of English narrative painters.[146] Indeed, Taine maintained that one could learn more from them: "Many are excellent observers, especially of moral expression," he wrote in 1864, "and will succeed very well in showing

you the soul by means of the face; one learns by looking at them, one follows with them a course in psychology."[147] And Ernest Chesneau, in reviewing the English works at the World's Fair, devoted a chapter to "The Physiognomists," marveling at their ability "to capture the expressive movements of the human countenance," and in it discussed two pictures of moral weakness or failure that must also have struck Degas —Alfred Elmore's *On the Brink* and Robert Martineau's *Last Day in the Old Home*.[148]

Still more relevant to the domestic drama Degas depicted in *Interior* is Augustus Egg's well-known triptych *Past and Present*, the central panel of which [156] shows the moment of confrontation between a despairing wife, who has been unfaithful, and an embittered husband, who foresees

156. Egg, *Past and Present, No. 1*, 1858. Oil on canvas.
Tate Gallery, London

the tragic consequences (shown in the other panels).[149] The design of Egg's picture is, to be sure, altogether different from that of Degas's, but the subtle portrayal of the figures' feelings in their faces and postures, the realistic description of their setting, whose banal details only heighten the mood of tragedy, and the use of light and shadow to create an atmosphere of dramatic tension are all respects in which they are alike. Even the symbolism of the pictures in the background—a shipwreck scene and an Expulsion from Eden—would have appealed to Degas, who, as we saw in Chapter III, often made use of such symbolism himself and also found it employed extensively both in *Thérèse Raquin* and in *Madeleine Férat*.[150] There is no evidence that he ever saw *Past and Present*, even in a reproduction; but when Thoré saw it in 1860, he described it in terms that bring both *Interior* and its literary sources to mind: "A theme for a drama in the theater more than a subject for a painting on canvas. But there is, in this triptych by M. Egg, an undefinable accent of fatality, and the figure of the woman flattened on the ground is of a fearful energy."[151]

Despite the similarities just discussed, there are, of course, fundamental differences between the realism of Degas and that of Victorian narrative painters, differences in pictorial power and imagination that necessarily limit the extent to which one can be considered an influence on the other. In fact, one could say it is in those respects in which *Interior* differs from Egg's *Past and Present* or even Millais's *Eve of St. Agnes*, in other words, those in which it resembles Monet's *The Dinner* or even Whistler's *White Girl*, that its effectiveness as a pictorial statement can be measured. In the final analysis, however, *Interior* belongs fully neither to one tradition nor to the other, but stands midway between the two; and not only in the abstract, merely verbal sense that such a formula implies, but in the concrete, historical sense determined by its position in Degas's artistic development. For it comes at a point in the 1860s when he has only recently ceased to paint the historical subjects with literary sources that dominate his early work, and has hardly begun to paint the modern subjects of purely visual significance that will occupy him henceforth. And in reconciling both tendencies, and holding them in balance—that remarkable balance of psychological subtlety and pictorial power which is its distinctive quality—it is in many

respects superior to both, and thus may justify the extravagant statements with which we began. "Among his masterpieces," it may indeed be *"the* masterpiece."

APPENDIX: *Interior, Madeleine Férat,* and *The New Painting*

In *The New Painting,* published in 1876, there is a passage strongly suggesting that Degas's *Interior* and Zola's *Madeleine Férat* were already linked in Duranty's mind, as they would be more explicitly in the minds of later writers. The passage occurs in a section concerned with the expressiveness of certain postures and gestures in daily life and their representation in the kind of realistic art Duranty is advocating: "The posture will inform us that this person is going to a business meeting, and this other one is returning from a lovers' meeting. *A man opens a door, he enters, that is enough: we see that he has lost his daughter.* Hands kept in the pockets can be eloquent. The pencil will be steeped in the juice of life."[152]

The sentence Duranty underlines strikes an oddly dramatic note, implausible in itself and inconsistent with the prosaic tone of those that precede and follow it. It is more like a memory of a novel or play than an illustration of a theory; and indeed, in conjunction with the phrase "this other one is returning from a lovers' meeting," it suggests that he is recalling the tragic scene in which Madeleine Férat, returning home from a meeting with her lover Jacques, finds that her daughter has died. For it is precisely the moment of stunned realization at the doorway that Zola describes: "She went to the room where Lucie's body was lying. . . . The atrocious sight that awaited her there, the child whose pale head sank into the pillow, . . . stopped her cold at the threshold. She understood everything at a glance. Then she came forward slowly."[153] Not unlike Jacques himself in the earlier scene at the Auberge du Grand Cerf, we might add, or like Laurent in the wedding night scene of *Thérèse Raquin.*

But the person Duranty describes is a man, and in the next sentence he speaks of a distinctly masculine gesture, the "hands kept in the pockets." Here it seems he is recalling another image, the man who stands in that very posture, also on the threshold of a room filled with impending tragedy, in Degas's *Interior*. This section of *The New Painting* is in fact largely based on Degas's art, as Rivière implied in quoting it in his book on the artist and as Duranty himself made clear in providing a key to the allusions in his pamphlet.[154] So unusual was this gesture in the kind of art he was discussing, however, that the connection with Degas would in any event have been clear. Probably the most astute observer of the attitudes and feelings revealed by such a seemingly banal or colloquial gesture, he was the first to make effective use of it, at least in painting.[155] And the first to note its subtly variable meaning: in his studies for a portrait of Manet, it conveys that debonair figure's worldly ease and confidence; in his portrait of Michel-Lévy [91], it suggests instead an attitude of resignation, even of despair.[156] But it is in *Interior* that it evokes the most complex feelings, at once casual and uncertain, arrogant and hesitant, and it was undoubtedly this example that Duranty had in mind and associated with *Madeleine Férat*, a work more intimately connected with it than he perhaps realized.

VI To Make Sculpture Modern

When, for the first time in his career, Degas exhibited one of his sculptures, the *Little Dancer of Fourteen Years* [157], at the Impressionist show of 1881, "Paris could scarcely maintain its equilibrium," it seemed to Mrs. Havemeyer. "[He] became the hero of the hour. His name was on all lips, his statue discussed by all the art world."[1] For as Huysmans observed more thoughtfully, he had in one stroke made sculpture audaciously modern, "at the first blow . . . overthrown the traditions of sculpture, just as he had long ago shaken the conventions of painting."[2] Despite this insistence on its modernity, however, the work had no immediate influence on the history of modern sculpture: its revolutionary use of materials was taken up in Cubist and Futurist art only thirty years later, independently of its example.[3] The real significance of the *Little Dancer* was in marking a turning point in Degas's own development as a sculptor. Whereas for over a decade he had concentrated on statuettes of horses, often related to those in his paintings, he now turned to what had always been the central subject of his art, the human figure. And in this first ambitious attempt, about two-thirds life size in scale, highly finished in execution, complex and ingenious in technique, he succeeded brilliantly. Only one of his surviving figurines is earlier than this one, and it is a study of a nude in the same pose, made in preparation for it [158].[4]

Both the achievement and its favorable reception, at least among certain artists and writers, must have encouraged Degas to undertake other difficult sculptural projects, for within the next few years he produced three works that were equally unconventional in their way: a large relief of young women picking apples in the country, the only experiment with this form he ever attempted [163]; a subtly modeled

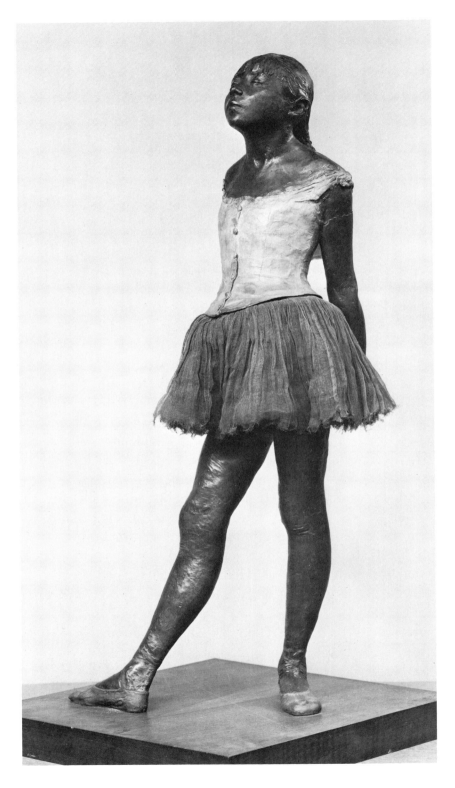

157.
Degas, *Little Dancer of Fourteen Years,* 1880–1881. Bronze with tulle skirt and satin hair ribbon.

Metropolitan Museum of Art, New York, The H. O. Havemeyer Collection, bequest of Mrs. H. O. Havemeyer, 29.100.370

158 (*right*).
Degas, Study for *Little Dancer of Fourteen Years,* 1879–1880. Bronze.

Metropolitan Museum of Art, New York, The H. O. Havemeyer Collection, bequest of Mrs. H. O. Havemeyer, 29.100.373

159 (*far right*).
Degas, *Dressed Dancer at Rest,* ca. 1900. Bronze.

Metropolitan Museum of Art, New York, The H. O. Havemeyer Collection, bequest of Mrs. H. O. Havemeyer, 29.100.392

figurine of a schoolgirl walking with her book bag [171]; and a bust of a young woman that eventually became a half-length figure with arms. Of the three, only the bust, which is mentioned in his correspondence, has been dated correctly to the summer of 1884; the relief has always been placed "well before 1870," and the figurine has been given no date or one ca. 1910.[5] When they, too, are situated in the early 1880s, solely on the basis of external evidence, their internal affinities with the bust and the *Little Dancer* also become more apparent. Together they constituted an enterprise whose goal for Degas was, as Huysmans realized, to make his sculpture modern in all the ways in which his painting was modern: thematically, in the choice of distinctly unheroic—in this case, awkwardly adolescent—figures from contemporary life; stylistically, in the stress on precise description of their postures, gestures, costumes, and expressions; and technically, in the search for novel, often vernacular materials and methods. How characteristic of that moment in his development this ambition was becomes evident when the *Little Dancer* is compared with the *Dressed Dancer at Rest* [159] of ca. 1900, one of

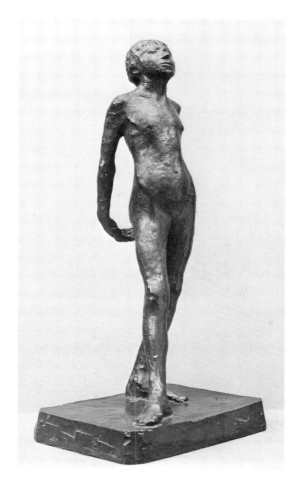

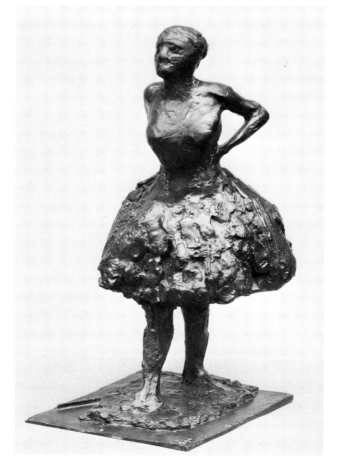

the very few clothed figures in his later sculpture.[6] By then the sophisticated illusionism had yielded to a more exclusive interest in form and movement; and the dancer's bodice and skirt, although impressive in their mass and silhouette, are far from realistic in texture, which varies from rough to smooth, but remains throughout that of scraped or modeled wax.

Affinities among his own works are not the only ones that emerge more clearly when Degas's sculptural projects of the early 1880s are viewed together. Their relation to the work of other artists, both professional sculptors such as Jules Dalou and Medardo Rosso and painter-sculptors such as Daumier and Gauguin, also becomes intelligible, and almost for the first time.[7] The discussion of Degas's sculpture has in general been so much dominated by efforts to relate it to his better-known paintings and pastels—even to the point where, in a recent study, the latter are assumed to be contemporary with bronzes representing the same subjects, whose dates they are thus assumed to provide[8]—that its connections with some of the most original sculpture of its time have largely been ignored. This is especially true of Gauguin's early works, which were made and exhibited in the same years as Degas's and are intimately related to them, having in some cases influenced and in others been influenced by them.

EVERYTHING about the *Little Dancer of Fourteen Years* [157] is unusual and intriguing, even the manner of its first exhibition. Although promised for the Impressionist show of 1880, it was evidently not ready in time, and only the glass case Degas had built for it was displayed. The effect of this empty, polished case must have been startling and, allowing for differences in taste and technology, rather like that of the first glass boxes of Larry Bell some eighty years later. Unfortunately, no contemporary reaction is recorded; it was only when the figurine itself was shown in 1881 that one writer mentioned the formerly empty case, "admired moreover for its magnificent simplicity."[9] He did not describe it further, but it may well have resembled the large vitrine, also elegantly simple, in which an Etruscan sarcophagus from Cerveteri was displayed in the Louvre. Degas had made a very careful drawing of this around 1879 [160],[10] in preparation for an etching showing Mary and Lydia

Cassatt in the Etruscan gallery [97], and may even have had his own project in mind when he chose this unusual subject to begin with. The sarcophagus, too, must have interested him, for its finely modeled and polychromed figures, somewhat smaller than life size, were a precedent for his own; and not only formally but expressively, in their strange blend of realism and artificiality. In fact, the very phrase used at the time to characterize the sarcophagus, "a strange work, at once refined and primitive," was also used by Huysmans in describing Degas's work, "at once refined and barbarous."[11]

So refined did the *Little Dancer* seem, when it was finally shown in 1881, that the public, "very bewildered and as though embarrassed," simply fled; "the terrible reality of this statuette obviously caused it discomfort."[12] Obliged to remain, the critics confessed themselves both fascinated and frightened. "The result is almost frightening," wrote Paul Mantz, a former Director-General of Fine Arts, who then acknowledged "the singular truthfulness of the overall movement," but was outraged by "the instinctive ugliness of a face on which all the vices imprint their detestable promises."[13] In his widely read column in *Le Temps*, the critic Jules Claretie, too, spoke of "a Naturalism that is strangely attractive, disturbing, unusual, . . . with a very Parisian, very pointed accent," and called particular attention to "the vicious muzzle of this little, barely adolescent girl, this little flower of the gutter."[14] More positive, though

160.
Degas, Study for *At the Louvre: Mary Cassatt in the Etruscan Gallery*, 1879–1880. Pencil.

Sterling and Francine Clark Art Institute, Williamstown

161.
Degas, Studies for *Little Dancer of Fourteen Years*, 1879–1880. Charcoal and white chalk.

Musée du Louvre, Paris

still quite critical, the collector and art historian Charles Ephrussi observed that the figure was impressive in execution, and "drawn in a rigorous, penetrating manner, which revealed with immense intelligence the intimate charms and profession of the subject," even if she herself was "frightfully ugly."[15] Apart from Renoir and Whistler, only Huysmans seems to have admired the work without reservation: fascinated by its "industrial costume," which included a gauze *tutu*, a linen bodice, satin slippers, and a silk hair ribbon, and by its subtly modeled and painted wax, "its colored, throbbing flesh wrinkled by the play of the muscles," he declared it "the only really modern attempt that I know of in sculpture."[16] The tension that all these writers felt between a scrupulously realistic technique and a psychologically disturbing content, a tension fundamental to the statuette's existence as Naturalist sculpture, emerges more clearly when we consider its sources and formal development.

With a thoroughness unusual in his mature work, Degas drew the figure at least sixteen times before undertaking to model it; there are that many studies, drawn in charcoal and pastel, on the six sheets that have survived.[17] His model, a young dance student at the Opera, has traditionally been identified as "the Van Goeten girl," and this is confirmed by Degas's notation of her address on one of the sheets [161]

and in a notebook he used at the time, largely in connection with sculptural projects.[18] A Belgian by birth, Marie Van Goethen was a familiar figure in artists' studios and in cafés such as the Nouvelle-Athènes, which Degas, too, frequented; in 1880 she may well have been fourteen, since her début at the Opera occurred only eight years later.[19] Proud of her long black hair, she supposedly insisted on wearing it hanging down her back when she danced, exactly as Degas had drawn her earlier. If several of his studies show her from behind, emphasizing her hair, in others she is seen in frontal, profile, and three-quarter views, clearly because he wished to record from every angle, in fully sculptural terms, the difficult pose she had assumed. Some of the drawings, made in preparation for the statuette showing her nude [158], reveal a surprisingly conventional interest in studying the anatomy thoroughly before depicting the figure clothed as it would eventually appear. But some of the others, drawn from a position well above her head, reflect a more personal interest in viewing figures from above in order to obtain a novel perspective. In a notebook used at this time, Degas wrote: "Set up platforms all around the room, to get used to drawing things from above and below. . . . Have the model pose on the ground level and work on the first level."[20] Here, however, his choice of a high viewpoint may also anticipate that of the spectator looking down at the statuette in its case.

Inevitably, the intense realism of Degas's method resulted in a work that struck most viewers as excessively real, hence repulsive; this was the dilemma faced by all Naturalist art, but by none more acutely than sculpture. One of the reasons, we have seen, was that the adolescent dancer's face, modeled in great detail [162], expressed emotions far

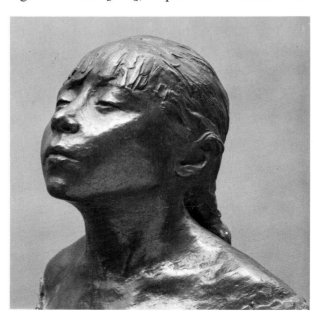

162.
Detail of Figure 157

removed from these viewers' idealized notion of the ballet. "Why is she so ugly?" demanded Mantz, deeply offended; "Why is her forehead, half concealed by her hair, already marked like her lips by a nature so profoundly vicious?"[21] Even a sympathetic critic, Ephrussi, lamented "her appalling ugliness, the vulgarly upturned nose, the protruding mouth, and . . . the little, half-closed eyes."[22] Initially the Belgian model herself may have been responsible for this effect; in Degas's drawings [e.g. 161], her angular, flattened features and dull stare, rendered with unflattering truthfulness, resemble nothing so much as those of the Neunen peasants in Van Gogh's early drawings. But as he developed it further, her physiognomy, oddly tilted up and thrust forward, came increasingly to express a sense of strain or suffering, reflecting her effort to maintain an awkward posture, and, mingled with it, a vaguely sensual yearning, especially in the half-closed eyes. That Degas deliberately sought this troubled expression becomes evident when it is compared with the more graciously smiling one he gave the same model in pictures of a dancer on stage for which she posed some years later.[23]

More than her features, what made the *Little Dancer* so disturbing was her extraordinarily lifelike appearance, enhanced by the use of painted wax and actual clothing. Searching for precedents, contemporary critics thought of certain forms of older religious art: Claretie was reminded of "the realism of Spanish polychromed sculpture," and Huysmans recalled "the Christ in the Cathedral of Burgos, whose hair is real hair, whose thorns are real thorns, whose drapery is a real fabric."[24] They might also have mentioned the popular wax figures, vividly painted and elaborately costumed, found in Neapolitan Nativity groups well into the nineteenth century; and with more justification, since Degas, a frequent visitor to Naples, was undoubtedly familiar with them.[25] But there was also a tradition of secular sculpture long accustomed to employing such techniques to achieve the kind of disturbing effect he unwittingly achieved in the *Little Dancer*—the tradition of the waxwork museum. It was also closer to home, having long been a familiar feature of the entertainment at rural fairs in France and a popular tourist attraction called Mme Tussaud's Exhibition in London, a city Degas visited several times in the 1870s. A collection of wax figurines owned by the journalist Henri Chabrillat had also been dis-

played in Paris, in a gallery near the Opera, toward the end of the previous decade.[26] In addition, the growing interest in illusionism that lies behind Degas's experiment manifested itself in a series of painted panoramas recreating famous battles of the Franco-Prussian War: against landscapes painted by Edouard Detaille, Alphonse de Neuville, and the like, grimly realistic wax soldiers wearing actual uniforms were deployed. As Claretie observed, "It is this mixture of the Morgue and the Luxembourg Museum, of a Salon of painting and a Mme Tussaud's Exhibition, which will insure the popularity of these panoramas."[27] This was in 1881, the year Degas's figurine was shown; one year later the Grévin Museum, a "very Parisian and very modern" version of Mme Tussaud's establishment, opened with great fanfare and achieved immediate popularity.[28]

Interestingly, one of the current celebrities represented in the inaugural exhibition was a dancer at the Opera, wearing the costume of a recent role: "Amidst a clump of foliage," the catalogue explained, "stands out the prima ballerina of the Opera, Rosita Mauri. She is shown in her costume from the ballet in 'Françoise de Rimini.'"[29] And just as this exhibit resembled Degas's sculpture in its ambiguous realism, so it recalled his painting *Dancer on Stage*, a roughly contemporary image of Rosita Mauri dancing against a verdant backdrop, in its subject and setting.[30] The parallels between his art and that of Grévin, whom he mentions in a letter of 1880,[31] do not end there. Another of the museum's inaugural exhibits, a "Salon of Famous Parisians," portrayed a group of artists and writers, among them Zola, Halévy, Daudet, Albert Wolff, and Detaille, all of whom Degas had known previously or met recently in Halévy's circle;[32] and from them he may well have learned about the museum at the time he was creating his own *tableau vivant*.

To heighten its naturalism, Degas gave his *Little Dancer*, in addition to the articles of clothing already mentioned, real hair and braids. Most modern writers ignore this fascinating detail, but Huysmans specified that she had "real hair . . . real tresses," and Mrs. Havemeyer, too, recalled that "real hair was hanging down her back. . . . How wooly the dark hair appeared."[33] We even know the unusual source Degas discovered in his search for a suitable material, thanks to the address of a Mme Cusset, supplier of "hair for puppets [or dolls]," in the same

notebook as Marie Van Goethen's address.[34] It was only later, probably when the work was cast in bronze, that a thin layer of wax was applied to the hair and braids, though Degas himself applied the wax to the bodice and slippers. The notebook reference to a puppet manufacturer is suggestive in another sense and perhaps of another source. It reminds us that the *Little Dancer*, a figurine about two-thirds life size, is itself a kind of puppet or doll, as two of the critics seem to have sensed in alluding to actual dolls.[35] Or it is a kind of artist's mannequin like the one, also slightly smaller than life yet disturbingly lifelike, which lies on the floor beside the painter Michel-Lévy in the portrait Degas made of him around 1878 [91], shortly before making the statuette.[36] That both creatures were surrogate females, elegantly dressed yet literally "puppets," "dummies," or "dolls," is an additional link between them, one that hints at a deeper meaning of the motif for Degas.

Thus the analogy with mannequins and waxwork figures holds on the metaphorical as well as the technical level, as if the realism that observers found frightening were also a form of surrealism. Indeed, it was the rich psychological potential of such creatures that the Surrealists, devotees of the Grévin Museum and inventors of strange dolls, rediscovered. Long before them, however, Zola had made the same discovery: collecting material for his novel *Ladies' Delight* in 1881, the very year the *Little Dancer* was exhibited, he was struck by the bizarre eroticism of the meticulously dressed yet headless dummies displayed in department store windows. "The headless mannequins wearing corsets and slips, fiercely obscene,"[37] he observed in taking notes; and in the novel itself he developed the theme further: "The dummies' round bosoms swelled out the material, their ample hips exaggerated the narrowness of the waists, . . . while mirrors on either side of the windows, by a deliberate trick, reflected and multiplied them endlessly. . . ."[38] Not only does this image resemble Degas's drawing of an Etruscan sarcophagus [160] in recording the complex play of light and reflection on a glass case; it is also similar to the *Little Dancer* in describing the figure on display, and helps explain why the latter, too, was found so provocative yet so fascinating.

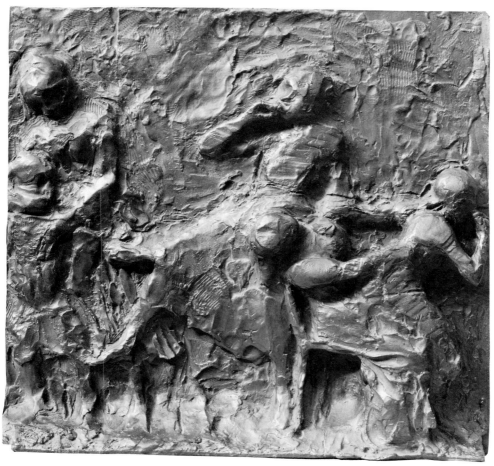

163. Degas, *The Apple Pickers*, 1881. Bronze.

Metropolitan Museum of Art, New York, The H. O. Havemeyer Collection, bequest of Mrs. H. O. Havemeyer, 29.100.422

The Apple Pickers, the only bas-relief Degas is known to have modeled, has not survived in its original form. Preserved only as a small wax sketch or replica [163], it was originally executed in clay on a much larger scale, but was allowed to dry and eventually to crumble.[39] Two of his friends recalled having seen it gradually disintegrating in his studio. "I saw a bas-relief by him," Renoir remarked, "which he allowed to crumble into dust; it was as handsome as the antique."[40] And according to P.-A. Lemoisne, the sculptor Bartholomé "remembered seeing him

make—very early, before 1870—a large bas-relief, half life size, of young girls picking apples; but the artist did nothing to preserve his work, which later fell literally into dust."[41] The statement "before 1870," although made many years later, when Bartholomé was over seventy, has never been questioned, and the work has therefore always been dated ca. 1865. In fact, however, he could hardly have known Degas at that time: born in 1848, Paul Bartholomé spent many years in the provinces studying law and then painting, and first exhibited in Paris at the Salon of 1879; it was only then that he reportedly came to Degas's attention, and the latter's earliest known letter to him is of 1882.[42]

In another letter, published in a relatively little-known Italian work,[43] there is more reliable evidence that Degas modeled the clay version of *The Apple Pickers* in the summer of 1881. The letter is addressed to his cousin Lucie de Gas, who lived in Naples with her guardian, the artist's sister Thérèse Morbilli; and though it is dated only "March 16th," it must have been written in 1882. For, on the one hand, it alludes to Lucie's recent trip to Paris with Thérèse, which we know from the latter's correspondence was in the summer of 1881;[44] and on the other, it refers to "the Cassatts" but does not mention the death of Mary's sister Lydia, which occurred in November 1882.[45] About the relief, Degas writes:

> The bas-relief was very much neglected this winter. It was necessary to produce pictures and other objects requested, without being able to touch it other than with a syringe to keep the clay moistened. I have found a young girl of your proportions, and I shall be able to use her instead of you when I resume work on this difficult piece. I had found another young girl, more youthful and boyish, whom I would have used in place of Anne, and whom I have lost. She was living with her grandmother, who has died, and she has been placed in an orphanage until she is eighteen. I shall have difficulty in replacing her.

In addition to establishing the date of *The Apple Pickers*, this passage makes it clear that, far from being indifferent to its fate as Bartholomé maintained, Degas kept the clay moist for many months, fully intending to resume work on it. If in fact he did not, it was for more practical reasons: he was under constant pressure to produce salable pictures and fans—a theme that runs through his correspondence in these years of great financial difficulty;[46] and he was unable to find models of the same character and proportions as those with which he had begun—an inter-

esting insight into the importance he continued to attach to working from life, even at a time when his art was becoming more independent of it. From this passage, it is evident that one of the four girls in the relief was modeled on Lucie de Gas,[47] and another on a girl named Anne. She was probably Anne Fèvre, the daughter of Degas's sister Marguerite, who is also mentioned in the letter; she must have been a year or two younger than Lucie, who was fourteen at the time, and indeed Degas describes the model he has found to replace Anne as "more youthful and boyish."[48] Both the presence of his cousin and niece and the summer date suggest that the relief was conceived and at least begun during a holiday at the country home of one of Degas's friends, some of whom he mentions elsewhere in the letter. This would, of course, also be consistent with its rural subject.

Its subject matter is further clarified by two drawings on single sheets and several sketches in the notebook of 1880–1884 mentioned earlier. Two addresses in this notebook, of a "dealer in clay" and a "carpenter for the bas-relief frame," are also related to *The Apple Pickers*.[49] Of the sketches, the most fully developed [164] shows the group of two girls at the right side; one is seated on a chair and the other on her lap, as in the wax version, but the contrast between their forms—one girl leaning forward as if to rise, the other leaning backward as if to restrain her—is more pronounced in the wax, and the movements of their arms are more vigorous.[50] As a result, the pattern of arms and intervening spaces becomes far more interesting. Another notebook sketch [165] shows the

164, 165.
Degas, Studies for
*The Apple
Pickers*, 1881.
Pencil.

Bibliothèque
Nationale, Paris

166. Degas, Study for *The Apple Pickers*, 1881. Pencil.
Bibliothèque Nationale, Paris

167. Degas, Study for *The Apple Pickers*, 1881. Black crayon and pastel.
Collection of Mrs. Lester Avnet, New York

little boy on the left, wearing the same clothing as in the surviving relief, but here facing fully toward the right and reaching up with his right arm as if to pick an apple, rather than standing frontal, his head alone in profile to the right, in the embrace of the girl who is seated behind him.[51] For the latter there is no preparatory study, but for the most prominent figure, the girl in the center who is seated on a low wall or hammock, eating an apple, there are two. In a rapid outline sketch in the same notebook [166], Degas studied the proportions of her foreshortened torso and limbs, which are ingeniously disposed to produce an active, open silhouette, and above the sketch he noted: "With the dividers. Six heads to the hem of the skirt—on the foot in front. Four [heads] from the mouth to the sole amidst the drapery [of the] foot

below."[52] In a more carefully rendered drawing on a larger sheet [167], he worked out many details of her costume, gestures, and expression.[53] They are not equally visible in the summarily executed wax version, but presumably were introduced into the larger clay version, whose degree of surface finish must more nearly have resembled that of the *Little Dancer of Fourteen Years.*

In addition to these studies for figures easily identified in the extant form of the relief, there are several others for a figure that was evidently intended for it and may even have appeared in its definitive form. They show an adolescent boy climbing a tree to pick fruit, and both this rural motif and the presence of some of these studies among those already discussed indicate his relation to it. In a brief notebook sketch [168], he is simply shown standing in a static position, for its principal purpose

168. Degas, Study for *The Apple Pickers,* 1881. Pencil.
Bibliothèque Nationale, Paris

169. Degas, *A Boy Climbing a Tree,* ca. 1881. Charcoal.
Collection of Mr. and Mrs. Paul Mellon, Upperville

was to record his proportions, which are marked on his figure and noted below it: "Five *têtes d'aune* from the feet to the nape of the neck."[54] In a larger, more detailed charcoal drawing [169], he assumes a more active position, leaning far to the right and reaching up with his right hand to pick fruit.[55] One of the many *pentimenti* depicts his right leg vertical, rather than parallel to his other leg as in the notebook sketch. Evidently still dissatisfied with this arrangement, Degas returned to the notebook and studied the figure again, once in a more vigorous climbing posture, and once straddling the tree trunk with his legs; and he re-studied the latter motif several times in another notebook, used concurrently with this one.[56]

By combining several sources of information, we can determine approximately how large the original version of *The Apple Pickers* was. According to Bartholomé, whose memory in this case was probably correct, the figures were half life size.[57] Their actual dimensions, or rather those of one of the models Degas used, presumably for the seated girl in the center, are listed in the same notebook as the studies for these figures, as follows: "Width of the shoulders, 30 cm. From the chin to the crown of the head, 18 cm. From the knee (in the middle) to the heel, 43 cm. From the end of the shoulder to the tips of the fingers, 61 cm. From the ground to the elbow (the hanging arm), 95 cm."[58] The proportions indicated by these dimensions do in fact coincide with those in the more detailed drawing of this figure [167], although one phrase, "from the end of the shoulder to the tips of the fingers," is difficult to relate to the drawing. When Bartholomé's statement and the actual dimensions of one figure are combined with the proportions seen in the wax version of the relief, it becomes evident that the clay version was about 87 cm. high by 90 cm. wide, that is, about 35 by 36 inches. Thus the simplicity and breadth of the composition—qualities not easily appreciated in the small, roughly executed wax—must have been enhanced by its physical size, and the effect must indeed have been "as handsome as the antique."[59]

Why did Degas undertake to model a relatively large relief, his first attempt at this form of sculpture, in the summer of 1881? The favorable reception of his *Little Dancer of Fourteen Years*, at least among some artists and writers, a few months earlier may well have encouraged him

to attempt it, but can hardly have suggested this form. He might also have learned, either from the artists themselves or from mutual friends, that two of the leading figures in contemporary French sculpture were at that time working on monumental reliefs: Rodin on the colossal *Gates of Hell*, commissioned in 1880, and Dalou on the *Fraternity* and *Mirabeau Replying to Dreux-Brézé*, both exhibited in 1883.[60] Degas was personally acquainted with both men—with Rodin not before ca. 1890 perhaps, but with Dalou much earlier, as is evident from his correspondence in 1875 and can be inferred from an address in the very notebook he used in preparation for *The Apple Pickers*.[61] However, more than the sophisticated, essentially pictorial compositions of Rodin and Dalou, the roughly modeled yet powerful reliefs of *Emigrants* by Daumier, a painter-sculptor like himself, would have appealed to Degas and stimulated him to undertake such a project.[62] Although executed much earlier, they were shown in the retrospective exhibition of Daumier's work in 1878, where Degas undoubtedly saw them, since he copied one of the lithographs in the same exhibition.[63] Even the material of *The Emigrants*, plaster tinted the color of clay, resembled that of his clay relief.

Probably of greater importance in explaining Degas's interest in relief sculpture around 1880 is the development within his own art at that time of a relief-like conception of form. Unlike his pictures of the preceding decade, whose extreme naturalism demanded a deep, illusionistic space and small figures set at unexpected intervals within it, those of the 1880s are often dominated by a few large, advancing figures, whose striking surface pattern resembles that of a relief.[64] It was evidently a conception that he sought to realize in sculpture as well as in painting, for in contrasting his own ideal of flatness with the conventional ideal of illusory volume, he wrote: "Apart from bas-relief itself, should not sculpture be the only art able to give a sense of form, while deceiving all the same as to relief? It is 'relief' that spoils everything, that is most deceptive, and that everyone believes in."[65] This new conception of form was already evident in the *Project for Portraits in a Frieze* [170], which he exhibited in 1879 and which, like *The Apple Pickers*, shows figures in contemporary costume silhouetted against a neutral ground.[66] Moreover, in the following year he sent to the Impressionist exhibition a work whose friezelike design was even more explicit and, in this case, more

170. Degas, *Project for Portraits in a Frieze*, 1879. Black chalk and pastel.
Formerly collection of Mme David-Weill, Paris

appropriate to its classical subject. Although an anomaly iconographi-
cally, the *Young Spartan Girls Provoking the Boys*, painted in 1860, may
well have seemed harmonious stylistically with the recent works of
classicizing form that he showed with it, just as it seems in retrospect
to announce *The Apple Pickers*, another monumental composition of
adolescent figures, that he began one year later.[67] Both the formal de-
sign and the playful, essentially bourgeois spirit of Degas's image of
apple picking become more apparent when it is compared with those
painted by Pissarro at exactly the same time. In the latter's *Apple Har-
vest* of ca. 1880 and *Gathering of Apples* of 1881, the figures are distinctly
peasant types, for whom the fruit exists to be harvested rather than
eaten, and who are set within the orchard in a random, naturalistic
manner rather than silhouetted against a neutral background.[68]

CONCURRENTLY with the relief of rural genre inspiration, Degas worked
on a figurine of an urban genre subject whose model was also an ado-
lescent girl, perhaps even one of those represented in the relief. Some-
times erroneously called *Woman Walking in the Street*, it shows a
schoolgirl carrying her book bag and holding her pigtails with the other
hand, which is behind her back, while leaning forward with her weight
on one leg, about to take a step [171, 172].[69] The subject was evidently
a popular one at the time, at least in painting: Renoir had portrayed
his patron Paul Bérard's son as *The Little Schoolboy* holding his books
in 1879, and Guillaumin had exhibited a picture called *The Schoolboy*

171, 172. Degas, *The Schoolgirl*, ca. 1881. Bronze. 56.173.

1987, The Detroit Institute of Arts, gift of Dr. and Mrs. George
Kamperman

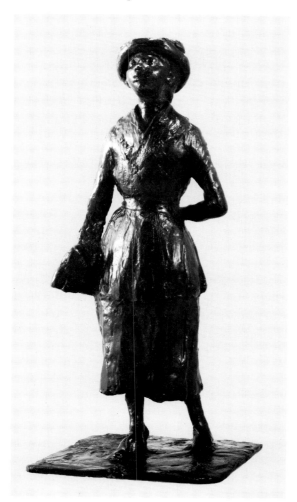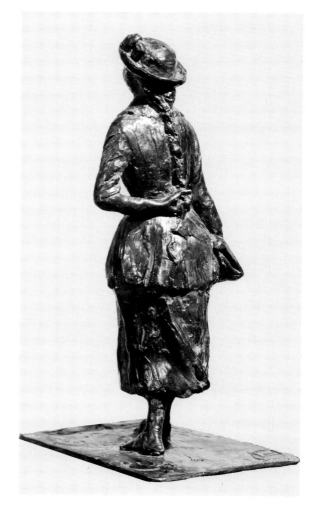

173, 174, 175.
Degas, Studies for *The Schoolgirl*,
ca. 1881. Pencil.

Bibliothèque Nationale, Paris

in the 1880 Impressionist show.[70] That Degas's *Schoolgirl* is indeed contemporary with these works, rather than dating from ca. 1910 as has been suggested,[71] is proved by the presence of studies for it in the same notebook as, and actually interspersed with, those for *The Apple Pickers;* hence it, too, must have been planned, if not completely finished, in the summer of 1881. To visualize the figure in the round, Degas drew it from life from three points of view: the front [173], the back [174], and the side [175].[72] And unlike the relief, which in its extant version shows many departures from the preparatory studies, the statuette follows them in almost all respects. In the front view, the costume is slightly different— the bodice is draped more simply and the skirt is somewhat shorter in the sculpture—but the only significant changes are seen in the back view, where the legs are spread to support the body's forward inclination, rather than crossed indolently as in the sketch, and in the side view, where the book bag is held at arm's length, rather than against the chest.

If Degas was more certain from the beginning about the final appear-

ance of *The Schoolgirl*, it was probably because he had already represented similar figures both in sculpture and in painting. In many respects it is a variation on the then recently completed *Little Dancer of Fourteen Years,* which likewise depicts an adolescent girl as a familiar social type, identified by her costume and accessories, and captures a characteristic attitude of awkward assertiveness largely through the remarkable tilt and thrust of the head.[73] Although the schoolgirl leans forward, shifting her weight before taking a step, and the young dancer leans backward in an exaggerated posture of rest, the similarities are unmistakable. Even the unusual manner in which the schoolgirl's left arm is bent behind her back recalls the dancer's arms held outstretched behind her back. In fact Mantz, in describing the latter's awkward posture, specifically compared it with a schoolgirl's "artificial grace of attitude" and "rude inelegance."[74]

Still more closely related to *The Schoolgirl* than is the *Little Dancer* are several pictures of a young woman in street costume that Degas

176.
Degas, *Ellen Andrée,* ca. 1879.
Crayon électrique.

Metropolitan Museum of Art, New York, gift of Mrs. Imri de Vegh, 49.127.8

painted or drew about 1880. One is an etching of the actress Ellen Andrée [176], looking up from under her large hat with the same assertive tilt of her head as in the statuette, and holding a book or small package against her chest, exactly as in one of the studies for it.[75] *The Schoolgirl* is in fact so similar to the etching, even in the features and expression of the face, that its model may well have been Ellen Andrée rather than one of Degas's cousins. Another closely connected image is the pastel *Woman Wearing a Violet Dress and Straw Hat,* which shows virtually the same figure, but in a different costume and facing to the right rather than the left.[76] Underlying both the etching and the pastel is another work, the slightly earlier *Project for Portraits in a Frieze* [170], which Degas exhibited at the Impressionist show in 1879.[77] The etching of Ellen Andrée, in which the figure appears reversed, seems in fact to have been copied from the right side of this composition, where Degas adroitly juxtaposes three women in modern dress in contrasting poses, as if they were seen waiting in line for a bus. Thus the isolation of one of the figures from this group had already occurred in two other works before it was carried to a logical conclusion in the free-standing statuette.

Is *The Schoolgirl* simply an outgrowth of these earlier pictures, or does

it have specifically sculptural sources as well? As in the case of *The Apple Pickers*, Daumier comes to mind first, for many of his realistically modeled genre figurines, themselves plastic interpretations of two-dimensional images in his oeuvre, are similar in conception and style to Degas's.[78] However, the only one he could have seen at the time was the famous statuette of *Ratapoil*, an emphatically caricatural work far removed from *The Schoolgirl* both in its political content and its flamboyant forms.[79] Closer to the latter in spirit, and also in their pictorial surface treatment, are the realistic genre statuettes modeled by Medardo Rosso in the early 1880s, some of which made use of found objects in a manner reminiscent of the *Little Dancer of Fourteen Years*. Thus, *The Kiss under the Lamppost*, a small group of 1882, had a real light shining in its miniature lamppost, and *The Unemployed Singer*, also of that year, had a real clay pipe in his mouth.[80] However, the earliest of Rosso's surviving statuettes were executed a year later than *The Schoolgirl* and in Milan, in an ambience altogether removed from Degas; it was only in 1884 that Rosso first went to Paris and, through Henri Rouart, probably met him.[81] Yet the fact that Rosso also met Dalou in that year, and

177.
Gauguin, *The Little Parisian*, 1879–1881. Terracotta.

Present whereabouts unknown

even worked as his assistant, is significant of the affinities among all three sculptors; for Dalou had in turn been known to Degas since the early 1870s, at which time he was already making genre statuettes and groups that in many respects anticipated those made by the other artists a decade later. Widely known through their editions in terracotta, bronze, and Limoges china, Dalou's popular sculptures of such subjects as *The Embroiderer, A Parisian Woman Nursing a Child,* and *The Reading Lesson* may well have inspired Degas to envisage contemporary genre figures, chosen among his habitual themes, in three-dimensional form.[82] But they would hardly have influenced his handling of them, since Dalou's charming, vaguely Rococo groups, with their meticulously detailed surfaces and idealized features, lack the uncompromising realism and freely pictorial modeling of Degas's statuette.

Appropriately, the work which, more than those just discussed, probably decided Degas to convert his earlier images of Ellen Andrée into plastic form was in its turn inspired by those images; namely, Gauguin's statuette *The Little Parisian* [177].[83] Shown at the Impressionist exhibition of 1881, where Degas himself displayed a sculpture, it can hardly have escaped his attention, especially since Gauguin was by then virtually his protégé and owed his opportunity to appear with the Impressionists largely to his support.[84] In a recently published letter to Pissarro, who admired his statuette, Gauguin revealed how deeply all three artists were interested in sculpture at this moment: "Decidedly, the craze for sculpture is growing. Degas, it seems, is doing horses in sculpture, and you are doing cows. . . ."[85] Technically, of course, *The Little Parisian* is much cruder than *The Schoolgirl,* particularly in the carved wood version that Gauguin exhibited; and its posture and proportions, which prompted Huysmans to describe it as "gothicly modern," are far more rigid.[86] Yet it is clearly based on the *Project for Portraits in a Frieze* [170], combining features of both Ellen Andrée at the right and the unidentified woman at the left, whose action of leaning on her umbrella evidently inspired the unusual positions of its arms. Although its exact date is unknown, it must have been carved between 1879 and 1881, for in a portrait drawing of Gauguin by Pissarro, with whom he was in closest contact in those years, he is shown working on it.[87] Having seen it in the spring of 1881, Degas may well have decided to model a similar

statuette of a young woman in contemporary costume and, with more justification than his follower Gauguin, to base it on a type he had already represented so ingeniously in two-dimensional images.

That Degas may have been influenced by the younger and less experienced Gauguin is not as improbable as it first appears. He was from the beginning, and always remained, one of the most loyal supporters of the latter's art, and was also one of the first to acquire examples of it for his collection; among the pictures exhibited by Gauguin in 1881 was one owned by Degas.[88] And when, at the Impressionist show of the following year, the younger artist exhibited a bust of his three-year-old son Clovis [178], a work whose subtlety of characterization and realism of surface detail would naturally have appealed to Degas, he was sufficiently impressed to copy it in his notebook [179].[89] Evidently done from memory, his sketch differs from its model in a number of details, but

178. Gauguin, *Bust of Clovis,* ca. 1881. Polychromed wax and wood.
Private collection, Paris

179. Degas, Copy after Gauguin's *Bust of Clovis,* 1882. Pencil.
Bibliothèque Nationale, Paris

its relation to it is unmistakable. So, too, is the significance of that work for his own sculpture, although this became evident only two years later, when he himself attempted to model a portrait bust. On the other hand, Gauguin's choice of painted wax for the head of Clovis—the torso is of carved wood—was unprecedented in his oeuvre and clearly recalled Degas's use of that medium in the *Little Dancer of Fourteen Years.* In fact Huysmans, the critic to whom Gauguin was then most responsive, had written of it: "Taking up again . . . the technique of painted wax, M. Degas has discovered one of the only methods suitable to the sculpture of our time,"[90] and this alone would have been a sufficient incentive for Gauguin to take it up.

In the summer of 1884, while staying with the Valpinçon family in Normandy, Degas was persuaded to model a portrait bust of their daughter Hortense. Like *The Apple Pickers,* then, it was an occasional piece, conceived at first as a kind of distraction during a vacation in the country, and inspired by the presence of a young woman whom he had long known—in this case, the daughter of an old friend, Paul Valpinçon.[91] Moreover, like the earlier work it was executed in clay, this time with small pebbles added, and despite Degas's efforts it eventually crumbled and disappeared, the process here having been hastened by his disastrous attempt to cast the finished bust in plaster. From the beginning, he had struggled with the technical problems involved, lamenting in some of his letters his lack of experience and expert knowledge: "One tells oneself in vain that with innocence one will accomplish everything; one succeeds perhaps, but so sloppily. . . . In a word, one only amuses oneself with things one cannot do, if one is as ill-balanced as I am."[92] In expressing this nostalgia for the certainty of traditional methods—an increasingly familiar theme in his later years, as we shall see in Chapter VII—Degas chose to ignore the equally familiar values of intuition and experimentation, which had already inspired some of his most original works and, precisely in the development of this one, had led him to transform a simple portrait bust into an ambitious half-length figure with arms.

Although the *Bust of Hortense Valpinçon* has not survived, its appearance is known from the unusually detailed account of its progress that

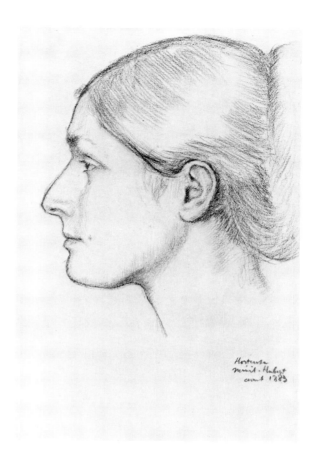

Hortense
menil-Hubert
aunt 1883

180.
Degas, *Hortense Valpinçon,*
1883. Black crayon.

Metropolitan Museum of Art,
New York, bequest of Walter
C. Baker

Degas gave his correspondents—partly to explain his continued absence from Paris in the autumn of 1884—and from a memoir given by the sitter herself to an art historian many years later.[93] There are also two carefully drawn portraits of Hortense in profile to the left, on which Degas may have relied in modeling the bust, since he felt a particular obligation to make it a good likeness. "The interest shown me strongly resembles malignant curiosity," he wrote, only half in jest, of her family, "and this results in a fanatic effort on my part to obtain a likeness and even something more."[94] The first of these drawings [180], now in the Metropolitan Museum, is a remarkably sober, penetrating study in the spirit of Holbein, which Degas later cherished and hung in his bedroom.[95] It is inscribed "Hortense, Ménil-Hubert, August 1883," and the sitter herself placed the creation of the bust in that year; yet the evidence of Degas's letters points unmistakably to the following year. Conceivably he in-

181.

Degas, Letter to Paul Bartholomé, October 3, 1884. Holograph.

Present whereabouts unknown

scribed the drawing inaccurately when he gave it to her twenty years later,[96] and this in turn influenced her memory of the event; but the form and content of the inscription suggest that it is contemporary with the image. Hence it is more likely that he returned to the earlier drawings when he began modeling her profile in the summer of 1884. Of the entire work, there is only a rapid sketch [181], illustrating a passage in one of his letters describing its development.[97]

From these sources, we learn that the "bust" changed considerably as Degas, following a pattern familiar enough in his drawings and pastels, continued to revise and expand it. As Hortense recalled, "He began as he began his sketches, without knowing exactly where he was going. From the simple head with which he began, he made a bust and finally that large, life-size sculpture terminating above the knees."[98] In choosing that unusual terminus—and it is clearly indicated in his sketch—Degas may well have had in mind the analogous solution found by Gauguin for his *Bust of Clovis*, a work that had earlier attracted his attention. Also reminiscent of the latter is the sloping vertical axis of Degas's sculpture, a feature of Gauguin's to which he was evidently responsive,

since he exaggerated it in reproducing it from memory. The effect of this tilted axis in expressing a mood of pensive withdrawal can be judged, more clearly than in his rapid sketch, in a portrait Degas painted two years later of Hélène Rouart [100], another young woman whose father was among his closest friends.[99] Significantly, the chair against which she leans serves to interrupt her figure, too, at a point below the waist, so that its upper part can in fact be seen as a reflection of the *Bust of Hortense Valpinçon* and as a fulfillment of its frustrated ambitions.

One striking feature of both works that obviously owed nothing to Gauguin was the prominent role given to the arms. Yet it was the one that Degas himself mentioned repeatedly in describing the bust. "I swear to you that it is a bust with arms," he wrote to Halévy, as if anticipating disbelief; "a large bust with arms, . . . which I am finishing very patiently," he wrote to Rouart, almost in disbelief himself.[100] And in the letter to Bartholomé containing a sketch of it, he gave the fullest, most ironic description: "There are two arms, I have told you; let it suffice for you to know also that, naturally, one of them, the one whose hand is visible, is behind the back. I am also the only one, perhaps, to whom this seems quite all right."[101] Here, too, he evidently had in mind one of his earlier works, the statuette of a schoolgirl [175], where the same motif—one arm hanging at the figure's side, the hand concealed, the other bent behind its back, the hand exposed—was employed, though the positions of the arms were reversed. It is also possible, though Degas does not mention this, that the hand behind the back held the girl's pigtails, as in the figurine. If so, this would have been one more link between the ambitious sculptural project of 1884 and those of the beginning of the decade.

Appropriately, in the same year Gauguin produced a sculpture that in its turn was based on paintings by Degas. Two of the reliefs decorating his carved wood box of 1884 [182, 183] contain figures copied from those in the older artist's pictures of the ballet.[102] The *Rehearsal of a Ballet on Stage*, now in the Metropolitan Museum, has been cited as a source for the dancers on the front panel, but in many respects they correspond more closely to another version of the *Rehearsal*, now in the Louvre [184].[103] Those on the top panel were derived from still other ballet pictures by Degas.[104] But in this panel there are several motifs, separated

from the dancers by an irregular form suggestive of a stage flat, that seem entirely unrelated to the ballet: a series of spherical forms against a striated background, a seated woman with heavily modeled breasts, and a mask said to represent Degas.[105]

Even if that identification is correct, these ambiguous and strangely juxtaposed motifs introduce an element of fantasy that has little in common with the sober objectivity of Degas's art. In fact, the spherical forms may be small, floating heads, based on those often found in Redon's visionary art, for example in the cover and frontispiece for the portfolio *The Origins*, published in 1883.[106] In this very panel partly inspired by Degas, then, Gauguin began to turn away from the Naturalism that he had largely identified with the older master and toward

182,183. Gauguin, Box with Carved Reliefs, 1884, top and front views. Wood. Collection of Halfdan Nobel Roede, Oslo

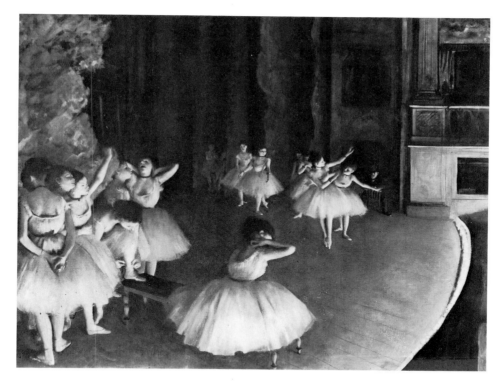

184. Degas, *Rehearsal of a Ballet on Stage*, 1874. *Peinture à l'essence* on canvas.

Musée du Louvre, Paris

the Symbolism that was eventually to dominate his art. Although this is not the last example in his sculptural oeuvre of borrowing from Degas—the half-length figure of a woman with which he decorated a ceramic vase around 1886 is clearly based on one of Degas's dancers[107]—it has rightly been called "the first example of the introduction of symbolic intent into the works of Gauguin,"[108] and as such it marks the end of that period of sustained and fruitful mutual influence which characterizes their sculpture of the early 1880s.

VII The Artist as Technician

In his attitude toward the technical aspects of his art, Degas was at once more radical and more conservative than any major artist of his generation. While other Realists and Impressionists were largely content to employ the conventional techniques of European art, even as they brought about far-reaching changes in its content and formal structure, he experimented constantly with materials and methods whose novelty would match that of his vision of modern life. But on the other hand, while his colleagues accepted the limitations of the relatively simple techniques they used, enjoying the spontaneity of expression these afforded, he longed for the virtuosity and mystery he associated with the more complex methods of the old masters, blaming their loss on the shallow materialism of his age. He could delight in the search for new procedures and remark with disdain, when told of another artist's satisfaction at having "found" his method, "Fortunately for me, I have not found my method; that would only bore me."[1] But he could also despair of his ignorance, asserting to the young Rouault, "apropos the supposed anarchy of modern art and the admirable technique of the old masters, 'We shall have to become slaves again.'"[2]

Underlying these contradictions in Degas's attitude was a more fundamental contradiction in his creative personality. In addition to the artist and the writer, there was in him something of the amateur scientist and inventor, who drew on the progressive currents in his culture to achieve some remarkable innovations in artistic technique. Yet there was also something of the disenchanted dreamer and reactionary, who regretted the disappearance of time-honored methods and who, despite the expert advice of friends, allowed many of his works to be disfigured or ruined by a curious indifference to material requirements.

Both the positive and the negative elements in this attitude have been discussed in Denis Rouart's pioneering monograph *Degas in Search of His Technique*,[3] but without sufficient attention to the strong convictions and prejudices reflected in them. Thus, the explanation of Degas's nostalgia for the so-called secrets of the masters seems to accept his own explanation too readily, failing to ask whether the loss was felt as keenly by many of his Impressionist colleagues, some of whom were as deeply interested in earlier art, or whether it was felt at all by many of his conservative colleagues, who continued to instruct their students in the use of old-fashioned procedures. Moreover, in the thirty years since that study was published, much has been learned from more detailed investigations of the artist's notebooks, sculptures, drawings, monotypes, and prints, all of which, when supplemented by Rouart's fine observations, provide a fuller understanding of this complex subject.

LET US BEGIN with the amateur scientist and inventor in Degas, since it is his remarkable achievement that makes the whole question worth discussing and at the same time requires most explanation. His attitude was one of endless curiosity about the methods he employed and of boundless enthusiasm for the novel results he obtained. Thus, his friend Marcellin Desboutin, describing Degas's recent experiments with printing monotypes from zinc and copper plates, wrote in July 1876: "He is up to the metallurgical phase in the reproduction of his designs by means of a printer's roller, and is running all over Paris—in this heat—to search out the industrial enterprise relevant to his obsession. It is altogether poetic!"[4] And Degas himself, proposing to Pissarro a new method of tinting etchings that made use of wood blocks and copper stencils, wrote in 1880: "One could make some nice experiments with original and unusually colored prints. . . . I shall send you soon some of my own attempts of this kind. It would be economical and novel."[5] Characteristically, he was far ahead of his time in this proposal, anticipating by more than a decade Gauguin's unorthodox use of stencils in printing color woodcuts. Indeed, while Desboutin, Pissarro, and most of their Impressionist colleagues were working with conventional techniques, Degas was converting his studio into a kind of attic laboratory in which he could experiment with altogether new ones, although some of his colleagues took up his innovations and carried them further.[6]

It is sometimes said that he was forced to do this because the recipes and procedures that had formerly been handed down from master to pupil had disappeared at the time of the French Revolution; and he himself says as much in a conversation reported by Georges Jeanniot.[7] Actually, there was no such dramatic breakdown of the studio tradition, and well into the nineteenth century conservative artists continued to study and employ Renaissance techniques. Degas himself was trained by disciples of Ingres who used them in their attempt to create a monumental religious art like that of the past, and with a few exceptions he followed their methods, at least in oil painting and drawing, during the first decade of his career. Nor did he abandon them altogether during the second decade, even though he was by then exploring both the modern urban themes and the novel compositions that characterize his mature art. Some of his most original pictures, such as *A Woman with Chrysanthemums* [36] and *Sulking* [83], were painted in those years in a conventional oil technique, a very sober technique of uniformly thin, flat strokes whose surface displays that smoothness which he described as *le demi-plein mince*—literally, "the thin half-full"—and which he later expressed admiration for in the work of Ingres and other masters.[8] It was only in the third decade of his career, between 1875 and 1885, that the iconographic and stylistic innovations he had achieved in works like these were accompanied by equally daring innovations in material or method.

What seems really to have motivated Degas was something more fundamental—a fascination with the technical as such. He lived in a period of rapid scientific and technological progress, when the experimental method was widely regarded as a model for intellectual achievement,[9] not only in the critical essays of Taine and his followers, but in the novels of the Goncourt brothers, Zola, and other Naturalist writers with whom, as we saw in Chapter IV, Degas was well acquainted. Hence it was logical for him to apply the same method to his own practice, or at least to invest the latter with an appearance of modernity, however far from strict empiricism his practice actually was. One of his closest friends, Henri Rouart, was an inventor and metallurgical engineer, whose circle consisted of other engineers, industrialists, and artillery officers, and as Jacques-Emile Blanche points out, "These gentlemen were accustomed to precision; they were specialists whose technical

language, scientific knowledge, and sense of order and discipline pleased M. Degas greatly."[10] All expressions of a specialized knowledge or skill seem to have interested him, as they did the writers and critics with whom he discussed art at the Café Guerbois. When he painted laundresses in their shops or dancers in their practice rooms, he observed their characteristic gestures and habits of speech, and later surprised Edmond de Goncourt, himself a connoisseur of the precise word, by showing him pictures of these women, while "speaking their language, explaining to us in technical terms the *applied* stroke of the iron, the *circular* stroke, etc. . . . And it is really very amusing to watch him on the tips of his toes, his arms rounded, combine with the aesthetic of the ballet master the aesthetic of the painter."[11] Many years later, the master founder Palazzolo was equally surprised to find the aged Degas making long trips to visit the foundry where some of his statuettes were being cast, not in order to supervise the work, but simply to observe professionals engaged in their tasks, to ask their advice about technical problems—in short, to enter their expert, specialized world.[12]

Nothing reveals Degas's fascination with the purely material aspects of his art more clearly than the recipes and projects scattered through his notebooks, some of them evidently recording practical advice given by colleagues, others more theoretical and even unrealizable, like many of those in Leonardo's notebooks. Around 1879, a period of very active interest in graphic methods for his projected magazine *Le Jour et la Nuit*, he made detailed notes on the laying down of an aquatint, notes probably based on discussions with Félix Bracquemond, with whom he corresponded about this subject at the time.[13] A few years earlier, he had recorded many other observations and recipes for printmaking, in terms that once again show a delight in professional parlance: "Lavender oil dissolves transfer ink better than turpentine. . . . On a zinc plate transfer an engraving impregnated with copper sulphate. By submerging it lightly in a bath of hydrochloric acid, one obtains a copperplate engraving. . . . On a silvered plate (daguerreotype) apply an engraving impregnated with (and wiped dry of) gold chloride. Pass through a press. The result is a plate damascened in reverse. . . . "[14]

In reading these impersonal formulas, devoted solely to the mastery of a difficult procedure, we are reminded of Valéry's conclusion that "art, for him, was simply a series of problems in a more subtle kind of

mathematics than the real one. . . . He would say a picture is the result of a *series of operations*."[15] Nor can we imagine as their author any other artist in the Impressionist group; even Renoir and Pissarro, both of whom were soon to seek alternatives to the intuitive, spontaneous methods they had previously employed, the one turning back to traditional art in a reactionary spirit that resembled the later Degas's,[16] the other temporarily adopting the rigorous process and scientific interests of Neo-Impressionism, never pursued their respective studies so intensively. Moreover, the advice Degas recorded in his notebooks was generally given by colleagues who, thanks largely to his own advocacy, sometimes exhibited with the Impressionists, but whose work sharply distinguished them from the latter; about aquatinting, for example, he learned from Bracquemond, about the monotype from Ludovic Lepic.[17] And the technical discussions he so much enjoyed were usually with artists outside Impressionism, such as Jeanniot, Luigi Chialiva, and Henri Rouart.

To APPRECIATE the extent to which Degas's lifelong search for technical mastery and innovation manifested itself in his art, we must examine in greater detail his uses of specific materials and media. Denis Rouart and others have described the remarkable number of ways in which he worked in pastel, a traditionally minor medium that he endowed with the versatility and power of a major one, and at a time when no one else was doing this.[18] If his early pastels, such as *The Ballet Rehearsal on Stage* [185] in the Metropolitan Museum, are smooth and highly finished, in the manner of La Tour and other eighteenth-century masters whom he admired, those of the 1880s, such as *The Toilette* [186], also

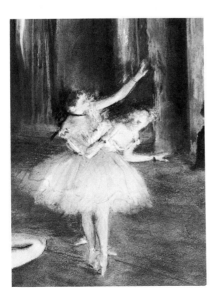

185. Degas, *The Ballet Rehearsal on Stage*, 1872–1874, detail. Pastel.

Metropolitan Museum of Art, New York, The H. O. Havemeyer Collection, bequest of Mrs. H. O. Havemeyer, 29.100.39

186. Degas, *The Toilette*, ca. 1885. Pastel.

Metropolitan Museum of Art, New York, The H. O. Havemeyer Collection, bequest of Mrs. H. O. Havemeyer, 29.100.35

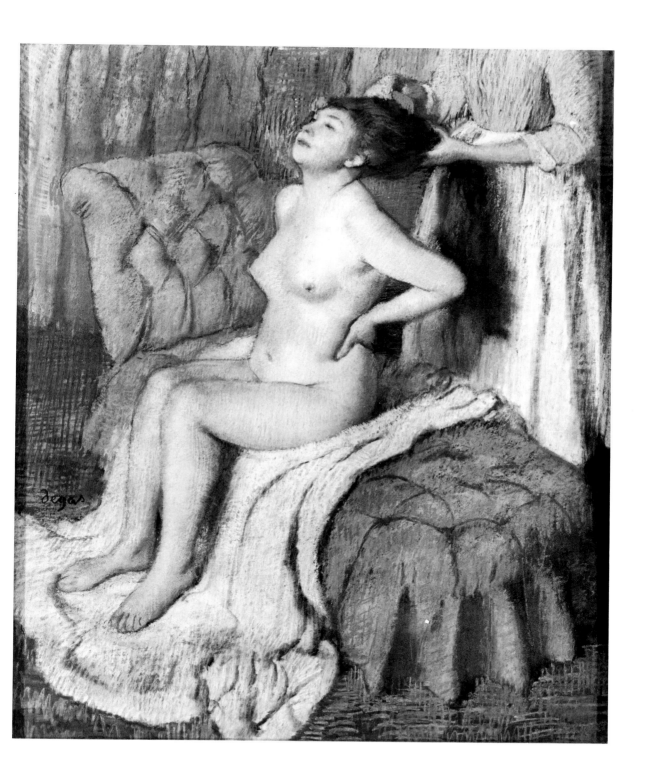

187. Degas, *Dancers in the Wings,* ca. 1896, detail. Pastel.
Formerly collection of Franz Koenigs, Haarlem

188. Degas, *Dancer with a Fan,* ca. 1879, detail. Pastel.
Private collection, courtesy of the Dallas Museum of Fine Arts

in the Museum, are rougher in texture and more vigorously executed, with strokes of vividly contrasted color overlapping each other to create a flickering surface not unlike that in contemporary paintings by Monet and Pissarro.[19] In the late pastels, such as *Dancers in the Wings* [187], these overlapping layers of chalk are heavier in substance and even more brilliant in hue, yet they are prevented from smudging by means of a fixative given to Degas by Chialiva, one whose composition was supposedly so secret—and how this aspect, too, must have delighted him—that it could never be duplicated.[20] Recent research, however, has indicated that this fixative may simply have been white shellac dissolved in pure methyl alcohol, and could therefore have been duplicated without difficulty.[21] Previously, Degas himself had devised an ingenious method of blowing steam over the initial layers of a pastel, either to dissolve them into a vaporous film that would seem to float on the surface or, on the contrary, to melt them into a paste that could then be reworked with visible strokes of the brush, as in the background of *Dancer with*

a Fan [188].[22] But whether he went so far as to use the "pastel-soap" that he mentions in a notebook of about 1880—"mixtures of water-soluble colors with glycerine and soda; one could make a pastel-soap; potash instead of soda"—we do not know.[23]

Even in oil painting, perhaps the most conventional of the media he employed, Degas experimented with a number of unusual procedures and pictorial effects. Although his early works are on the whole rather straightforward technically, there are among them preparatory studies for larger compositions, such as the one [189] for *The Young Spartan Girls Provoking the Boys*, which are painted in oil colors on a sheet of previously oiled paper, so that the brush would slide more swiftly—"with ease and delight," as he reportedly used to say.[24] Later, while continuing to use this method occasionally, he also discovered a means of obtaining the opposite effect, equally smooth but dry and chalky, without sacrificing ease of execution; this he did by soaking the oil out of the colors, diluting them with turpentine—hence the name *peinture à l'essence*—and applying them to a matte surface, as in the famous *Dancers at the Bar* [190] in the Metropolitan Museum.[25] And toward the end of his life, when his approach was in general becoming much bolder, he employed the brush with extraordinary freedom and inventiveness, spreading

189.

Degas, Study for *The Young Spartan Girls Provoking the Boys*, 1860. Oil on paper.

Fogg Art Museum, Cambridge, 1927.62, gift of Mrs. Albert D. Lasker

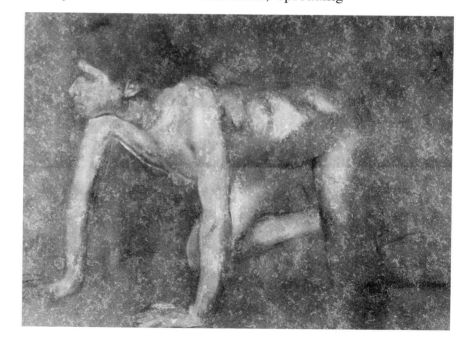

rather dry paint in swirling rhythms reminiscent of chalk rather than oil strokes, as in *Scene from a Ballet* [191]; or he abandoned the brush altogether and dabbed on paint in heavy masses with a rag or his fingers, thus suggesting in an easel picture something of the roughness and strength of a frescoed wall, as in *The Bath* [192].[26] According to the dealer Ambroise Vollard, he had always wanted to paint an actual fresco like those he admired in Renaissance art: "All my life I have dreamed of painting on walls. . . ."[27]

In view of the great importance Degas attached to drawing, it is surprising that he rarely experimented in it with new techniques, except of course in pastel, which is as much a form of painting. This was probably because, like Leonardo da Vinci, he conceived of drawing as an instrument of thought and intimate expression, in which manipulation for artistic effect would be unnecessary or inappropriate. From the beginning, however, he did delight in exploring the traditional methods of drawing and in combining them in unusual ways. Close examination

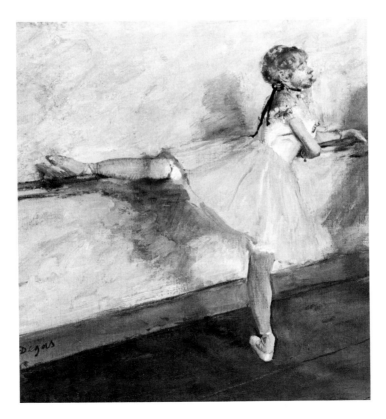

190.
Degas, *Dancers at the Bar,* 1876–1877, detail. *Peinture à l'essence* on canvas.

Metropolitan Museum of Art, New York, The H. O. Havemeyer Collection, bequest of Mrs. H. O. Havemeyer, 29.100.34

191.
Degas, *Scene from
a Ballet,* ca. 1888,
detail. Oil on
canvas.

Formerly collection
of Mouradian and
Vallotton, Paris

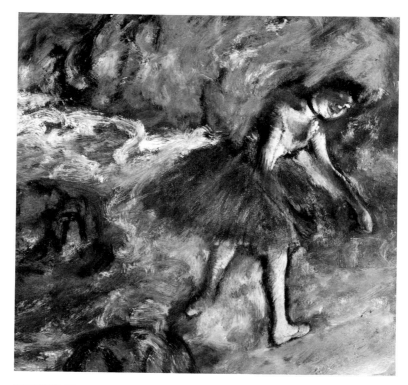

192.
Degas, *The Bath,*
ca. 1890, detail.
Oil on canvas.

The Carnegie
Museum of Art,
Pittsburgh, gift of
Mrs. Alan M. Scaife,
1962

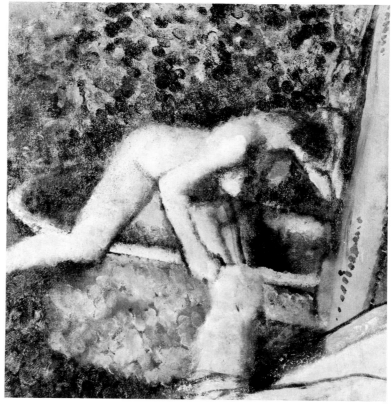

of a preparatory study [193] for his first major composition, *Dante and Virgil* of ca. 1857, shows that, despite its simple appearance, he used pencil and sanguine for the figures and black chalk and wash for the background.[28] And in a study [194] for *The Misfortunes of the City of Orleans* [146], he seems to have analyzed the structure of a figure by outlining its unclothed forms in sanguine and superimposing its costume in pencil with white chalk accents, the differences in color corresponding to different levels of visibility.[29] Later he continued to exploit the chromatic contrasts between media, often choosing a sheet of tinted paper to begin with. The powerfully realistic drawing of a young woman on a sofa [195], in the Metropolitan Museum, for example, combines

193. Degas, Study for *Dante and Virgil*, 1857–1858, detail. Pencil, sanguine, black chalk, and wash.

Formerly collection of Mr. and Mrs. Norton Simon, Los Angeles

194. Degas, Study for *The Misfortunes of the City of Orleans*, 1864–1865. Sanguine, pencil, and white chalk.

Musée du Louvre, Paris

Degas 1875

195. Degas, *A Woman on a Sofa*, 1875. Oil and pastel on paper.

Metropolitan Museum of Art, New York, The H. O. Havemeyer Collection, bequest of Mrs. H. O. Havemeyer, 29.100.185

196.
Degas, *The Ballet Master*,
1875–1877. Pencil, black ink,
watercolor, and oil.

Art Institute of Chicago, gift of
Robert Sonnenschein II,
1951.110b

transparent and opaque *peinture à l'essence* and delicate pastel on a
rose-beige paper; and that of a ballet master seen from behind [196],
which is more complex in technique, was begun in pencil, reworked in
pen and ink, shaded in watercolor or gouache, and finally revised in
diluted oil paint.[30] In the 1890s, Degas also developed two unusual, if
not novel, methods of correcting his charcoal and pastel drawings more
easily: by pulling counterproofs of them on heavy, dampened paper, or
by tracing their outlines on thin, transparent paper, then in each case
beginning anew. Hence those groups of virtually identical, but reversed
or slightly enlarged, drawings that are so characteristic of his late work.[31]
Ironically, in view of his contempt for the Ecole des Beaux-Arts, he
learned of the tracing method from a student of architecture there, where
it had long been standard practice.[32]

In the decade 1875–1885, probably the most creative phase of his

technical experimentation, Degas began in his paintings and pastels to combine different media, as he had done previously only in his drawings. The advantages were twofold: he could increase the variety of represented textures, without abandoning his principle of smooth, flat painting; and—something that was always important and that probably accounts for his predilection for pastels, monotypes, and wax sculpture—he could prolong indefinitely the process of revision, since each phase of the process was undertaken in a different medium. Denis Rouart has described in detail this use of pastel combined with other media. In *At the Café-Concert: The Song of the Dog* [197], for example, Degas contrasted the smoothly modeled arms and face of the figure, drawn in pastel, with the mottled forms of the foliage behind her, painted in gouache.[33] In the technically more complex *Dancers behind a Stage Flat* [198], he evidently drew the whole in pastel, reworked the floor and stage

197. Degas, *At the Café-Concert: The Song of the Dog,* 1875–1877, detail. Pastel and gouache.

Collection of Mrs. Horace Havemeyer, New York

198. Degas, *Dancers behind a Stage Flat,* ca. 1880, detail. Pastel and tempera.

Estate of Mrs. Harriet H. Jonas

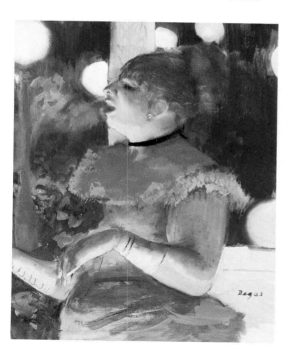
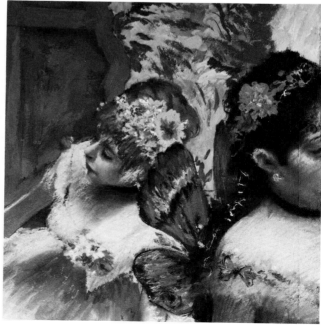

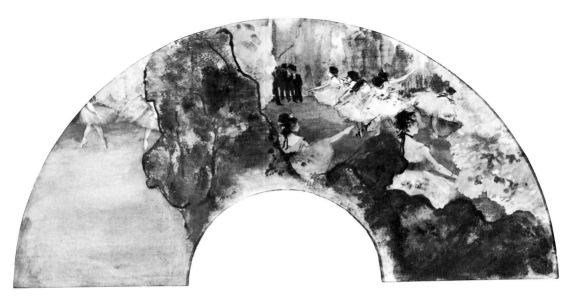

199. Degas, *Fan: Dancers*, ca. 1879. Oil, gouache, pastel, silver, and gold on silk.

Collection of Mrs. W. Hilding Lindberg, Tacoma

flat in powdered pastel diluted with water, and accented the background foliage and the dancers' flowers in tempera or gouache, thus attaining a remarkable diversity of texture.[34] And in the *Fan: Dancers* [199] and similar fans, he achieved a virtual tour de force by using pastel, gouache, and *peinture à l'essence* to establish the forms, adding gold and silver paint to the costumes and décor, and finally sprinkling on flecks of gold leaf in a manner reminiscent of Japanese *surimono* prints, so that the surfaces themselves would suggest the brilliant artificiality of the theaters in which such fans were meant to be used.[35]

The unconventionality of this mixing of media was already appreciated during Degas's lifetime. In an article published in 1890, George Moore observed, presumably apropos the Metropolitan Museum's *Rehearsal of a Ballet on Stage* [200], which was then in an English collection, "There are examples extant of pictures begun in water color, continued in gouache, and afterwards completed in oils; and if the picture be examined carefully it will be found that the finishing hand has been given with pen and ink."[36] In fact, the pen drawing—on paper, later mounted on canvas—must have come first, for as recent research has shown, the

picture was submitted in that state to the *Illustrated London News*, and only after it was rejected for publication was it entirely reworked in the semi-transparent media of *peinture à l'essence*, watercolor, and pastel.[37]

It was also in the 1870s that Degas began to combine several techniques in his graphic works and sculpture. If his prints of the previous decade were almost exclusively simple etchings, with aquatint occasionally added in later states, those of about 1880 were complex combinations of pure etching, soft-ground etching, aquatint, and other techniques, a system so complicated that more than twenty trial proofs had to be pulled of certain plates, such as *At the Louvre: Mary Cassatt in the Painting Gallery* [201].[38] In the same years, Degas experimented with

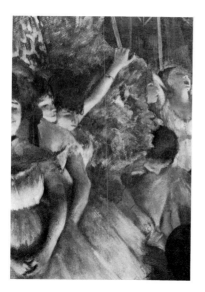

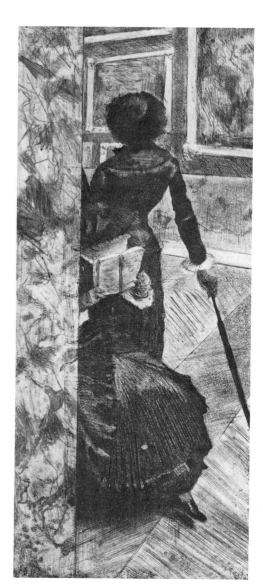

200.

Degas, *Rehearsal of a Ballet on Stage*, ca. 1873, detail. *Peinture à l'essence*, watercolor, pastel, and ink on paper applied to canvas.

Metropolitan Museum of Art, New York, gift of Horace Havemeyer, 29.160.26

201.

Degas, *At the Louvre: Mary Cassatt in the Painting Gallery*, 1879–1880. Etching, aquatint, drypoint, and *crayon électrique*.

Art Institute of Chicago, gift of Walter S. Brewster, 1951.323

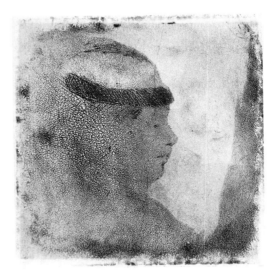

202. Degas, *Two Dancers*, 1876–1877. Aquatint and drypoint.

Metropolitan Museum of Art, New York, Harris Brisbane Dick Fund, 25.73.1

203. Degas, *Head of a Woman*, ca. 1879. Aquatint.

Metropolitan Museum of Art, New York, The H. O. Havemeyer Collection, bequest of Mrs. H. O. Havemeyer, 29.107.52

the use of aquatint and drypoint to obtain an effect like that of a pastel, by establishing the major areas of tone with aquatint, drawing the lighter forms over them with a burnisher, and adding the dark accents in drypoint, as in *Two Dancers* [202].[39] Working closely with Pissarro, who later made extensive use of it, he also perfected a method of simulating the effect of a very fine-grained aquatint by rubbing the plate with a pointed emery stone, which roughened it sufficiently for it to retain a film of ink and to print as a delicate gray tone—hence its name, *manière grise*.[40] He even took up again a plate he had etched twenty years earlier,

transforming its delicately bitten lines into a somber Rembrandtesque chiaroscuro by heavily inking the surface and wiping it unevenly before printing.[41] Indeed, so complex and varied were the methods he now employed that their exact description still eludes us at times; about the unique proof in the Metropolitan Museum of the *Head of a Woman* [203], on which Mary Cassatt had written the cryptic phrase, "experiment with liquid grains," the most recent authority can only state, "this technique is enigmatic."[42]

If Degas's lithographs, more limited than his etchings in number and in chronological span, pose fewer problems of procedure, they are no less original technically. For some prints, such as *Nude Woman Standing, at Her Toilette* [204], he abandoned the lithographic crayon and drew on the stone almost exclusively with a brush and lithographic ink (called *tusche*).[43] Here he also used the scraper afterward to define a few highlights; elsewhere he employed it much more extensively, either held at an angle to create areas of soft illumination or held upright to pick out

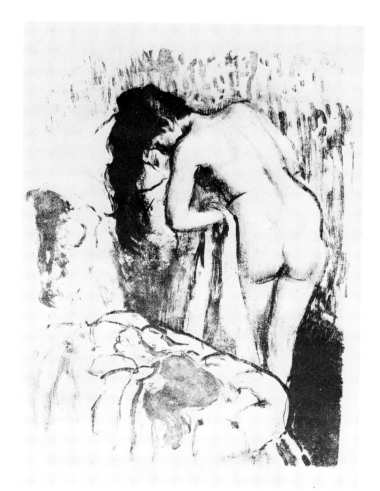

204.
Degas, *Nude Woman Standing at Her Toilette*, 1890–1892. Lithograph.

Metropolitan Museum of Art, New York, purchase, Mr. and Mrs. Douglas Dillon Gift, 1972.626

brilliant light shapes against a dark ground, as in *At Les Ambassadeurs: Mlle Bécat* [205].[44] Despite the coloristic effects thus obtained in black and white, he felt compelled to add accents of pastel color to some impressions of this and similar prints; and inevitably, once he had begun retouching, he proceeded so far that other impressions became complete pastels, whose lithographic bases were almost entirely obscured. In the late 1870s, having mastered the monotype process, he ingeniously applied it to lithography, drawing the design first in printer's ink on a copper plate or sheet of celluloid, printing it on a prepared stone rather than a sheet of paper, and reworking it with lithographic ink and crayons in the usual manner.[45] The use of celluloid, of course, made it possible to see the design reversed, as it would ultimately appear.

Far more than a first stage in the creation of lithographs, the monotype soon became for Degas an end in itself, a spontaneous form of graphic expression that allowed and even encouraged him to experiment with unorthodox methods. Working in the "dark-field manner," where the design is produced by removing ink from a plate completely covered with it, he was forced to abandon conventional means of defining form and to improvise new ones, including the use of rags, pieces of gauze,

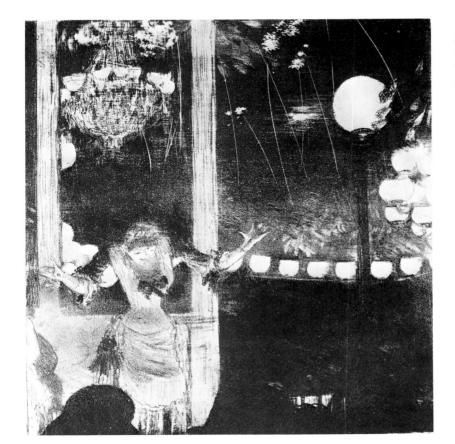

205.

Degas, *At Les Ambassadeurs: Mlle Bécat*, 1875–1877. Lithograph.

Metropolitan Museum of Art, New York, Rogers Fund, 19.29.3

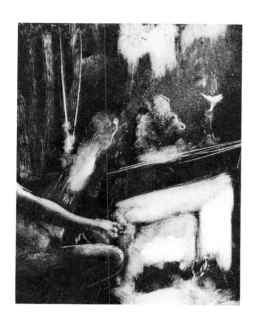

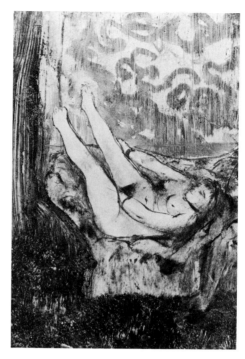

206. Degas, *The Foyer*, ca. 1880, detail. Monotype.

Metropolitan Museum of Art, New York, Elisha Whittelsey Fund,
Douglas Dillon Gift, 68.670

207. Degas, *Siesta in the Salon*, ca. 1880, detail. Monotype.

Private collection, United States

blunt and pointed instruments, and his fingers, with which he could
blend two tones or create a distinct texture, as in *The Foyer* [206],
recently acquired by the Metropolitan Museum.[46] He also learned to vary
the viscosity of the medium itself, contrasting areas of diluted ink
brushed on (or off) with a rag or soft brush and areas of thick, tacky
ink worked with a stiff bristle brush. And if, when working in the
"light-field manner," he did draw directly on the plate with a brush, he
often combined this more incisive draftsmanship with densely textured
or patterned forms produced in the other manner, as in *Siesta in the
Salon* [207].[47] The outstanding examples of his confidence in the sug-
gestiveness of such forms, an attitude that anticipates twentieth-century

208.
Degas, *Landscape with Chimneys*,
1890–1893, detail. Monotype.

Private collection, New York

practice, yet also recalls a famous passage in Leonardo's notebooks, are
the landscape monotypes Degas executed in the early 1890s. For here
printer's ink or oil pigment was manipulated by all the means previously
mentioned, but was also allowed to spread and drip into accidental
patterns of its own, as in the *Landscape with Chimneys* [208].[48] Equally
prophetic here are the chromatic effects he achieved by reworking in
pastel an impression printed in oil colors rather than black ink, the two
types of color partly harmonizing and partly contrasting, so that "the
most dramatic spatial effect is not in the view represented, but rather
in the optical vibration set up between the two layers of color."[49]

There was a similar development toward greater colorism and techni-
cal complexity in Degas's sculpture. If the earlier statuettes of horses
and jockeys were modeled entirely in monochromatic wax with the
intention of casting them eventually in bronze, the later ones, represent-
ing more difficult subjects with clothed and unclothed figures and occa-
sional accessories, were made of multicolored waxes, of clay with small
pebbles sometimes added, or even of wax combined with actual objects
and fabrics. When it was exhibited in 1881, the *Little Dancer of Fourteen
Years* [157], a figurine of astonishingly lifelike colored wax, wore a linen

bodice, a muslin *tutu*, a satin ribbon on her hair, and satin slippers, which heightened its startling illusionism.[50] As we saw in Chapter VI, even the long braids were made of real hair, which Degas had bought from a manufacturer of dolls' or puppets' wigs. Among those who viewed it, however, Huysmans alone realized that with this work Degas had challenged the principle of material unity which governed most traditional sculpture.[51] What Huysmans could not foresee, of course, was the extent to which it also anticipated the assemblage techniques of the twentieth century, preparing the way, in its realism that was also a form of surrealism, both for the brilliantly inventive formalism of Cubist sculptures and the psychologically disturbing combinations in Surrealist and later works, even if it did not directly inspire them.[52] Nor was this the only example of such a practice in Degas's sculptural oeuvre: in the *Woman Washing Her Left Leg*, he placed beside the wax figurine a porcelain pot, playing its cool green tone against the warmer hues of the wax; and in *The Tub* [209], he set a similar figurine of red-brown

209. Degas, *The Tub*, ca. 1889. Bronze.

Metropolitan Museum of Art, New York, The H. O. Havemeyer Collection, bequest of Mrs. H. O. Havemeyer, 29.100.419

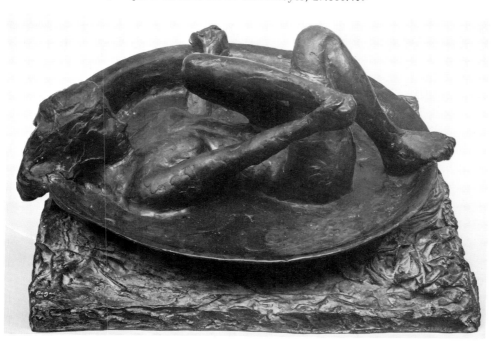

wax inside a metal basin, surrounded it with a piece of cloth, then coated the basin and cloth with liquefied plaster.[53] It was very likely this procedure that he described in a letter to the sculptor Paul Bartholomé in 1889: "I have worked a great deal on the little wax. I have made a base for it with pieces of cloth soaked in a plaster more or less well mixed."[54]

Nothing is more revealing of the confidence and even the audacity with which Degas approached technical problems in his maturity than the delight he took in triumphing over them under particularly difficult conditions. He seems in fact to have gone out of his way to practice his art during vacations in his friends' country homes and at other times when he was deprived of the materials normally available to him. Thus, when the civil war in Paris forced him to remain at the Valpinçons' estate in Normandy in 1871, without his usual canvas and stretchers, he contrived to paint a most engaging portrait of their daughter Hortense anyway, using a piece of cotton ticking taken from the lining of a cupboard and fastened to an improvised frame.[55] And when a heavy sleet storm prevented him from leaving the house of Alexis Rouart one day in 1882, he succeeded nevertheless in making an etching, the *Woman Leaving Her Bath* [210], by using a *crayon électrique*, an instrument made of the carbon filament from an electric light bulb, which Rouart had found in his factory next door; and typically, this then became one of Degas's favorite means of etching.[56] And again, when an attack of bronchitis obliged him to take a cure at Mont-Doré in 1895, he took up outdoor photography with what was, even for him, an extraordinary fervor, ordering the latest panchromatic plates from Paris and specifying unusual methods of development in returning them, so that he could capture such subtle effects as the fleeting illumination of dusk.[57]

His references to panchromatic plates in letters of August 1895 seem all the more remarkable when we learn that the earliest scientific report on their usage, employing the term *panchromatisme* for the first time, had been made by Auguste and Louis Lumière only a few months earlier.[58] After Degas's death, enlargements of similar photographs, taken of the countryside around Saint-Valéry-sur-Somme, were found in his studio and recognized to have been the inspiration for a number of the landscapes he had made in the 1890s. And according to Cocteau, he worked directly on some of these photographs in pastel, "amazed

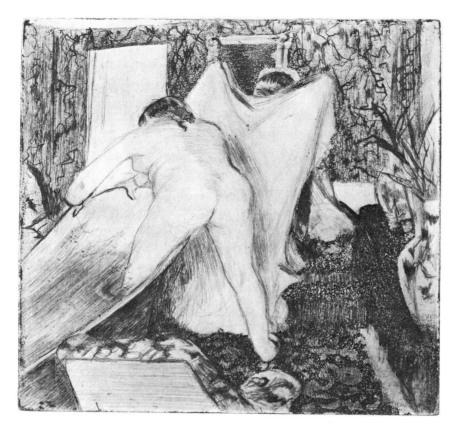

210. Degas, *Woman Leaving Her Bath*, ca. 1882. *Crayon électrique,*
etching, drypoint, and aquatint.

Metropolitan Museum of Art, New York, Rogers Fund, 21.39.1

by the composition, the foreshortening, the distortion of the planes,"
all realistic aspects of their design, but at the same time unwittingly
anticipating what would later become a familiar Surrealist technique.[59]
In a simpler form, he had already employed such a technique earlier,
working over a photograph of one of his drawings in order to produce
a new version without destroying the older one, just as he did in using
a tracing or counterproof as the basis for another work.[60] His eagerness,
in ordering panchromatic plates, to exploit the latest technological ad-
vance is also evident earlier in the enthusiasm with which he studied
and assimilated the discoveries of Eadweard Muybridge and Jules Marey
concerning the forms of animals and figures in rapid movement. One

of his notebooks contains a reference to the 1878 volume of *La Nature*, a serious scientific journal, where an article by Marey on the representation of horses in motion and a report on Muybridge's experiments, accompanied by the first reproductions of his "instantaneous" photographs, had just appeared.[61] In the following decade, Degas copied extensively from such photographs, even imitating their metric grids at times, and, fascinated by their novelty and authenticity, incorporated their images into his pictures and statuettes of race horses.[62]

PHOTOGRAPHY was evidently one of the few fields in which Degas remained enthusiastic about technical innovations in his old age, for as he grew more disillusioned and conservative generally, he seems to have turned more nostalgically toward the art of the past. All those who knew him at that time report his fascination with the methods employed by the Renaissance masters, the loss of which eventually came to obsess him. "He spoke to me of Memling and Van Eyck," Rouault recalled, "he would have liked *a rare medium*, but one that was solid and eternal. 'Those pictures by Memling have not budged yet,' he used to say."[63] And in one of those numerous discussions of technique with Chialiva and Jeanniot, about which the latter informs us, Degas sounded the familiar lament: "We are living in a strange era, it must be admitted. This oil painting that we undertake, this very difficult craft that we practice without understanding it! Such incomprehension has never before been seen."[64] In this situation, he found at once a further reason for rejecting what he considered the shallow, merely naturalistic art of his own age and an initiation into the cult of the mysterious past. "Beauty is a mystery," he told Daniel Halévy, "but no one knows it any more. The recipes, the secrets are forgotten. A young man is set in the middle of a field and told, 'Paint.' And he paints a sincere farm. It's idiotic."[65] In this nostalgia for the technical secrets of the Renaissance, there was, of course, also a certain amount of fantasy, of which his remark that "Van Dyck obtained from an old spinster, whom he had known in Genoa, secrets confided to her by Titian" is an amusing example.[66]

The so-called secrets of the Venetians, the methods of underpainting and glazing, whereby they achieved subtle, glowing colors, which had

previously intrigued three generations of English artists from Reynolds
to Turner, also preoccupied Degas. Around 1865, he had already made
three careful copies in oil [e.g. 211][67] of a *Holy Family* in the Louvre
that was then attributed to Giorgione, but his study of its coloristic
structure seems to have remained without immediate influence on his
own art. Some fifteen years later, however, Jeanniot was amazed to see
him finish a picture of jockeys by adding oil glazes: "This so-called
'Impressionist' liked old-fashioned methods, which were in his opinion
still the best."[68] Moreover, he began to seek similar effects, based on
the interaction of warm and cool tones at different levels of the color
structure, in the pastels to which he turned increasingly after 1875, and
above all in those that he drew over a monotype base, which constitute
about one-fourth of the total. Indeed, so fascinated was he with this
procedure, that he began regularly to pull two impressions of his mono-
types, so that the second one could be reworked extensively in pastel.[69]

211.
Degas, Copy after
Sebastiano del
Piombo's *Holy Family*,
ca. 1865. Oil on
canvas.

Collection of Mme
Marcel Nicolle, Paris

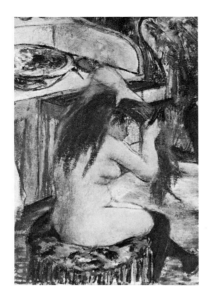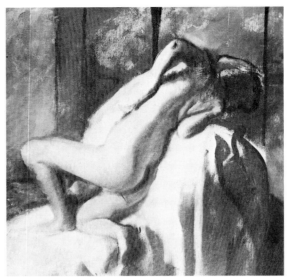

212. Degas, *Nude Woman Combing Her Hair,* 1877–1879, detail. Pastel over monotype.

Collection of Mrs. Henry Ittleson, New York

213. Degas, *After the Bath,* ca. 1896, detail. Oil on canvas.

Collection of H. Lutjens, Zurich

By allowing the layers of chalk to remain distinguishable from that of the ink below them, thus partly blending and partly competing with it in pattern and color value, as in the *Nude Woman Combing Her Hair* [212], he obtained an effect not unlike those he admired in Venetian art, although more modern in its directness and intensity.[70] He must in fact have studied the Venetian masters closely again in the 1890s, for in a number of oil paintings he seems to have followed their procedure of underpainting in monochromatic cool tones and glazing in warm bright ones, as is particularly evident in *After the Bath* [213], which was left unfinished in the grisaille state.[71]

In the mistaken belief that Mantegna, too, had employed this method, Degas insisted that Ernest Rouart, an informal pupil of his in 1897, copy the *Virtues Victorious over the Vices* in the Louvre by underpainting in

earth green tones and, when these did not seem bright enough, in apple green tones, and then glazing in red and orange tones. The results were, of course, disastrous, for as the young Rouart himself realized, "he had some novel ideas about how the old masters worked, and wanted me to make the copy according to a technique he had thought up, which was much closer to that of the Venetians than to that of Mantegna."[72] Ironically, Degas's own copy of the *Virtues Victorious over the Vices* [214], which he began at the same time, working in his studio from a photograph, was drawn directly on a brown-toned canvas in charcoal and white chalk.[73] Yet there was some reason in his apparently foolish instructions to his pupil: he had probably read about just such a pro-

214. Degas, Copy after Mantegna's *Virtues Victorious over the Vices*, 1897. Charcoal and pastel on canvas.

Musée du Louvre, Paris

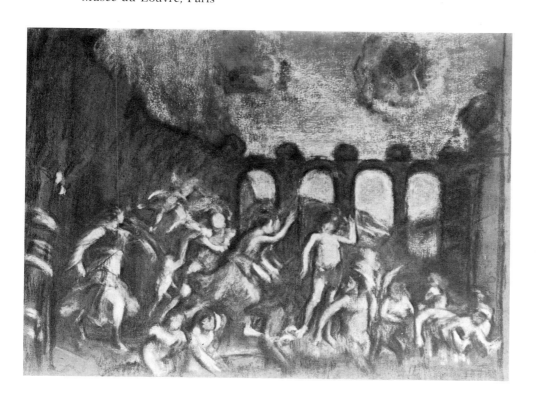

gression from green to red tones in the discussion of fresco painting in Cennino Cennini's *The Craftsman's Handbook*, where in fact it is recommended that the same procedure also be followed in easel painting.[74] A translation of Cennini's treatise by Victor Mottez, a pupil of Ingres, had been published in 1858, at just the time when Degas, who had studied under other pupils of Ingres dedicated to the revival of monumental religious art, would have been most inclined to read it. According to his niece Jeanne Fèvre, his library already contained by then "works on the painter's techniques, in particular the amazing treatise on fresco painting by Cennino Cennini."[75]

Among the other technical books in his library was probably Charles Eastlake's *Materials for a History of Oil Painting*, an equally popular work, in which Degas would have found a chapter describing what "the Venetian Methods" actually were.[76] It was evidently this account of their system of underpainting in red, black, and white tones, laying on a thin, semi-transparent film of white, and glazing over it in warm tones that Degas had in mind when he painted a café interior in the presence and for the benefit of Jeanniot. According to the latter, he outlined its principal lines in black ink on a white canvas, drew a grid of red and yellow lines over them, dissolved and spread these colors over the surface to produce a warm, semi-transparent film, and finally reworked individual forms in more opaque colors.[77] Obviously, however, Degas's method was as much his own invention as a faithful imitation of the Venetian one, and although his café interior is unknown today, it can hardly have possessed the subtlety or depth of color he admired in that art. It is interesting that Degas, in attempting thus to combine effects of transparency and opacity in a single process, was repeating Leonardo's equally unsuccessful experience when painting *The Last Supper*, as Rouault seems already to have realized at the time: "Like Leonardo, Degas had dreamed of mixing fresco painting and oil painting; in other words, of uniting two somewhat opposed qualities."[78]

THE STORY of Ernest Rouart's copy is not the only instance, even in Degas's own oeuvre, of failure due to inadequate knowledge of or indifference to traditional techniques. One of his most important early pictures, *Mlle Fiocre in the Ballet from "La Source"* [9], was partly ruined

when he tried to remove a coat of varnish he had impulsively decided to have applied on the eve of its exhibition at the Salon of 1868, and it was only many years later that he was able to have the remainder of the varnish removed and to repair the damaged areas; even then, "he was never more than half satisfied with the results."[79] Another picture, painted entirely in egg tempera, quickly cracked and was ruined, because he had used as a vehicle the white rather than the yolk, though here, too, it is possible that he was confused by Cennini's discussion of the legitimate uses of egg white in tempera painting.[80] When another picture became badly cracked, he at first blamed modern methods of color manufacture, expressing a reactionary attitude typical of his old age: "One will never know all the harm that chemistry has done to painting."[81] But as Vollard, who tells the story, goes on to explain, the damage was in fact caused by Degas's having painted on a canvas whose lead white priming was not thoroughly dry. That he was always somewhat uneasy about the consequences of his technical experiments is evident from a remark reported by Edmond de Goncourt in 1890: "He has not gone to see his pictures in the sale of the May Collection, because he . . . fears a disintegration of his painting, due to a mixture of vinegar and something else, a mixture he was infatuated with at a certain time."[82]

If the number of Degas's pictures ruined by unsound procedures is relatively small, the number of those disfigured by later revisions, often in a different medium from the one originally employed, is surprisingly large. After his death, a great many of these partially repainted works were found in his studio, including not only youthful ones such as *Alexander and Bucephalus* [215], whose very carefully rendered details were half obliterated by heavy paint applied with a palette knife rather than a fine brush, but also mature ones such as *The Ballet Class* [216], a picture of around 1880, whose equally destructive repainting many years later is more difficult to understand.[83] Probably the most poignant evidence of this dangerous compulsion to revise is found, once again, in Ernest Rouart's memoir:

> After seeing again and again at our house a delightful pastel my father had bought and was very fond of, Degas was seized with his habitual and imperious urge to retouch it. He would not let the matter alone, and in the end my father, from sheer weariness, let him take it away Often

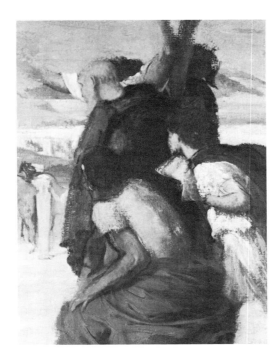

215.
Degas, *Alexander and Bucephalus*,
1859–1860, detail. Oil on canvas.

Private collection, New York

> my father would ask him about his beloved pastel; Degas would put him
> off in one way or another, but in the end he had to confess his crime: the
> work entrusted to him for a few retouches had been completely destroyed.[84]

When he replaced it with another work, the *Dancers at the Bar* [190],
he found something there, too, that he wished to revise, but this time
was prevented from doing so.

Still more numerous are the examples of Degas's sculpture disfigured
by excessive revision or by technical inexperience—indeed, so numerous
that they constitute the rule rather than the striking exception. Deter-
mined to create figures with a powerful effect of movement and imme-
diacy, yet impatient with the usual methods of building armatures, he
improvised with pieces of wire and wood; and when these began to
collapse, as they inevitably did, he repaired them with matchsticks or
paintbrushes, or simply propped up the broken limb with whatever was
at hand.[85] For perverse reasons of economy, he also insisted on making
his own wax, which soon became too friable, and on mixing into it some
tallow, which made it less durable. At times he also added bits of cork,
which periodically rose to the surface, destroying the subtle modeling

and making necessary extensive repairs.[86] It is not surprising, then, that when his dealer Durand-Ruel inventoried the contents of his house after his death, he found "about one hundred and fifty pieces [of sculpture] scattered over the three floors in every possible place. Most of them were in pieces, some almost reduced to dust."[87] Indeed, as early as 1890, before the majority of them had been made, George Moore wrote that in Degas's studio "there is much decaying sculpture—dancing girls modeled in red wax, some dressed in muslin skirts, strange dolls. . . ."[88]

It has been argued that what led Degas to devise such primitive methods, rather than to rely on the sounder ones urgently recommended by his friend Bartholomé, a professional sculptor, was his love of independence and improvisation; and it is true that with it he was able to create effects of motion and intimacy unknown to Bartholomé and his colleagues.[89] Nevertheless, there is something paradoxical in the obstinacy with which Degas, who had long been fascinated by artistic techniques and by the technical as such, refused to follow expert advice or even common sense and instead allowed many of his finest statuettes

216.
Degas, *The Ballet Class*, ca. 1880, detail. Oil on canvas.

Private collection, Zurich

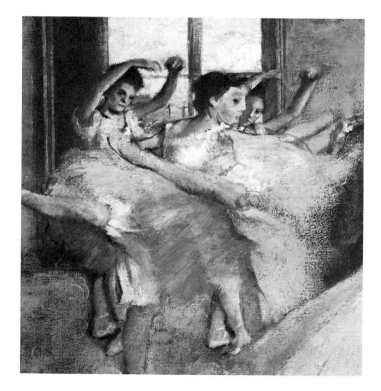

to be destroyed. Nor was this attitude typical only of his old age, when a profound pessimism seems to have pervaded all of his activities. In 1882, he allowed an ambitious clay relief with figures half life size, his one attempt at bas-relief sculpture, and one that Renoir considered "as handsome as the antique," gradually to dry and eventually to crumble into dust.[90] This is *The Apple Pickers*, of which only a small wax replica or sketch now survives [163].[91] And in 1884, after weeks of patient and laborious work on a bust of Hortense Valpinçon—typically, it had become a half-length figure by the time he had finished—he decided impulsively to mold it himself, rather than call in an expert as he had planned, and then he mixed ordinary plaster with the inadequate supply of molding plaster he had at hand, so that both the figure and its mold were broken and soon lost.[92] While working on the bust, he had lamented his insufficient technical knowledge, but far from trying to supplement it, he seems to have enjoyed groping and experimenting. "How I floundered at first, good God!" he wrote to Henri Rouart, "And how little we know what we are doing when we do not let our craft take care a bit of the things we need. One tells oneself in vain that with innocence one will accomplish everything; one succeeds perhaps, but so sloppily."[93] In this case, unfortunately, he did not succeed at all.

The chronicle of these technical disasters recalls those that beset Leonardo da Vinci, with whom we have already compared Degas several times. The older master's "disregard for media of execution," writes Kenneth Clark, "marked all his most important works. *The Last Supper, The Battle of Anghiari*, the canalisation of the Arno were all damaged or even annihilated by this defect, which sprang not only from impatience and experimentalism, but from a certain romantic unreality."[94] The same might be said of much of the sculpture and some of the painting of Degas, whose artistic personality and attitude toward creation resembled Leonardo's in many respects. This fascinating parallel, which we have already seen Rouault draw,[95] has struck other artists who knew Degas or have studied his oeuvre closely. Thus, the American painter R. H. Ives Gammell, for whom Degas's notes and remarks are equaled only by those of Leonardo and Ingres as "verbal records of their professional thinking which are of comparable value to practicing painters," concludes that Degas's "experimental turn of mind and widely

ranging curiosity relate his thinking more closely to Leonardo's. . . ."[96] And the French painter Henri Rivière, "evoking for us memories of Degas, was reminded by him of Leonardo da Vinci's scruples, . . . scruples which were admirable in their humility but, if they impelled the artist into useful investigations, also led him into disappointments that hindered his production."[97] As in Leonardo, however, the "romantic unreality" in Degas was only the reverse of the coin: its obverse was a remarkable ingenuity and daring in the invention of new media or new methods of combining traditional ones. No matter how poignant or baffling the failures may seem, it is because the successes were so brilliant that the problem is worth discussing at all.

Notes

Frequently Cited Sources

ADHEMAR. J. Adhémar and F. Cachin, *Edgar Degas, gravures et monotypes*, Paris, 1973, catalogue of etchings and lithographs.

ATELIER. *Catalogue des tableaux, pastels et dessins par Edgar Degas et provenant de son atelier*, Galerie Georges Petit, Paris, I. May 6–8, 1918; II. December 11–13, 1918; III. April 7–9, 1919; IV. July 2–4, 1919.

CACHIN. J. Adhémar and F. Cachin, *Edgar Degas, gravures et monotypes*, Paris, 1973, catalogue of monotypes.

LEMOISNE. P.-A. Lemoisne, *Degas et son oeuvre*, 4 vols., Paris, 1946–1949, text and catalogue of paintings and pastels.

LETTRES. *Lettres de Degas*, ed M. Guérin, Paris, 1945. The English translation, by M. Kay, Oxford, 1947, has been revised here where necessary.

NOTEBOOK. T. Reff, *The Notebooks of Edgar Degas*, 2 vols., Oxford, 1976, catalogue of notebooks, cited by notebook number and page.

REWALD. J. Rewald, *Degas Sculpture, The Complete Works*, New York, 1956, catalogue of sculptures.

Introduction

1. L. E. Duranty, *La Nouvelle Peinture*, ed. M. Guérin, Paris, 1946 [1st ed. 1876], p. 43. He identified Degas explicitly in annotating a copy of the pamphlet; see O. Reuterswärd, "An Unintentional Exegete of Impressionism," *Konsthistorisk Tijdskrift*, 4, 1949, p. 112.

2. L. E. Duranty, "Le Peintre Louis Martin," *Le Pays des arts*, Paris, 1881, pp. 335–336; from *Le Siècle*, November 13–16, 1872.

3. G. Moore, letter to Daniel Halévy, 1931, *Lettres*, Eng. trans., p. 237.

4. P. Valéry, *Degas Manet Morisot*, trans. D. Paul, New York, 1960, p. 63; from *Degas danse dessin*, Paris, 1936.

5. *Ibid.*, pp. 5–6.

6. See the bibliography in J. Rewald, *The History of Impressionism*, 4th ed., New York, 1973, pp. 629–634; and the works of Adhémar, Cachin, and Reff listed in the Frequently Cited Sources, above.

7. G. Moore, "Degas, The Painter of Modern Life," *Magazine of Art*, 13, 1890, p. 423.

8. J.-K. Huysmans, "L'Exposition des Indépendants en 1880," *L'Art moderne*, Paris, 1883, pp. 120–121.

I. The Butterfly and the Old Ox

1. J. Engelhart, "Meine Erlebnisse mit James McNeill Whistler aus dem Jahre 1898," *Der Architekt*, 21, 1916–1918, p. 53.

2. See Notebook 12, pp. 11, 72, and Notebook 13, pp. 41–45; used in 1858–1859. The portrait is Lemoisne, no. 105; dated 1862.

3. See D. Sutton, *Nocturne, The Art of James McNeill Whistler*, London, 1963, pp. 21–22, 72–74, 78–79, etc.; also p. 134 on a self-portrait of 1898 inspired by Velázquez.

4. J. Raunay, "Degas, souvenirs anecdotiques," *Revue de France*, 11, Part 2, 1931, p. 482.

5. Letter of February 18, 1873, Paris, Bibliothèque Nationale, Nouv. Acq. Fr. 13005, fol. 9; published only in English, in *Lettres*, Eng. trans., p. 32. Letter of August 22, 1875; T. Reff, "Some Unpublished Letters of Degas," *Art Bulletin*, 50, 1968, pp. 89–90.

6. Letter of May 2, 1882, *Lettres*, p. 62. The picture is in the collection of Ian Gilmour, London.

7. Letters dated "9 March" and "Saturday"; Glasgow, University Library, B. P. II, D/4 and D/5. I am indebted to the late McLaren Young for making photocopies of the Whistler-Degas correspondence there available to me.

8. Letter of November 27, 1891; *Correspondance Mallarmé-Whistler*, ed. C. P. Barbier, Paris, 1964, p. 129. The picture is in the Louvre.

9. J.-E. Blanche, *Propos de peintre, de David à Degas*, Paris, 1919, p. 54.

10. Draft of an undated letter; Glasgow, University Library, B. P. II, D/6.

11. Draft of an undated letter; Glasgow, University Library, B. P. II, D/7.

12. D. Cooper, *The Courtauld Collection, A Catalogue and Introduction*, London, 1954, p. 18.

13. *Catalogue des estampes . . . collection Edgar Degas*, Hôtel Drouot, Paris, November 6–7, 1918, nos. 316–323.

14. W. Rothenstein, *Men and Memories*, 3 vols., New York, 1931–1938, I, p. 101.

15. *Ibid.*, pp. 101–102.

16. G. Moore, "Degas, The Painter of Modern Life," *Magazine of Art*, 13, 1890, p. 425; see also the remarks reported on p. 420.

17. Letters exchanged October 20 and 25, 1890; *Correspondance Mallarmé-Whistler*, pp. 71–72.

18. Draft of an undated letter; Glasgow, University Library, B. P. II, D/8.

19. H. Meilhac and L. Halévy, *Théâtre*, 8 vols., Paris, 1900–1902, III, pp. 88–89, 120; first produced October 6, 1877. See Chap. IV, pp. 186–187.

20. J. Hollingshead, *The Grasshopper, A Drama in Three Acts*, London, 1877, p. 27; first produced December 10, 1877. On Pellegrini's caricature, see the appendix to this chapter.

21. Lemoisne, no. 245; dated ca. 1869.

22. E. R. and J. Pennell, *The Life of James McNeill Whistler*, 2 vols., Philadelphia, 1908, I, p. 235.

23. Lemoisne, nos. 199–205, 217–253; all dated ca. 1869.

24. Pennell, *Life of Whistler*, I, p. 234. G. Jeanniot, "Souvenirs sur Degas," *Revue Universelle*, 55, 1933, p. 281.

25. Jeanniot, "Souvenirs sur Degas," p. 158. J. M. Whistler, *The Gentle Art of Making Enemies*, New York, 1890, pp. 142–143; the lecture was first given February 20, 1885, and published in 1888.

26. Letter of September 1885, *Lettres*, p. 109. Degas had evidently heard, or heard about, the lecture when Whistler repeated it in Dieppe that summer; see *ibid.*, note 4.

27. See Whistler's letter to Mallarmé, June 19, 1891, *Correspondance Mallarmé-Whistler*, p. 90.

28. Pennell, *Life of Whistler*, I, p. 165.

29. T. R. Way, *Memories of James McNeill Whistler*, London, 1912, pp. 2–25, 50, 55–56, 71, 90–91. Pennell, *Life of Whistler*, I, pp. 164–165.

30. See D. Rouart, *Degas à la recherche de sa technique*, Paris, 1945; and Chap. VII, pp. 294–298.

31. See Way, *Memories of Whistler*, pp. 95–96; and Chap. VII, pp. 298–302.

32. See Pennell, *Life of Whistler*, I, pp. 179–180; and Way, *Memories of Whistler*, pp. 54–55.

33. E. Degas, "A Propos du Salon," *Paris-Journal*, April 12, 1870; reprinted in Reff, "Some Unpublished Letters," pp. 87–88.

34. E. Moreau-Nélaton, "Deux heures avec Degas," *L'Amour de l'Art*, 12, 1931, p. 268; based on an interview in December 1907.

35. See L. W. Havemeyer, *Sixteen to Sixty, Memoirs of a Collector*, New York, 1961, p. 250; A. Vollard, *Degas*, Paris, 1924, pp. 72–74; and Notebook 30, pp. 19, 25–26, etc.

36. Lemoisne, no. 517; dated 1879.

37. See Wildenstein, New York, *From Realism to Symbolism, Whistler and His World*, March 4—April 3, 1971, no. 140, and the works cited there.

38. Paul Poujaud, letter to Marcel Guérin, July 11, 1936, *Lettres*, p. 256.

39. Lemoisne, no. 79; dated 1860–1862, but more likely of 1859–1860. The other works are illustrated in J. Rewald, *The History of Impressionism*, 4th ed., New York, 1973, pp. 32–33; see also Sutton, *Nocturne*, pp. 25–26.

40. The first works in which such features occur are *Mlle Fiocre in the Ballet from "La Source"* [9], 1866–1868, and *Thérèse Morbilli* [77], ca. 1869; Lemoisne, nos. 146, 255. See J. Sandberg, "'Japonisme' and Whistler," *Burlington Magazine*, 106, 1964, p. 503.

41. Lemoisne, no. 125; dated 1865. *Wapping* is illustrated in D. Sutton, *James McNeill Whistler*, London, 1966, pl. 11.

42. Lemoisne, no. 313; dated 1872–1873.

43. See Sandberg, "'Japonisme' and Whistler," pp. 500–507; and B. Gray's reply in *Burlington Magazine*, 107, 1965, p. 324. The picture is illustrated in Sutton, *James McNeill Whistler*, pl. 44.

44. Lemoisne, no. 175. Another example, also of 1866, is *The Collector of Prints* [65], where a Chinese ceramic and Japanese textiles appear in the background; Lemoisne, no. 138.

45. Letter to Fantin-Latour, September 1867; quoted in Sutton, *Nocturne*, pp. 56–57. On the influence of Ingres, see also *ibid.*, p. 60.

46. *Ibid.*, pp. 20–21. Notebook 2, p. 48; used in 1854–1855.

47. See A. Jullien, *Fantin-Latour, sa vie et ses amitiés*, Paris, 1909, pp. 62–65.

48. See this chapter, note 40; and *From Realism to Symbolism*, no. 63.

49. Notebook 20, p. 17; used in 1864–1867.

50. L. Bénédite, "Whistler," *Gazette des Beaux-Arts*, 34, 1905, pp. 154–158. On its correct date, and the presence of Whistler's painting in Paris, see *From Realism to Symbolism*, no. 18.

51. On the influence of another Whistler, *The White Girl*, 1862, see A. Staley, "Whistler and His World," *From Realism to Symbolism*, p. 22. *Repose* is illustrated in Rewald, *History of Impressionism*, p. 225.

52. Letter of November 19, 1872; Paris, Bibliothèque Nationale, Nouv. Acq. Fr. 13005, fol. 6; published only in English, in *Lettres*, Eng. trans., p. 19.

53. Letter of February 18, 1873; see this chapter, note 5.

54. Cooper, *Courtauld Collection*, p. 22, note 1. A dance picture, Lemoisne, no. 298, was exhibited there in November 1872; see R. Pickvance, "Degas's Dancers, 1872–1876," *Burlington Magazine*, 105, 1963, pp. 256–257.

55. See this chapter, note 3; and E. and J. de Goncourt, *Journal, mémoires de la vie littéraire*, ed. R. Ricatte, 22 vols., Monaco, 1956, X, pp. 163–165, dated February 13, 1874.

56. See Arts Council Gallery, London, *James McNeill Whistler*, September 1–24, 1960, no. 36; also nos. 33, 34.

57. Lemoisne, no. 404; dated 1876–1877. See also nos. 372, 405, etc.

58. W. Sickert, *A Free House! or The Artist as Craftsman*, ed. O. Sitwell, London, 1947, p. 147.

59. T. R. Way, *Mr. Whistler's Lithographs*, 2nd ed., London, 1905, nos. 43–45, 48–50, 53–59. The painting is illustrated in Sutton, *James McNeill Whistler*, pl. 103.

60. Lemoisne, no. 368; dated ca. 1875. See also the monotypes, Cachin, nos. 56–68; dated ca. 1880, but more likely of ca. 1878. For Bonnard's series, see C. Roger-Marx, *Bonnard lithographe*, Monte Carlo, 1952, nos. 56–68.

61. Lemoisne, no. 438; dated ca. 1876. See Sutton, *James McNeill Whistler*, pl. 114; on its debt to Degas, see A. McLaren Young, "Whistler Unattached," Nottingham University Art Gallery, *James McNeill Whistler*, January 10–February 4, 1970, p. 8.

62. Pennell, *Life of Whistler*, 5th ed., 1911, p. 157.

63. Way, *Memories of Whistler*, pp. 21–22. See Way, *Mr. Whistler's Lithographs*, nos. 10, 81, 114; the last two, printed in 1895–1896, may have been drawn earlier, then transferred to stones.

64. J. Hollingshead, *My Lifetime*, 2 vols., London, 1895, II, pp. 154–155; from the *Daily News*, December 14, 1877. See also Hollingshead, II, pp. 120–121.

65. A. E. Gallatin, *The Portraits and Caricatures of James McNeill Whistler*, London, 1913, no. 154, with illustration.

66. Lemoisne, no. 407; dated 1876–1877. See J. S. Boggs, *Portraits by Degas*, Berkeley, 1962, p. 53.

67. Notebook 27, pp. 8, 18, 28, 34, 98; used in 1875–1878. Notebook 26, pp. 4, 50, 78, 98; used in 1875–1877.

II. "Three Great Draftsmen"

1. G. Moore, "Degas, The Painter of Modern Life," *Magazine of Art*, 13, 1890, p. 423.

2. For Ingres, see this chapter, pp. 43–50; for Flaxman, T. Reff, "Degas's Copies of Older Art," *Burlington Magazine*, 105, 1963, p. 248; for David, *ibid.*, pp. 247–248, and Lemoisne, no. 8, dated 1854–1855.

3. Reff, "Degas's Copies of Older Art," pp. 245, 248; and T. Reff, "New Light on Degas's Copies," *Burlington Magazine*, 106, 1964, p. 257.

4. See this chapter, pp. 55–60; also P. Pool, "The History Pictures of Edgar Degas and Their Background," *Apollo*, 80, 1964, pp. 306–311.

5. For Fromentin, see Reff, "New Light on Degas's Copies," p. 257; for Chassériau, Notebook 14A, p. 9. For Lawrence, see Lemoisne, nos. 81, 189; both dated 1868–1870, but more likely of 1860–1862.

6. For Géricault, see T. Reff, "Further Thoughts on Degas's Copies," *Burlington Magazine,* 113, 1971, pp. 537–538; for De Dreux, Notebook 13, pp. 60, 61, 65–66, 68, etc., used in 1858–1860.

7. For Meissonier, see Reff, "Further Thoughts on Degas's Copies," pp. 537–538; for Herring, Chap. III, p. 117.

8. See J. S. Boggs, *Portraits by Degas,* Berkeley, 1962, pp. 32–33; and T. Reff, "Manet's Portrait of Zola," *Burlington Magazine,* 117, 1975, p. 39. Compare, among others, Degas's *At the Café-Concert,* Lemoisne, no. 380, with Manet's *Café-Concert Singer,* P. Jamot and G. Wildenstein, *Manet,* 2 vols., Paris, 1932, no. 333; and Degas's *Absinthe,* Lemoisne, no. 393, with Manet's *In the Café,* Jamot-Wildenstein, no. 314. There are also similarities between their pictures of nudes around 1880: compare Degas's *Crouching Nude Seen from Behind,* Lemoisne, no. 547, with Manet's *Woman in a Tub,* Jamot-Wildenstein, no. 424; and Degas's *Leaving the Bath,* Lemoisne, no. 554, with Manet's *The Toilette,* Jamot-Wildenstein, no. 421.

9. For Daumier, see this chapter, pp. 74–80; for Gavarni, p. 311, notes 115, 116.

10. For Victorian art, see Chap. V, pp. 227–236. For Menzel, see Reff, "New Light on Degas's Copies," p. 255; and Lemoisne, no. 190, incorrectly dated 1868–1870; also Chap. V, notes 88, 97.

11. Compare the collection of his close friend Henri Rouart, which was strong in Delacroix, as well as Corot and Daumier, but weak in Ingres; *Catalogue des tableaux . . . collection de feu M. Henri Rouart,* Galerie Manzi-Joyant, Paris, December 9–11 and 16–18, 1912, *passim.*

12. A. M. Wagner, "Degas's Collection of Art, An Introductory Essay and Catalogue," M. A. Thesis, Brown University, 1974, p. 187.

13. G. Jeanniot, "Souvenirs sur Degas," *Revue Universelle,* 55, 1933, p. 171. According to Lemoisne, I, p. 141, Degas began frequenting the Café de la Rochefoucauld ca. 1883.

14. Notebook 27, p. 43; used in 1875–1878. See T. Reff, "A Page of Degas Signatures," *Gazette des Beaux-Arts,* 55, 1960, pp. 183–184, on which the following is partly based.

15. For samples of their signatures, see A. Jullien, *Ernest Reyer, sa vie et ses oeuvres,* Paris, n. d., opposite pp. 12, 36, 78; and E. Bénézit, *Dictionnaire critique et documentaire des peintres, dessinateurs et graveurs,* 8 vols., Paris, 1950, III, p. 56 (Daumier), p. 126 (Delacroix), p. 311 (Doré), and V, p. 65 (Ingres).

16. Compare the signatures on Lemoisne, nos. 339, 363, 380, with those on nos. 393, 409, 444; the former group dated 1874–1875, the latter group 1876–1877.

17. Notebook 12, pp. 106–107; used in 1858–1859.

18. Notebook 11, pp. 104–105; used in 1857–1858.

19. G. Rouault, *Souvenirs intimes,* Paris, 1927, p. 94.

20. P. Valéry, *Degas Manet Morisot,* trans. D. Paul, New York, 1960, pp. 34–35; from *Degas danse dessin,* 1936.

21. *Ibid.,* p. 35. See also D. Halévy, *My Friend Degas,* trans. M. Curtiss, Middletown, 1964, pp. 49–50; and E. Moreau-Nélaton, "Deux heures avec Degas," *L'Amour de l'Art,* 12, 1931, pp. 269–270.

22. Notebook 2, pp. 48, 68; see also the copies on pp. 9, 54; used in 1855.

23. For the *Martyrdom,* see Reff, "New Light on Degas's Copies," p. 255, fig. 6; for the *Bather,* Notebook 2, p. 59. For Ingres's copies, see G. Wildenstein, *Ingres,* London, 1954, nos. 29–32, 66–68, 149–151, etc.

24. Notebook 2, pp. 30, 79, 82, 83 (illustrated above).

25. Drawing in the planned Fifth Sale of Degas's studio; Durand-Ruel photograph no. 15408 (illustrated above). Notebook 19, p. 50; see also p. 49; used in 1860–1862.

26. Lemoisne, nos. 91 (illustrated above), 92, 93; dated 1861–1862, but more likely of 1859–1860.

27. Notebook 15, pp. 2, 8, 16, 38; used in 1859–1860. The painting is Lemoisne, no. 94; dated 1861–1864, but more likely of 1859–1860.

28. See Reff, "Further Thoughts on Degas's Copies," pp. 534, 537; and Chap. IV, pp. 150–152.

29. See E. Galichon, "Description des dessins de M. Ingres exposés au Salon des Arts-Unis," *Gazette des Beaux-Arts,* 9, 1861, pp. 343–362, and 11, 1861, pp. 38–48.

30. The study is *Atelier,* IV, no. 120c. The early version is Lemoisne, no. 95, dated 1861–1864, but more likely of 1859–1860.

31. J. Rosenberg, *Great Draughtsmen from Pisanello to Picasso,* Cambridge, 1959, pp. 106–107.

32. See Boggs, *Portraits by Degas,* p. 9, pls. 11, 12; and Lemoisne, no. 5. There are studies for the latter, together with copies after Ingres, in Notebook 2, pp. 58B, 84–85; used in 1854–1855.

33. Notebook 17, p. 5; probably drawn ca. 1860.

34. For example, in Lemoisne, I, p. 34; and Boggs,

Portraits by Degas, p. 13. The portrait is Lemoisne, no. 79; dated 1860–1862, but more likely of 1859–1860.

35. See Lemoisne, I, p. 37; and S. Barazzetti, "Degas et ses amis Valpinçon," *Beaux-Arts,* no. 190, August 21, 1936, p. 3.

36. See Rosenberg, *Great Draughtsmen,* p. 109. However, Degas could not have known the portrait of Mme Ingres; on its provenance, see Fogg Art Museum, Cambridge, *Ingres, Centennial Exhibition,* February 12– April 9, 1967, no. 104.

37. Lemoisne, no. 255; dated ca. 1869. Wildenstein, *Ingres,* no. 248.

38. Lemoisne, no. 333; dated ca. 1873. Compare the *Portrait of a Young Woman* that was later in Degas's collection, *Ingres, Centennial Exhibition,* no. 4.

39. Lemoisne, no. 389; dated 1875–1880. Wildenstein, *Ingres,* no. 81.

40. C. Ephrussi, "Exposition des Artistes Indépendants," *Gazette des Beaux-Arts,* 21, 1880, p. 486.

41. L. E. Duranty, "Salon de 1872," *Paris-Journal,* May 11–June 15, 1872; quoted in M. Crouzet, *Un Méconnu du Réalisme: Duranty,* Paris, 1964, p. 310.

42. L. E. Duranty, *La Nouvelle Peinture,* ed. M. Guérin, Paris, 1946 [1st ed. 1876], pp. 32–33.

43. See H. Lapauze, "Ingres chez Degas," *La Renaissance de l'Art Français,* 1, no. 1, March 1918, p. 9.

44. See L. Hoctin, "Degas photographe," *L'Oeil,* no. 65, May 1960, pp. 36–38. The photographer was a young Englishman named Barnes, whom Degas befriended.

45. Valéry, *Degas Manet Morisot,* pp. 32–33.

46. Letter to Ludovic Halévy, September 1885, *Lettres,* p. 112.

47. Moore, "Degas," p. 422.

48. Letter to P.-A. Bartholomé; undated, but probably written in the spring of 1889, when many of Ingres's drawings were shown at the Palais du Champ de Mars as part of the World's Fair; *Lettres,* p. 127.

49. Halévy, *My Friend Degas,* p. 50.

50. Valéry, *Degas Manet Morisot,* p. 82. Halévy, *My Friend Degas,* p. 50.

51. Letters to the Mayor of Montauban, August 25, 1897, and Alexis Rouart, July 28, 1896, *Lettres,* pp. 217–218, 211–212. He also offered to cooperate in publishing a catalogue of the Montauban drawings; see Lapauze, "Ingres chez Degas," p. 9.

52. Letter of August 30, 1898, *Lettres,* p. 220. The copy in question was either of *The Envoys of Agamemnon* or of *Oedipus and the Sphinx,* Wildenstein, *Ingres,* nos. 8, 61.

53. *Catalogue des tableaux . . . collection Edgar Degas,* Galerie Georges Petit, Paris, March 26–27, 1918, nos. 50–69, 182–214; and November 15–16, 1918, nos. 182–212. On the Leblanc portraits, see the appendix to this chapter.

54. Valéry, *Degas Manet Morisot,* p. 34; dated October 22, 1905.

55. See Lapauze, "Ingres chez Degas," pp. 9–10.

56. E. and J. de Goncourt, *Manette Salomon,* Paris, 1894 [1st ed. 1867], p. 16. See F. A. Trapp, "The Universal Exhibition of 1855," *Burlington Magazine,* 107, 1965, pp. 300–305.

57. Moreau-Nélaton, "Deux heures avec Degas," p. 268; dated December 26, 1907.

58. Letter of January 4, 1859; quoted in Lemoisne, I, p. 229, note 35.

59. See this chapter, p. 41; and P. Pool, "Degas and Moreau," *Burlington Magazine,* 105, 1963, pp. 251–256. See also Degas's letters to Moreau of 1858–1859; T. Reff, "More Unpublished Letters of Degas," *Art Bulletin,* 51, 1969, pp. 281–286.

60. L. E. Duranty, "Salon de 1859," *Courrier de Paris,* April 19 and 26, and May 3, 1859; quoted in Crouzet, *Un Méconnu du Réalisme,* pp. 89–90, 199–200.

61. See A. Jullien, *Fantin-Latour, sa vie et ses amitiés,* Paris, 1909, pp. 62–65, with illustration.

62. Notebook 13, p. 53; used in 1858–1860. Notebook 18, p. 127; used in 1859–1864.

63. Drawings formerly in the collections of Jeanne Fèvre and Maurice Exsteens; see G. Fries, "Degas et les maîtres," *Art de France,* 4, 1964, pp. 354, 355, notes 36, 37.

64. Notebook 16, p. 35; used in 1859–1860. Reff, "New Light on Degas's Copies," p. 252.

65. Notebook 14, pp. 59, 63–65, 70, 72–74; used in 1859–1860.

66. For the *Christ,* see Notebook 16, p. 20A; for the *Combat,* Fries, "Degas et les maîtres," pp. 353, 355; for the *Mirabeau,* Notebook 18, p. 53. Other copies after Delacroix made in this period are in Notebook 14, p. 44 (*Hamlet and the Two Gravediggers*), and Notebook 16, p. 36 (*Massacre at Scio*).

67. Notebook 18, p. 53A. See Fries, "Degas et les maîtres," p. 354.

68. Notebook 14, p. 1. In Naples the following year, he was reminded of the similar tonality of the seascape in Delacroix's *Demosthenes Addressing the Waves of the Sea;* Notebook 19, p. 15; used in 1860–1862.

69. Notebook 15, p. 6; used in 1859–1860. The original coloring of Jephthah's costume appears in the cracks that have developed in the present paint surface.

70. See Fries, "Degas et les maîtres," pp. 354–355.

71. Lemoisne, no. 96; dated 1861–1864, but more likely of 1859–1860. On the influence of Delacroix, see also E. Mitchell, "La Fille de Jephté par Degas," *Gazette des Beaux-Arts*, 18, 1937, pp. 181–182.

72. A leaping dog had already appeared in some of the studies: Notebook 18, pp. 5, 15, 17; and Lemoisne, no. 97.

73. See Valéry, *Degas Manet Morisot*, pp. 91–93; and Chap. VII, pp. 299–302.

74. See C. Sterling, "Chassériau et Degas," *Beaux-Arts*, no. 21, May 26, 1933, p. 2.

75. Goncourt, *Manette Salomon*, p. 13. See L. Rosenthal, *Du Romantisme au Réalisme*, Paris, 1914, pp. 157–167.

76. Lemoisne, nos. 124, 125; both are signed and dated 1865.

77. A. Robaut, *L'Oeuvre complet de Eugène Delacroix*, Paris, 1885, nos. 557 (illustrated above), 1012, 1041, 1071, 1072 (Metropolitan Museum). On the possible influence of Courbet and Millet, see Boggs, *Portraits by Degas*, p. 32.

78. See the examples by Paolo Porpora and Andrea Scacciati that Degas might have seen in Naples and Florence; Palazzo Reale, Naples, *La Natura Morta Italiana*, October–November 1964, nos. 58, 168. The laboratory examination report is in Metropolitan Museum of Art, New York, *Impressionism, A Centenary Exhibition*, December 12, 1974–February 10, 1975, p. 73.

79. See the remarks reported in E. and J. de Goncourt, *Journal, Mémoires de la vie littéraire*, ed. R. Ricatte, 22 vols., Monaco, 1956, X, pp. 164–165; dated February 13, 1874.

80. Letter to P.-A. Bartholomé, September 9, 1882, *Lettres*, p. 69.

81. Letter to the same, September 18, 1889, *Lettres*, p. 145.

82. Letter to Henri Rouart, October 26, 1880, *Lettres*, p. 60. The pastel in question is probably Robaut, *Eugène Delacroix*, no. 329 or 1057.

83. J.-K. Huysmans, "L'Exposition des Indépendants en 1880," *L'Art moderne*, Paris, 1883, pp. 119–120.

84. See the provenance in M. Sérullaz, *Mémorial de l'Exposition Eugène Delacroix*, Paris, 1963, no. 123; both earlier and later, the picture was in private collections.

85. Lemoisne, no. 101; dated 1862–1880.

86. See A. Michel, "L'Exposition d'Eugène Delacroix à l'Ecole des Beaux-Arts," *Gazette des Beaux-Arts*, 31, 1885, pp. 285–308.

87. Lemoisne, no. 772; dated 1884, but first exhibited in 1886, hence possibly of ca. 1885. The use of cross-hatched, complementary colors in *The Toilette* [186], another pastel of this period in the Metropolitan Museum, also shows Delacroix's influence; see Lemoisne, no. 847, dated ca. 1885.

88. Fries, "Degas et les maîtres," pp. 355–356. I am indebted to Mr. Fries for the photograph. If the picture framer on the rue Fontaine whose stamp appears on the back of Degas's copy (*ibid.*, p. 356, note 59) was Tasset et Lhote, this would support a date in the mid-1890s rather than earlier; see J. Fèvre, *Mon Oncle Degas*, ed. P. Borel, Geneva, 1949, p. 140.

89. See Reff, "New Light on Degas's Copies," p. 256, fig. 5. The Delacroix figured in a sale in 1897 for which Durand-Ruel, Degas's dealer, was the expert; see Sérullaz, *Mémorial de l'Exposition Eugène Delacroix*, no. 490.

90. For example, in *Four Dancers Waiting in the Wings*, Lemoisne, no. 1267; dated 1896–1899.

91. See D. Rouart, *Degas à la recherche de sa technique*, Paris, 1945, p. 46, for this and what follows.

92. Halévy, *My Friend Degas*, pp. 72–73; on the lithographs, see p. 57. According to Valéry, *Degas Manet Morisot*, p. 71, Degas already "greatly admired" *The Battle of Taillebourg*.

93. See Jeanniot, "Souvenirs sur Degas," p. 158.

94. *Ibid.*, pp. 284–285.

95. See Paul Poujaud's letter to Marcel Guérin, January 15, 1933, *Lettres*, p. 253; and *Catalogue des tableaux . . . collection Edgar Degas*, March 26–27, 1918, nos. 24–36.

96. *Ibid.*, nos. 110–165; and *ibid.*, November 15–16, 1918, nos. 86–153.

97. See, for example, his *Ménagerie parisienne*, Paris, 1854, pls. 10, 12, etc.; and his illustrations for B. Jerrold, *London, A Pilgrimage*, London, 1872, pp. 161, 167, etc. The Dante illustration in Notebook 18, p. 116, ca. 1861, is clearly based on those by Doré in the Paris, 1861, edition of *The Inferno*.

98. D. Halévy, *Pays parisiens*, Paris, 1929, p. 60.

99. See Crouzet, *Un Méconnu du Réalisme*, pp. 332–344.

100. Jeanniot, "Souvenirs sur Degas," p. 171. The proofs were of *The Rue Transnonain* and *Liberty of the Press;* L. Delteil, *Honoré Daumier (Le Peintre-graveur illustré)*, 10 vols., Paris, 1925–1926, nos. 135, 133, respectively; both dated 1834.

101. Jeanniot, "Souvenirs sur Degas," p. 171.

102. Notebook 6, pp. 15–18; used in 1856.

103. Lemoisne, no. 766 *bis;* dated 1884. See also the drawings, *Atelier*, IV, nos. 264b, 272b, 276b; and Boggs, *Portraits by Degas*, pp. 67–68.

104. Dayton Art Institute, *Jean-Léon Gérôme*, November 10–December 30, 1972, nos. 41, 42.

105. L. E. Duranty, "Daumier," *Gazette des Beaux-Arts*, 17, 1878, p. 429.

106. *Ibid.*, pp. 432, 439. See Delteil, *Honoré Daumier*, no. 131; dated 1834.

107. Notebook 31, p. 6; used in 1878–1879. Significantly, the 1878 article was the only one Duranty wrote on Daumier, other than a partial repetition of it in 1879; see Crouzet, *Un Méconnu du Réalisme*, p. 374, note 119.

108. Duranty, "Daumier," pp. 438–440.

109. *Ibid.*, pp. 429–430.

110. See T. Reff, *The Notebooks of Edgar Degas*, 2 vols., Oxford, 1976, I, pp. 25–28, on which the following is based.

111. Notebook 21, pp. 18 (illustrated above), 20, 20 verso; used in 1865–1868. See Delteil, *Honoré Daumier*, no. 76; dated 1834. Another example is *1830 and 1833, ibid.*, no. 66; dated 1834.

112. Notebook 23, pp. 32, 33, 84, 148–151, 153 (illustrated above); used in 1868–1872. The quotation is from E. Kris, *Psychoanalytic Explorations in Art*, New York, 1952, pp. 191–192.

113. Notebook 31, pp. 84, 85 (illustrated above), 92, 96; used in 1878–1879. See the photographs reproduced in L. Deffoux, *Chronique de l'Académie Goncourt*, Paris, 1909, opposite pp. 40, 112.

114. See Lemoisne, I, pp. 95–97; Boggs, *Portraits by Degas*, pp. 29, 53–54; and P. Jones, "Daumier et l'Impressionnisme," *Gazette des Beaux-Arts*, 55, 1960, pp. 247–250. The one exception is M. E. Fahs, "Daumier's Influence on Degas, Cézanne, and Seurat," M. A. Thesis, Columbia University, 1961, on which the following is partly based.

115. Lemoisne, I, pp. 181–182. It may be significant that Lemoisne is also the author of the standard monograph on Gavarni.

116. Jeanniot, "Souvenirs sur Degas," p. 171. However, see Chap. V, note 155, for one instance of the type of influence Gavarni may have exerted on Degas.

117. Lemoisne, no. 186; dated 1868–1869. Delteil, *Honoré Daumier*, no. 2243; dated 1852.

118. Lemoisne, no. 295; dated 1872. Delteil, *Honoré Daumier*, no. 2908; dated 1857.

119. Lemoisne, no. 433; dated ca. 1877. Delteil, *Honoré Daumier*, no. 3277; dated 1864.

120. Lemoisne, no. 405; dated 1876–1877. Delteil, *Honoré Daumier*, no. 2231; dated 1852.

121. Lemoisne, no. 380; dated 1875–1877. Delteil, *Honoré Daumier*, no. 2245; dated 1852.

122. Cachin, no. 56; dated ca. 1880, but more likely of ca. 1878. Delteil, *Honoré Daumier*, no. 2903; dated 1857. I owe this comparison to Barbara Mathes. For the influence of a Daumier print on *Portraits at the Bourse*, Lemoisne, no. 499, dated 1878–1879, see Boggs, *Portraits by Degas*, p. 54.

123. See Lemoisne, I, pp. 180–181. Only 746 prints are listed in the *Catalogue des estampes . . . collection Edgar Degas*, Hôtel Drouot, Paris, November 6–7, 1918, nos. 61–103, the rest presumably having been withheld from sale.

124. See Lemoisne, I, pp. 146–148; and K. E. Maison, *Honoré Daumier*, 2 vols., Greenwich, 1968, I, pp. 31–33, 46.

125. A. Silvestre, review of the exhibition in *La Vie Moderne*, April 24, 1879; quoted in Lemoisne, I, p. 245, note 131. The painting is Lemoisne, no. 410; dated 1876–1878, but possibly as early as 1874: see Notebook 22, p. 186; used in 1867–1874.

126. Maison, *Honoré Daumier*, nos. I-159 and I-84, respectively. However, Duranty recalled the latter clearly enough in 1878; "Daumier," p. 538.

127. Lemoisne, no. 685; dated 1882.

128. For example, Lemoisne, no. 846; dated 1885. See also the etching, Adhémar, no. 32; dated ca. 1879.

129. Lemoisne, no. 647; dated ca. 1881. Maison, *Honoré Daumier*, no. I-146.

130. Lemoisne, no. 478 *bis;* dated 1878. Maison, *Honoré Daumier*, nos. I-128, I-129, I-223.

131. These are *Catalogue des tableaux . . . collection Edgar Degas*, March 26–27, 1918, nos. 23, 106–108; and November 15–16, 1918, no. 85.

132. Corot, Courbet, Millet, and Ingres are also the ones Duranty singles out as important predecessors in *La Nouvelle Peinture*, pp. 32–33.

133. See T. Reff, "Copyists in the Louvre, 1850–1870," *Art Bulletin*, 46, 1964, pp. 552–553; and K. S. Champa, *Studies in Early Impressionism*, New Haven, 1973, pp. 15–16.

134. See F. Daulte, "Renoir's 'Ingres' Crisis," Art Institute of Chicago, *Paintings by Renoir*, February 3–April 1, 1973, pp. 13–17; and M. Drucker, *Renoir*, Paris, 1944, pp. 24–25, 35–36, 195, 198, etc., on Delacroix.

135. See G. Mack, *Paul Cézanne*, New York, 1942, pp. 146–149, 380, on Ingres, and pp. 143, 201, on Daumier; also S. Lichtenstein, "Cézanne and Delacroix," *Art Bulletin*, 46, 1964, pp. 55–67.

136. See A. de Leiris, *The Drawings of Edouard Manet*, Berkeley, 1969, pp. 59–63, on Ingres, and pp. 18, 62–63, on Delacroix; also J. Richardson, *Manet*, London, 1969, pp. 10, 14, 89, on Daumier.

137. Valéry, *Degas Manet Morisot*, p. 25.

138. I am grateful to Philippe Brame for arranging for me to consult them. A sheet with notes on Delacroix's *Entombment*, which became separated from the others, was sold recently by the Maison Charavay, Paris; see their *Bulletin d'Autographes à Prix Marqués*, September 1975, no. 36602.

139. Halévy, *My Friend Degas*, pp. 85–86. Curiously, the passage is dated January 21, two days before the date Degas himself gives for their acquisition.

140. Metropolitan Museum of Art, *French Paintings*, ed. C. Sterling and M. Salinger, 3 vols., New York, 1935–1966, II, pp. 9–11; also H. Naef, "Ingres to M. Leblanc," *Metropolitan Museum of Art Bulletin*, 29, 1970, pp. 183–184.

141. Now in the Louvre; they were bought by Bonnat in 1890 and remained in his possession until his death, like the painted portraits bought by his friend Degas. See H. Naef, "Ingres und die Familie Leblanc," *Du-Atlantis*, 26, 1966, pp. 121, 133, figs. 2, 3.

142. Now in the Louvre; *ibid.*, p. 133, fig. 7.

143. Now in the Musée Bonnat, Bayonne; *ibid.*, p. 133, figs. 1, 8.

144. Was it in fact made in 1886, when Mme Place considered selling the portraits to the Louvre (*ibid.*, pp. 132–133)?

145. Actually, it is a warm brown with touches of red, but it does differ from the darker, cooler background of the other portrait.

III. Pictures within Pictures

1. On the history of this motif in European art, see A. Chastel, "Le Tableau dans le tableau," *Stil und Ueberlieferung in der Kunst des Abendlandes* (*Akten des 21. Internationalen Kongresses für Kunstgeschichte*), 3 vols., Berlin, 1967, I, pp. 15–29.

2. Traditionally, this has been the function of the paintings and prints represented in *trompe-l'oeil* still lifes, but this genre held no appeal for Degas. See M. Faré, *La Nature morte en France*, 2 vols., Geneva, 1962, II, pls. 103–112, 151–153, 448–453; also this chapter, note 167.

3. Lemoisne, nos. 213, 297; dated 1869 and 1872. Mirrors are also employed, sometimes very ingeniously, in Lemoisne, nos. 298, 348, 397, 516, 709, 768, 1227. Window views also occur in Lemoisne, nos. 48, 116, 174, 303, 324, 447, 700.

4. Lemoisne, no. 312; dated 1872–1873. In fact, it represents Degas's bedroom in the Valpinçons' chateau at Ménil-Hubert, and was probably painted during a visit in August 1892. See his letters to P.-A. Bartholomé, August 16 and 27, 1892, *Lettres*, pp. 192–194. I am indebted for this identification to the late Paul Brame, who visited Ménil-Hubert after the Second World War and recognized the room.

5. Notebook 2, p. 1; used in 1854–1855. See T. Reff, "New Light on Degas's Copies," *Burlington Magazine*, 104, 1964, p. 250.

6. Notebook 18, p. 35; used in 1859–1864.

7. Notebook 18, p. 117; used in 1859–1864.

8. The most thoughtful discussion of this interest remains that in J.-K. Huysmans, "Le Salon de 1879," *L'Art moderne*, Paris, 1883, pp. 111–123. On the parallel tendency in Naturalist literature, see this chapter, notes 64, 170.

9. L. E. Duranty, *La Nouvelle Peinture*, ed. M. Guérin, Paris, 1946 [1st ed. 1876], p. 45. Several of the paintings he alludes to are identified in Lemoisne, I, p. 238, note 117.

10. See Chastel, "Le Tableau dans le tableau," pp. 21–24. On Vermeer's use of the motif, see also L. Gowing, *Vermeer*, New York, 1953, pp. 48–53.

11. See W. Bürger [T. Thoré], "Van der Meer de Delft," *Gazette des Beaux-Arts*, 21, 1866, pp. 460–461; and S. Meltzoff, "The Rediscovery of Vermeer," *Marsyas*, 2, 1942, pp. 145–166.

12. Quoted in Paul Poujaud's letter to Marcel Guérin, July 11, 1936, *Lettres*, p. 256. Examples in which pictures appear are Fantin-Latour's *Two Sisters* and Whistler's *At the Piano*, both dated 1859; illustrated in J. Rewald, *The History of Impressionism*, 4th ed., New York, 1973, pp. 32–33.

13. See the other versions of the latter, Lemoisne, no. 583, and Adhémar, no. 54; both dated 1879–1880. Also the slightly earlier *Visit to the Museum*, Lemoisne, nos. 464, 465; dated 1877–1880. On their place in the views of Louvre galleries, which were popular at the time, see J. J. Marquet de Vasselot, "Répertoire des vues des salles du Musée du Louvre," *Archives de l'Art Français*, 20, 1946, pp. 266–279.

14. See Chastel, "Le Tableau dans le tableau," pp. 18–19, 25. On the "painted galleries" in particular, see S. Speth-Holterhoff, *Les Peintres flamands de cabinets d'amateurs au xviie siècle*, Brussels, 1957.

15. For Bronzino, see Notebook 2, p. 40; used in 1854–1855. For Mantegna's series, see Notebook 14A, pp. 15, 17, 19, and Notebook 15, pp. 19, 21–23, 36–37; used in 1859–1860.

16. See C. de Tolnay, "Velázquez' *Las Hilanderas* and *Las Meniñas*," *Gazette des Beaux-Arts*, 35, 1949, pp. 32–38; and Reff, "New Light on Degas's Copies," p. 252, fig. 4.

17. Lemoisne, no. 79; dated 1860–1862, but more likely of 1859–1860. See J. S. Boggs, "Edgar Degas and the Bellellis," *Art Bulletin*, 37, 1955, pp. 127–136.

18. The outstanding examples are *The Bellelli Family* itself and *The Daughter of Jephthah*, Lemoisne, no. 94; dated 1861–1864, but more likely of 1859–1860.

19. Letter from Achille de Gas, May 14, 1859; collection the late Jean Nepveu-Degas, Paris, who kindly allowed me to consult his unpublished family papers.

20. According to R. Raimondi, *Degas e la sua famiglia in Napoli*, Naples, 1958, pp. 261–262, it originally represented the Baron Bellelli, but was repainted during a restoration ca. 1900. This has not been confirmed by a technical examination, as Madeleine Hours of the Laboratoire du Musée du Louvre has kindly informed me.

21. Lemoisne, no. 33; dated 1857, incorrectly identified as Auguste de Gas, the artist's father. Adhémar, no. 6; dated 1856. The latter's identification is confirmed by

the sketches of René-Hilaire in Notebook 4, pp. 21–23; used in 1855–1856.

22. On August 31, 1858; see Raimondi, *Degas e la sua famiglia*, p. 126.

23. See de Tolnay, "Velázquez' *Las Hilanderas*," pp. 32–34; and M. Friedländer, *Die altniederländische Malerei*, 14 vols., Leiden, 1924–1937, XIII, p. 69, pl. xxxvii.

24. Letter from Laure Bellelli, April 5, 1859; collection the late Jean Nepveu-Degas, Paris.

25. For drawings by them in the Louvre by this time, see E. Moreau-Nélaton, *Les Clouet et leurs émules*, 3 vols., Paris, 1924, II, figs. 298–313.

26. *Atelier*, IV, no. 87d; probably 1855–1856; after Moreau-Nélaton, *Les Clouet*, II, fig. 308. Notebook 14, p. 67; used in 1859–1860; after Louvre 130. Degas refers to the latter—as "Janet, the Wife of Charles IX"—in planning a portrait of a woman, in Notebook 18, p. 194; used in 1859–1864.

27. Notebook 13, p. 10; used in 1859–1860. The frame on the drawing shown in *The Bellelli Family* is similar to the nineteenth-century one reproduced in Raimondi, *Degas e la sua famiglia*, pl. 20, but is not identical with it as is stated there.

28. Lemoisne, no. 138; signed and dated 1866.

29. E. Moreau-Nélaton, "Deux heures avec Degas," *L'Amour de l'Art*, 12, 1931, pp. 267–270. This type of collector is vividly evoked in E. de Goncourt, *La Maison d'un artiste*, 2 vols., Paris, 1931 [1st ed. 1881], I, pp. 33–36.

30. Lemoisne, no. 647; dated ca. 1881.

31. See K. E. Maison, *Honoré Daumier*, 2 vols., Greenwich, 1968, I, pls. 84–99, and II, pls. 115–130. *The Collector* is Lemoisne, no. 648; dated ca. 1881.

32. See H. Béraldi, *Les Graveurs du xixe siècle*, 12 vols., Paris, 1885–1892, XI, pp. 177–178, especially *Les Roses* (1835) and *Choix de soixante roses* (1836).

33. For similar examples, see E. Fuchs, *Tang-Plastik*, Munich, n.d. [1924], pls. 46, 48; and especially Shensi Province, *Selected T'ang Dynasty Figurines*, Peking, 1958 (in Chinese), pl. 160. I am indebted to Jane Gaston Mahler for these references.

34. See Victoria and Albert Museum, *Guide to the Japanese Textiles, Part I, Textile Fabrics*, London, 1919, pp. 20–21, pl. x; the examples date from the late eighteenth and early nineteenth centuries.

35. Goncourt, *La Maison d'un artiste*, I, pp. 182–183; also *ibid.*, pp. 11–17, on his own collection of Japanese fabrics, especially the so-called *fukusas*, small embroidered squares similar to those in Degas's painting.

36. See E. Chesneau, "Le Japon à Paris," *Gazette des Beaux-Arts*, 18, 1878, p. 387; and L. Bénédite, "Whistler," *ibid.*, 34, 1905, pp. 143–144. If the collector in Degas's portrait specialized in Japanese art, he is not one of those mentioned in these sources.

37. For the former, see D. Sutton, *James McNeill Whistler*, London, 1966, pl. 30; for the latter, Museum of Art, Rhode Island School of Design, Providence, *James Jacques Joseph Tissot*, February 28–March 29, 1968, no. 12. On the vogue of Japanese art in the 1860s, see G. P. Weisberg, "Japonisme: Early Sources and the French Printmaker, 1954–1882," in *Japonisme, Japanese Influence on French Art, 1854–1910*, Cleveland, 1975, pp. 1–12.

38. Victoria and Albert Museum, *Guide to the Japanese Textiles*, p. 21, pl. x, no. 98.

39. Z. Astruc, "L'Empire du soleil levant," *L'Etendard*, March 23, 1867. Sharon Flescher has kindly provided me with photocopies of Astruc's articles on *japonisme*.

40. Lemoisne, no. 175; dated 1868, but more likely of 1866–1868. See Boggs, *Portraits by Degas*, p. 106.

41. J.-E. Blanche, *Propos de peintre, de David à Degas*, Paris, 1919, p. 54, describes Whistler wielding "a bamboo mahlstick instead of a walking-stick."

42. In a self-portrait of this period, *James Jacques Joseph Tissot*, no. 8, he appears in a similarly pensive mood. Both works suggest something of the Romantic notion of the melancholy artist; see W. Hoffman, *The Earthly Paradise*, New York, 1961, pp. 227–231, pls. 56–61.

43. Lemoisne, no. 105; dated 1862. See also *ibid.*, no. 116, dated ca. 1864, where his friend De Valernes appears in a pose almost identical to Tissot's; and the latter's portrait of Degas, ca. 1865, illustrated in *ibid.*, I, opposite p. 62.

44. F. Villot, *Notice des tableaux... du Musée Impérial du Louvre*, 3 vols., Paris, 1855, II, no. 99. It is one of several workshop replicas of an earlier portrait; see M. Friedländer and J. Rosenberg, *Die Gemälde von Lucas Cranach*, Berlin, 1932, p. 58, no. 151.

45. On Tissot and Leys, see T. Gautier, *Abécédaire du Salon de 1861*, Paris, 1861, pp. 338–342; on Leys and German art, E. Chesneau, *Les Nations rivales dans l'art*, Paris, 1868, pp. 84–93.

46. For the drawings, see Notebook 14, pp. 15, 17, 19, 22, 24–26; and Notebook 18, p. 115; used in 1859–1860 and 1859–1864, respectively. The photographs are listed in Notebook 23, p. 40; used in 1868–1872.

47. Notebook 18, p. 194. It was the project for which he also referred to a Clouet portrait; see this chapter, note 26.

48. L. Binyon, *A Catalogue of Japanese and Chinese Woodcuts... in the British Museum*, London, 1916, p. 165, no. 32; see also p. 164, no. 30, for a similar example. I am indebted to Basil Gray and Jack Hillier for this suggestion, which they have made independently.

49. Letter to his mother, November 12, 1864; D. G. Rossetti, *Family Letters*, 2 vols., London, 1895, II, p. 180. See also William Rossetti's memoir, *ibid.*, I, p. 263.

50. Unpublished painting in the Musée des Beaux-Arts, Dijon. Willard Misfeldt has kindly provided information on this and other works by Tissot of the 1860s, in many cases known only from photographs in an album constituted by the artist.

51. See this chapter, note 36. At his death, Degas owned over one hundred prints, drawings, and albums by Japanese masters; *Catalogue des estampes... collection Edgar Degas*, Hôtel Drouot, Paris, November 6–7, 1918, nos. 324–331.

52. *James Jacques Joseph Tissot*, no. 9. It was evidently inspired by the hunting scenes of Courbet and the picnic scenes of Monet.

53. Not in Lemoisne. See Klipstein and Kornfeld, Bern, *Choix d'une collection privée*, October 22–November 30, 1960, no. 9; dated ca. 1865. See also the *Children and Ponies in a Park*, Lemoisne, no. 171; dated ca. 1867.

54. Illustrated in Rewald, *History of Impressionism*, p. 77. It is also reminiscent of Monet's *Luncheon on the Grass* of 1866, illustrated in *ibid.*, p. 119.

55. Hence the suggestion in J. Laver, "*Vulgar Society*," *The Romantic Career of James Tissot*, London, 1936, p. 13, that "it may form part of Tissot's Faust and Marguerite series," is unfounded. In view of Degas's competitive attitude toward Manet, it is worth noting that he, too, depicted the Finding of Moses; see R. E. Krauss, "Manet's *Nymph Surprised*," *Burlington Magazine*, 109, 1967, pp. 622–623, fig. 20.

56. Villot, *Notice des tableaux*, III, no. 202. On the influence of Veronese's version on French art at the time of La Fosse, see K. T. Parker and J. Mathey, *Antoine Watteau, catalogue complet de son oeuvre dessiné*, 2 vols., Paris, 1957, I, nos. 345, 352, and II, no. 859.

57. See Reff, "New Light on Degas's Copies," pp. 255–256; and the illustration in *Burlington Magazine*, 105, 1963, p. 249, fig. 11.

58. Letter of September 18 [1860?]; quoted in Lemoisne, I, p. 230, note 45. Titian's *Assumption of the Virgin* is in Santa Maria dei Frari; Tintoretto's *St. Mark Rescuing a Slave* is in the Accademia.

59. Lemoisne, no. 255; dated ca. 1869. Degas implies that it was recently completed in a note in Notebook 23, p. 43; used in 1868–1872.

60. Raimondi, *Degas e la sua famiglia,* p. 150. See J. S. Boggs, "Edgar Degas and Naples," *Burlington Magazine,* 105, 1963, pp. 275–276.

61. Lemoisne, no. 109; according to René de Gas, it was painted in Paris early in 1863, during Thérèse's engagement.

62. Notebook 19, p. 11; drawn in March 1860. Its relation to the portrait of Thérèse was pointed out verbally by Gerhard Fries.

63. See L. Eitner, "The Open Window and the Storm-Tossed Boat," *Art Bulletin,* 37, 1955, pp. 281–287; and J. A. Schmoll gen. Eisenwerth, "Fensterbilder," *Beiträge zur Motivkunde des 19. Jahrhunderts,* ed. L. Grote, Munich, 1970, especially pp. 82–143.

64. E. and J. de Goncourt, *Germinie Lacerteux,* Paris, 1897 [1st ed. 1865], pp. 2–3; English trans., New York, 1955. For other examples, see J. Dangelzer, *La Description du milieu dans le roman français de Balzac à Zola,* Paris, 1938, pp. 25–54, 135–151; and this chapter, note 170.

65. *Catalogue des tableaux . . . collection Edgar Degas,* Galerie Georges Petit, Paris, March 26–27, 1918, no. 4. See L. Vaillat and P. Ratouis de Limay, *J. B. Perronneau,* rev. ed., Paris, 1923, pp. 200, 227; and Boggs, *Portraits by Degas,* p. 31.

66. But see the observations on his other early portraits of her in Boggs, *Portraits by Degas,* pp. 17–18.

67. Letters from Thérèse in Paris to her husband in Naples, 1879–1881; quoted in Boggs, "Edgar Degas and Naples," p. 276.

68. See Boggs, *Portraits by Degas,* pp. 118, 125, and the works listed there.

69. See Lemoisne, I, pp. 8–9, 173. The late Paul Brame kindly confirmed that three of these pastels had been bought by his father, Hector Brame. Among them were probably A. Besnard, *La Tour,* Paris, 1928, no. 390 (identical with no. 874), listed as "former collection de Gast," and no. 326, lent to an exhibition in 1874 by "M. de Gas."

70. See J.-E. Blanche, "Portraits de Degas," *Formes,* 12, February 1931, p. 22; and J. Fèvre, *Mon Oncle Degas,* ed. P. Borel, Geneva, 1949, pp. 69–70, where, however, Perronneau is not mentioned explicitly.

71. Quoted in Vaillat and Ratouis de Limay, *Perronneau,* pp. 144–146, where the revival of interest in him is traced. At this time, too, Degas copied after a portrait by La Tour that was formerly attributed to Perronneau; see

T. Reff, "Further Thoughts on Degas's Copies," *Burlington Magazine,* 113, 1971, p. 539, fig. 59.

72. See E. and J. de Goncourt, *Journal, mémoires de la vie littéraire,* ed. R. Ricatte, 22 vols., Monaco, 1956, VI, p. 164, dated December 30, 1863, and XVI, p. 201, dated January 8, 1890.

73. Lemoisne, no. 335; dated 1873–1875, but more likely of 1869–1871, since there are studies for it in Notebook 25, pp. 36, 37, 39, which was used in those years.

74. The engraving, by J. Harris, was published as "Fores's National Sports," pl. 2, on October 25, 1847. Its presence in *Sulking* was discovered independently by Ronald Pickvance; see Wildenstein, New York, *Degas's Racing World,* March 21–April 27, 1968, Introduction.

75. Lemoisne, no. 258; dated 1869–1872.

76. Notebook 18, p. 163; written in September–October 1861. He may already have owned by then the engraving by Harris of another sporting picture by Herring that is listed in *Catalogue des estampes . . . collection Edgar Degas,* no. 199.

77. See P. Lafond, *Degas,* 2 vols., Paris, 1918–1919, II, p. 5, where it is called *The Office;* however, in *ibid.,* I, p. 37, it is called *Sulking.*

78. See H. de Mirabal, *Manuel des courses,* Paris, 1867, pp. 407–408, 413–414; and H. Lee, *Historique des courses de chevaux,* Paris, 1914, pp. 368–373, 398–399. The first issue of the *Journal des Courses,* published by Oller, appeared on June 5, 1869.

79. See the description of such a bank in G. Rivière, *Mr. Degas, bourgeois de Paris,* Paris, 1935, pp. 7–8; and the studies cited in this chapter, note 73.

80. See Lemoisne, I, p. 83; and *Lettres,* p. 31, note 1. The influence of *Sulking* is evident in a contemporary work by De Valernes, *The Visit to the Notary;* see Musée de Carpentras, *De Valernes et Degas,* May 19–September 5, 1963, no. 31; also J.-L. Vaudoyer, *Beautés de la Provence,* Paris, 1926, p. 79.

81. See A. Scharf, *Art and Photography,* Baltimore, 1974, pp. 186–187; the photograph illustrated there postdates the picture by more than twenty years.

82. See C. de Tolnay, *"The Syndics of the Drapers' Guild* by Rembrandt," *Gazette des Beaux-Arts,* 23, 1943, pp. 31–38; and Reff, "New Light on Degas's Copies," p. 251, for his interest in Rembrandt.

83. See, for example, D. C. Rich, *Degas,* New York, 1951, p. 62; and J. Bouret, *Degas,* New York, 1965, p. 81.

84. On their friendship, see L.-E. Tabary, *Duranty, étude biographique et critique,* Paris, 1954, pp. 146–149.

85. Notebook 23, pp. 44–47; used in 1868–1872. L. E. Duranty, "Sur la physionomie," *La Revue Libérale*, 2, 1867, pp. 499–523.

86. Lemoisne, no. 517; dated 1879. See also the study for it in the Metropolitan Museum [26]; and Desboutin's etched portrait of Duranty, illustrated in Rewald, *History of Impressionism*, p. 377.

87. A. Silvestre, *Au Pays des souvenirs*, Paris, 1887, pp. 174–175. Similar descriptions are given in George Moore's memoir, quoted in Rewald, *History of Impressionism*, p. 435, note 6; and in J. Claretie, *La Vie à Paris, 1880*, Paris, 1881, p. 77.

88. Lemoisne, no. 198; signed and dated 1869. See T. Reff, "Some Unpublished Letters of Degas," *Art Bulletin*, 50, 1968, p. 91.

89. Lemoisne, no. 864; dated 1885–1895. In a letter to Mme de Fleury, January 8, 1884, *Lettres*, p. 76, Degas mentions "an intimate portrait, in which M. and Mme Bartholomé are represented in their city dress." For photographs of them, see T. Burrollet, "Bartholomé et Degas," *L'Information de l'Histoire de l'Art*, 12, 1967, pp. 119–126.

90. Lemoisne, no. 188; dated 1868–1869. Degas notes two addresses of Pilet and an appointment with him, in Notebook 24, pp. 33, 99, 117; used in 1869–1873.

91. See Y. Shinoda, *Degas, der Einzug des Japanischen in die französische Malerei*, Tokyo, 1957, pp. 21–22.

92. Published in the series "Galerie de la Gazette Musicale," no. 2, 1842. See also Kriehuber's lithograph *Une Matinée chez Liszt*, 1846, illustrated in R. Bory, *La Vie de Frans Liszt par l'image*, Paris, 1936, p. 124.

93. For portraits, see R. Bory, *La Vie de Frédéric Chopin par l'image*, Paris, 1951, p. 138 (Chopin), p. 89 (Heine), p. 114 (Liszt), and p. 88 (Delacroix).

94. For portraits, see Bory, *Frédéric Chopin*, p. 91 (Halévy), p. 89 (Berlioz); and Bory, *Frans Liszt*, p. 59 (Balzac).

95. For portraits, see Bory, *Frédéric Chopin*, p. 141 (Gautier), p. 136 (Sand), p. 86 (Zalewski); and Bory, *Frans Liszt*, p. 56 (Musset).

96. For portraits, see Bory, *Frédéric Chopin*, p. 90 (Hiller), p. 142 (Bocage), and p. 92 (Franchomme). For help in identifying the figures in Degas's picture, I am indebted to Mlle Boschot of the Bibliothèque de l'Opéra, Paris.

97. F. Liszt, *Frédéric Chopin*, Eng. trans., New York, 1963, pp. 90–99; first published serially in *La France Musicale*, 1851, and in book form, Paris, 1852.

98. Lemoisne, no. 186; dated 1868–1869. On Degas's

friendships with musicians at this time, see *ibid.*, I, pp. 58–60.

99. See T. Reff, "Manet's Portrait of Zola," *Burlington Magazine*, 117, 1975, pp. 35–44.

100. See T. Reff, "Pissarro's Portrait of Cézanne," *Burlington Magazine*, 109, 1967, pp. 627–633. The background images in Renoir's *At the Inn of Mother Anthony*, 1866, play a similar role; see Reff, "Manet's Portrait of Zola," p. 42, fig. 37.

101. Among others, the ones in Notebook 28, *passim*; used in 1877. On his interest in caricature, see Boggs, *Portraits by Degas*, pp. 53–54.

102. W. Sickert, "Degas," *Burlington Magazine*, 31, 1917, p. 186. The portrait is Lemoisne, no. 207; dated 1869.

103. He had been a member of the orchestra since 1845, according to a chart in Paris, Archives Nationales, AJ.XIII.478: Personnel des choeurs et de l'orchestre de l'Opéra.

104. Letter to Emile Perrin, Director of the Opera, January 11, 1866; Archives Nationales, AJ.XIII.478. On the musicians' demands for higher wages, see also *Le Temps*, July 11, 1865, and subsequent issues.

105. See his open letter to the jury of the Salon of 1870; Reff, "Some Unpublished Letters," pp. 87–88.

106. Lemoisne, no. 326; dated ca. 1873, but more likely of ca. 1878, as we shall see.

107. Compare the appearance of the male figure in *Interior*, Lemoisne, no. 348, who also leans against a wall with his hands in his pockets.

108. See Boggs, *Portraits by Degas*, p. 55; National Gallery of Art, *European Paintings from the Gulbenkian Collection*, Washington, 1950, pp. 28–29; and the letter from Bernard Dorival cited there, p. 28, note 2.

109. See J. Rewald, *Paul Cézanne*, London, 1950, pls. 42, 47 (photographs), pls. 41, 46 (self-portraits), pl. 42 (Renoir's portrait).

110. *Catalogue de la 4me exposition de peinture*, 28 Avenue de l'Opéra, Paris, April 10–May 11, 1879, no. 69. See Lemoisne, I, p. 243, note 129.

111. Lemoisne, nos. 175, 337; dated 1868 and 1873–1879. According to Lemoisne, it was the latter that Degas exhibited; according to Lafond, *Degas*, II, p. 15, it was the former. Neither statement is supported by the provenance given by Degas himself; and Lemoisne compounds the error by placing Mr. H. M.-L. in Montreal, probably because the Gulbenkian picture was formerly in the collection of Sir George Drummond, Montreal.

112. L. E. Duranty, "Réflexions d'un bourgeois sur le salon de la peinture," *Gazette des Beaux-Arts*, 15, 1877, p. 560. On Michel-Lévy and Monet, see L. Venturi, *Les Archives de l'Impressionnisme*, 2 vols., Paris, 1939, I, pp. 248, 249, note 1.

113. Notebook 22, pp. 216, 221; used in 1867–1874. Notebook 24, p. 117; used in 1869–1873.

114. R. Gimpel, *Journal d'un collectionneur*, Paris, 1963, pp. 262–263; dated March 27, 1924, recording information given to Lucien Guiraud by Michel-Lévy himself. His sale of Degas's portrait was listed in the account book of the dealers Boussod and Valadon on March 13, 1891; see J. Rewald, "Theo Van Gogh, Goupil, and the Impressionists," *Gazette des Beaux-Arts*, 81, 1973, p. 90.

115. *Explication des ouvrages . . . exposés au Palais des Champs-Elysées*, Paris, 1878, no. 1435. See also the review of his retrospective exhibition in *La Chronique des Arts*, 48, 1911, p. 277.

116. *Explication des ouvrages . . . exposés au Palais des Champs-Elysées*, Paris, 1879, no. 2147. The photograph was published by Goupil et Cie.

117. *Catalogue des tableaux . . . atelier de M. M.-L.*, Hôtel Drouot, Paris, December 21, 1891, nos. 1–54. Galerie Bernheim-Jeune, Paris, *Exposition Henri Michel-Lévy*, November 20–December 2, 1911, *passim*.

118. *Catalogue des tableaux . . . collection H. Michel-Lévy*, Galerie Georges Petit, Paris, May 12–13, 1919. On this sale, see *La Chronique des Arts*, 54, 1917–1919, p. 191.

119. For similar observations on the mannequin, the paintings, and his own position, "trapped like an animal in a corner," see Boggs, *Portraits by Degas*, pp. 55–56.

120. J. Auberty and C. Pérusseaux, *Jacques Villon, catalogue de son oeuvre gravé*, Paris, 1950, no. 7.

121. Dated 1878, illustrated in Rewald, *History of Impressionism*, p. 427.

122. L. Vauxcelles, preface to the catalogue of the *Exposition Henri Michel-Lévy*, cited in this chapter, note 117.

123. Letter to Henri Lerolle, August 21, 1884, *Lettres*, pp. 79–80. See also the letter to P.-A. Bartholomé, December 19, 1884; quoted in Chap. V, p. 215.

124. Lemoisne, no. 424; dated ca. 1877.

125. Galerie Paul Rosenberg, Paris, *Peintures et aquarelles par Henri Rouart*, March 20–April 12, 1933, preface by P. Valéry. For other examples of his art, see

the catalogue of a similar exhibition at Galeries Durand-Ruel, Paris, March 16–30, 1912. The late Louis Rouart also expressed the opinion that the picture in Degas's portrait could not be one by his father.

126. See G. Wildenstein, *Ingres*, London, 1956, nos. 86, 88, 89, etc. (the "Raphael"), nos. 46, 253 (the "Tintoretto"). Also C. de Tolnay, "'Michel-Ange dans son atelier' par Delacroix," *Gazette des Beaux-Arts*, 59, 1962, pp. 43–52.

127. Lemoisne, no. 519; dated 1879. On his career and contact with Degas, see L. Vitali, "Three Italian Friends of Degas," *Burlington Magazine*, 105, 1963, pp. 269–270.

128. The only possibilities would be the works by De Nittis and Zandomeneghi, for which see A. Jahn-Rusconi, *La Galleria d'Arte Moderna a Firenze*, Rome, 1934, pp. 17, 23. The inventory is now in Florence, R. Biblioteca Marucelliana, Raccolta Martelli; I am indebted to Lamberto Vitali for information on its contents.

129. Lemoisne, no. 520; dated 1879. For preparatory studies that show the background, see Notebook 31, p. 25; *Fifty Master Drawings in the National Gallery of Scotland*, Edinburgh, 1961, no. 49; and J. S. Boggs, *Drawings by Degas*, Greenwich, 1967, no. 88.

130. Lemoisne, no. 581; dated 1880, but more likely of 1879, since it seems to be the work Degas lists among those he plans to show in the Impressionist exhibition of 1879, in Notebook 31, pp. 66, 68. For other versions, see this chapter, note 13.

131. See F. A. Sweet, *Miss Mary Cassatt*, Norman, 1966, p. 50. Compare the appearance of Lydia in *ibid.*, pls. IV, 10, contemporary genre pictures by Cassatt, on which see *ibid.*, pp. 51, 64–65.

132. See Shinoda, *Degas, der Einzug des Japanischen*, pp. 81–82, pls. 73–74; and especially C. F. Ives, *The Great Wave: The Influence of Japanese Woodcuts on French Prints*, New York, 1974, pp. 36–38.

133. Sweet, *Miss Mary Cassatt*, p. 50; see also *ibid.*, pp. 32–33, 39–40, on her friendship with Degas. The studies are in Notebook 33, pp. 8 verso, 9, 15; used in 1879–1882. Another study is illustrated in Boggs, *Drawings by Degas*, no. 85.

134. Villot, *Notice des tableaux*, II, no. 441; it was hung then in the Grande Galerie. Degas's drawing is in Notebook 33, p. 1, and on its verso he observed with equal concern for accuracy: "In the Grande Galerie the black draperies and silk hangings are lighter than the dark pictures."

135. Adhémar, no. 54; dated 1879–1880. Illustrated above is the third state. For further details, see University of Chicago, *Etchings by Edgar Degas*, May 4–June 12, 1964, no. 30.

136. H. O'Shea, *Les Musées du Louvre, guide populaire*, Paris, 1892, p. 398. On contemporary attitudes to Etruscan art, see Staatlichen Kunstsammlungen, Dresden, *Dialoge: Kopie, Variation und Metamorphose alter Kunst . . .*, September 27–December 31, 1970, no. 189.

137. See Degas's letters to Bracquemond and Pissarro, 1879–1880, *Lettrès*, pp. 45–55.

138. See H. J. Gourley III, "Tissots in the Museum's Collection," *Bulletin of the Rhode Island School of Design*, 50, March 1964, pp. 3–4, figs. 8–9; and *James Jacques Joseph Tissot*, no. 37. Not identified there is the statue of Dionysos (Louvre 222) at the extreme right.

139. *Atelier*, IV, no. 250a.

140. Lemoisne, no. 869; dated 1886. Reproduced in color in Boggs, *Portraits by Degas*, pl. 124.

141. For the studies, see Lemoisne, nos. 870, 870 *bis*, 871, all signed and dated 1886; and Notebook 37, pp. 204–207, used in 1882–1886.

142. For a similar comparison, see Boggs, *Portraits by Degas*, p. 68. The appearance and atmosphere of Rouart's home are vividly evoked in Blanche, *Propos de peintre*, pp. 245–276.

143. See F. Petrie, *Shabtis*, London, 1935, pls. XLIV, XLV; and Gimpel, *Journal d'un collectionneur*, p. 418, dated April 30, 1930, recording information given by Louis Rouart. I am indebted to the latter for discussing his collection with me.

144. For the example illustrated here, see H. d'Ardenne de Tizac, *The Stuffs of China, Weavings and Embroideries*, London, 1924, p. 12, pl. 34.

145. Fèvre, *Mon Oncle Degas*, p. 50. On the early copies, see T. Reff, "Addenda on Degas's Copies," *Burlington Magazine*, 107, 1965, pp. 320–323.

146. *Catalogue des tableaux . . . collection de feu M. Henri Rouart*, Galerie Manzi-Joyant, Paris, December 9–11, 1912, nos. 104–149, *passim;* the Naples landscape, dated 1828, is no. 144. See Musée de l'Orangerie, Paris, *Degas*, March–April 1937, no. 44.

147. D. Baud-Bovy, *Corot*, Geneva, n. d. [1957], pp. 38–41. On Rouart's preference for the early Corot, see Blanche, *Propos de peintre*, p. 274.

148. *Catalogue des dessins . . . collection de feu M. Henri Rouart*, Galerie Manzi-Joyant, Paris, December 16–18, 1912, nos. 209–266, *passim;* the drawing of a peasant woman is no. 231.

149. Blanche, *Propos de peintre*, p. 270. On Rouart's acquaintance with Millet, see Lemoisne, I, pp. 145–146.

150. See his letters to P.-A. Bartholomé and Ludovic Halévy, written from Naples in January 1886, *Lettres*, pp. 113–119; and Boggs, "Edgar Degas and Naples," p. 276.

151. Notebook 19, p. 6; written in March 1860.

152. Not in Lemoisne. See *Catalogue des tableaux . . . collection Edgar Degas*, Hôtel Drouot, Paris, November 15–16, 1918, no. 42 (as "Ecole moderne"); and *Catalogue des tableaux . . . collection de Mlle J. Fèvre*, Galerie Charpentier, Paris, June 12, 1934, no. 142.

153. Letter of June 30, 1898, *Lettres*, p. 223. For the Corots he owned, see *Catalogue des tableaux . . . collection Edgar Degas*, March 26–27, 1918, nos. 16–22. On his admiration for that master, see Baud-Bovy, *Corot*, pp. 130, 268.

154. *Catalogue des tableaux . . . collection Edgar Degas*, March 26–27, 1918, nos. 82, 231.

155. Sickert, "Degas," p. 186.

156. See this chapter, note 4. In the letter to P.-A. Bartholomé, August 27, 1892, cited there, Degas characteristically refers only to the technical problem of representing an interior in correct perspective.

157. Lemoisne, no. 1115; dated 1892. There is also another, less finished version, *ibid.*, no. 1114. On the circumstances in which they were painted, see S. Barazzetti, "Degas et ses amis Valpinçon," *Beaux-Arts*, no. 192, September 4, 1936, p. 1.

158. See Chap. II, notes 20, 21.

159. Duranty, *La Nouvelle Peinture*, pp. 45–46.

160. For information on this and the following work, I am indebted to the late Paul Brame, who made an inventory of the collection at Ménil-Hubert after the Second World War.

161. Not listed in A. Mezzetti, "Contributi alla pittura italiana dell' 800," *Bollettino d'Arte*, 40, 1955, pp. 244–258, 334–335; but see p. 339, fig. 20, a similar work dated 1866.

162. See Chap. II, p. 69; and Chap. VII, p. 297.

163. See Eitner, "The Open Window," pp. 285–287; and Donat de Chapeaurouge, "Das Milieu als Porträt," *Wallraf-Richartz-Jahrbuch*, 22, 1960, pp. 137–158.

164. *Catalogue des tableaux . . . collection Edgar Degas*, March 26–27, 1918, no. 31. See Paul Poujaud's letter to Marcel Guérin, January 15, 1933, *Lettres*, p. 253; and M. Sérullaz, *Mémorial de l'Exposition Eugène Delacroix*, Paris, 1963, no. 193.

165. Lemoisne, nos. 1288, 1454; dated ca. 1897 and ca. 1906.

166. See L. Hoctin, "Degas photographe," *L'Oeil*, no. 65, May 1960, pp. 36–43; and the photographs reproduced in D. Halévy, *My Friend Degas*, trans. M. Curtiss, Middletown, 1964, opposite pp. 64, 81.

167. See L. Venturi, *Cézanne, son art, son oeuvre*, 2 vols., Paris, 1936, nos. 494, 496, 706, 707; and G. Wildenstein, *Gauguin*, Paris, 1964, especially nos. 183, 375, 604, but also nos. 174, 287, 377, 380, etc. For examples in earlier art, see this chapter, note 2.

168. Duranty, *La Nouvelle Peinture*, pp. 44–46. In his "Salon de 1870," *Paris-Journal*, May 8, 1870, Duranty had mildly criticized Degas's portrait of Mme Camus, Lemoisne, no. 271, for its lack of "the agreement, to which he normally attaches such importance, between the figure and the interior."

169. Lemoisne, nos. 320, 321, 323; all dated 1873.

170. See J. C. Lapp, *Zola before the Rougon-Macquart*, Toronto, 1964, pp. 96–98, 124–125; and Chap. V, pp. 204–208.

171. See Reff, "New Light on Degas's Copies," pp. 250–256, and the memoir by Thiébault-Sisson cited there, p. 252, note 31. According to Fèvre, *Mon Oncle Degas*, pp. 52–53, he was able to reproduce a Corot so well that his colleagues took it for the original.

172. See also the studies for a projected portrait of Mme Rouart and Hélène contemplating a Tanagra figurine in their collection; Boggs, *Portraits by Degas*, pp. 67–68, pls. 122–123.

173. See Reff, "Addenda on Degas's Copies," p. 230; and P. Valéry, *Degas Manet Morisot*, trans. D. Paul, New York, 1960, pp. 24–25, from *Degas danse dessin*, Paris, 1936.

174. For further examples, some more convincing than others, see Shinoda, *Degas, der Einzug des Japanischen*, passim; Ives, *The Great Wave*, pp. 34–44; and Weisberg, "Japonisme," pp. 12–14, 46–49.

175. E.g., in Chastel, "Le Tableau dans le tableau," pp. 26–27.

176. Illustrated in Rewald, *History of Impressionism*, p. 355 (Renoirs); J. Rewald, *Post-Impressionism from van Gogh to Gauguin*, New York, 1956, pp. 47 (Van Gogh), 309 (Gauguin).

177. Illustrated in Hofmann, *The Earthly Paradise*, pl. 178 (Fantin-Latour); Rewald, *History of Impressionism*, p. 235 (Bazille); and Rewald, *Post-Impressionism*, p. 107 (Seurat). See also Corot's *Studio*, which is contemporary with, and compositionally similar to, Degas's portrait of Tissot; illustrated in Hofmann, pl. VI.

178. See M.-L. Bataille and G. Wildenstein, *Berthe Morisot*, Paris, 1961, no. 19 (the fan is Lemoisne, no. 173); Wildenstein, *Gauguin*, no. 131 (the pastel is Lemoisne, no. 699); and Orangerie des Tuileries, Paris, *Collection Jean Walter–Paul Guillaume*, 1966, no. 31 (the paintings are Lemoisne, nos. 486, 702).

179. I am grateful to the following for arranging to have detail photographs made: Hélène Adhémar, Musée de l'Impressionnisme, Paris; Peter Gimpel, Gimpel Fils, Ltd., London; and Mlle Minet, formerly Collection David-Weill, Paris.

IV. The Artist and the Writer

1. Letter to Maurice Fabre, 1895; O. Redon, *Lettres, 1878–1916*, Paris, 1923, pp. 22–23.

2. J. Fèvre, *Mon Oncle Degas*, ed. P. Borel, Geneva, 1949, pp. 72–73; this is, however, a biased, somewhat unreliable source.

3. P. Valéry, *Degas Manet Morisot*, trans. D. Paul, New York, 1960, p. 62; from *Degas danse dessin*, Paris, 1936.

4. G. Rouault, *Souvenirs intimes*, Paris, 1927, p. 98.

5. Valéry, *Degas Manet Morisot*, p. 63. On Degas's poetry and its relation to his painting, see also *Huit Sonnets d'Edgar Degas*, Paris, 1946, preface by J. Nepveu-Degas, especially pp. 6–7, 14–22.

6. Letter to P.-A. Bartholomé, September 9, 1882, *Lettres*, p. 69. On their literary quality, see George Moore's letter to Daniel Halévy, 1931, *ibid.*, pp. 259–261.

7. See Fèvre, *Mon Oncle Degas*, pp. 50–51, 71–73; and *Huit Sonnets d'Edgar Degas*, Preface, p. 11.

8. On these developments, see L. Hautecoeur, *Littérature et peinture en France du xviie au xxe siècle*, Paris, 1942, Chaps. IV, V, VI, where, however, there is little on Degas's contacts with particular writers or texts.

9. The standard account, in Lemoisne, I, pp. 41–45, focuses on a few major works, ignoring a score of other projects in small canvases, drawings, and notebooks. I plan to discuss all this material on another occasion.

10. Fèvre, *Mon Oncle Degas*, pp. 50, 72, 117. Flaubert's correspondence was first published in 1887–1893.

11. D. Halévy, *My Friend Degas*, trans. M. Curtiss, Middletown, 1964, pp. 41–43, 97. Perhaps inspired by one of Dumas's *Musketeer* novels is the small panel *The Duel*, ca. 1865; not in Lemoisne; see *Catalogue des tableaux . . . succession Georges Viau*, Hôtel Drouot, Paris, December 11, 1942, no. 86.

12. Notebook 21, p. 9 verso; used in 1865–1868. Baudelaire's *Théophile Gautier, notice littéraire*, had appeared in 1859.

13. Collection the late Jean Nepveu-Degas, Paris, who kindly allowed me to consult his unpublished family papers. It must have been written in July 1869, since it refers to Scherer's article on Baudelaire, which appeared then.

14. P. Pool, "The History Pictures of Edgar Degas and Their Background," *Apollo*, 80, 1964, p. 310.

15. R. Gimpel, *Journal d'un collectionneur*, Paris, 1963, p. 186; dated April 27, 1921. Gautier's remark is quoted in Pool, "History Pictures of Edgar Degas," p. 310, with no indication of its source.

16. Herodotus, I. 10; trans. A. D. Godley, London, 1920. Beneath the first study, in Notebook 6, p. 63, Degas cites Herodotus, I. 7–12; the other studies are in Notebook 6, pp. 62 (illustrated above), 60–54, 40, 36–35; used in 1856.

17. T. Gautier, "Le Roi Candaule," *Nouvelles*, Paris, 1923 [1st ed. 1845], p. 400; trans. F. C. de Sumichrast, London, n.d.

18. Dayton Art Institute, *Jean-Léon Gérôme*, November 10–December 30, 1972, no. 8.

19. Notebook 6, pp. 53–51, 48–44, 40. D'Hancarville's four-volume work was published at Florence, 1801–1808.

20. Gautier, "Le Roi Candaule," p. 398.

21. *Ibid.* On his use of other ancient sources for this story, see L. B. Dillingham, *The Creative Imagination of Théophile Gautier*, Bryn Mawr, 1927, pp. 157–158.

22. *Ibid.*, pp. 154–157. See also A. Coleman, "Some Sources of the *Roman de la Momie*," *Modern Philology*, 19, 1921–1922, pp. 337–360.

23. Lemoisne, no. 94; dated 1861–1864, but more likely of 1859–1860. For copies of Egyptian art, including some in Notebook 18, pp. 85–86, datable 1859–1860, see T. Reff, "Addenda on Degas's Copies," *Burlington Magazine*, 107, 1965, pp. 320–323; on his enthusiasm for *The Romance of the Mummy*, Fèvre, *Mon Oncle Degas*, p. 50.

24. See Judges 11: 29–40; and especially W. O. Sypherd, *Jephthah and His Daughter*, Newark, 1949, pp. 227–234, on earlier pictorial representations.

25. See E. Mitchell, "La Fille de Jephté par Degas," *Gazette des Beaux-Arts*, 18, 1937, pp. 183–184, fig. 15; also figs. 11, 16.

26. See Fèvre, *Mon Oncle Degas*, p. 117; and A. de Vigny, *Poèmes*, ed. F. Baldensperger, Paris, 1914, pp. 383–403, on the many nineteenth-century editions.

27. *Ibid.*, pp. 57–60; from *Poésies*, Paris, 1822.

28. See Sypherd, *Jephthah and His Daughter*, pp. 129–180, for literary treatments before ca. 1860.

29. See J. G. Clemenceau le Clercq, *L'Inspiration biblique dans l'oeuvre poétique d'Alfred de Vigny*, Annemasse, 1937, pp. 46–58. On his interest in the visual arts, see M. Citoleux, "Vigny et les beaux-arts," *Revue Universitaire*, 31, 1922, pp. 194–208, 276–292.

30. G. Sand, *La Mare au diable*, ed. P. Salomon and J. Mallion, Paris, 1956 [1st ed. 1846], pp. 161–162; trans. J. M. and E. Sedwick, Boston, 1894. Degas transcribed the entire passage from "Her cornet of light cotton" to "more profound and idealistic," but without identifying it. I am indebted to Jean Seznec for doing that.

31. Notebook 18, pp. 209 (illustrated above), 212; used in 1859–1864.

32. See Musée du Louvre, *Inventaire général des dessins des écoles du nord, maîtres des anciens Pays-Bas nés avant 1550*, ed. F. Lugt, Paris, 1968, no. 14.

33. Sand, *La Mare au diable*, pp. 4–5, 6–7.

34. *Ibid.*, Introduction, p. v. On her interest in the visual arts, see M. L'Hôpital, *La Notion d'artiste chez George Sand*, Paris, 1946, pp. 49–51, 162–170.

35. P. Ganz, *The Paintings of Hans Holbein*, London, 1956, pls. 55, 47. A study for the Solothurn Virgin's head is in the Louvre.

36. Lemoisne, no. 173; dated 1867–1869. For the identification of Musset, see Orangerie des Tuileries, Paris, *Degas*, 1937, no. 185.

37. See M. Allem, *Alfred de Musset*, Paris, 1911, pp. 165, 173, 181, 187; and especially M. Clouard, *Documents inédits sur Alfred de Musset*, Paris, 1900, pp. 13–19, on Charles Landelle's well-known portrait.

38. Letter to Edma Morisot, March 18, 1869; B. Morisot, *Correspondance*, ed. D. Rouart, Paris, 1950, p. 23; trans. B. W. Hubbard, London, 1957.

39. M.-L. Bataille and G. Wildenstein, *Berthe Morisot*, Paris, 1961, no. 19.

40. P. Jamot and G. Wildenstein, *Manet*, 2 vols., Paris, 1932, nos. 150, 48. A. de Leiris, *The Drawings of Edouard Manet*, Berkeley, 1969, no. 175.

41. Notebook 16, pp. 6–7; used in 1859–1860.

42. C. Gould, *National Gallery Catalogues, The Sixteenth-Century Venetian School*, London, 1959, pp. 59–61.

43. See Clouard, *Documents inédits sur Alfred de Musset*, pp. 91–97, 106–109.

44. A. de Musset, *Oeuvres complètes en prose*, ed. M. Allem and P. Courant, Paris, 1960, pp. 412–453. On his own interest in the visual arts, see R. Bouyer, "Musset, critique d'art," *Revue Bleue*, 48, 1910, pp. 789–792.

45. Notebook 28, pp. 46–47; used in 1877. See J. Canu, *Barbey d'Aurevilly*, Paris, 1965, pp. 379–380.

46. See J.-P. Seguin, *Iconographie de Barbey d'Aurevilly*, Geneva, 1961, pl. 84 and caption; also the description of Barbey by Octave Uzanne, quoted in *ibid.*, pl. 89 caption.

47. Notebook 29, p. 33; used in 1877–1880. See E. Degas, *Album de dessins*, Paris, 1949, Preface by D. Halévy, unpaged, on the sketches of Barbey.

48. Halévy, *My Friend Degas*, pp. 61–62.

49. J.-E. Blanche, *Propos de peintre, de David à Degas*, Paris, 1919, p. 303.

50. Notebook 22, p. 6; used in 1867–1874. Barbey's aphorism appeared in *Le Nain Jaune*, April 7, 1867, as "Quelques bouts d'idées," no. CXXIX.

51. See his letters to P.-A. Bartholomé, August 16, 1884, and September 9, 1889, *Lettres*, pp. 79, 133. According to D. Halévy, *Pays parisiens*, Paris, 1929, p. 52, Degas illustrated one of the episodes in *The Arabian Nights*.

52. See W. Rothenstein, *Men and Memories*, 3 vols., New York, 1931–1938, I, p. 159; and this chapter, note 54.

53. Fèvre, *Mon Oncle Degas*, p. 73.

54. *Ibid.*, p. 73, note 1. On Maupassant and the visual arts, see A. Vial, *Guy de Maupassant et l'art du roman*, Paris, 1954, pp. 335–338; and G. de Lacaze-Duthiers, "Guy de Maupassant critique d'art," *Revue Mondiale*, 166, 1925, pp. 169–172.

55. See F. Steegmuller, *Maupassant, A Lion in the Path*, New York, 1949, pp. 402–403. Degas's monotypes of brothels, although later used by Vollard to "illustrate" an edition of the book, were not, of course, conceived as such.

56. See M. Crouzet, *Un Méconnu du Réalisme, Duranty*, Paris, 1964, p. 335. According to Lemoisne, I, pp. 49–50, they had met as early as 1861–1863.

57. See Crouzet, *Un Méconnu du Réalisme*, pp. 335–336.

58. Lemoisne, no. 335; dated 1873–1875, but more likely of 1869–1871. See Chap. III, pp. 117–119, on which the following is partly based.

59. L. E. Duranty, "Sur la physionomie," *La Revue Libérale*, 2, 1867, pp. 499–523. Notebook 23, pp. 44–47; used in 1868–1872.

60. Notebook 25, pp. 36, 37 (illustrated above), 39; used in 1869–1872.

61. L. E. Duranty, "Le Salon de 1869," *Paris*, May 14, 1869; quoted in Crouzet, *Un Méconnu du Réalisme*, p. 337. On his art criticism, see also R. Baschet, "La Critique d'art de Duranty," *Revue des Sciences Humaines*, no. 125, 1967, pp. 125–135. The portrait is Lemoisne, no. 165; signed and dated 1867.

62. See Crouzet, *Un Méconnu du Réalisme*, pp. 315–316; and L. E. Duranty, "Le Peintre Louis Martin," *Le Pays des arts*, Paris, 1881, pp. 315–350.

63. Lemoisne, no. 273; dated 1870. See T. Reff, "New Light on Degas's Copies," *Burlington Magazine*, 106, 1964, p. 255; and Duranty, "Le Peintre Louis Martin," pp. 335–336.

64. *Ibid.*, p. 337.

65. *Ibid.*, p. 335. Duranty was, however, also critical of Degas's work at this time; see Crouzet, *Un Méconnu du Réalisme*, p. 335.

66. L. E. Duranty, *La Nouvelle Peinture*, ed. M. Guérin, Paris, 1946 [1st ed. 1876], p. 43. He identified Degas explicitly in annotating a copy of the pamphlet; see O. Reuterswärd, "An Unintentional Exegete of Impressionism," *Konsthistorisk Tijdskrift*, 4, 1949, p. 112.

67. Duranty, *La Nouvelle Peinture*, p. 45.

68. *Ibid.* The works alluded to are *Portraits in an Office*, *Dancers Preparing for the Ballet*, and *Laundress Ironing*, Lemoisne, nos. 320, 512, 356, respectively; all were exhibited in 1876.

69. H. Thulié, "Du Roman, description," *Réalisme*, no. 3, January 15, 1857, p. 38. On the periodical *Réalisme* and Henry Thulié's part in it, see Crouzet, *Un Méconnu du Réalisme*, pp. 66–74.

70. See *ibid.*, pp. 652–660.

71. E. Zola, *Les Romanciers naturalistes*, 1881, *Oeuvres complètes*, ed. H. Mitterand, 15 vols., Paris, 1966–1969, XI, pp. 74–76.

72. *Ibid.* See also his definition of description as "the necessary portrayal of the milieu," in *Le Roman expérimental*, 1881, *Oeuvres complètes*, X, p. 1301.

73. E. Zola, "Deux expositions d'art au mois de mai," *Le Messager de l'Europe*, June 1876, *Oeuvres complètes*, XII, pp. 970–971. See the latest anthology of his art criticism, *Le Bon Combat*, ed. J.-P. Bouillon, Paris, 1974, with full bibliography, pp. 318–330, and G. Picon's essay, "Zola et ses peintres," pp. 7–22.

74. E. Zola, "Le Naturalisme au Salon," *Le Voltaire*, June 18–22, 1880, *Oeuvres complètes*, XII, pp. 1013–1014.

75. E. Zola, "Notes parisiennes," *Le Sémaphore de Marseille*, April 19, 1877, *Oeuvres complètes*, XII, p. 975.

76. Letter to J.-K. Huysmans, May 10, 1883, *Oeuvres complètes*, XIV, p. 1427. The same description occurs in E. and J. de Goncourt, *Journal, mémoires de la vie littéraire*, ed. R. Ricatte, 22 vols., Monaco, 1956, XV, pp. 109–110; dated May 8, 1888.

77. G. Moore, *Impressions and Opinions*, London, 1891, p. 319.

78. Halévy, *My Friend Degas*, p. 41.

79. *Ibid.* See also G. Rivière, *Mr. Degas, bourgeois de Paris*, Paris, 1935, p. 142, quoting his rejection of "the exaggeration of a Naturalism turned into debauchery" in Zola's novels.

80. Valéry, *Degas Manet Morisot*, p. 84, quoting Berthe Morisot's recollections of Degas.

81. *Ibid.* See also the story told here of Degas's sarcastic remark to Daudet.

82. Moore, *Impressions and Opinions*, pp. 298–299. On Moore's contacts with French writers, and especially Zola, see G.-P. Collet, *George Moore et la France*, Geneva, 1957, pp. 19–21, 122–147.

83. Letter to Lucien Pissarro, February 5, 1886; C. Pissarro, *Lettres à son fils Lucien*, ed. J. Rewald, Paris, 1950, p. 93; trans. L. Abel, New York, 1943.

84. See Lemoisne, I, p. 237, note 114; and Zola, *Oeuvres complètes*, III, p. 947.

85. See this chapter, note 73. Neither did Degas mention the resemblance, when he later acknowledged having read *The Dram-Shop*; see Halévy, *My Friend Degas*, p. 41.

86. See Lemoisne, I, p. 236, note 111; and E. Zola, *Les Rougon-Macquart*, ed. A. Lanoux and H. Mitterand, 5 vols., Paris, 1960–1967, II, pp. 1541–1542.

87. E. Zola, *L'Assommoir*, 1877, *Oeuvres complètes*, III, pp. 705–706; trans. A. Symons, New York, 1924. The painting is Lemoisne, no. 356; dated ca. 1874.

88. Zola, *L'Assommoir*, pp. 713–714. The *Laundress* is not in Lemoisne; see G. Bazin, *French Impressionist Paintings in the Louvre*, New York, 1966, pp. 276, 306.

89. Zola, *L'Assommoir*, pp. 707, 711.

90. Goncourt, *Journal*, X, pp. 163–164; dated February 13, 1874.

91. Remark reported by Mme Emile Straus to Marcel Guérin; see *Lettres*, p. 147, note 1. On Zola's repeated visits to Parisian department stores, see Zola, *Rougon-Macquart*, III, p. 1677.

92. Lemoisne, no. 682; signed and dated 1882. The others in the series are nos. 681, 683, 684, etc., also of 1882.

93. G. Moore, *Confessions of a Young Man*, ed. S. Dick, Montreal, 1972 [1st ed. 1888], p. 69. According to Berthe Morisot, Degas "professed the liveliest admiration for the intensely *human* quality of young shopgirls"; see this chapter, note 80.

94. E. Zola, *Au Bonheur des Dames*, 1882, *Oeuvres complètes*, IV, pp. 906–908; trans. A. Fitzlyon, London, 1958.

95. Lemoisne, no. 393; dated 1876. Zola, *L'Assommoir*, pp. 868–869. The quotation is from Bazin, *French Impressionist Paintings*, p. 180; but given its date, *Absinthe* can hardly have been "inspired by that novel."

96. Lemoisne, no. 499; dated 1878–1879. E. Zola, *L'Argent*, 1891, *Oeuvres complètes*, VI, pp. 354, 574, etc. See Bibliothèque Nationale, Paris, *Emile Zola*, 1952, no. 422.

97. J.-K. Huysmans, *L'Art moderne*, 1883, *Oeuvres complètes*, ed. L. Descaves, 18 vols., Paris, 1928–1934, VI, pp. 136–137.

98. Rivière, *Mr. Degas*, pp. 104–107. On their relation to the visual arts, see A. Brookner, *The Genius of the Future*, London, 1971, pp. 121–144; also K. V. Maur, "Edmond de Goncourt et les artistes de la fin du xixe siècle," *Gazette des Beaux-Arts*, 72, 1968, pp. 214–217.

99. Moore, *Impressions and Opinions*, p. 308, reporting a conversation that took place at the Cirque Fernando.

100. Lemoisne, no. 522; dated 1879. On its sources, see M. Davies, *National Gallery Catalogues, French School, Early 19th Century, etc.*, London, 1970, pp. 51–53.

101. Rivière, *Mr. Degas*, pp. 104–107.

102. E. de Goncourt, *Les Frères Zemganno*, Paris, 1891 [1st ed. 1879], pp. 55–57.

103. J. Barbey d'Aurevilly, "Les Frères Zemganno," *Le Constitutionnel*, May 12, 1879; quoted in H. Trudgian, *L'Evolution des idées esthétiques de J.-K. Huysmans*, Paris, 1934, pp. 120–121.

104. Notebook 28, pp. 13 verso-14, 15, 16, 17, 18, 23, 33; used in 1877. See E. de Goncourt, *La Fille Elisa*, Paris, 1877, pp. 113–121.

105. *Ibid.*, pp. iii-v. By contrast, when Toulouse-Lautrec began to illustrate *La Fille Elisa* ca. 1896—supposedly at the urging of Degas, among others—he depicted all its aspects and characters; see the facsimile edition with his watercolors, Paris, 1931.

106. See G. Geffroy, *Constantin Guys, l'historien du Second Empire*, Paris, 1904, pp. 144–148; and R. Ricatte, *La Genèse de "La Fille Elisa,"* Paris, 1960, pp. 140–154.

107. Goncourt, *Journal*, XXI, p. 41; dated April 22, 1895. See also J. Adhémar, "Lettres adressées aux Goncourt, concernant les beaux-arts, conservées à la Bibliothèque Nationale," *Gazette des Beaux-Arts*, 72, 1968, p. 235.

108. Goncourt, *Journal*, XIII, p. 22; dated March 31, 1883. See also *ibid.*, XII, pp. 100, 114, dated January 29 and May 15, 1881; XIV, p. 197, dated February 14, 1887; etc.

109. Notebook 31, p. 85; used in 1878–1879. Similar sketches are in this notebook, pp. 84, 92, 96; in Notebook 28, p. 72, used in 1877; etc. See the photographs in L. Deffoux, *Chronique de l'Académie Goncourt*, Paris, 1909, opposite pp. 40, 112.

110. Letter to Ludovic Halévy, 1884, *Lettres*, p. 86. See also the letters to Henri Rouart, May 2, 1882, and P.-A. Bartholomé, ca. 1885, *ibid.*, pp. 63, 107.

111. Goncourt, *Journal*, X, pp. 164–165; dated February 13, 1874. See also *ibid.*, XV, p. 86, dated February 26, 1888, a pointed attack on Degas, Raffaëlli, and others.

112. *Ibid.*, X, p. 164, note 1, an addendum of 1891.

113. J. Elias, "Degas," *Die Neue Rundschau*, 28, 1917, p. 1566. On the significance of *Manette Salomon* for Degas, see Lemoisne, I, pp. 98–99.

114. See R. Ricatte, *La Création romanesque chez les Goncourt, 1851–1870*, Paris, 1953, pp. 365–366, 370, note 189. Degas's *Laundresses* is Lemoisne, no. 410; dated 1876–1878.

115. Rothenstein, *Men and Memories*, I, p. 159. See also Edmond's bitter remarks, in Goncourt, *Journal*, XV, pp. 109–110; dated May 8, 1888.

116. These parallels were first drawn by F. Fosca [Traz], *Edmond et Jules de Goncourt*, Paris, 1941, pp. 357–359, but with little attempt to analyze their meaning.

117. Goncourt, *Journal*, V, pp. 72–73; dated March 12, 1862. For other relevant passages, see *ibid.*, IV, pp. 162–163, dated March 6, 1861, and VI, pp. 70–71, dated May 22, 1863. Degas's *Ballet* is Lemoisne, no. 476; dated ca. 1878.

118. Valéry, *Degas Manet Morisot*, p. 97, quoting Ernest Rouart's reminiscences of Degas. On his early interest in Rembrandt, see Reff, "New Light on Degas's Copies," p. 251.

119. See Ricatte, *La Création romanesque chez les Goncourt*, p. 59.

120. Letter to Lucien Pissarro, May 13, 1883; Pissarro, *Lettres à son fils Lucien*, pp. 44–45.

121. P. Ward-Jackson, "Art Historians and Art Critics VIII: Huysmans," *Burlington Magazine*, 109, 1967, p. 618. For a more positive view, see H. Jouvin, "Huysmans critique d'art," *Cahiers J.-K. Huysmans*, no. 20, 1947, pp. 356–375.

122. J.-K. Huysmans, untitled review, *Gazette des Amateurs*, 1876, *Oeuvres complètes*, VI, pp. 130–131.

123. J.-K. Huysmans, "Les Folies-Bergère en 1879," *Croquis parisiens*, 1880, *Oeuvres complètes*, VIII, pp. 19–20; trans. R. Griffiths, London, 1960. Degas's *Dancers* is Lemoisne, no. 572; dated ca. 1879.

124. See M. Harry, *Trois Ombres*, Paris, 1932, pp. 26–27; and R. Baldick, *The Life of J.-K. Huysmans*, Oxford, 1955, p. 60.

125. J.-K. Huysmans, *En Ménage*, 1881, *Oeuvres complètes*, IV, pp. 119–120. The pictures cited are Lemoisne, nos. 544, 783; dated ca. 1879 and ca. 1884.

126. For example, *Backstage at the Opera in 1880* (sale, Hôtel Drouot, Paris, June 10, 1937, no. 36) and *Behind the Scenes* (sale, Sotheby's, London, July 3, 1968, no. 1). See J. Jacquinot, "Deux amis: Huysmans et Forain," *Cahiers J.-K. Huysmans*, no. 38, 1959, pp. 440–449.

127. Huysmans, "Les Folies-Bergère en 1879," *Croquis parisiens*, pp. 15–17. On its relation to *Les Frères Zemganno*, see Trudgian, *L'Evolution des idées esthétiques de J.-K. Huysmans*, pp. 120–121.

128. M. Guérin, *J.-L. Forain, aquafortiste*, 2 vols., Paris, 1912, I, nos. 17, 20. See Huysmans' comments on Forain's paintings of these subjects, in *L'Art moderne*, pp. 122–123.

129. *Ibid.*, p. 137.

130. J. S. Boggs, *Drawings by Degas*, Greenwich, 1967, no. 84.

131. Interesting in this respect are Degas's remarks: "Art is vice. One does not marry it, one rapes it. Whoever says art, says artifice. Art is dishonest and cruel." J.-M. Lhôte, *Les Mots de Degas*, Paris, 1967, p. 41.

132. See, for example, Cachin, no. 113, dated ca. 1880; and J.-K. Huysmans, *Marthe, histoire d'une fille*, 1876, *Oeuvres complètes*, II, pp. 34–35.

133. *Ibid.*, p. 35; trans. S. Putnam, Chicago, 1927, but here revised where necessary. For the history of its publication, see *ibid.*, pp. 141–148.

134. Cachin, no. 87; dated ca. 1880.

135. Cachin, no. 97; dated ca. 1880. On the series of brothel monotypes, see *ibid.*, pp. xxvii-xxix; and E. P. Janis, *Degas Monotypes*, Cambridge, 1967, pp. xix-xxi, where, however, a specific relation to Huysmans' novel is denied.

136. Guérin, *J.-L. Forain*, I, nos. 12, 13. However, in *L'Art moderne*, pp. 125–126, Huysmans expresses admiration for Forain's brothel scenes, especially for one entitled *The Client* (sale, Nicolas Rauch, Geneva, June 13–15, 1960, no. 447).

137. Lemoisne, no. 526; dated ca. 1879.

138. L. Halévy, "Carnets," *Revue des Deux Mondes*, 42, 1937, p. 823; dated April 15, 1879. On his early contacts with the Opera, see E. Brieux, *Discours de réception à l'Académie française*, Paris, 1910, pp. 11–13.

139. Halévy, "Carnets," *Revue des Deux Mondes*, 43, 1938, p. 399; dated January 1, 1882.

140. H. Roujon, "En Souvenir de Ludovic Halévy," *Revue de Paris*, 11, no. 4, 1908, pp. 50–51.

141. Cachin, no. 56; dated ca. 1880, but more likely of ca. 1878. See also the related images, *ibid.*, nos. 57, 58, of which the last is closest to the portrait.

142. L. Halévy, *La Famille Cardinal*, Paris, 1883, pp. 1–5; illustrated by E. Mas. It comprised stories written over a number of years and collected in *Madame et Monsieur Cardinal*, Paris, 1872, illustrated by E. Morin, and in *Les Petites Cardinal*, Paris, 1880, illustrated by H. Maigrot.

143. Cachin, no. 67; dated ca. 1880, but more likely of ca. 1878. See also the related image, *ibid.*, no. 66.

144. Halévy, *La Famille Cardinal*, pp. 68–70.

145. *Ibid.*, pp. 23–28. The monotypes are Cachin, nos. 81 (illustrated above), 82.

146. See Janis, *Degas Monotypes*, pp. xxi-xxii, based on information from Mina Curtiss, who had access to the Halévy archives.

147. E. Zola, review of *La Cigale*, *Le Bien Public*, October 15, 1877, *Oeuvres complètes*, XI, p. 716. For the stage directions, see H. Meilhac and L. Halévy, *La Cigale*, *Théâtre*, 8 vols., Paris, 1900–1902, III, p. 107; first produced October 15, 1877.

148. Letter to Ludovic Halévy, September 1877, *Lettres*, pp. 41–42. See also his letter to Halévy, September 1891, *ibid.*, p. 190, concerning a new production.

149. Rivière, *Mr. Degas*, pp. 88, 91. On their collaboration, see L. Tannenbaum, "*La Cigale*, by Henri Meilhac and Ludovic Halévy—and Edgar Degas," *Art News*, 65, no. 9, January 1967, pp. 55, 71.

150. Duranty, *La Nouvelle Peinture*, pp. 28–29, note 1. Meilhac and Halévy, *La Cigale*, p. 17.

151. Meilhac and Halévy, *La Cigale*, pp. 88–89.

152. Notebook 29, pp. 11, 12; used in 1877–1880. Meilhac and Halévy, *La Cigale*, p. 120.

153. See Zola, *L'Assommoir*, pp. 610–615.

154. Meilhac and Halévy, *La Cigale*, pp. 124–125.

155. For example, Courbet's *Stormy Sea*, 1870, and Jules Dupré's *Sunset at Sea*, ca. 1871; see C. Sterling and H. Adhémar, *Musée du Louvre, peintures, école française, xixe siècle*, 4 vols., Paris, 1958–1961, I, no. 484, and II, no. 817.

156. Lemoisne, no. 245; dated ca. 1869. See also the other pastels in this series, especially *ibid.*, nos. 226, 227, 233.

157. Goncourt, *Journal*, XIV, p. 23; dated July 24, 1885. See Maur, "Edmond de Goncourt," pp. 223–224.

158. See Halévy, *My Friend Degas*, pp. 56–57; and E. Dujardin, *Antonia, tragédie moderne*, Paris, 1891, first produced April 20, 1891.

159. See his letter to Ernest Rouart, January 24, 1898; A. Gide, *Oeuvres complètes*, ed. L. Martin-Chauffier, 15 vols., Paris, 1932–1939, II, p. 486; also his "Promenade au Salon d'Automne," 1905, *ibid.*, IV, pp. 423–431; and his "Witold Wojtkiewicz," 1907, *ibid.*, V, pp. 285–287. See also this chapter, note 210.

160. See his letter to Christian Cherfils, ca. 1889, *Lettres,* Eng. trans., p. 64; Halévy, *My Friend Degas,* pp. 76–77; and C. Cros, *Oeuvres complètes,* ed. L. Forestier and P. Pia, Paris, 1964, p. 88.

161. S. Mallarmé, "The Impressionists and Edouard Manet," *Art Monthly Review,* 1, 1876, p. 121. See J. C. Harris, "A Little-Known Essay on Manet by Stéphane Mallarmé," *Art Bulletin,* 46, 1964, pp. 559–563.

162. Valéry, *Degas Manet Morisot,* p. 40. For the date of the photograph, see Halévy, *My Friend Degas,* p. 73.

163. H. de Régnier, *Nos Rencontres,* Paris, 1931, pp. 201–203.

164. Valéry, *Degas Manet Morisot,* pp. 28–31. On Mallarmé's far more sympathetic attitude, see L. J. Austin, "Mallarmé and the Visual Arts," *French 19th Century Painting and Literature,* ed. U. Finke, Manchester, 1972, pp. 232–257.

165. See S. Mallarmé, *Oeuvres complètes,* ed. H. Mondor and G. Jean-Aubry, Paris, 1956, pp. 1523, 1536, on the earlier project, and pp. 1403–1404, on the later one. See also Degas's letter to him, August 30, 1888; S. Mallarmé, *Correspondance,* ed. H. Mondor and L. J. Austin, 4 vols., Paris, 1959–date, III, p. 254, note 2.

166. S. Mallarmé, "Ballets," 1886, *Oeuvres complètes,* pp. 303–307; trans. B. Cook, Baltimore, 1956.

167. Letter to Berthe Morisot, February 17, 1889, her *Correspondance,* p. 145.

168. Valéry, *Degas Manet Morisot,* p. 62. See Degas's admiring letter, presumably to Mallarmé, ca. 1889, *Lettres,* p. 87.

169. Valéry, *Degas Manet Morisot,* pp. 62–63. On the significance of this doctrine for Valéry's own aesthetic, see R. A. Pelmont, *Paul Valéry et les beaux-arts,* Cambridge, 1949, pp. 79–83.

170. *Ibid.,* pp. 30–32, 105–107. For a more negative view, see A. Lhote, "Degas et Valéry," *Nouvelle Revue Française,* 52, 1939, pp. 133–142.

171. Letter of February 7, 1896; A. Gide and P. Valéry, *Correspondance, 1890–1942,* ed. R. Mallet, Paris, 1955, p. 260.

172. Valéry, *Degas Manet Morisot,* p. 11.

173. See C. A. Hackett, "Teste and *La Soirée avec Monsieur Teste,*" *French Studies,* 21, 1967, pp. 112–113; and Edmond Jaloux's recollections, in P. Valéry, *Oeuvres,* ed. J. Hytier, 2 vols., Paris, 1957–1960, II, pp. 1383–1384.

174. Valéry, *Degas Manet Morisot,* p. 11.

175. See his letters to Gide, October 5, 1896, and March 11, 1898, on exhibitions, and February 14, 1898, on photographs; Gide and Valéry, *Correspondance,* pp. 281, 314, 312, respectively.

176. P. Valéry, *La Soirée avec Monsieur Teste,* 1896, *Oeuvres,* II, pp. 20–21; trans. J. Mathews, New York, 1973.

177. Quoted in Eugène Rouart's letter to Valéry, September 27, 1896; Valéry, *Oeuvres,* II, p. 1386. See also Gide's letter to Valéry, March 25, 1896, and Valéry's to Rouart, September 19, 1896; Gide and Valéry, *Correspondance,* pp. 261, 277–278.

178. Letter to Gide, March 28, 1898, *ibid.,* p. 316.

179. B. Nicolson, "Degas as a Human Being," *Burlington Magazine,* 105, 1963, p. 240.

180. A. Vollard, *Degas,* Paris, 1924, pp. 11–14. On Mirbeau's art criticism, see F. Cachin, "Un Défenseur oublié de l'art moderne," *L'Oeil,* no. 90, June 1962, pp. 50–55, 75.

181. See M. Schwarz, *Octave Mirbeau, vie et oeuvre,* The Hague, 1966, pp. 47–57, where, however, the relation to Degas is overlooked.

182. O. Mirbeau, *Le Calvaire,* Paris, 1925 [1st ed. 1887], pp. 78–80; trans. L. Rich, New York, 1922.

183. *Ibid.,* pp. 81–83. Compare Degas's identical remark, reported by Lafond, in Lemoisne, I, p. 101. For Mirbeau's brief critical comments on Degas, see his *Des Artistes, deuxième série,* Paris, 1924, pp. 66, 173.

184. F. Champsaur, *L'Amant des danseuses,* Paris, 1888, p. 5. On Decroix's resemblance to Degas, see Adhémar, pp. x–xi; on Champsaur's career, H.-A. Mercier, "Félicien Champsaur," *Cahiers de Marottes et Violons d'Ingres,* no. 60, 1962, pp. 80–89.

185. See P. Gauguin, *Avant et après,* Paris, 1923, pp. 113–114, dated January 20, 1903; and Champsaur, *L'Amant des danseuses,* pp. 318–319.

186. See J. Claretie, *La Vie à Paris, 1880,* Paris, 1881, pp. 499–501.

187. Champsaur, *L'Amant des danseuses,* pp. 322–323.

188. *Ibid.,* pp. 3–4.

189. *Ibid.,* pp. 261–263. See Lemoisne, no. 522, dated 1879; and Huysmans, *L'Art moderne,* p. 137.

190. C. Mauclair, *La Ville lumière,* Paris, 1903, p. 15. On its topical significance, see T. Bowie, *The Painter in French Fiction,* Chapel Hill, 1950, pp. 10, 14–15, 19, etc.

191. Mauclair, *La Ville lumière,* pp. 39–41.

192. *Ibid.*, p. 40.

193. See G. Jean-Aubry, *Camille Mauclair*, Paris, 1905, especially pp. 28–29. Yet he was hostile to most of the original art of his day; see Pissarro's letter to Lucien, May 29, 1894, *Lettres à son fils Lucien*, p. 344, note 1.

194. Mauclair, *La Ville lumière*, pp. 183–185.

195. C. Mauclair, *L'Impressionnisme, son histoire, son esthétique, ses maîtres*, Paris, 1904, p. 86. He later published widely on Degas and Impressionism.

196. Blanche, *Propos de peintre*, pp. i–xxxv. The essay on Degas, *ibid.*, pp. 286–308, appeared first in *Revue de Paris*, 20, 1913, pp. 377–392.

197. J.-E. Blanche, *Aymeris*, Paris, 1922 [written 1911–1914], p. 106. On its autobiographical elements, see *idem*, *La Pêche aux souvenirs*, Paris, 1949, pp. 91–92.

198. Blanche, *Aymeris*, pp. 111–112, 116.

199. *Ibid.*, p. 117. The references are, of course, to *The Young Spartan Girls Provoking the Boys* and *Semiramis Founding a City*, Lemoisne, nos. 70, 82; dated 1860 and 1861.

200. Blanche, *Aymeris*, p. 119. See also p. 204, where Aymeris quotes one of Degas's sayings.

201. Interview quoted in S. Barazzetti, "Jacques-Emile Blanche, portraitiste de Degas," *Beaux-Arts*, no. 220, March 19, 1937, p. 3.

202. Lemoisne, no. 824; dated 1885. See Blanche, *Propos de peintre*, p. 296; and J. S. Boggs, *Portraits by Degas*, Berkeley, 1962, pp. 70–72.

203. Letter to J.-E. Blanche, January 25, 1919; M. Proust, *Correspondance générale*, ed. R. Proust and P. Brach, 6 vols., Paris, 1930–1936, III, p. 156.

204. See J. Monnin-Hornung, *Proust et la peinture*, Geneva, 1951, p. 19. For works owned by Blanche, see Lemoisne, nos. 430, 444, 824, 1118; for those owned by the Prince de Wagram, nos. 362, 476, 530, 1297.

205. R. Allard, "Les Arts plastiques dans l'oeuvre de Marcel Proust," *Nouvelle Revue Française*, 20, 1923, pp. 228–229. M. E. Chernowitz, *Proust and Painting*, New York, 1944, pp. 115–116.

206. See P. Howard-Johnston, "Bonjour M. Elstir," *Gazette des Beaux-Arts*, 69, 1967, pp. 247–250; and Monnin-Hornung, *Proust et la peinture*, pp. 95–100.

207. M. Proust, *Sodome et Gomorrhe*, 1922, *A la Recherche du temps perdu*, ed. P. Clarac and A. Ferré,

3 vols., Paris, 1964–1965, II, pp. 844–845; trans. C. K. Scott-Moncrieff, New York, 1927.

208. *Ibid.*, pp. 811–813. The same lady also declares: "Monet, Degas, Manet, yes, those are painters."

209. Moore, *Impressions and Opinions*, p. 321; the date he gives, 1840, is presumably a misprint for 1870. J. Meier-Graefe, *Degas*, New York, 1923, pp. 22–23, referring to the 1890s.

210. A. Gide, *Journal, 1889–1939*, Paris, 1951, p. 77, quoting a letter from Athman ben Sala to Degas, 1896; trans. J. O'Brien, New York, 1947. See also *ibid.*, pp. 127–128, 274–275; dated February 6, 1902, and July 4, 1909.

211. See this chapter, note 63; and T. Reff, "Cézanne and Poussin," *Journal of the Warburg and Courtauld Institutes*, 23, 1960, pp. 164–169, on the reactionary Neoclassicism of ca. 1900.

V. "My Genre Painting"

1. Lemoisne, no. 348; dated ca. 1874, but more likely of 1868–1869, as we shall see. I am grateful to Mr. McIlhenny for allowing me to examine the picture.

2. G. Grappe, *Edgar Degas*, Paris, n. d. [1908], pp. 50, 55.

3. A. Alexandre, "Degas, nouveaux aperçus," *L'Art et les Artistes*, 29, 1935, pp. 167–168.

4. Its provenance, too, has remained somewhat uncertain; see this chapter, note 35. According to the archives of the Durand-Ruel gallery, Paris, and the Alfred A. Pope Collection, now the Hill-Stead Museum, Farmington, Conn., it was bought from the artist by Durand-Ruel, June 15, 1905, and sold to A. F. Jaccaci, New York, August 31, 1909; bought by Harris Whittemore, October 23, 1909; given to Mr. Pope, December 1909; returned to H. Whittemore and Co., Naugatuck, Conn., 1913; sold to M. Knoedler and Co., New York, 1936; bought by Mr. McIlhenny, 1936. I am indebted for this information to Charles Durand-Ruel and Jean C. Harris.

5. See P.-A. Lemoisne, *Degas*, Paris, n. d. [1912], pp. 61-62; P. Lafond, *Degas*, 2 vols., Paris, 1918–1919, II, p. 4; and Grappe, *Edgar Degas*, p. 50.

6. P. Jamot, "Degas," *Gazette des Beaux-Arts*, 60, 1918, pp. 130–132. The same statement occurs in his *Degas*, Paris, 1924, pp. 70–71.

7. G. Jeanniot, "Souvenirs sur Degas," *Revue Uni-*

verselle, 55, 1933, p. 167. He gives no date for the restoration; but E. Rouart, "Degas," *Le Point*, 2, no. 1, February 1937, p. 21, recalls that it was done ca. 1903.

8. Reported by Mr. McIlhenny to Quentin Bell; see the latter's *Degas, Le Viol* (Charlton Lectures on Art), Newcastle-upon-Tyne, 1965, unpaged [p. 16], note 12. In the Durand-Ruel archives, too, the picture is listed as *Interior*.

9. Letter to Marcel Guérin, July 11, 1936, *Lettres*, p. 255. See also his letter of January 15, 1933, *ibid.*, p. 253.

10. G. Rivière, *Mr. Degas, bourgeois de Paris*, Paris, 1935, pp. 97–98. On Rivière, see J. Rewald, *The History of Impressionism*, 4th ed., New York, 1973, pp. 370, 385–386, 392–394.

11. R. H. Wilenski, *Modern French Painters*, New York, 1940, p. 53. C. Mauclair, *Degas*, Paris, 1937, p. 14. *Huit Sonnets d'Edgar Degas*, Paris, 1946, Preface by J. Nepveu-Degas, p. 9.

12. M. Crouzet, *Un Méconnu du Réalisme, Duranty*, Paris, 1964, p. 335, note 106.

13. L.-E. Tabary, *Duranty, étude biographique et critique*, Paris, 1954, p. 149.

14. L. E. Duranty, *Les Combats de Françoise du Quesnoy*, Paris, 1873, pp. 74–75, 284–285, are the scenes that correspond most closely. It was first published serially in 1868; see Crouzet, *Un Méconnu du Réalisme*, p. 739.

15. J. Adhémar, in Bibliothèque Nationale, Paris, *Emile Zola*, 1952, no. 114. The argument is developed further in H. and J. Adhémar, "Zola et la peinture," *Arts*, no. 389, December 12–18, 1952, p. 10; and is repeated in P. Cabanne, *Edgar Degas*, Paris, 1957, p. 110, no. 49.

16. Bell, *Degas, Le Viol*, unpaged [p. 9]. See E. Zola, *Madeleine Férat*, 1868, *Oeuvres complètes*, ed. H. Mitterand, 15 vols., Paris, 1966–1969, I, pp. 845–846, for this scene, and pp. 819–820, for Zola's description of the room.

17. Bell, *Degas, Le Viol*, unpaged [p. 9].

18. E. Zola, *Madeleine*, 1889 [written 1865], *Oeuvres complètes*, XV, p. 105. This, rather than the novel, is what the authors cited in this chapter, note 15, quote.

19. J. S. Boggs, *Drawings by Degas*, Greenwich, 1967, no. 61. See Zola, *Madeleine Férat*, pp. 798–801.

20. T. Reff, "Degas and the Literature of His Time," *Burlington Magazine*, 113, 1970, p. 585. See Zola, *Madeleine Férat*, pp. 831–834.

21. Bell, *Degas, Le Viol*, unpaged [p. 9].

22. P. Valéry, *Degas Manet Morisot*, trans. D. Paul, New York, 1960, pp. 134–135; from "Autour de Corot," preface to *Vingt Estampes de Corot*, Paris, 1932. See also the remarks on Zola reported in D. Halévy, *My Friend Degas*, trans. M. Curtiss, Middletown, 1964, p. 41.

23. See Notebook 28, pp. 13 verso-14, 15, 16, etc.; and Cachin, nos. 56–82; the former drawn in 1877, the latter ca. 1878.

24. See P. Pool, "The History Pictures of Edgar Degas and Their Background," *Apollo*, 80, 1964, pp. 306–311; and Chap. IV, pp. 150–154.

25. A brief version with the same title had appeared in *Le Figaro*, December 24, 1866; see Zola, *Oeuvres complètes*, I, pp. 670–673.

26. F. W. Hemmings, *Emile Zola*, 2nd ed., Oxford, 1966, p. 40. On this aspect of the novel, see also M. Claverie, "*Thérèse Raquin*, ou les Atrides dans la boutique du Pont-Neuf," *Cahiers Naturalistes*, 14, 1968, pp. 138–147.

27. E. Zola, *Thérèse Raquin*, 1867, *Oeuvres complètes*, I, p. 605; trans. L. Tancock, London, 1962. Some of these elements also appear in the woodcut by Castelli illustrating a later moment in the same chapter, in the first illustrated edition, Paris, 1881.

28. He was, in fact, obliged to do so, since Zola provides no other details, even in his earlier description of the room, *Thérèse Raquin*, pp. 527–528.

29. See Grappe, *Edgar Degas*, p. 50; and Lemoisne, *Degas*, pp. 61–62. Jamot, "Degas," p. 131, even observed that the man, "'a gentleman,' has his back to the door, as if to prevent any thought of flight."

30. Zola, *Thérèse Raquin*, pp. 602, 605.

31. Louvre, Cabinet des Dessins, RF 31779; see Orangerie des Tuileries, Paris, *Degas, Oeuvres du Musée du Louvre*, June 27–September 15, 1969, no. 166.

32. E. Zola, "Thérèse Raquin," *L'Artiste*, 37, 1867, pp. 26–27. On this edition, see Zola, *Oeuvres complètes*, I, p. 514.

33. Boggs, *Drawings by Degas*, no. 61. Two other works of this period—*Mlle Fiocre in the Ballet from "La Source*,*"* Lemoisne, no. 146, dated 1866–1868; and *The Ballet from "Robert le Diable*,*"* *ibid.*, no. 294, dated 1872—do in fact represent theatrical performances.

34. E. Zola, *Thérèse Raquin, drame en quatre actes*, 1873, *Oeuvres complètes*, XV, p. 175; the set itself is described in *ibid.*, p. 169.

35. Reported by Roger Fry to Quentin Bell; see the latter's *Degas, Le Viol*, unpaged [pp. 4, 16, note 3]. The museum in question was probably the Metropolitan, and the trustee J. P. Morgan; see Fry's letter to A. F. Jaccaci, June 18, 1906, *Letters of Roger Fry*, ed. D. Sutton, 2 vols., New York, 1972, I, p. 266, reporting on his recent examination, with Morgan, of "the Degas," presumably this one, at Durand-Ruel's gallery in Paris. However, his statement that the dealer then "sold it immediately" does not agree with the note in Durand-Ruel's stock book that it was bought in 1909 by Jaccaci himself; see this chapter, note 4.

36. The quotations are from Zola, *Madeleine Férat*, pp. 819–820, 828; trans. A. Brown, New York, 1957, but inaccurately, and here revised. I owe this suggestion to Anne Macrae.

37. See Zola, *Oeuvres complètes*, I, p. 897. It was published as a volume in December, with a dedication to Manet. See also the appendix to this chapter.

38. Lemoisne, no. 353; incorrectly dated ca. 1874.

39. Bell, *Degas, Le Viol*, unpaged [p. 10].

40. *Atelier*, I, no. 16. The dimensions given there are 41 × 27 cm., whereas those of Lemoisne, no. 353, are 34.9 × 20.9 cm.

41. I am indebted to Maurice Tuchman, Senior Curator of Modern Art, Los Angeles County Museum of Art, for arranging to have these photographs taken; to Ben B. Johnson, Head of Conservation there, for taking them; and to Mrs. Julius Held for expert advice in interpreting them.

42. Notebook 22, p. 98; used in 1867–1874.

43. *Atelier*, IV, no. 266b.

44. Notebook 22, p. 100. Inscribed at the upper right: "very light," probably in reference to the man's collar, which is marked with an X. Inscribed at the right: "chain and cuff of the hand in the pocket very light."

45. *Atelier*, III, no. 113c.

46. See Zola, *Thérèse Raquin*, p. 605; and Lemoisne, *Degas*, pp. 61–62. See also Jamot, "Degas," pp. 131–132.

47. Lemoisne, no. 352; incorrectly dated ca. 1874.

48. Lemoisne, no. 349; incorrectly dated ca. 1874. Another study of the head was supposedly no. 172 in a sale at the Hôtel Drouot, Paris, either on April 4, 1928 (Lemoisne, under no. 348) or on August 4, 1928 (*Degas, Oeuvres du Musée du Louvre*, under no. 20), but I have not found it listed in any sale on either date.

49. Zola, *Thérèse Raquin*, p. 602.

50. *Atelier*, III, no. 406b.

51. Lemoisne, no. 350; incorrectly dated ca. 1874. Reproduced in color in H. Rivière, *Les Dessins de Degas*, 2 vols., Paris, 1922–1923, no. 24.

52. Lemoisne, no. 353; dated ca. 1874. See Rivière, *Dessins de Degas*, no. 78; and Boggs, *Drawings by Degas*, no. 61.

53. See Hemmings, *Emile Zola*, pp. 28–29. Degas began appearing there in the same year; see Rewald, *History of Impressionism*, pp. 197–199.

54. See Zola's letter to Huysmans, May 10, 1883, *Oeuvres complètes*, XIV, p. 1427; and G. Moore, *Impressions and Opinions*, London, 1891, p. 319.

55. See E. Zola, "Mon Salon," 1868, *Oeuvres complètes*, XII, p. 882; and Halévy, *My Friend Degas*, p. 41.

56. E. Zola, *Edouard Manet, étude biographique et critique*, 1867, *Oeuvres complètes*, XII, pp. 821–845. On its aesthetic program, see G. H. Hamilton, *Manet and His Critics*, New Haven, 1954, pp. 87–104.

57. L. Ulbach, "La Littérature putride," *Le Figaro*, January 23, 1868; reprinted, with Zola's reply, in his *Oeuvres complètes*, I, pp. 673–680. See also his preface to the second edition of *Thérèse Raquin*; ibid., pp. 519–523.

58. G. Vapereau, review of *Thérèse Raquin*, *L'Année Littéraire et Dramatique*, 10, 1867; quoted in E. Zola, *Thérèse Raquin*, ed. M. Le Blond, Paris, 1928, p. 250.

59. Ulbach, "La Littérature putride," reprinted in Zola, *Oeuvres complètes*, I, p. 676.

60. See J. C. Lapp, *Zola before the Rougon-Macquart*, Toronto, 1964, pp. 91–92. In the wedding-night scene itself, the vacillating, ruddy light of the fire plays such a role; see Zola, *Thérèse Raquin*, pp. 605–606.

61. See H. Mitterand, *Zola journaliste*, Paris, 1962, p. 71; and Claverie, "*Thérèse Raquin*, ou les Atrides," p. 145, who cites the portrayal of Thérèse on her wedding night as one example.

62. See Lapp, *Zola before the Rougon-Macquart*, pp. 97, 101. On their artistic affinities at this time, see *ibid.*, pp. 129–132; and M. Schapiro, *Paul Cézanne*, rev. ed., New York, 1962, pp. 22–25.

63. Lapp, *Zola before the Rougon-Macquart*, pp. 103–104. See also the debate between Zola and Sainte-Beuve on the plausibility of these scenes; M. Kanes, "Autour de *Thérèse Raquin*, un dialogue entre Zola et Sainte-Beuve," *Cahiers Naturalistes*, 12, 1966, pp. 23–31.

64. B. Nicolson, "Degas as a Human Being," *Burlington Magazine*, 105, 1963, pp. 239–240, with further

references. Zola himself based the misogynistic traits of Claude Lantier, the artist hero of *The Masterpiece*, on those of Degas; see R. J. Niess, *Zola, Cézanne, and Manet, A Study of L'Oeuvre*, Ann Arbor, 1970, pp. 186–187.

65. See Notebook 11, pp. 94–95, used in 1857–1858; and his letter to Henri Rouart, December 5, 1872, *Lettres*, pp. 27–28.

66. Letter to P.-A. Bartholomé, December 19, 1884, *Lettres*, p. 99. For a similar expression, see his letter to Henri Lerolle, August 21, 1884; quoted in Chap. III, p. 130.

67. E. Bergerat, "Edgar Degas, souvenirs," *Le Figaro*, May 11, 1918. The author had met Degas in 1870, during the siege of Paris.

68. Manet, quoted by Berthe Morisot in a letter to her sister Edma, spring 1869; her *Correspondance*, ed. D. Rouart, Paris, 1950, p. 31; trans. B. W. Hubbard, New York, 1959.

69. Lemoisne, no. 79; dated 1860–1862, but more likely of 1859–1860. On Degas's awareness of the nature of their marriage, see the letters quoted in Chap. III, pp. 95–97.

70. Lemoisne, nos. 335, 41, 70, 124, respectively. The last two are correctly dated 1860 and 1865, but the first two are contemporary with *Interior*, not of 1857–1859 and 1873–1875 as stated there. See the studies for no. 335 in Notebook 25, pp. 36, 37, 39, used in 1869–1872; and those for no. 41 in Notebook 22, p. 119, used in 1867–1874, and Notebook 23, p. 34, used in 1868–1872.

71. Bell, *Degas, Le Viol*, unpaged [pp. 12–13].

72. Compare the more banal composition of the work that may have been its source, Joseph Liès's *Evils of War* of 1859; P. Pool, "The History Pictures of Edgar Degas and Their Background," *Apollo*, 80, 1964, p. 311, fig. 2.

73. Notebook 23, p. 44; used in 1868–1872.

74. See Musée National de Versailles, *Charles Le Brun*, July–October 1963, pp. 302–307; and J. Locquin, *La Peinture d'histoire en France de 1747 à 1785*, Paris, 1912, pp. 80–81.

75. Notebook 23, p. 47.

76. For example, J. C. Lavater, *La Physionomie*, trans. H. Bacharach, Paris, 1845; and A. David, *Le Petit Lavater portatif*, Paris, 1854. On his popularity in France, see J. Baltrusaitis, *Aberrations*, Paris, 1957, pp. 34–46; and this chapter, note 82.

77. Notebook 21, p. 4; used in 1865–1868. The quotation is from J. W. von Goethe, *Dichtung und Wahr-*

heit, Book XIX; *Oeuvres*, trans. J. Porchat, 10 vols., Paris, 1861–1863, VIII, p. 640.

78. See E. Levy, "Delsarte's Cours d'Esthétique Appliquée," M. A. thesis, Louisiana State University, 1940, pp. 70–71; and Abbé Delaumosne, *Pratique de l'art oratoire de Delsarte*, Paris, 1874, pp. 77–84, on the eye.

79. Grappe, *Edgar Degas*, p. 50.

80. E. and J. de Goncourt, *Journal, mémoires de la vie littéraire*, 9 vols., Paris, 1935–1936, III, p. 26; dated March 5, 1866. For other examples, see R. Ricatte, *La Création romanesque chez les Goncourt*, Paris, 1953, p. 365.

81. L. E. Duranty, "Sur la physionomie," *La Revue Libérale*, 2, 1867, p. 510. For a summary of his views, see Crouzet, *Un Méconnu du Réalisme*, pp. 248–249, 456–457.

82. F. Baldensperger, "Les Théories de Lavater dans la littérature française," *Etudes d'histoire littéraire, 2e série*, Paris, 1910, p. 89; on Gautier, Sand, and Balzac, see pp. 70–87.

83. Zola, *Thérèse Raquin*, p. 541. On his method of characterization, see H. Mitterand, "Corrélations lexicales et organisation du récit, le vocabulaire du visage dans *Thérèse Raquin*," *Linguistique et Littérature* (*La Nouvelle Critique*, special number), Paris, 1968, pp. 21–28.

84. Lemoisne, no. 638; dated ca. 1881. See also *ibid.*, no. 639; and the studies in Notebook 32, pp. 5 verso–15 verso, *passim*.

85. C. Lombroso, *L'Uomo delinquente*, Milan, 1876. A second, much larger, edition was published in Turin in 1878. On Bordier, Lombroso, and others of this period, see C. Bernaldo de Quirós, *Modern Theories of Criminality*, Boston, 1912, pp. 1–45.

86. Notebook 23, p. 45; used in 1868–1872.

87. Lemoisne, no. 271; dated 1870. On its relation to the notebook text, see *ibid.*, I, p. 56; and J. S. Boggs, *Portraits by Degas*, Berkeley, 1962, pp. 25–26.

88. Lemoisne, nos. 186, 294; dated 1868–1869 and 1872. Both works are anticipated, if not influenced, by Menzel's *Théâtre Gymnase* of 1856; see E. Waldmann, *Der Maler Adolph Menzel*, Vienna, 1941, pl. 52. Degas was in contact with Menzel in 1867–1868—see Lemoisne, I, p. 233, note 63—but few of the latter's works were exhibited in Paris before that date. On their relationship, see J. Meier-Graefe, *Degas*, New York, 1923, pp. 47–52.

89. L. E. Duranty, "Le Salon de 1870," *Paris-Journal*, May 8, 1870; quoted in Lemoisne, I, p. 62.

90. See Degas's notes on this effect; quoted in this chapter, note 44.

91. Zola, *Thérèse Raquin*, p. 605. Further on, the fire's ruddy light becomes a symbol of violence: "Now and then the wood spurted jets of ruddy flame, and then the murderers' faces were touched with fleeting gleams of blood," *ibid.*, p. 606.

92. Lapp, *Zola before the Rougon-Macquart*, p. 91.

93. L. E. Duranty, "Le Salon bourgeois," *La Rue*, July 13, 1867; quoted in Crouzet, *Un Méconnu du Réalisme*, p. 655, note 257.

94. See J. Rewald, "Notes sur deux tableaux de Claude Monet," *Gazette des Beaux-Arts*, 70, 1967, pp. 245–248, where the other version, in the collection of Mr. and Mrs. Paul Mellon, is also illustrated.

95. See, for example, Courbet's etching *The Andler Keller*, 1862, illustrated in Rewald, *History of Impressionism*, p. 36; and Legros's etched illustrations of Poe's *Histoires extraordinaires*, illustrated in *A Catalogue of the Etchings . . . by Professor Alphonse Legros in the Collection of Frank E. Bliss*, London, 1923, pls. XLIII, XLIV, XLV.

96. E. G. Kennedy, *The Etched Work of Whistler*, New York, 1910, nos. 32, 33. There is an etching of the same subject and date by Seymour Haden (Harrington, no. 9) and a lithograph of a similar subject by Théodule Ribot (not in Béraldi; proof in New York Public Library).

97. Again Menzel's work provides a close precedent, if not a direct influence; see his *Interior with Menzel's Sister* of 1847, illustrated in Waldmann, *Der Maler Adolph Menzel*, pl. 13. Similarly, his *Evening Reunion* of ca. 1848, illustrated in *ibid.*, pl. 30, closely resembles the Monets and Whistlers just discussed.

98. For example, the small oil sketch of 1856–1857, also entitled *Interior*, in the Louvre. Not in Lemoisne; see *Degas, oeuvres du Musée du Louvre*, no. 160, where it is incorrectly related to a picture of 1872–1873.

99. Lemoisne, nos. 79, 175; dated 1859–1860 and 1866–1868. For a similar effect, see *Mlle Dubourg* and *Thérèse Morbilli*, *ibid.*, nos. 137, 255; dated 1866 and ca. 1869.

100. Lemoisne, no. 82; dated 1861. See especially the perspective study for it; *Degas, oeuvres du Musée du Louvre*, no. 77.

101. Lemoisne, no. 320; signed and dated 1873. See A. Scharf, *Art and Photography*, Baltimore, 1974,

pp. 190–192. Interesting in relation to *Interior*, in its figures as well as its setting, is Robert Tait's *Chelsea Interior* of 1858; illustrated in *ibid.*, p. 192.

102. See, among others, *The Dance Class*, *The Dance Rehearsal*, and *Two Dancers Seated on a Bench*, Lemoisne, nos. 341, 430, 559; dated ca. 1875, ca. 1877, and ca. 1879, respectively.

103. Letter to P.-A. Bartholomé, August 27, 1892; *Lettres*, pp. 193–194. The pictures he had been struggling with when he wrote this are Lemoisne, nos. 1114, 1115; dated 1892.

104. Described in J. Raunay, "Degas, souvenirs anecdotiques," *Revue de France*, 11, no. 2, 1933, pp. 472–473. Similar devices were recommended in popular manuals, such as Armand Cassagne's *Traité pratique de perspective*, 1873, and were used by Van Gogh; see A. S. Wylie, "An Investigation of the Vocabulary of Line in Vincent van Gogh's Expression of Space," *Oud Holland*, 85, 1970, pp. 213–218.

105. Jeanniot, "Souvenirs sur Degas," p. 281.

106. Halévy, *My Friend Degas*, p. 103. For similar statements by him, see Chap. VII, p. 294.

107. See this chapter, note 110.

108. See his letter to Poujaud, July 6, 1936, and the latter's reply, July 11, 1936; Paris, Bibliothèque Nationale, Nouv. Acq. Fr. 24839, fols. 480–481, 483–485. Guérin published the reply in *Lettres*, pp. 255–256, but deleted all references to the document in question.

109. This was his address from at least 1865 to at least 1870; see Lemoisne, I, p. 231, note 47, p. 233, notes 63 *bis*–66.

110. Paris, Bibliothèque Nationale, Nouv. Acq. Fr. 24839, fol. 596.

111. *Ibid.*, fol. 596 verso. I have relied on Guérin's transcription, *ibid.*, fol. 486, where the original was difficult to read.

112. See this chapter, note 108.

113. Notebook 22, p. 215; used in 1867–1874. Notebook 23, p. 159; used in 1868–1872.

114. Prins had been friendly with Manet since the early 1860s, and at his home had met Jenny's sister Fanny Clauss, whom he married in 1869, the year in which she also posed for Manet's *The Balcony*; see [E. L. P. Prins], *Pierre Prins et l'époque impressionniste*, Paris, 1949, pp. 18–26. I owe this suggestion to the late Denis Rouart.

115. See especially the letter to Degas, September 18 [1860?], Paris, formerly collection of Jean Nepveu-

Degas; and the one to Bathhonne, December 14, 1878, Bowling Green, collection of Willard Misfeldt. I am indebted to the latter and to David Brooke for information on Tissot.

116. He had been exhibiting genre pictures and portraits successfully at the Salon since 1864; see Museum of Art, Rhode Island School of Design, Providence, *James Jacques Joseph Tissot*, February 28–March 29, 1968, unpaged [p. 13], nos. 7, 10.

117. See Berthe Morisot's letter to her sister Edma, fall 1871, her *Correspondance*, p. 67. Her reference to "the little Clauss" could only be to Jenny.

118. Notebook 22, pp. 217, 222; used in 1867–1874. Notebook 21, p. 13 verso; used in 1865–1868. For the portrait, see Lemoisne, no. 175; dated 1866–1868.

119. *James Jacques Joseph Tissot*, no. 27; for the others, see fig. 6 (under no. 50), no. 16. On the mood of alienation in these works, see also H. Zerner's introductory essay, *ibid.*, unpaged [pp. 10–11].

120. Lemoisne, no. 335; on its date, see this chapter, note 70. Tissot's pictures in turn influenced later scenes of marital estrangement, such as Orchardson's *The First Cloud;* illustrated in G. Reynolds, *Victorian Painting*, London, 1966, pl. 130.

121. Some of the *pentimenti* may date from ca. 1903, when Degas restored the picture. But according to Jeanniot, "Souvenirs sur Degas," p. 167, only the man's head was retouched; and according to Guérin, letter to Poujaud, cited this chapter, note 108, it was only the lampshade and the woman's head.

122. Compare Tissot's use of such a shadow beneath the sofa in *The Club of the Rue Royale* of 1868; *James Jacques Joseph Tissot*, no. 10.

123. See this chapter, note 29.

124. Dated 1863; see Walker Art Gallery, Liverpool, and Royal Academy of Arts, London, *Millais*, January–April 1967, no. 63, with further references.

125. W. Bürger [T. Thoré], "L'Exposition Universelle de 1867," *Salons, 1861–1868*, Paris, 1870, pp. 402–403. On the obscurity of Millais's title, see also E. Chesneau, *Les Nations rivales dans l'art*, Paris, 1868, pp. 41–43.

126. Letter to Fantin-Latour, April 1863; quoted in L. Bénédite, "Whistler," *Gazette des Beaux-Arts*, 33, 1905, pp. 510–511.

127. L. E. Duranty, "John Everett Millais," *Illustrated Biographies of Modern Artists*, ed. F. G. Dumas, London, 1882, pp. 41–42. For other reactions, see J. Lethève, "La Connaissance des peintres préraphaél-

ites anglais en France (1855–1900)," *Gazette des Beaux-Arts*, 53, 1959, pp. 317, 320–321, 327–328.

128. See J. Laver, "*Vulgar Society*," *The Romantic Career of James Tissot*, London, 1936, pp. 25–32. This was also the year of Degas's first visit to London; see his letter to Legros, October 1871; T. Reff, "Some Unpublished Letters of Degas," *Art Bulletin*, 50, 1968, pp. 88–89.

129. P. Mantz, "Salon de 1865," *Gazette des Beaux-Arts*, 19, 1865, pp. 11–12. See also P. Burty, "Exposition de la Royal Academy," *ibid.*, 25, 1868, pp. 62–63, on the influence of English art on Tissot's *The Club of the Rue Royale*.

130. *James Jacques Joseph Tissot*, no. 11. The preparatory drawing is *ibid.*, no. 43.

131. See J. G. Millais, *The Life and Letters of Sir John Everett Millais*, 2 vols., London, 1899, I, pp. 380–383, illustrated p. 369. I owe this observation to Allen Staley.

132. See A. Grieve, "Whistler and the Pre-Raphaelites," *Art Quarterly*, 34, 1971, pp. 219–220.

133. Letter of November 19, 1872; Paris, Bibliothèque Nationale, Nouv. Acq. Fr. 13005, fols. 5–6; published only in English, in *Lettres*, Eng. trans., pp. 17–19.

134. Letter of February 18, 1873; Paris, Bibliothèque Nationale, Nouv. Acq. Fr. 13005, fols. 8–9; published only in English, in *Lettres*, Eng. trans., pp. 29–32. In the same letter, he refers to "that English art, which pleases us so much."

135. Notebook 21, pp. 30, 31, 31 verso; used in 1865–1868. For the works he lists, see Paris Universal Exhibition, *Complete Official Catalogue*, 2nd ed., London and Paris, 1867, pp. 100–103, nos. 49a, 49b, 55, 64, 99a, and pp. 103–106, nos. 38, 55, 55a, 68, 90a.

136. E. Degas, "A Propos du Salon," *Paris-Journal*, April 12, 1870; reprinted in Reff, "Some Unpublished Letters," pp. 87–88. For *Golden Hours*, see E. Staley, *Lord Leighton of Stretton*, London, 1906, pp. 66–67, illustration opposite p. 48; for *Sulking*, Lemoisne, no. 335, and this chapter, note 70, on its date. There are also affinities between Leighton and Degas in the 1850s, as Richard Ormond kindly informs me.

137. See Chap. III, p. 117.

138. See Wildenstein, New York, *From Realism to Symbolism, Whistler and His World*, March 4–April 3, 1971, comments on nos. 18, 108; and A. Staley, "The Condition of Music," *Art News Annual*, 33, 1967, pp. 80–87, on Moore and Whistler.

139. See From *Realism to Symbolism*, nos. 18, 63; and Chap. I, on Whistler and Degas.

140. Letter to Whistler, February 12, 1867; quoted in *From Realism to Symbolism*, under no. 135.

141. *Ibid.*, comment on no. 12. On the relation between the two works, see also Grieve, "Whistler and the Pre-Raphaelites," pp. 219–220.

142. J.-A. Castagnary, "Salon des Refusés, 1863," *Salons (1858–1870)*, Paris, 1892, p. 179. Another critic asked: "What does she want of us, with her hair untied, her large eyes drowned in ecstasy, her languid posture . . . ?" P. Mantz, "Salon de 1863," *Gazette des Beaux-Arts*, 15, 1863, p. 61.

143. See *From Realism to Symbolism*, comments on nos. 12, 104; and Grieve, "Whistler and the Pre-Raphaelites," p. 220.

144. See Hamilton, *Manet and His Critics*, pp. 104–105; and G. Mack, *Gustave Courbet*, New York, 1950, pp. 215–219.

145. See *Millais*, nos. 328–335, with further references; also D. Sutton, "Victorian Cross-Currents," *Apollo*, 85, 1967, pp. 6–8, on the personal and social context.

146. These copies, largely after *The Rake's Progress* and *The Harlot's Progress*, are in Notebook 4, pp. 25–33; probably used in 1859–1860.

147. H. Taine, *Histoire de la littérature anglaise*, 4 vols., Paris, 1892 [1st ed. 1863–1864], IV, p. 468. He develops the theme further in *Notes sur l'Angleterre*, Paris, 1871, pp. 348–352.

148. Chesneau, *Les Nations rivales dans l'art*, pp. 50–55. For the pictures cited, see the *Complete Official Catalogue*, pp. 101–102, nos. 30b, 79.

149. See R. Lister, *Victorian Narrative Paintings*, London, 1966, pp. 54–59; and P. Ferriday, "Augustus Egg," *Architectural Review*, 134, 1963, pp. 420–422.

150. See Lapp, *Zola before the Rougon-Macquart*, pp. 96–98.

151. W. Bürger [T. Thoré], "Exposition des Beaux-Arts à Bruxelles," *Gazette des Beaux-Arts*, 8, 1860, pp. 94–95.

152. L. E. Duranty, *La Nouvelle Peinture*, ed. M. Guérin, Paris, 1946 [1st ed. 1876], pp. 42–43.

153. Zola, *Madeleine Férat*, pp. 887–888.

154. Rivière, *Mr. Degas*, p. 67. See O. Reuterswärd, "An Unintentional Exegete of Impressionism," *Konsthistorisk Tidskrift*, 4, 1949, p. 112.

155. In the more popular medium of lithography, however, he was anticipated by Daumier and Gavarni in the 1840s and 1850s. See, for example, P.-A. Lemoisne, *Gavarni, peintre et lithographe*, 2 vols., Paris, 1928, I, opposite pp. 86, 196, and II, pp. 115, 139, 217.

156. For the former, see *Atelier*, II, no. 220; and Rivière, *Dessins de Degas*, no. 19. For the latter, see Lemoisne, no. 326; and Chap. III, pp. 125–130. See also the seated man at the far right in *Rehearsal of a Ballet on Stage*, Lemoisne, no. 400; dated 1873–1874.

VI. To Make Sculpture Modern

1. L. W. Havemeyer, *Sixteen to Sixty, Memoirs of a Collector*, New York, 1961, pp. 254–255. Illustrated above is one of the bronze casts made in 1921 from the original wax version, which is now in the collection of Mr. and Mrs. Paul Mellon. See Rewald, pp. 16–20, no. XX.

2. J.-K. Huysmans, "L'Exposition des Indépendants en 1881," *L'Art moderne*, Paris, 1883, p. 226.

3. See L. Tannenbaum, "Degas, Illustrious and Unknown," *Art News*, 65, no. 1, January 1967, p. 53.

4. Rewald, no. XIX; dated 1879–1880.

5. See this chapter, notes 39, 69, 71, respectively.

6. Rewald, no. LII; dated 1896–1911. A dressed figure also occurs in *The Masseuse, ibid.*, no. LXXIII; dated 1896–1911.

7. G. Bazin, "Degas sculpteur," *L'Amour de l'Art*, 12, 1931, pp. 293–301, compares his sculpture with that of Renoir and Maillol in very general terms. The one specific connection drawn thus far is between his early horses and those of Joseph Cuvelier; see P.-A. Lemoisne, "Les Statuettes de Degas," *Art et Décoration*, 36, 1914–1919, pp. 110–111.

8. M. Beaulieu, "Les Sculptures de Degas, essai de chronologie," *Revue du Louvre*, 19, 1969, pp. 369–380. This argument ignores not only the frequent repetition of subjects in Degas's oeuvre but the evidence for dating certain statuettes, such as Rewald, no. XXXVI, a decade later than the related paintings and pastels.

9. Unsigned notice in *Chronique des Arts*, 18, 1881, pp. 109–110. The case was not acquired by Mr. and Mrs. Mellon, and its whereabouts is not known.

10. *Atelier*, III, no. 280a.

11. H. O'Shea, *Les Musées du Louvre, guide populaire*, Paris, 1892, p. 398. Huysmans, *L'Art moderne*, p. 227. The etching is Adhémar, no. 53; dated 1879–1880.

12. Huysmans, *L'Art moderne*, p. 226.

13. P. Mantz, "L'Exposition des Indépendants," *Le Temps*, April 23, 1881; reprinted in Lemoisne, I, p. 249, note 141.

14. J. Claretie, *La Vie à Paris, 1881*, Paris, 1882, p. 150; from *Le Temps*, April 5, 1881.

15. C. E[phrussi], "Exposition des Artistes Indépendants," *Chronique des Arts*, 18, 1881, pp. 126–127.

16. Huysmans, *L'Art moderne*, p. 227. For Renoir's reaction, see A. Vollard, *Auguste Renoir*, Paris, 1920, p. 95; for Whistler's, J.-E. Blanche, *Propos de peintre, de David à Degas*, Paris, 1919, p. 54.

17. Lemoisne, nos. 586 *bis*, 586 *ter*; dated ca. 1880. *Atelier*, III, nos. 277, 341b (illustrated above), 386. *Atelier*, IV, no. 287a.

18. Notebook 34, p. 4; used in 1880–1884; inscribed: "Marie Van Gutten, 36 rue de Douai." The sheet of studies [161] is inscribed: "36 rue de Douai-Marie." For the traditional identification of the model, see Beaulieu, "Sculptures de Degas," p. 375.

19. See J. Hugard, *Ces Demoiselles de l'Opéra*, Paris, 1923; cited in L. Browse, *Degas Dancers*, London, 1949, p. 62. See also J.-G. Prod'homme, *L'Opéra (1660–1925)*, Paris, 1925, p. 146.

20. Notebook 30, p. 210; used in 1877–1883.

21. Mantz, "L'Exposition des Indépendants," p. 250.

22. C. E[phrussi], "Exposition des Artistes Indépendants," p. 127.

23. Lemoisne, nos. 471, 473, 483, 484, 486; all dated ca. 1878, but more likely of 1884–1888. For the date and the model's identity, see Browse, *Degas Dancers*, notes on pls. 160–165.

24. Claretie, *La Vie à Paris, 1881*, p. 150. Huysmans, *L'Art moderne*, pp. 226–227.

25. See, among others, G. Borrelli, *Il Presepe Napoletano*, Rome, 1970, *passim*; also J. S. Boggs, "Edgar Degas and Naples," *Burlington Magazine*, 105, 1963, pp. 273–276. I owe this suggestion to Thomas Sokolowski.

26. See J. Claretie, *La Vie à Paris, 1882*, Paris, 1883, pp. 273–278; from *Le Temps*, June 2, 1882. He does not specify the date, but it must have been shortly after Chabrillat moved to Paris from Dijon ca. 1866.

27. Claretie, *La Vie à Paris, 1881*, pp. 435–439; from *Le Temps*, November 29, 1881.

28. Unsigned, "Courrier de Paris," *L'Illustration*, June 10, 1882. See also Claretie, *La Vie à Paris, 1882*, pp. 300–303; from *Le Temps*, June 9, 1882.

29. Musée Grévin, *Catalogue illustré*, Paris, 1882, no. 1. The latter is not illustrated; but for a comparable example, see Musée Grévin, *Principaux tableaux du Musée reproduits par la photographie*, Paris, n.d. [1887], pl. 4.

30. Lemoisne, no. 469; dated 1877–1880. The identification of the model, first proposed in Cleveland Museum of Art, *Works by Edgar Degas*, February 5–March 9, 1947, no. 5, has been tentatively rejected by Browse, *Degas Dancers*, note on pl. 176.

31. Letter to Henri Rouart, October 26, 1880, *Lettres*, pp. 59–60.

32. Musée Grévin, *Catalogue illustré*, no. 4. On Zola, Halévy, and Daudet, see Chap. IV, pp. 164–170, 182–188, 161; on Wolff and Detaille, Notebook 29, p. 3, used in 1877–1880.

33. Huysman, *L'Art moderne*, p. 227. Havemeyer, *Sixteen to Sixty*, pp. 254–255.

34. Notebook 34, p. 228; used in 1880–1884. According to the *Bottin*, Mme Cussey [sic] was a "manufacturer of wigs for puppets [or dolls]."

35. Mantz and Ephrussi; see this chapter, notes 13, 15. The *Little Dancer* is 39 inches high; the average child of fourteen, about five feet high.

36. Lemoisne, no. 326; dated ca. 1873, but more likely of ca. 1878. See Chap. III, pp. 125–130.

37. E. Zola, *Au Bonheur des Dames*, ed. M. Le Blond, Paris, 1928 [1st ed. 1882], p. 476.

38. *Ibid.*, p. 11; trans. A. Fitzlyon, London, 1958. For other parallels between this novel and Degas's art, see Chap. IV, pp. 168–170.

39. Rewald, no. I; dated ca. 1865. It is difficult to decide whether the wax version is a replica, as stated there, or a sketch, as stated in Beaulieu, "Sculptures de Degas," p. 369; the latter seems the more likely.

40. Vollard, *Auguste Renoir*, p. 95.

41. Lemoisne, "Statuettes de Degas," p. 110.

42. Letter of September 9, 1882; *Lettres*, pp. 69–71. On their relationship, see T. Burollet, "Bartholomé et Degas," *L'Information de l'Histoire de l'Art*, 12, 1967, pp. 119–126. In "Degas, oeuvres du Musée du Louvre," *Revue de l'Art*, no. 7, 1970, p. 104, published concurrently with the first version of this essay, Thérèse Burollet, too, observes that *The Apple Pickers* cannot be dated in the 1860s stylistically, and confirms that Bartholomé cannot have known Degas before 1878–1880.

43. R. Raimondi, *Degas e la sua famiglia in Napoli,* Naples, 1958, pp. 276–277; see also pls. 25a–d, photographs of the letter, from which some errors in the transcription can be corrected.

44. See her letters to her husband, undated but probably 1881, and July 4, 1881; quoted in Boggs, "Edgar Degas and Naples," pp. 275–276. Thérèse was in Paris again the following summer, but Lucie apparently did not accompany her; moreover, Degas does not anticipate her visit in his letter.

45. See F. Sweet, *Miss Mary Cassatt,* Norman, 1966, p. 70.

46. See, for example, his letters to J.-B. Faure, March 1877, and Alexis Rouart, 1882, *Lettres,* pp. 40, 61–62.

47. Degas had portrayed her with her uncle around 1876; Lemoisne, no. 394. But neither from this portrait nor from the photograph of her, also of ca. 1876, reproduced in Boggs, "Edgar Degas and Naples," p. 272, fig. 34, is it possible to identify her in the preparatory studies for the relief.

48. See this chapter, note 43. Anne's birth date, 1868, recorded by one of her relatives, was kindly communicated by Maître Ernest Michel, Nice. In Notebook 34, p. 3, the one containing studies for *The Apple Pickers,* there is a sketch of Anne's sister Madeleine.

49. Notebook 34, pp. 225, 223; used in 1880–1884.

50. *Ibid.,* p. 25. Reproduced in J. S. Boggs, "Degas Notebooks at the Bibliothèque Nationale—III," *Burlington Magazine,* 100, 1958, fig. 41, but like the other studies, described in *ibid.,* p. 246, not related to the relief.

51. Notebook 34, p. 29. This figure is more difficult than the others to read in the wax version.

52. *Ibid.,* p. 15. Degas had originally written: "Six heads to the seam."

53. *Atelier,* II, no. 279. New York Cultural Center, *A Selection of Drawings, . . . Collection of Mr. and Mrs. Francis Avnet,* December 9, 1969—January 25, 1970, no. 26.

54. Notebook 34, p. 21. The phrase *têtes d'aune* is confusing, since the *aune,* an outmoded unit reserved for measuring fabrics, was equivalent to 47 inches, which would make Degas's figure about 20 feet high. However, it does appear to be the height of five *têtes,* the length of a human face and a traditional unit of measure in the fine arts; and since the expression *figure longue d'une aune* means "a face as long as a fiddle," the *tête d'aune* may signify an unusually long face used as such a unit.

55. *Atelier,* IV, no. 156.

56. Notebook 34, pp. 37, 45; there is also a brief study on p. 43. Notebook 30, pp. 184, 186, 190, 212–213; used in 1877–1883.

57. Lemoisne, "Statuettes de Degas," p. 110.

58. Notebook 34, p. 1.

59. Vollard, *Auguste Renoir,* p. 95. The wax version is 46 by 49 cm., or about 18 by 19 inches.

60. See A. Elsen, *Rodin,* New York, 1963, pp. 35–48; and M. Dreyfous, *Dalou, sa vie et son oeuvre,* Paris, 1903, pp. 140–144, 170–178.

61. See his letter to Charles Deschamps, August 22, 1875; T. Reff, "Some Unpublished Letters of Degas," *Art Bulletin,* 50, 1968, p. 89. See also Notebook 34, p. 223, listing the address of Bingen, a founder who rediscovered the lost-wax technique ca. 1880, and was thereafter employed by Dalou (Dreyfous, *Dalou,* p. 120), from whom Degas presumably learned about him. For his contacts with Rodin, see Elsen, *Rodin,* p. 145, quoting the memoir of Victor Frisch, Rodin's assistant from 1890 on.

62. See J. L. Wasserman et al., *Daumier Sculpture,* Cambridge, 1969, pp. 174–183.

63. Notebook 31, p. 6; used in 1878–1879. His model was *The Legislative Belly,* a lithograph of 1834; see Chap. II, pp. 73–74.

64. Three iconographically dissimilar examples, all dated ca. 1880, are *At the Races, Café-Concert Singer,* and *Three Dancers;* Lemoisne, nos. 502, 504, 602, respectively.

65. Letter to P.-A. Bartholomé, August 14, 1889, *Lettres,* pp. 138–139. By "relief," of course, Degas means three-dimensional form; on its importance in academic instruction throughout the century, see A. Boime, *The Academy and French Painting in the Nineteenth Century,* London, 1971, pp. 28–30.

66. Lemoisne, no. 532; dated ca. 1879.

67. Lemoisne, no. 70; dated 1860. This stylistic affinity may, in fact, explain why he chose to exhibit it in 1880.

68. L. R. Pissarro and L. Venturi, *Camille Pissarro, son art, son oeuvre,* 2 vols., Paris, 1939, nos. 517, 545.

69. Rewald, no. LXXIV; not dated.

70. F. Daulte, *Auguste Renoir,* 5 vols., Lausanne, 1971–, I, no. 280; see *ibid.,* nos. 281, 282, 337, all related subjects. For the type of Guillaumin shown, see C. Gray, *Armand Guillaumin,* Chester, 1972, no. 60, pl. 77.

71. See E. H. Payne, "A Little-Known Bronze by Degas," *Bulletin of the Detroit Institute of Arts*, 36, 1956–1957, pp. 82–85.

72. Notebook 34, pp. 13, 17, 19, respectively; used in 1880–1884. Their relation to this sculpture was first noted in Boggs, "Degas Notebooks," p. 246, though they were also related, incorrectly, to the *Bust of Hortense Valpinçon*.

73. If the Impressionist modeling of *The Schoolgirl* differs considerably from the smooth surface treatment of the *Little Dancer*, it is very similar to that of the nude study for the latter.

74. Mantz, "L'Exposition des Indépendants," p. 250.

75. Adhémar, no. 52; dated ca. 1879. See J. S. Boggs, *Portraits by Degas*, Berkeley, 1962, pp. 49–50.

76. Lemoisne, no. 651; dated ca. 1881.

77. Lemoisne, no. 532; dated ca. 1879. See Boggs, *Portraits by Degas*, p. 50.

78. See Wasserman et al., *Daumier Sculpture*, pp. 205–247, *passim*; however, the attribution to Daumier is seriously questioned there.

79. *Ibid.*, pp. 161–173. Although not included in the retrospective exhibition of 1878, it was discussed by Degas's friend, L. E. Duranty, "Daumier," *Gazette des Beaux-Arts*, 17, 1878, p. 532.

80. See M. S. Barr, *Medardo Rosso*, New York, 1963, pp. 12–13; also *ibid.*, pp. 18–19, a photograph of Rosso's studio in 1882, showing a bronze bust draped with a real cloth.

81. *Ibid.*, p. 25.

82. See Mallet at Bourdon House, London, *Sculptures by Jules Dalou*, April 28–May 9, 1964, pp. 7–8, nos. 1–6; also this chapter, note 61.

83. C. Gray, *Sculpture and Ceramics of Paul Gauguin*, Baltimore, 1963, no. 4. Illustrated above is the terracotta version, rather than the wooden one that Gauguin exhibited, since it is in better condition.

84. See J. Rewald, *The History of Impressionism*, 4th ed., New York, 1973, pp. 423, 439, 449; also *ibid.*, pp. 493, 514, 542–543, on their disagreements.

85. Letter of 1881 or 1882; *Archives de Camille Pissarro*, Hôtel Drouot, Paris, November 21, 1975, no. 46. See also his previous letter; *ibid.*, no. 45.

86. Huysmans, *L'Art moderne*, p. 242.

87. Gray, *Sculpture and Ceramics of Paul Gauguin*, p. 2, fig. 1; dated there ca. 1880–1883. In reviewing the latter, in *Art Bulletin*, 46, 1964, p. 582, W. V. Andersen

argued that *The Little Parisian* "should be dated to the summer of 1881, when Gauguin worked with Pissarro at Pontoise." But he overlooked that they had also worked together in 1879 and 1880; see Rewald, *History of Impressionism*, pp. 602–603.

88. See L. Venturi, *Les Archives de l'Impressionnisme*, 2 vols., Paris, 1939, II, p. 266; and F. Cachin, *Gauguin*, Paris, 1968, pp. 52–55.

89. Notebook 34, p. 208; used in 1880–1884. See Gray, *Sculpture and Ceramics of Paul Gauguin*, no. 6.

90. Huysmans, *L'Art moderne*, pp. 228–229.

91. Rewald, pp. 21–22. On Degas and the Valpinçons, see Boggs, *Portraits by Degas*, pp. 35–37; and this chapter, note 94.

92. Letters to Henri Rouart, September 1884, and P.-A. Bartholomé, September 15, 1884; *Lettres*, pp. 89, 91.

93. In addition to the letters cited in the previous note, see those in *Lettres*, pp. 86, 90, 91–92, 93, most of which are undated and may be in the wrong order. For Hortense Valpinçon's memoir, see S. Barazzetti, "Degas et ses amis Valpinçon," part 1, *Beaux-Arts*, no. 190, August 21, 1936, p. 3, and part 2, *ibid.*, no. 191, August 28, 1936, pp. 1, 4.

94. Letter to Ludovic Halévy, 1884, *Lettres*, p. 90. On the drawings, see J. S. Boggs, *Drawings by Degas*, Greenwich, 1967, nos. 113, 114; and Barazzetti, "Degas et ses amis Valpinçon," part 1, p. 3, and part 2, p. 1.

95. See C. Virch, *Master Drawings in the Collection of Walter C. Baker*, New York, 1962, no. 104; and Barazzetti, "Degas et ses amis Valpinçon," part 2, p. 1.

96. See Barazzetti, "Degas et ses amis Valpinçon," part 2, p. 1. On his later dating of early drawings, sometimes inaccurately, see T. Reff, "New Light on Degas's Copies," *Burlington Magazine*, 106, 1964, p. 251.

97. Letter to P.-A. Bartholomé, October 3, 1884, *Lettres*, pp. 92–93; the presence of the sketch is not indicated there. It was published in J. Rewald, *Degas, Works in Sculpture*, New York, 1944, p. 10.

98. See Barazzetti, "Degas et ses amis Valpinçon," part 2, p. 1, quoting Hortense.

99. Lemoisne, no. 869; dated 1886. According to Boggs, *Portraits by Degas*, p. 68, it had been begun one or two years earlier; thus it was strictly contemporary with the bust of Hortense.

100. Letters to Ludovic Halévy and Henri Rouart, 1884, *Lettres*, pp. 86, 89.

101. See this chapter, note 97.

102. Gray, *Sculpture and Ceramics of Paul Gauguin*, no. 8. Although dated ca. 1881 in the older literature, it is inscribed 1884.

103. Lemoisne, no. 340; dated 1873–1874. The Metropolitan Museum's version is no. 400; dated 1873–1874. Moreover, in the 1880s no. 340 was in French collections and no. 400 in a less accessible English collection; see R. Pickvance, "Degas's Dancers, 1872–1876," *Burlington Magazine*, 105, 1963, pp. 259–260.

104. The dancer at the right of this group is based on *The Ballet* or its variant, *Dancers*, Lemoisne, nos. 838, 841; dated ca. 1885, but more likely of ca. 1880. The dancer in the center is apparently based on *Two Dancers Coming on Stage*, ibid., no. 448; dated 1877–1878. The dancer at the left has no obvious source in Degas, but is similar to a type seen in *The Ballet*, ibid., no. 838.

105. See Gray, *Sculpture and Ceramics of Paul Gauguin*, pp. 4–5.

106. A. Mellerio, *Odilon Redon*, Paris, 1913, no. 44. The same print influenced a later work of Gauguin's; see M. Roskill, *Van Gogh, Gauguin, and the Impressionist Circle*, Greenwich, 1970, p. 243.

107. Gray, *Sculpture and Ceramics of Paul Gauguin*, no. 12. The type of dancer represented is that in *Dancer Bowing with a Bouquet*, Lemoisne, no. 474; dated ca. 1878.

108. See this chapter, note 105. In his paintings, Gauguin continued to be influenced by Degas as late as 1889; see Tate Gallery, London, *Gauguin and the Pont-Aven Group*, January 7–February 13, 1966, nos. 16–19.

VII. The Artist as Technician

1. A. Vollard, *Degas*, Paris, 1924, p. 80. This statement and the others in A. Vollard, "Degas et la technique," *Beaux-Arts*, no. 219, March 12, 1937, p. 3, are simply reprinted from the earlier publication.

2. G. Rouault, *Souvenirs intimes*, Paris, 1927, p. 99. Rouault had met Degas in the 1890s, through his teacher Gustave Moreau.

3. D. Rouart, *Degas à la recherche de sa technique*, Paris, 1945. See the review by J. Rewald, in *Magazine of Art*, 40, 1947, p. 38.

4. Letter to Léontine de Nittis, July 1876; M. Pittaluga and E. Piceni, *De Nittis*, Milan, 1963, p. 359.

5. Letter to Pissarro, 1880, *Lettres*, pp. 52–54. According to Guérin, ibid., p. 54, note 2, "Degas never carried out these experiments."

6. For Pissarro's experiments, see B. S. Shapiro, *Camille Pissarro, The Impressionist Printmaker*, Boston, 1973, unpaged [pp. 7–9].

7. G. Jeanniot, "Souvenirs sur Degas," *Revue Universelle*, 55, 1933, pp. 167–168. Jeanniot had met Degas around 1881.

8. Letter to James Tissot, February 18, 1873; Paris, Bibliothèque Nationale, Nouv. Acq. Fr. 13005, fol. 6; published only in English, in *Lettres*, Eng. trans., p. 32. His later views are reported in P. Valéry, *Degas Manet Morisot*, trans. D. Paul, New York, 1960, p. 99; from *Degas danse dessin*, Paris, 1936.

9. See D. G. Charlton, *Positivist Thought in France during the Second Empire*, Oxford, 1959, especially Chap. V.

10. J.-E. Blanche, *Propos de peintre, de David à Degas*, Paris, 1919, p. 258. See also D. Halévy, *My Friend Degas*, trans. M. Curtiss, Middletown, 1964, pp. 59–60, reporting his remark, "The conversation of specialists is so enjoyable; you don't understand it, but it's charming."

11. E. and J. de Goncourt, *Journal, mémoires de la vie littéraire*, ed. R. Ricatte, 22 vols., Monaco, 1956, X, pp. 163–165; dated February 13, 1874.

12. See J. Adhémar, "Before the Degas Bronzes," *Art News*, 54, no. 7, November 1955, p. 35; based on an interview with Palazzolo, who had known Degas around 1910.

13. Letter to Bracquemond, 1879, *Lettres*, pp. 48–50. The notes on aquatinting are in Notebook 30, p. 22; used in 1877–1883.

14. Notebook 26, pp. 67, 60, 58, respectively; used in 1875–1877.

15. Valéry, *Degas Manet Morisot*, pp. 5–6.

16. See the remarks reported by A. André, *Renoir*, Paris, 1928, pp. 13–14, 55–60; also Renoir's preface to C. Cennini, *Le Livre de l'art*, trans. V. Mottez, Paris, 1911 [1st ed., without preface, 1858], pp. viii–ix.

17. See E. P. Janis, *Degas Monotypes*, Cambridge, 1968, pp. xvii–xviii.

18. Rouart, *Degas à la recherche de sa technique*, pp. 16–34. See also D. Cooper, *Pastels by Edgar Degas*, New York, 1953, pp. 12–13; and B. Dunstan, "The Pastel Techniques of Edgar Degas," *American Artist*, 36, no. 362, September 1972, pp. 41–47.

19. Lemoisne, nos. 498, 847; dated 1878–1879 and ca. 1885. But no. 498 is in fact no later than 1874, as R. Pickvance, "Degas's Dancers, 1872–1876," *Burlington*

Magazine, 105, 1963, p. 263, has shown. On Degas's admiration for La Tour, see J. Fèvre, *Mon Oncle Degas*, ed. P. Borel, Geneva, 1949, pp. 69–70.

20. See E. Moreau-Nélaton, "Deux heures avec Degas," *L'Amour de l'Art*, 12, 1931, p. 269; based on an interview in 1907. According to E. Rouart, "Degas," *Le Point*, no. 1, February 1937, p. 22, Chialiva also gave him pastels that were both vivid and light-fast. *Dancers in the Wings* is Lemoisne, no. 1015; dated ca. 1896.

21. See Dunstan, "The Pastel Techniques of Edgar Degas," p. 46.

22. Lemoisne, no. 545; dated ca. 1879. For descriptions of the techniques employed, see Rouart, *Degas à la recherche de sa technique*, pp. 22–25; and J. S. Boggs, *Drawings by Degas*, Greenwich, 1967, no. 93.

23. Notebook 33, p. 3 verso; used in 1879–1882.

24. See M. Guérin, "Notes sur les monotypes de Degas," *L'Amour de l'Art*, 5, 1924, p. 77. The preparatory study is Lemoisne, no. 70; dated 1860. See also Boggs, *Drawings by Degas*, no. 36.

25. Lemoisne, no. 408; dated 1876–1877. Rouart, *Degas à la recherche de sa technique*, p. 10, states incorrectly that the medium is tempera. Later examples of Degas's use of oiled paper are *Achille de Gas* and *Four Studies of a Groom*, Lemoisne, nos. 307, 383; dated 1872–1873 and 1875–1877.

26. Lemoisne, nos. 610, 1029; dated ca. 1888 and ca. 1890, though no. 610 was evidently begun about 1880 and reworked at the later date. On the technique of no. 1029, see Rouart, *Degas à la recherche de sa technique*, pp. 44–49.

27. Vollard, *Degas*, pp. 77–78. However, Vollard is often an unreliable source; see T. Reff, "Cézanne and Poussin," *Journal of the Warburg and Courtauld Institutes*, 23, 1960, pp. 154–155.

28. See Boggs, *Drawings by Degas*, no. 25 verso, though the description of the media employed is incomplete.

29. *Ibid.*, no. 41. Reproduced in color in H. Rivière, *Les Dessins de Degas*, 2 vols., Paris, 1922–1923, no. 14.

30. Lemoisne, nos. 363, 367 *bis*; dated 1875 and ca. 1875. The redating of the latter to ca. 1872 in Boggs, *Drawings by Degas*, no. 66, is unconvincing.

31. A charcoal drawing and its reworked counterproof are illustrated in Dunstan, "Pastel Techniques of Edgar Degas," p. 47.

32. See J. Chialiva, "Comment Degas a changé sa technique du dessin," *Bulletin de la Société de l'Histoire de l'Art Français*, 24, 1932, pp. 44–45; he was a student at the Ecole from 1897 to 1906. See also Rouart, *Degas à la recherche de sa technique*, pp. 63, 67–68.

33. Lemoisne, no. 380; dated 1875–1877. For a more detailed analysis, see Rouart, *Degas à la recherche de sa technique*, p. 22.

34. Lemoisne, no. 585; dated ca. 1880. See Rouart, *Degas à la recherche de sa technique*, pp. 18–20.

35. Lemoisne, no. 564; dated ca. 1879. On some of his other fans, see Klipstein and Kornfeld, Bern, *Choix d'une collection privée*, October 22–November 30, 1960, pp. 18–33. On the *surimono* prints, already popular by 1880, see P. D. Cate, "Japanese Influence on French Prints, 1883–1910," in *Japonisme, Japanese Influence on French Art, 1854–1910*, Cleveland, 1975, p. 54.

36. G. Moore, "Degas, The Painter of Modern Life," *Magazine of Art*, 13, 1890, p. 423. See Lemoisne, no. 400; dated ca. 1876, but more likely of 1873; see the following note.

37. See Pickvance, "Degas's Dancers," pp. 259–263.

38. Adhémar, no. 54; dated 1879–1880. Illustrated above is the fifteenth state.

39. Adhémar, no. 37; dated 1876–1877. The *pentimenti* visible in the standing figure suggest that the design was drawn directly on the plate, without a preliminary study.

40. See Shapiro, *Camille Pissarro*, unpaged [p. 8].

41. It is *The Engraver Joseph Tourny*, Adhémar, nos. 7, 8; dated 1857. The later technique was evidently inspired by the so-called *eau-forte mobile* of Degas's friend Ludovic Lepic; see University of Chicago, *Etchings by Edgar Degas*, May 4–June 12, 1964, no. 8.

42. Adhémar, no. 50; dated ca. 1879, a time when Degas and Cassatt were collaborating on prints.

43. Adhémar, no. 63; dated ca. 1890. See Washington University, St. Louis, *Lithographs by Edgar Degas*, January 7–28, 1967, no. 18.

44. Adhémar, no. 42; dated ca. 1877. See *Lithographs by Edgar Degas*, no. 3.

45. See Guérin, "Notes sur les monotypes de Degas," p. 77; and *Lithographs by Edgar Degas*, nos. 5, 6.

46. Cachin, no. 167; dated ca. 1880. See Janis, *Degas Monotypes*, Catalogue, no. 37.

47. Cachin, no. 111; dated ca. 1880. For the range of effects that Degas could obtain by these means, see the other monotypes in this series, *ibid.*, nos. 83–123.

48. Not in Cachin, because reworked in pastel. See Lemoisne, no. 1054, dated 1890–1893; and Janis, *Degas Monotypes*, Catalogue, no. 68. For the notebook passage, see I. A. Richter, *The Literary Works of Leonardo da Vinci*, 2 vols., London, 1939, I, pp. 311–312.

49. Janis, *Degas Monotypes*, p. xxvi. For color reproductions, see D. Rouart, "Degas, paysages en monotype," *L'Oeil*, no. 117, September 1964, pp. 10–15.

50. Rewald, no. xx; dated 1880–1881, See *ibid.*, pp. 16–20; and Chap. VI, pp. 242–248. Illustrated above is a bronze cast with a muslin *tutu* and satin ribbon only.

51. See J.-K. Huysmans, "L'Exposition des Indépendants en 1881," *L'Art moderne*, Paris, 1883, p. 227.

52. See L. Tannenbaum, "Degas, Illustrious and Unknown," *Art News*, 65, no. 1, January 1967, p. 53.

53. Rewald, nos. LXVIII, XXVII; dated 1896–1911 and ca. 1886, though the latter is more likely of ca. 1889—see the following note. Illustrated above is a bronze cast of it, where the differences in material are obscured.

54. Letter to P.-A Bartholomé, June 13, 1889, *Lettres*, p. 135.

55. Lemoisne, no. 206; dated 1869, but more likely of ca. 1871. See S. Barazzetti, "Degas et ses amis Valpinçon," *Beaux-Arts*, no. 190, August 21, 1936, p. 3; based on an interview with Hortense Valpinçon.

56. Adhémar, no. 49; dated 1879–1880, but more likely of ca. 1882. See Rouart, *Degas à la recherche de sa technique*, p. 65; and Degas's letter to Alexis Rouart, 1882, *Lettres*, pp. 61–62. Illustrated above is the eighth state.

57. See B. Newhall, "Degas, photographe amateur," *Gazette des Beaux-Arts*, 61, 1963, pp. 61–64, and the letters published there.

58. In the *Bulletin de la Société Française de Photographie*, June 15, 1895; see Newhall, "Degas, photographe amateur," p. 61.

59. J. Cocteau, *Le Secret professionel*, Paris, 1922; quoted in L. Hoctin, "Degas photographe," *L'Oeil*, no. 65, May 1960, pp. 39–40. See also Guérin's remarks, in *Lettres*, p. 224, note 1.

60. See A. Scharf, *Art and Photography*, Baltimore, 1974, p. 356.

61. Notebook 31, p. 81; used in 1878–1879. See E. J. Marey, "Moteurs animés, expériences de physiologie graphique," *La Nature*, October 5, 1878; and G. Tissandier, "Les Allures du cheval," *ibid.*, December 14, 1878.

62. See Scharf, *Art and Photography*, pp. 205–208, 359; and Van Deren Coke, *The Painter and the Photograph*, Albuquerque, 1964, pp. 158–162.

63. Rouault, *Souvenirs intimes*, p. 94. The choice of Memling as an example, however, suggests Rouault's interests of the 1890s more than Degas's.

64. Jeanniot, "Souvenirs sur Degas," pp. 167–168. See also Vollard, *Degas*, p. 79, reporting his uncertainty about methods of priming a canvas.

65. Halévy, *My Friend Degas*, pp. 103–104.

66. Moreau-Nélaton, "Deux heures avec Degas," p. 269.

67. Not in Lemoisne; see T. Reff, "New Light on Degas's Copies," *Burlington Magazine*, 106, 1964, pp. 255–256, fig. 10. For the other copies, see Lemoisne, nos. 193, 193 *bis*; dated 1868–1872, but more likely of ca. 1865.

68. Jeanniot, "Souvenirs sur Degas," p. 154.

69. See E. P. Janis, "The Role of the Monotype in the Working Method of Degas," *Burlington Magazine*, 109, 1967, pp. 21–22. According to this source, about eighty monotypes were reworked in pastel.

70. Lemoisne, no. 456; dated 1877–1879. See Janis, *Degas Monotypes*, Checklist, no. 43; and H. Troendle, "Das Monotype als Untermalung; zur Betrachtung der Arbeitsweise von Degas," *Kunst und Künstler*, 23, 1925, pp. 357–360.

71. Lemoisne, no. 1231; dated ca. 1896. For a more detailed discussion, see Rouart, *Degas à la recherche de sa technique*, p. 50.

72. Valéry, *Degas Manet Morisot*, p. 94. For Rouart's copy, which has recently come to light, see Musée du Louvre, Paris, *Le Studiolo d'Isabelle d'Este*, May 31–October 13, 1975, no. 187.

73. Not in Lemoisne; published in Reff, "New Light on Degas's Copies," p. 256, fig. 5; see also *Le Studiolo d'Isabelle d'Este*, no. 186. Rouart, quoted in Valéry, *Degas Manet Morisot*, p. 95, describes Degas working on it.

74. Cennini, *Le Livre de l'art*, pp. 51–54, 107–108. Mottez's notes, *ibid.*, p. 153, actually state that "this system of Giotto's was later that of Titian and of the whole Venetian school." And the well-known treatise by J. F. L. Mérimée, *The Art of Painting in Oil and in Fresco*, London, 1839 [1st ed. Paris, 1830], pp. 284–285, cites Cennini's passage as a model for coloring in general.

75. Fèvre, *Mon Oncle Degas*, p. 26.

76. C. L. Eastlake, *Materials for a History of Oil Painting*, 2 vols., London, 1847–1869, II, chap. VI. There was no French translation, but Degas did read English. See also Mrs. [M. P.] Merrifield, *Original Treatises . . . on the Arts of Painting*, 2 vols., London, 1849, I, pp. cxvii-cxlviii, summarizing "opinions of eminent Italian artists as to the practice of the old masters."

77. Jeanniot, "Souvenirs sur Degas," pp. 293–294. The only known picture that fits this description, *In the Café*, Lemoisne, no. 624, dated 1880–1885, is painted on panel, not canvas.

78. Rouault, *Souvenirs intimes*, p. 94. Significantly, Degas's friend Chialiva maintained that Leonardo had used *peinture à l'essence* as a means of underpainting before glazing; see Rouart, *Degas à la recherche de sa technique*, p. 15.

79. Valéry, *Degas Manet Morisot*, pp. 93–94; from the reminiscences of Ernest Rouart. The picture is Lemoisne, no. 146; dated 1866–1868.

80. Rouart, *Degas à la recherche de sa technique*, p. 10. See Cennini, *Le Livre de l'art*, pp. 94–95, 117.

81. Vollard, *Degas*, pp. 75–76.

82. Goncourt, *Journal*, XVII, p. 64; dated June 7, 1890. The picture in question is probably *The Dancing School*, Lemoisne, no. 399, dated ca. 1876; it is painted in distemper.

83. Lemoisne, nos. 91, 587; dated 1861–1862 and ca. 1880. See also Ernest Rouart's observation, reported in Valéry, *Degas Manet Morisot*, pp. 92–93: "The urge to revise an unfinished work to his taste never left him, and many were the canvases he kept at home with a view to retouching them."

84. *Ibid.*, p. 92.

85. See Jeanniot, "Souvenirs sur Degas," pp. 299–300; and P.-A. Lemoisne, "Les Statuettes de Degas," *Art et Décoration*, 36, 1914–1919, p. 114.

86. See A. Michel, "Degas et son modèle," *Mercure de France*, 131, 1919, pp. 471–473. The author had been his model in the early 1900s.

87. Letter to R. Cortissoz, June 7, 1919; quoted in the latter's *Personalities in Art*, New York, 1925, pp. 245–246.

88. Moore, "Degas, The Painter of Modern Life," p. 416. Only one of the figurines, the *Little Dancer of Fourteen Years*, was dressed in a muslin skirt, as far as we know.

89. See Rewald, pp. 12–13. However, according to Adhémar, "Before the Degas Bronzes," p. 35, he did seek advice from experts such as Palazzolo about reinforcing the armatures of his statuettes.

90. A. Vollard, *Auguste Renoir*, Paris, 1920, p. 95. See also the memoir of Bartholomé, recorded in Lemoisne, "Statuettes de Degas," p. 110.

91. Rewald, no. I; dated 1865–1870, but in fact of ca. 1881. On its date and development, see Chap. VI, pp. 249–256.

92. See Rewald, pp. 21–22; and Barazzetti, "Degas et ses amis Valpinçon," pp. 1, 4; also Chap. VI, pp. 264–267.

93. Letter to Henri Rouart, 1884, *Lettres*, p. 89.

94. K. Clark, *Leonardo da Vinci*, Cambridge, 1939, p. 88. See the interpretation proposed in S. Freud, *Leonardo da Vinci*, Eng. trans., New York, 1947, pp. 32–35, 115–116.

95. See this chapter, p. 298. The comparison was drawn still earlier by Diego Martelli in his pamphlet *Gli Impressionisti*, Pisa, 1880; reprinted in his *Scritti d'arte*, ed. A. Boschetto, Florence, 1952, p. 106.

96. R. H. Ives Gammell, *The Shop-Talk of Edgar Degas*, Boston, 1961, p. 46.

97. Henri Rivière's reminiscence of Degas; reported in Lemoisne, I, p. 46. He had known Degas in the 1890s.

Index

Page numbers in italic type indicate illustrations.